TREASURES
from
The Art Institute of Chicago

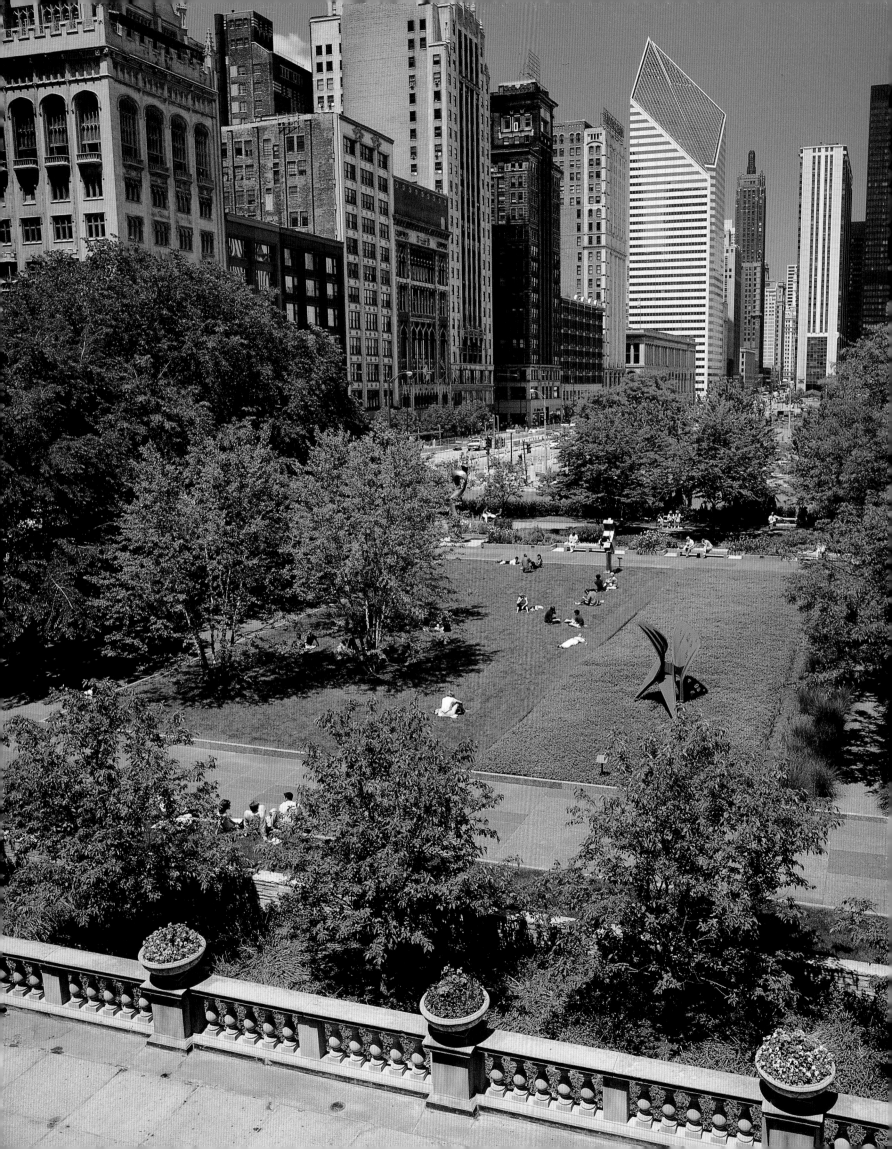

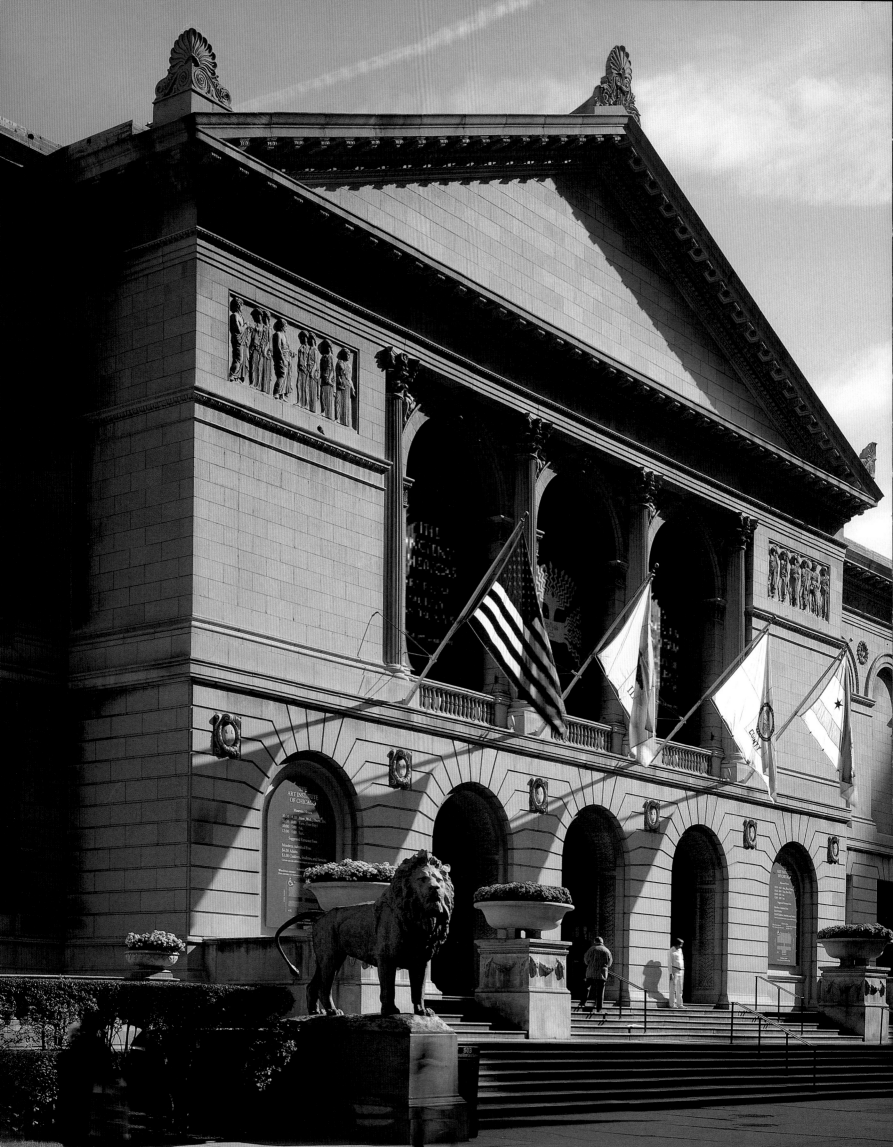

Treasures from The Art Institute of Chicago

Selected by James N. Wood, Director and President

with commentaries by Debra N. Mancoff

THE ART INSTITUTE OF CHICAGO

DISTRIBUTED BY HUDSON HILLS PRESS, INC., NEW YORK

This book was made possible by a grant from the Julius Frankel Foundation

Produced by the Publications Department, The Art Institute of Chicago, Susan F. Rossen, Executive Director
Edited by Laura J. Kozitka and Catherine A. Steinmann
Production by Amanda W. Freymann, Associate Director, and Stacey A. Hendricks, Production Assistant
Photo edited by Stacey A. Hendricks and Karen Altschul
Photography by the Department of Imaging, Alan B. Newman, Executive Director
Designed by Katy Homans, New York
Color separations by Prographics, Rockford, Illinois
Printed and bound by Mondadori Printing, S.p.A., Verona, Italy

First Edition
Published by The Art Institute of Chicago, 111 South Michigan Avenue, Chicago, Illinois 60603-6110;
http:/www.artic.edu/aic/books
Distributed by Hudson Hills Press, Inc., 122 East 25th Street, 5th floor, New York, New York 10010-2936
Editor and Publisher: Paul Anbinder
Distributed in the United States, its territories and possessions, and Canada through National Book Network

10 9 8 7 6 5 4 3 2 1
LIBRARY OF CONGRESS CATALOG CARD NUMBER: 99-069501
ISBN 0-86559-182-2

Front cover: René Magritte, *Time Transfixed*, 1938 (p. 279)
Endsheets: Dankmar Adler and Louis Sullivan, Stencil on the face of the main trusses of the Trading Room of the Chicago Stock Exchange (detail), 1893–94 (p. 178)
Back cover: left to right, top to bottom: *Mask* (Mukenga), Kuba, late 19th/mid-20th century (p. 24); *Mummy Case of Paankhenamun*, Egypt, 945/715 B.C. (p. 68); Winslow Homer, *The Water Fan*, 1898/99 (p. 180); Frank Lloyd Wright, *Triptych Window from a Niche in the Avery Coonley Playhouse, Riverside, Illinois*, 1912 (p. 245); Charles Honoré Lannuier, *Card Table*, c. 1815 (p. 161); *Nō Drama Robe*, Japan, 16th century (p. 47); Francesco Mochi, *Bust of a Youth*, c. 1630 (p. 112); Henri Cartier-Bresson, *Hyères, France*, 1932 (p. 270); Pierre Auguste Renoir, *Two Sisters (On the Terrace)*, 1881 (p. 206)
Photographs of The Art Insititue of Chicago: p. 1: north garden looking south to the Allerton Building; p. 2: south garden looking east to the Morton Wing; p. 3: north garden looking northeast; pp. 4–5: Allerton Building, Michigan Avenue entrance; p. 8: Main staircase, Allerton Building, looking east to the Spanish paintings gallery; p. 9: (above) Allerton Building, gallery of Japanese art designed by Tadao Ando; (below) Morton Wing, twentieth-century art galleries.

Contents

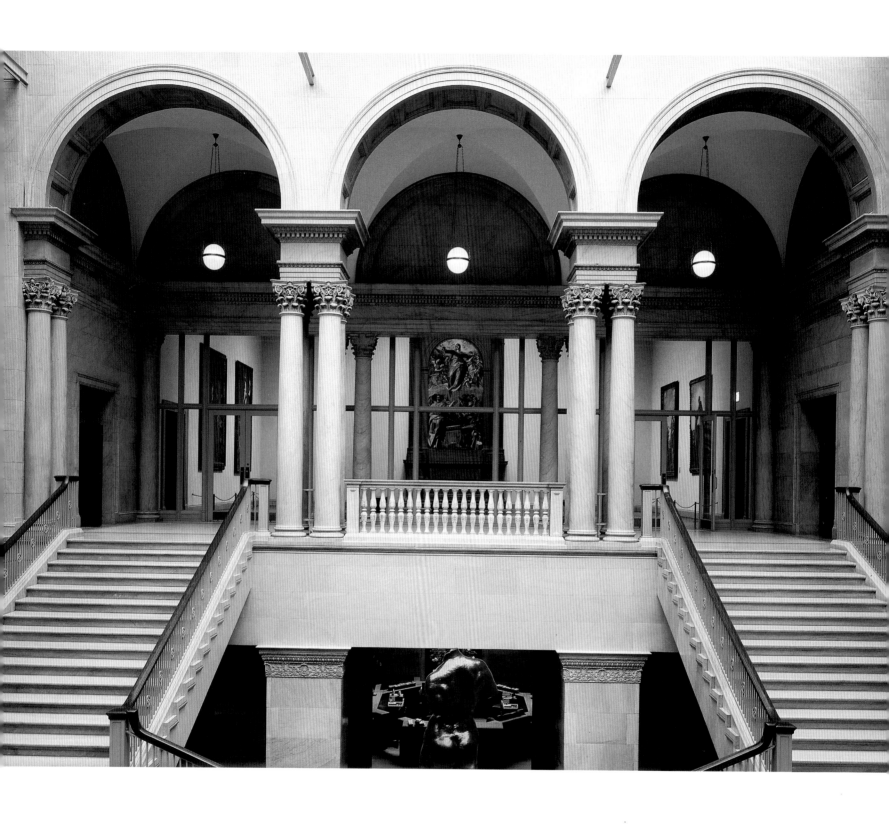

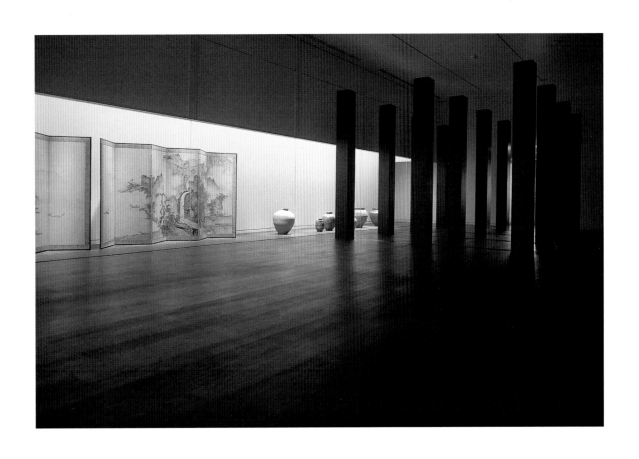

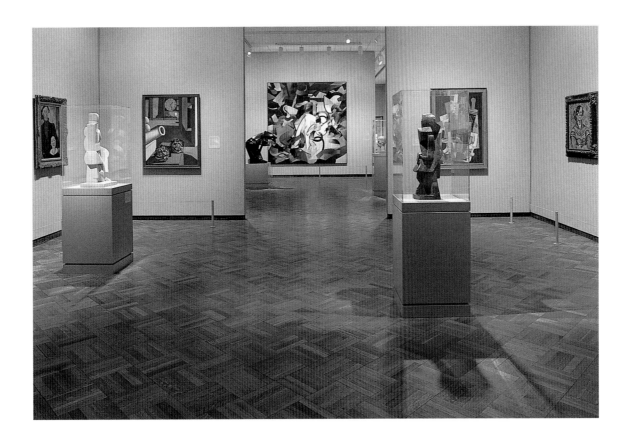

9

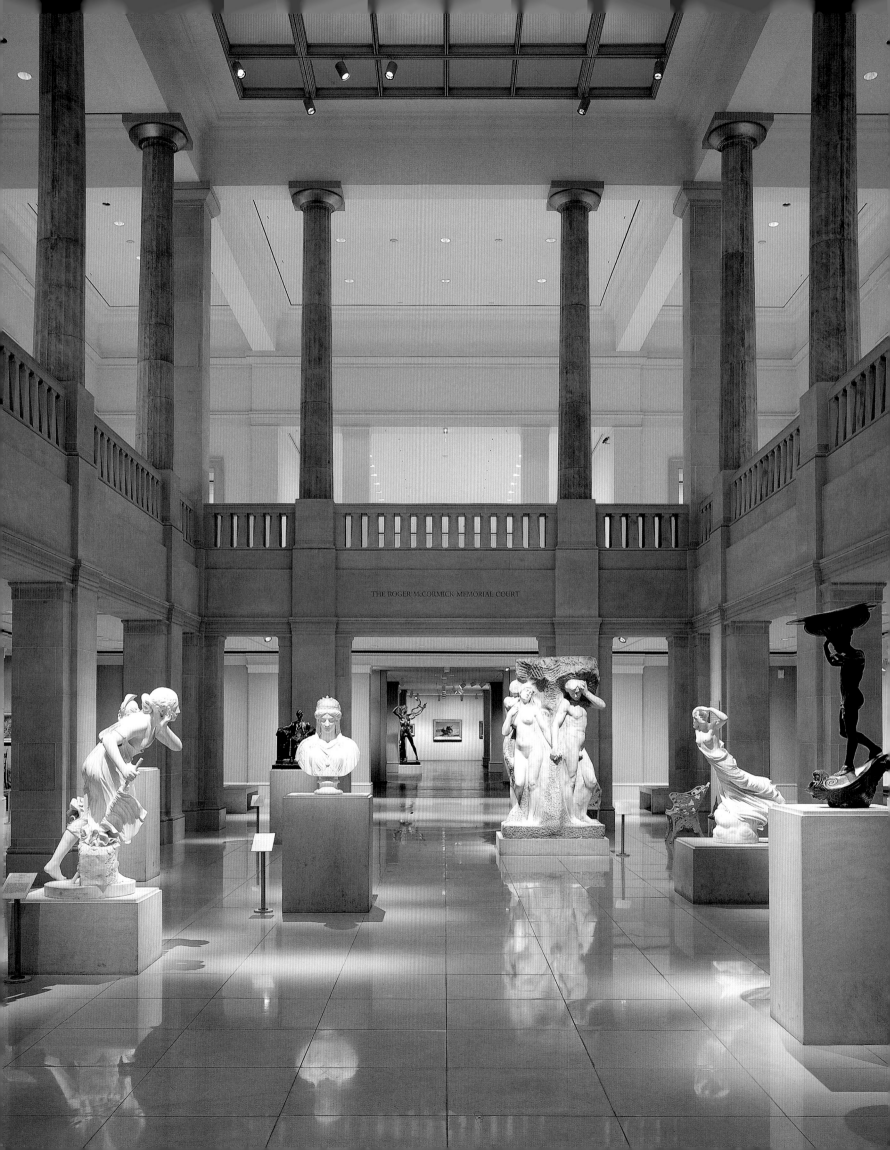

THE ROGER McCORMICK MEMORIAL COURT

Featuring over four hundred works of art, *Treasures from The Art Institute of Chicago* is the most comprehensive publication ever devoted to this museum. In this extensive, full-color volume, cultures worldwide are represented by objects in many media and from numerous periods—from antiquity through the late twentieth century. *Treasures* is unique for us in another way: it is arranged not, as in other books on the collections we have published, according to curatorial departments—many of which are defined by media—but rather in cultural and chronological sections, so that readers can enjoy a fuller sense of the extent of the museum's collections and of the civilizations and history these artistic achievements represent.

The use of the word "treasures" in the title of this book and as a principle of selection for its contents proved both a pleasure and a challenge, since the concept of a "treasure" can never be fixed. The treasures that the museum displayed in its earliest years, over a century and a quarter ago, were a comprehensive collection of plaster casts (see Introduction, p. 13, and fig. 2), which, as the museum added authentic objects to its holdings, became devalued and, sometime in the 1950s, destroyed. Today, we consider this regrettable, and would, if we still had these facsimiles, value them not for their purported closeness to distant originals but for what they could tell us about taste and culture at the end of the nineteenth century. The lesson to be learned from this story is the importance of a permanent collection, one that is studied, preserved, built upon, expanded, and reinterpreted as we learn more about what is in our care, about ourselves and our preconceptions about what "art" is or should be. Thus, we offer here a selection that, as readers will note in examining the captions for each plate, includes many accessions from the museum's early decades and an impressive number acquired more recently, to illustrate shifts in the cultural canon as well as the way continuity coexists with change.

Preface and Acknowledgments

James N. Wood, Director and President
The Art Institute of Chicago

As Director and President of The Art Institute of Chicago for nearly twenty years, I am deeply aware of, and grateful for, the role private individuals and organizations have played, in insuring the continuing greatness and vitality of our museum. The reader will note in nearly every credit line names of donors and supporters of this institution. So too this book is the result of a very generous grant from the Julius Frankel Foundation. We could never have produced such an inclusive and lavish publication without such support, and are very grateful at the foundation to Nelson D. Cornelius, John C. Georgas, and Rebecca J. McDade for their assistance and enthusiasm for this project.

I would also like to acknowledge a number of museum staff who made initial selections, supplied documentation for the plates, and provided guidance to the book's author and editorial team. In the African and Amerindian Art, Richard F. Townsend, Kathleen E. Bickford-Berzock, and Anne King; in American Arts, Judith A. Barter, Andrew J. Walker, Jennifer M. Downs, and Suzanne F. Gould; in Architecture, John R. Zukowsky and Luigi H. Mumford; in Asian Art, Stephen L. Little, Bernd Jesse, and Betty Seid; in European Decorative Arts, Sculpture, and Classical Art, Ian B. Wardropper, Ghenete Zelleke, Mary C. Gruel, Maren C. Nelson, Rebekah L. Levine, Karen Alexander, and Kirsten Darnton; in European Painting, Gloria L. Groom, Martha A. W. Wolff, Adrienne L. Jeske, and Kathy Galitz; in Modern and Contemporary Art, Stephanie D'Alessandro, James Rondeau, and Daniel Schulman; in Photography, David B. Travis, former staff member Sylvia M. Wolf, and Kristen S. Nagel Merrill; in the Department of Prints and Drawings, Douglas W. Druick, Suzanne McCullagh, Martha Tedeschi, Mark Pascale, Jay Clarke, Barbara Hinde, and Kate Reid; and in Textiles, Christa C. Thurman and Sherry L. Huhn. For their advice, we thank, in Museum Education,

Robert W. Eskridge, Katherine M. Bunker, and Margaret F. Farr; and, in the Museum Shop, Elizabeth Grainer, Melanie J. Eckner, Richard T. Fox, and Marianne L. Rathslag. I would also like to thank Meredith M. Hayes and Lisa Key in Foundation and Corporate Relations for their help in securing the support of and working with the Julius Frankel Foundation.

Special thanks are due to Debra N. Mancoff, who wrote the text for this volume. In Publications I wish to thank Laura J. Kozitka, Catherine A. Steinmann, Susan F. Rossen, and former intern Sarah Hezel for organizing, editing, and preparing the book's text. Amanda Freymann and Stacey A. Hendricks were responsible for its production. Ms. Hendricks and Karen Altschul managed photo rights. Photography was provided by Imaging Services; I am grateful to Alan B. Newman, Christopher Gallagher, Carrie Schweiger, Gregory Williams, and former staff members Sydney Orr and Iris Wong. The elegant design is that of Katy Homans, New York. We are pleased that Paul Anbinder, Publisher, Hudson Hills Press, has again agreed to distribute an Art Institute publication; his enthusiasm for our collections-related books and dedication to them are admirable. The book was beautifully printed by Arnoldo Mondadori Editore, Verona, Italy. Finally, I would like to acknowledge the great efforts and skills of our color separator, Pat Goley, his associate Cynthia Richards, and his team at Prographics, Rockford, Illinois, whose concern for excellence and exactitude helped make this volume worthy of the works it reproduces.

A museum is known to the world through its treasures. The Art Institute of Chicago's collections of nineteenth- and twentieth-century European and American art, Japanese woodblock prints, Old Master prints and drawings, and much more have helped rank this museum as one of the world's most important. The history of the Art Institute's growth from a small selection of instructional objects to a repository of outstanding works reflects that of a midwestern American city's developing identity as a cultural center. Indeed, much about the Art Institute and Chicago is revealed in the depth and breadth of the collections, which have been shaped by enduring standards of quality, the insight and interests of notable individuals, and evolving aesthetic and intellectual criteria for what a great art museum should be.

After the Great Fire that destroyed much of Chicago in 1871, the rapid reconstruction of the city evoked the image of a phoenix, rising magnificently from the ashes of destruction. A combination of

The Art Institute of Chicago: An Introduction

Debra N. Mancoff

entrepreneurial spirit, optimistic ethos, and booming economy fueled a vision of Chicago that was as vital and cosmopolitan as the urban centers of America's East Coast. Prominent Chicagoans understood that cultural institutions were key in transforming the city into a sophisticated metropolis; they supported the development of a symphony, libraries, universities, and museums dedicated to natural history, science, and the fine arts.

In 1879, through the initiative of private citizens, the Chicago Academy of Fine Arts replaced the failing Academy of Design (founded in 1866). The mission of this invigorated institution expanded the old Academy's educational aims to include the "formation and exhibition of objects of art, and the cultivation and extension of the arts by any appropriate means." William M. R. French (brother of sculptor Daniel Chester French) served as the first director, from 1885 to 1914.

Within three years of its founding, the Academy changed its name to The Art Institute of Chicago and elected financier Charles L. Hutchinson as the first president of its board of trustees. In 1887 the museum and its school moved into a new building, designed by the Chicago firm Burnham and Root, on the southwest corner of Michigan Avenue and Van Buren Street, to accommodate its growing needs.

The early collections supported the institution's primary mission, providing examples to instruct students. The Antiquarian Society (founded in 1877 as the Chicago Society of Decorative Arts; it became affiliated with the Art Institute in 1894) made a generous donation of vestments and tapestries in 1890 and, in the following year, established a fund for the purchase of "industrial arts." In 1893 the Art Institute acquired a collection of casts of classical sculptures (see fig. 2), the largest in the country to date. Study of the antique was considered critical to an artist's training; and, at a time when only privileged Chicagoans could travel abroad, reproductions of works of art served as important tools for cultural education.

In 1893 the city drew international attention by hosting the World's Columbian Exposition. Buoyed by civic confidence, the Art Institute took a bold step toward establishing a new identity. Hutchinson, who also chaired the exposition's Commission of Fine Arts, convinced the fair's managers to partly subsidize the construction of a building on Michigan Avenue at Adams Street (fig. 1). The structure's Beaux-Arts design, by the firm of Shepley, Rutan, and Coolidge, symbolized the museum's elevated ambitions: with the names of renowned classical and European artists (as well as one from Japan) carved on the entablature of its temple front and along its sides, the building promised a future when the galleries would be filled with a distinguished collection.

Limited in its funds, the Art Institute benefited from the support of its trustees. In 1890, when a prominent European art patron, Prince Anatole Demidoff, offered to sell thirteen works from his collection of Dutch masters—including examples by Frans Hals, Meindert Hobbema, and Rembrandt van Rijn—Hutchinson, Martin A. Ryerson, and other leading Chicagoans guaranteed their purchase. A gift from Edward S. Stickney, including 460 master prints and a collections fund, further expanded the European holdings. Frank Gurley's donation in 1922, in memory of his mother, Leonora Hall Gurley, formed the foundation of a drawings collection. Cataloguing of these six thousand works is still in process; in 1996 one Gurley drawing (p. 91) was attributed to Raphael.

The acquisition of El Greco's *Assumption of the Virgin* (p. 99) in 1906, on the advice of artist Mary Cassatt (see pp. 176–77), demonstrated the confidence and foresight that would guide the museum to assemble its highly distinctive collection. In a period when Dutch, Flemish, and Italian pictures set the standard of a masterwork for collections, a Spanish painting was a bold purchase. Hutchinson and Ryerson arranged for temporary donors until 1915, when Nancy Atwood Sprague provided funds for the acquisition.

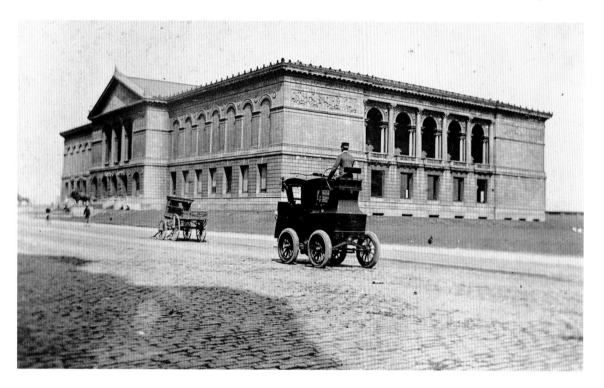

Figure 1. The Art Institute of Chicago, looking northeast across Michigan Avenue, c. 1894.

The core collections of European art continued to grow. In 1906, prompted by the closing of the Field Museum of Natural History's Industrial Arts division, Ryerson convinced the Art Institute's trustees to purchase the textile collection assembled by Edward E. Ayer during his European travels. With the advice and support of architect David Adler, antiquities and classical sculptures were added, supplanting the collection of casts. Established in 1916, the museum's Department of Decorative Arts quickly began to acquire European objects, including medieval and Renaissance works presented by Lucy Maud Buckingham, faience and furniture from Robert Allerton, and the Mühsam collection of northern and central European glass. With an extensive list of individual patrons and the Antiquarian Society, the museum's oldest continuing support group, this collection has evolved into one of the Art Institute's largest; two extensive gifts received in recent years have proven immensely popular: Arthur Rubloff's collection of glass paperweights and the Harding Collection of Arms and Armor.

Long connected with this department, although with a small staff of its own by the late 1940s, the textile collection became a separate entity in 1961. With support from many donors, including the Textile Society of the Art Institute, it has built upon its strengths in western textile arts while expanding into areas such as Pre-Columbian, Near and Far Eastern, and contemporary textile arts.

During the 1920s and 1930s, generous bequests transformed the paintings collection. Mrs. Palmer's initial interest in French Romantic and naturalist painting led her to the Impressionists. In 1922, when the collection of Mr. and Mrs. Potter Palmer was bequeathed to the museum, her farsighted choices laid the foundation for the Art Institute's pre-eminence in nineteenth-century art. Just four

years later, in 1926, the Art Institute accepted the Helen Birch Bartlett Collection, presented by Frederic Clay Bartlett in memory of his wife. This, the first group of Post-Impressionist paintings to enter an American museum, included, among other notable works, Georges Seurat's monumental *Sunday on La Grande Jatte—1884* (p. 211). When the Bartlett Collection was unveiled in the galleries, an editorial in a New York newspaper declared, "Americans who wish to enjoy the acquaintance of the leading European modernist artists must make the journey to the metropolis of the Middle West."

In 1933 the museum received what remains to date its greatest gift: the collection of Mr. and Mrs. Martin A. Ryerson. This extraordinary bequest included not only Old Master and modern European works, but also American paintings and outstanding prints, textiles, and decorative arts. Annie Swann Coburn's bequest, which entered the Art Institute the same year as that of the Ryersons, reflected her love of Impressionism and Post-Impressionism. Charles H. and Mary F. S. Worcester assembled their personal collection with the intention of eventually supplementing the museum's holdings. Their gifts, made between 1925 and 1947, added cohesion to the museum's selection of European paintings; they also established a purchasing fund that would help the museum to complement its recognized strengths, most notably Gustave Caillebotte's *Paris Street; Rainy Day* (p. 204). As recently as 1999, with the donation of twelve works from the Sara Lee Corporation, the museum's almost unparalleled collection of nineteenth- and early twentieth-century European works has continued to grow.

With an emphasis on French masters, the prints and drawings collection developed in accord with that of paintings, helping to provide a context for those works and filling in salient voids. In 1938 Kate S. Buckingham donated her brother's collection of master prints and established a fund that has allowed such purchases as drawings and etchings by Rembrandt van Rijn (see pp. 118–19) and woodcuts by Paul Gauguin (see p. 221). After World War II, patrons Margaret Day Blake, Pauline Palmer, and Helen Regenstein helped establish a collection of French drawings that has since attained international recognition.

In the late nineteenth century, and well into the twentieth, European art served as the measure of strength of an international collection. All too often this meant that objects outside of that tradition were relegated to culturally specific collections or displayed as artifacts in historical or natural-history museums. But over the course of the twentieth century, as the western world view widened and American communities increasingly diversified, museums such as the Art Institute have become more inclusive, expanding their holdings in depth and dimension.

Chicago's interest in Asian art can be traced to the display in the Japanese Pavilion at the Columbian Exposition; among the many visitors were Clarence Buckingham and architect Frank Lloyd Wright, both of whom became enthusiastic collectors. Drawing upon local collections, Wright designed two exhibitions of Japanese prints for the Art Institute, in 1906 and 1908. Established in 1922, the Department of Oriental Art benefited enormously, just three years later, from the bequest of Buckingham's remarkable collection, which included Chinese and Japanese paintings, Chinese prints, and an outstanding and extensive array of Japanese prints. In 1938 a donation by Buckingham's sister, Kate, significantly strengthened the museum's Chinese holdings. Renamed in 1988, the Department of Asian Art now includes works from many cultures, from the Near East to India and the Far East. Recently, the generosity of James and Marilynn Alsdorf and the Alsdorf Foundation resulted in important additions of the art of India, the Himalayan nations, and Southeast Asia.

For many years, the arts of Africa and of the Indian Americas, while of interest to individual collectors, were largely defined as anthropological objects and thus rarely displayed in art museums. In 1927 a week-long exhibition, "The Negro in Art," held at the Art Institute, provided the occasion to display a selection of works, from what was then the Belgian Congo, from the Blondiau Collection.

During the 1930s, '40s, and '50s, knowledgable individuals in Chicago, such as Nathan Cummings, Emil Meier, Raymond Wielgus, and the Wasserman-San Blas family actively collected African and Amerindian art. Established in 1958, the Art Institute's Department of African Art staged its first exhibition, "Primitive Art in Chicago," in 1960, drawing upon these collections. The renaming of the department as that of African and Amerindian Art, adopted in 1997, reveals the greater scope made possible by bequests of generous donors, as well as the museum's expanded sense of itself as an active participant in a world culture.

In recognizing the importance of an international collection, the Art Institute has also maintained a clear sense of the need to reflect artistic achievement in the United States. The "American Exhibition," initiated in 1888, created a forum for contemporary American artists. In 1900 the museum established for this annual exhibition a purchase prize, which guaranteed the regular acquisition of American works, including such important paintings as Henry Ossawa Tanner's *Two Disciples at the Tomb* (p. 234) and Willem de Kooning's *Excavation* (pp. 286 and 295). The arts of North America also appealed to many local collectors; the gifts of such donors as James and Charles Deering, Samuel Nickerson, the Palmers, the Ryersons, and others helped build a strong foundation for a comprehensive survey of the arts of this nation. The Friends of American Art, a purchasing group founded in 1910, worked to fill the lacunae in the collection, as has continuing support from the McCormick and Field families. The Department of American Arts was established in 1975; it includes paintings, sculptures, and the decorative arts from the European settlement of North America through the nineteenth century.

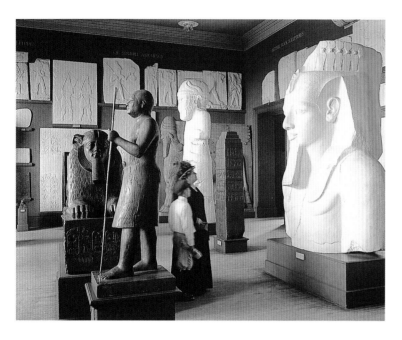

Figure 2. Gallery, with plaster casts of Egyptian and Assyrian sculptures, at The Art Institute of Chicago, 1917.

Chicago's architecture has become a defining element of the city's identity. The Department of Architecture, created in 1981, documents the unique developments in the building arts in Chicago and its environs. In 1912 architect Daniel Burnham bequeathed funds for the museum's important architectural library, which bears his name. Over the years, the Art Institute has become an important repository and center for studying the region's great and continuing architectural legacy—from the influential Prairie School (see p. 245) to the classic modernism of Ludwig Mies van der Rohe (see p. 296) and the city's many fine postmodernist structures (see pp. 318–19). The archival origins of the collection have shaped its contents. In 1922 the museum commissioned the impoverished Louis Sullivan to produce his important *System of Architectural Ornament* (see p. 262); many years later, the museum was able to preserve and install the Trading Room (p. 178) of this architect's Stock Exchange, which was demolished in 1971, with the support of Mrs. Edwin J. De Costa and the Walter E. Heller Foundation.

Throughout the twentieth century, the Art Institute has been attentive to contemporary trends, keeping the collection current and staging exhibitions that offer audiences opportunities to deepen their understanding and appreciation of the art of their own time. In 1913 the museum hosted the "International Exhibition of Modern Art," known as the Armory Show (see fig. 3). Although the institution's director, the press, and even many art students found the works of Marcel Duchamp, Henri Matisse, Pablo Picasso, and others too extreme, local collectors such as Arthur Jerome Eddy embraced modernism, as did Robert B. Harshe, who became director in 1921. That year the museum received the unusual and farsighted bequest of Joseph Winterbotham, which provided funds for the purchase of thirty-five works and mandated that any of these could be sold to improve the collec-

tion. Ten years later, the museum secured several works from Eddy's outstanding contemporary collection. Named Harshe's successor in 1938, Daniel Catton Rich served as director until 1958; during his tenure, he championed modern art, creating a curatorship devoted to twentieth-century painting and sculpture in 1953 (a separate department was established in 1966; it has recently been renamed the Department of Modern and Contemporary Art).

In 1949 Rich's close friend the artist Georgia O'Keeffe, an alumna of the School of the Art Institute, donated to the museum a number of works from the collection of her husband, photographer and dealer Alfred Stieglitz. The photographs in that bequest provided the impetus for forming a photography collection and naming staff to care for and expand it; the Department of Photography was established in 1974. In only a few decades, this department's holdings have become renowned through the support of many groups and individuals. one of whom was Julien Levy, for many years America's leading dealer in Surrealism. The museum's strong representation of Surrealist art extends to paintings, sculptures, assemblages, prints, drawings, book bindings, and other materials, thanks to the generosity of individuals such as Levy, Mary Reynolds, Joseph Randall Shapiro, and Lindy and Edwin Bergman. In recent years, gifts such as those of the Society of Contemporary Art and the Lannan

Figure 3. The Armory Show installed at The Art Institute of Chicago in 1913.

Foundation have furthered the museum's identity as a discerning proponent of new work.

In the past twenty years, under the leadership of Director and President James N. Wood, the Art Institute has continued to add to and diversify its holdings; to reconsider them in a number of significant reinstallations of the permanent-collections galleries; and to reassess and enrich its relationship with its growing audiences through expanded programming, extensive reconfiguration of the current museum campus, and planning of future building spaces.

In the over one hundred twenty years of its existence, the museum has evolved from a modest, midwestern center for visual education into an important art school and an internationally renowned collection of world art. This period has witnessed an enormous transformation of the relatively monolithic artistic canon that the museum's founders shared. A single standard defining a treasure by culture, date, and hand no longer exists; certainly, the list of treasures presented here will be as different one hundred years hence as it would have been one hundred years ago.

Yet perhaps it is safe to say that the most treasured objects share an iconic quality that resonates with human experience and possesses the innate power to move us beyond the constraints of time, place, and circumstance. The selections in *Treasures from The Art Institute of Chicago* reveal more than the history of one city's taste; they create a vivid portrait of a museum's ongoing attempt to achieve balance between the age-old traditions it preserves and the new ideas and challenges that confront it in our ever-changing world. This process of debate and contemplation keeps the museum and its community vital and permits them to develop fresh criteria for what constitutes a treasure.

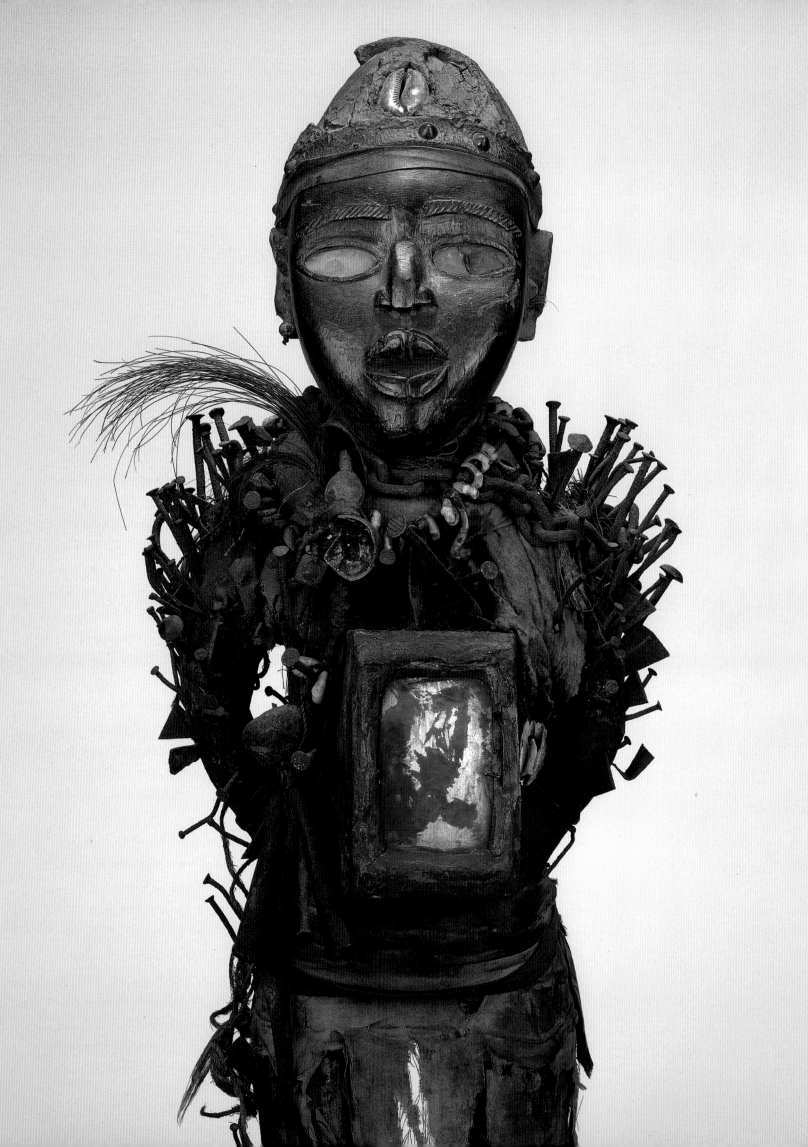

The singular designation of "sub-Saharan African art" encompasses the artistic production of a vast, culturally diverse, and historically deep cross-section of the African continent. The collection of sub-Saharan African art in the Art Institute strives to reflect this heterogeneity, ranging in form from figures to masks to furniture, and in material from wood to terracotta to mixed media. The museum is fortunate to have a small number of archeological sculptures, including a group of ancient terracotta figures that were found in the present-day nation of Mali (p. 20). However, the hot and humid climate that predominates in much of West and Central Africa is not conducive to the preservation of perishable materials; many objects made from such materials have not survived through the centuries. Reflecting this, the majority of artworks in the Art Institute's collection, such as the spectacular mixed-media mask from the Kuba region of the Democratic Republic of the Congo (p. 24), were made in the nineteenth and twentieth centuries. These works of art are part of

Sub-Saharan Africa

a larger continuum of varied and expressive artistic traditions that have endured and expanded over time.

The varied geography of Africa has contributed to the development of different material traditions across the continent. An animated pair of animal headdresses from Mali (p. 20) represents the Bamana culture of the Western Sudan, a fertile savanna where rituals and masquerades celebrate the agricultural cycle. To the south of this, stretching from Senegal to Cameroon, is the Guinea Coast, home to the kingdoms of Asante, Yoruba, and Benin. Artists of this region have produced works that evoke and enhance royal power, such as the regal and expressive figural veranda post by the great Yoruba sculptor Olowe of Ise (p. 21), which was conceived as part of an elaborate architectural ensemble for the palace of a king. The Equatorial Forest, which includes the modern nations of Cameroon, Gabon, and the Democratic Republic of the Congo, has seen recurrent migrations. Masterpieces such as the delicate and detailed Luluwa maternity figure (p. 25) have become distinctive icons of these fluid communities.

Many of the museum's sub-Saharan African artworks have a profound expressive appeal, but it is important to be aware that, removed from their original settings and functions, they are incomplete. For example the projecting nails that stud the body of the Kongo male figure (pp. 18 and 23) give it a harsh, provocative look; however, the violence they suggest can be misleading. In fact the nails document the many instances in which this *nkisi* (power figure) mediated between spiritual forces and human experience: the figure was made for a ritual specialist, who provoked the forces it contained through actions that included driving a nail into the form. The most immediate impression museum viewers have of the Kuba mask is the richness of its materials; but, when worn as part of a ceremony performed at the funeral of an elite member of a community, it crowned a costumed dancer wearing a stunning ensemble of layered raffia skirts, belts, bracelets, and anklets, many embellished with cowrie shells and glass beads. Thus, the layers of symbolism of the complete costume, along with the dancer's movement, combined to enhance the visual effect of this mask. Approaching such an object in a museum gallery, we can only appreciate a single dimension of its arresting power.

It is the aesthetic qualities of these treasures of sub-Saharan African art that speak to viewers. For example the hand of a master is found in the distinctive artistry of Olowe of Ise, making the figures on the veranda post unmistakably his work. Moreover, an object such as the refined Luluwa maternity figure illustrates that an important function—in this case the enhancement of fertility and easing of childbirth—can be expressed through beauty that, as in all great art, transcends context and communicates across cultures.

Male Figure (Nkisi Nkondi) (detail).
See page 17.

West Africa

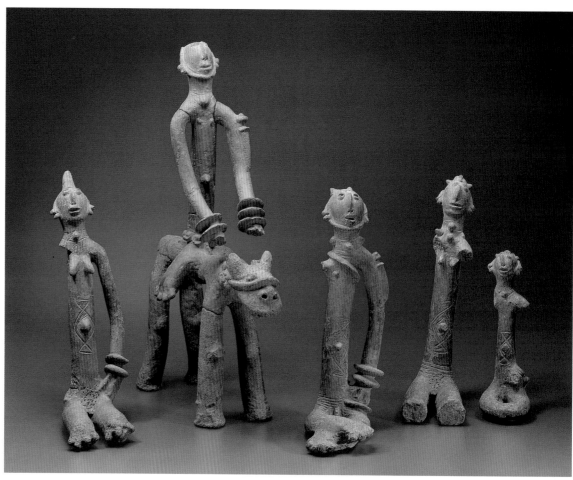

Equestrian and Four Figures

Mali, Bougouni, Bankoni, probably late 14th/early 15th cen.

Terracotta; equestrian: 70 x 21 x 48.5 cm (27½ x 8¼ x 19 in.); other figures: max. h. 46 cm (18 in.)
Ada Turnbull Hertle Endowment, 1987.314.1–5

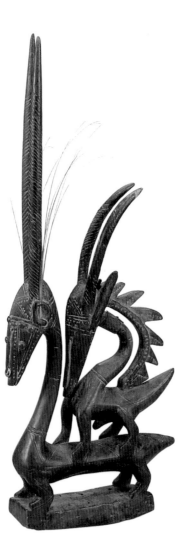

Headdresses
(Chiwara Kunw)

Mali, Segou, Bamana, mid-19th/early 20th cen.

Wood, brass tacks, metal, and quills; left: 98.4 x 40.9 x 10.8 cm (38¾ x 16⅛ x 4¼ in.); right: 79.4 x 31.8 x 7.6 cm (31¼ x 12½ x 3 in.)
Ada Turnbull Hertle Endowment, 1965.6–7

Ceremonial Drum (Pinge)

Ivory Coast (Côte d'Ivoire), Senufo,
1930/50

Wood, hide, and applied color;
h. 122.9 cm (48⅜ in.);
diam. at top 49.2 cm (19⅜ in.)
Robert J. Hall, Herbert R. Molner,
Curator's Discretionary, and
Departmental Purchase funds; Arnold
Crane, Mrs. Leonard Florsheim, O.
Renard Goltra, Holly and David Ross,
Departmental Acquisitions, Ada
Turnbull Hertle, Marion and Samuel
Klasstorner endowments; through prior
gifts of various donors, 1990.137

Olowe of Ise
(Yoruba; c. 1873–1938)

*Veranda Post of an
Enthroned King and Senior
Wife from the
Palace of the Ogoga
of Ikere* (Opo Ogoga)

Nigeria, Ekiti, Ikere; Yoruba, 1910/14
Wood and pigment;
152.5 x 31.8 x 40.6 cm (60 x 12½ x 16 in.)
Major Acquisitions Centennial
Endowment, 1984.550

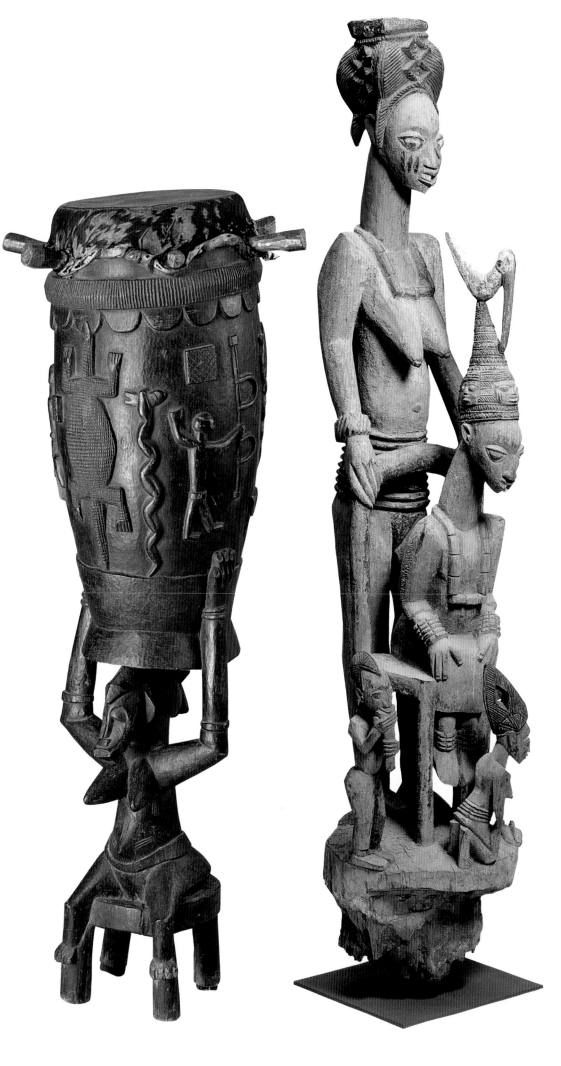

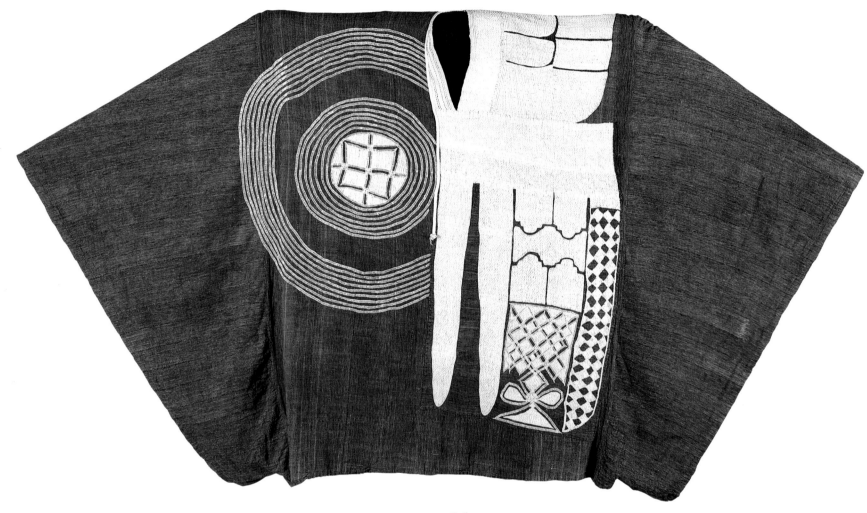

Robe

Nigeria, Nupe or Hausa, 1940s

Cotton, pieced narrow strips of
plain weave; embroidered with cotton
in buttonhole, knotted buttonhole,
open chain, and stem stitches;
edged with oblique interlacing;
134.4 x 256.4 cm (52⅞ x 101 in.)
Restricted gift of Mr. and Mrs. David C.
Ruttenberg, 1986.1004

Central and South Africa

Mbeudjang
(Bangwa; active early 20th cen.)

Seated Figure of Metang, the Tenth King (Fon) *of Batufam*

Batufam Kingdom, Cameroon; Bamileke, 1912/14
Wood and traces of pigment; 131 x 43.2 x 31 cm (51½ x 17 x 12¼ in.)
Major Acquisitions Centennial Endowment, 1997.555

Male Figure (Nkisi Nkondi)

Democratic Republic of Congo (formerly Zaire), Kongo, Vili sub-group, early/mid-19th cen.

Wood, metal, glass, fabric, fibers, cowrie shells, bones, leather, gourds, and feathers; 72 x 24.1 x 19.7 cm (28½ x 9½ x 7¾ in.)
Ada Turnbull Hertle Endowment, 1998.502

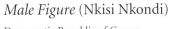

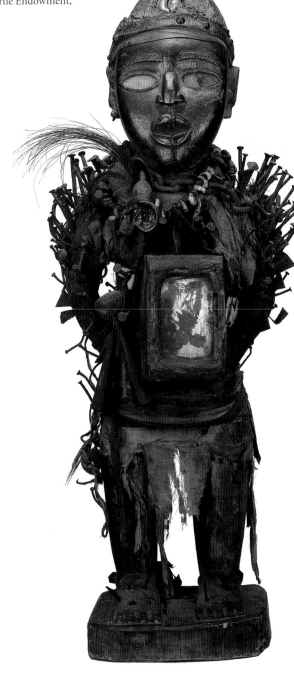

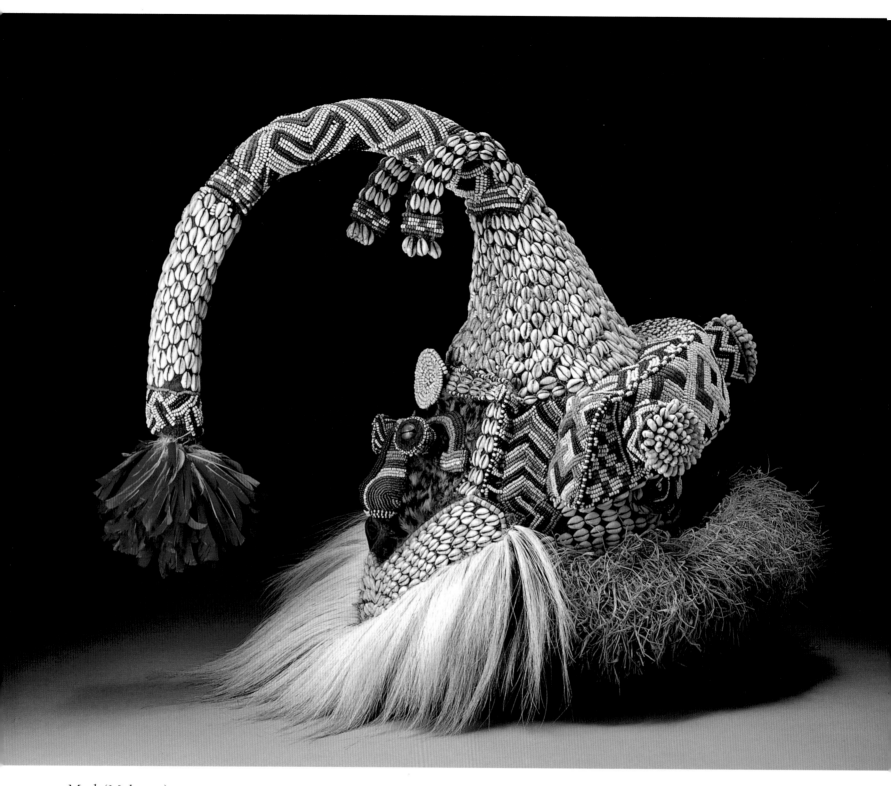

Mask (Mukenga)

Democratic Republic of Congo
(formerly Zaire), Western Kasai,
Kuba, late 19th/mid-20th cen.

Wood, glass beads, cowrie shells,
feathers, raffia, fur, fabric, string, and
bells; 57.5 x 22.9 x 20.3 cm (22⅝ x
9½ x 8 in.)
Laura T. Magnuson Fund, 1982.1504

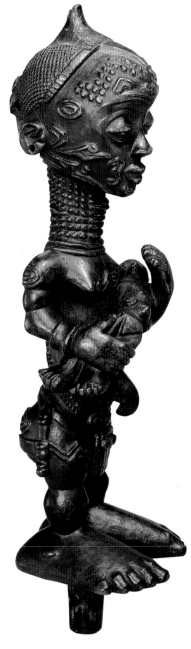

Maternity Figure

Democratic Republic of Congo (formerly Zaire), Luluwa, mid-/late 19th cen.

Wood and pigment; 28.9 x 8.6 x 8.2 cm (11⅜ x 3⅜ x 3¼ in.)
Wirt D. Walker Endowment, 1993.354

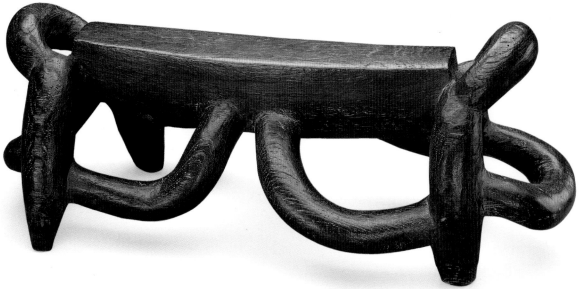

Neck Rest (Isicamelo)

South Africa, Northern Nguni, probably Zulu, early/mid-19th cen.

Wood; 17.8 x 43.8 x 16.2 cm (7 x 17¼ x 6⅜ in.)
Edward E. Ayer Endowment in memory of Charles L. Hutchinson, 1996.434

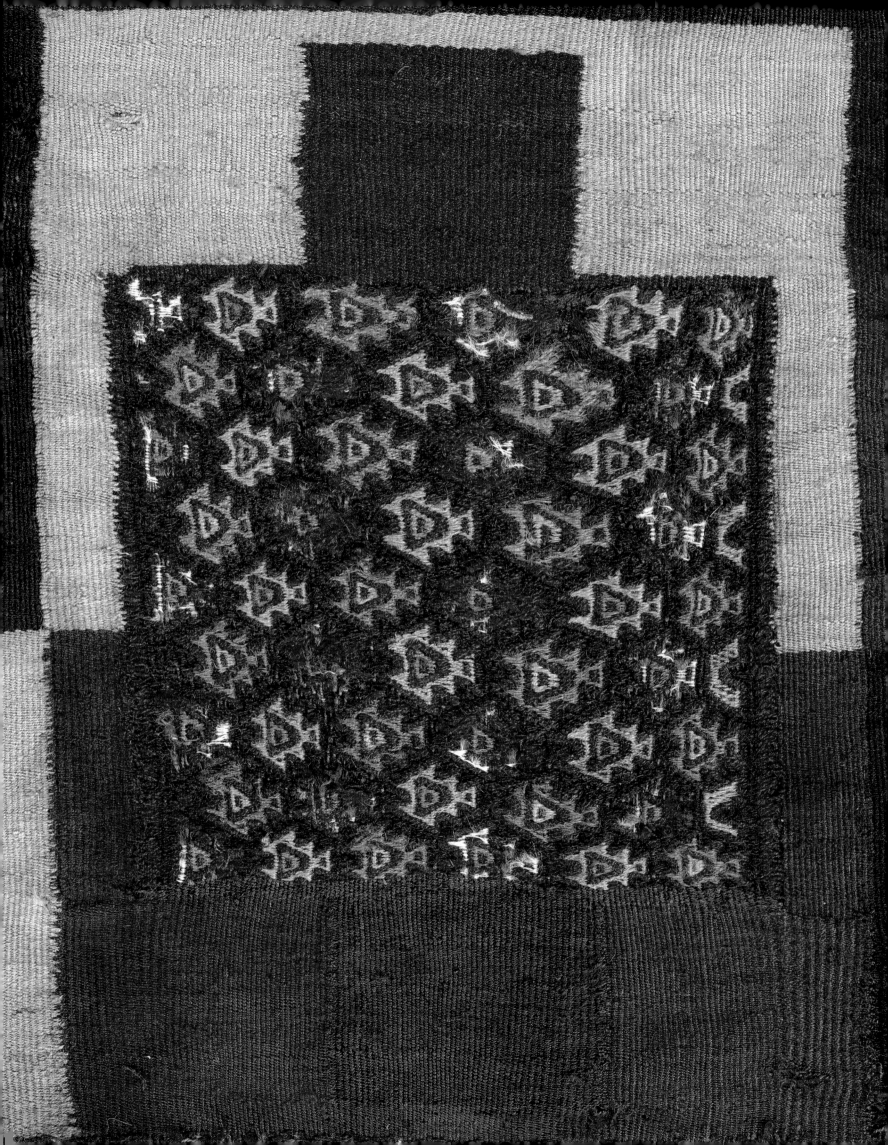

The *Stone of the Five Suns* (p. 30) commemorates a crucial event in the history of the Aztecs. The ideograms in the corners represent four previous mythical eras of the Aztec world and the circumstances that brought about their violent end. In the center, the X-shaped form denotes the present era of Aztec domination, while the square cartouche below and the crocodile above indicate the year and the day (15 July 1503, according to the European calendar) that marked the coronation date of Motecuhzoma II (formerly called Montezuma). The monument officially designated Motecuhzoma II as the ruler of the world, so destined by a cosmology of birth, decline, and renewal that was deeply connected to Aztec history. Yet his reign was to end in less than two decades, when an army of Spaniards and their Indian allies led by Hernán Cortés destroyed the Aztec empire.

Agricultural settlements emerged in Mesoamerica as early as the eighth millennium B.C., encompassing the Mexican plateau, the Yucatan peninsula, and present-day Guatemala and Honduras. By the first millennium before the Common Era, urban societies with monumental architecture, intricate systems of writing and calendrics, as well as refined cultural traditions, rose in this region. Other

The Indian Americas

societies of similar complexity developed along the coastal lands and in the Andes of modern-day Peru and Bolivia. The first centuries of the Common Era saw the astonishing growth of the great city-states of Mesoamerica; Teotihuacan, located thirty miles northeast of present-day Mexico City, reached its apex around 650. The Maya peoples to the south built Tikal and many other centers of power. The great Aztec capital Tenochtitlan equaled the grandeur of the past; during the reign of Motecuhzoma II, broad avenues, pyramid-temples, and palaces graced an island in the high lake basin where Mexico City stands today.

Although these societies had individual identities and modes of expression, they shared the concerns of all social orders based on agriculture, depending upon the regular regeneration of their lands through the cycle of the seasons. Such concerns are reflected in the artistic production of these peoples. For example the ritual-center model from West Mexico (p. 28) portrays a ceremonial feast; these celebrations occurred throughout the year in observance of the stages of the seasons. Made as a burial object, the sculpture testifies to life's perpetuating power. As in most agricultural societies, it was the religious responsibility of the ruler to negotiate with the gods representing the forces of nature that sustained earthly existence. Images such as the Olmec figurine (p. 28) and the Mayan stela (p. 29) commemorate rites of passage—maturation or the assumption of power—in the lives of important leaders. The mural fragment (p. 29) from the grand city of Teotihuacan depicts a high priest in a ritual costume expressing his people's gratitude for water.

Works of art made in the Indian Americas are equally distinctive for their supreme level of craftsmanship. For example the Olmec were master carvers, working stone without metal implements. The Inca were unsurpassed in their weaving technology; the woven patterns of the Inca poncho (p. 32) create a rhythm as complex as polyphonic music. Ancient Peruvian metallurgy, as seen in the ceremonial knife from Lambayeque (p. 32), achieved expertise in the full repertory of goldsmithing, including casting, cutting, and repoussé (hammering a relief form into metal from the back side). Basketry has ancient and utilitarian origins, but the exquisite patterns of objects such as the gambling tray from early twentieth-century California (p. 33) illustrates the sophisticated aesthetic inherent to the craft. Even today, with the grand cities of Mesoamerica known only through archeological remains, the fine standards of these peoples' traditions endure in such modern-day objects.

Inca Poncho (Burial Mantle)(detail). See page 32.

Mesoamerica

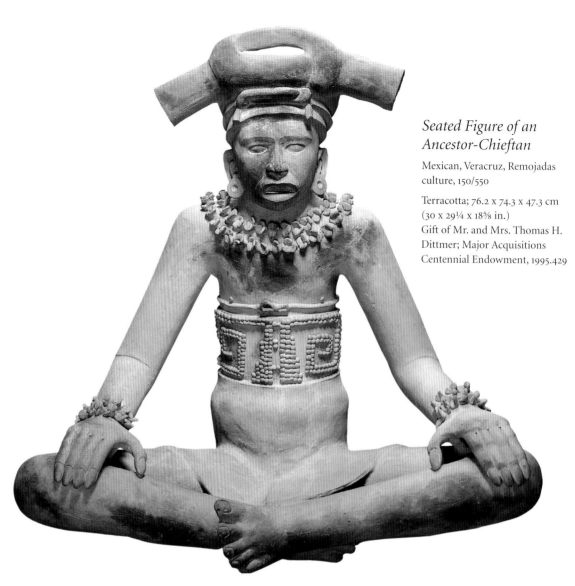

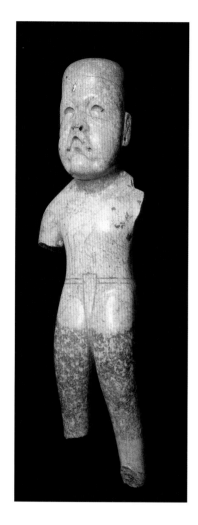

*Seated Figure of an
Ancestor-Chieftan*

Mexican, Veracruz, Remojadas
culture, 150/550

Terracotta; 76.2 x 74.3 x 47.3 cm
(30 x 29¼ x 18⅝ in.)
Gift of Mr. and Mrs. Thomas H.
Dittmer; Major Acquisitions
Centennial Endowment, 1995.429

Votive Figurine

Mexican, Olmec culture, 1150/900 B.C.

Hornfels; 30.2 x 8.6 x 4.8 cm
(11⅞ x 3⅜ x 1⅞ in.)
Ada Turnbull Hertle Endowment,
1971.314

Ritual Center Model

West Mexican, Nayarit, Ixtlán del Río
style, 200 B.C./700 A.D.

Terracotta; h. 21.9 cm (8⅝ in.);
diam. 34.9 cm (13¾ in.)
Gift of Ethel and Julian R. Goldsmith,
1989.639

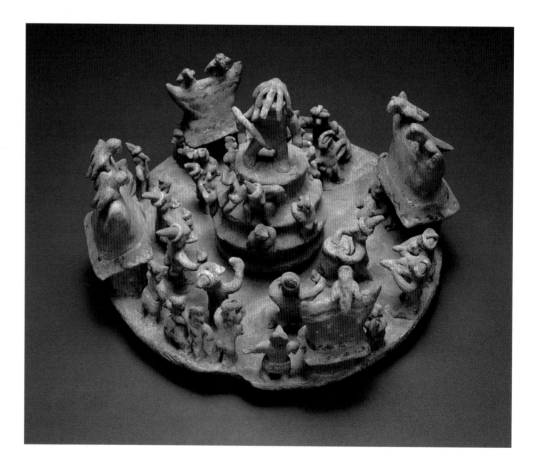

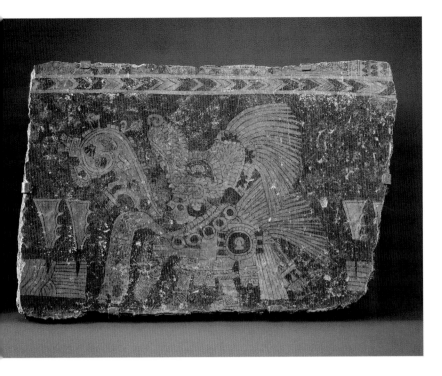

Mural Fragment Depicting Rain Priest

Mexican, Teotihuacan culture, 400/750

Lime plaster with burnished mineral
pigment; 62 x 95 x 6 cm
(24⅜ x 37⅜ x 2⅜ in.)
Primitive Art Purchase Fund, 1962.702

Classic Maya Stela

Mexican, Maya culture, 702

Stone; 146.1 x 69.9 x 34 cm
(57½ x 27½ x 13⅜ in.)
Wirt D. Walker Endowment, 1990.22

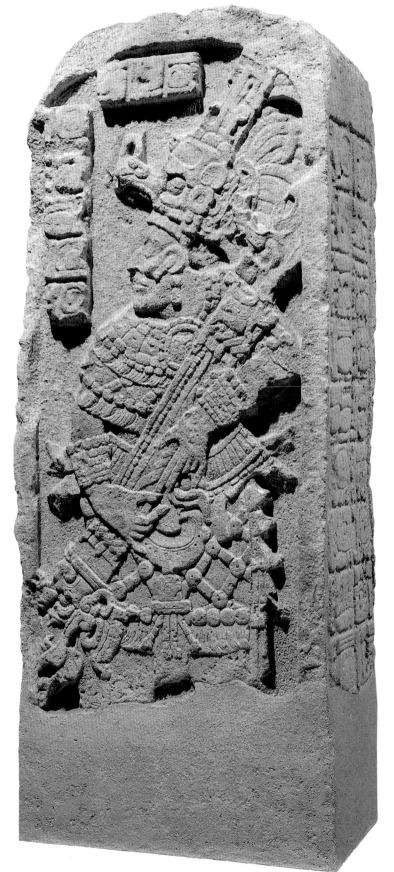

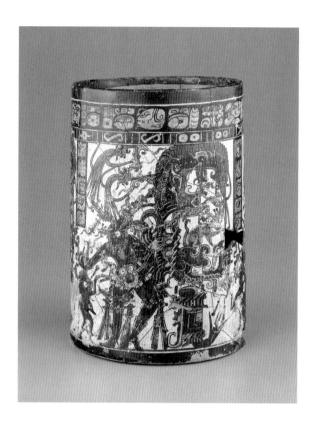

Vase of the Dancing Lords

Guatemalan, Maya culture, 7th/8th cen.

Ceramic; h. 23.5 cm (9¼ in.);
diam. 14 cm (5½ in.)
Ethel T. Scarborough Fund, 1986.1081

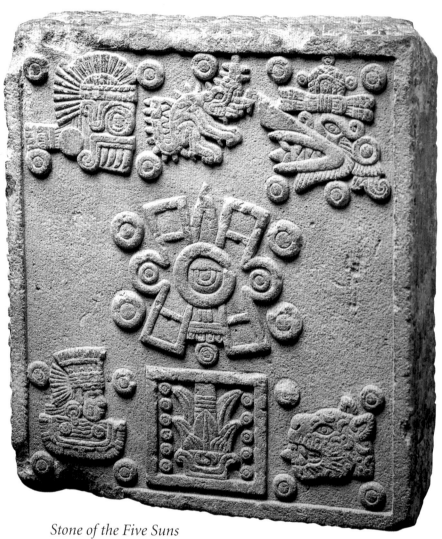

Stone of the Five Suns

Mexican, Aztec culture, 1503

Stone; 55.9 x 66 x 22.9 cm
(22 x 26 x 9 in.)
Wirt D. Walker Endowment, 1990.21

The Andes

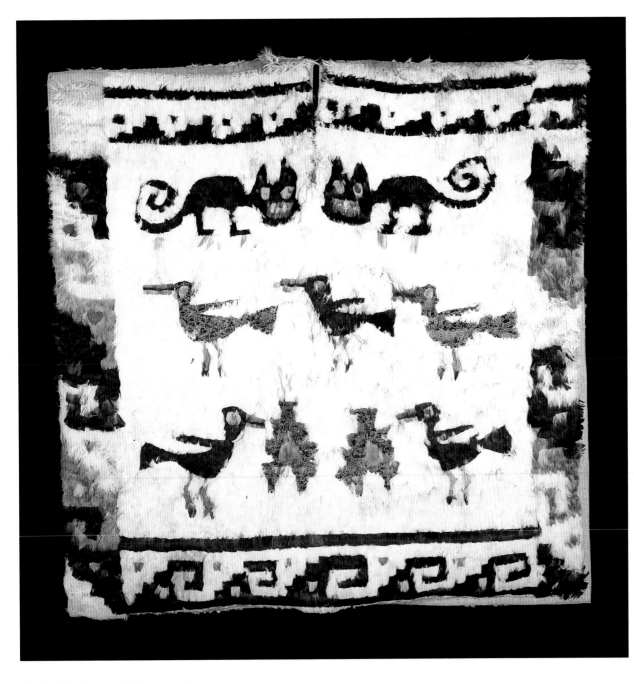

Tunic Depicting Felines and Birds

Peruvian, Nazca culture, 3rd/4th cen.

Cotton, plain weave; embellished with
feathers knotted and attached with
cotton yarns in overcast stitches;
85.2 x 86 cm (33½ x 33⅞ in.)
Kate S. Buckingham Endowment,
1955.1789

Portrait Vessel of a Ruler

Peruvian, Moche culture, 4th/7th cen.

Earthenware with pigmented clay slip;
35.6 x 24.1 cm (14 x 9½ in.)
Kate S. Buckingham Endowment,
1955.2338

Ceremonial Knife (Tumi)

Peruvian, Lambayeque culture,
900/1250

Gold and turquoise; 34 x 12.7 cm
(13⅜ x 5 in.)
Ada Turnbull Hertle Endowment,
1963.841

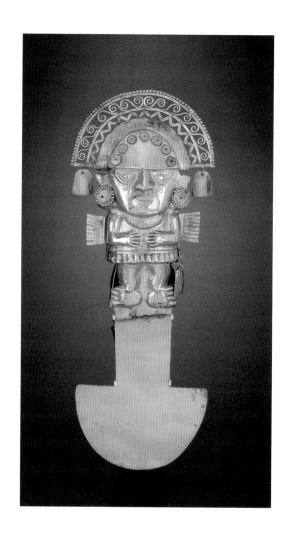

Inca Poncho (Burial Mantle)

Peruvian, Ica Valley, Inca culture,
1470/1535

Camelid wool, single interlocking
tapestry weave and complementary
weft weave with center band of
complementary weft weave;
199.4 x 257.5 cm (78½ x 101⅜ in.)
Ada Turnbull Hertle Endowment,
1999.290

North America

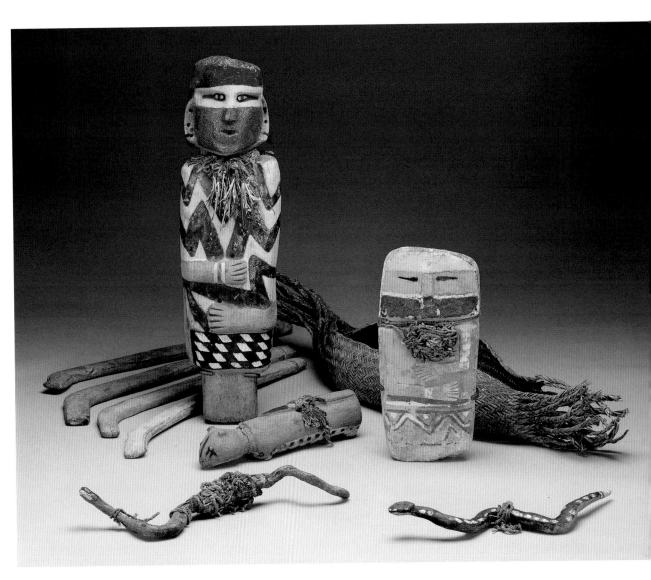

Gambling Tray

American (Native American),
California, Yokuts tribe, c. 1900

Vegetable fiber; tray: h. 4.1 cm (1⅝ in.);
diam. 56.5 cm (22¼ in.); game pieces:
h. 2.5 cm (1 in.); diam. 1.6 cm (⅝ in.)
(each)
Mrs. Leonard S. Florsheim, Jr.
Endowment, 1994.312

Ritual Cache Figures

American (Native American),
New Mexico, Salado culture, c. 1150

Stone, wood, cotton, feathers, and
pigment; basket: l. 97 cm (38⅛ in.);
ritual figures: h. 64 cm (25¼ in.) and
36 cm (14⅛ in.); snakes: l. 40 cm (15¾
in.) and 44 cm (17⅜ in.); mountain
lion: h. 9 cm (3½ in.); four sticks:
h. 61.5 cm (24¼ in.) (each)
Major Acquisitions Centennial
Endowment, 1979.17.1–11

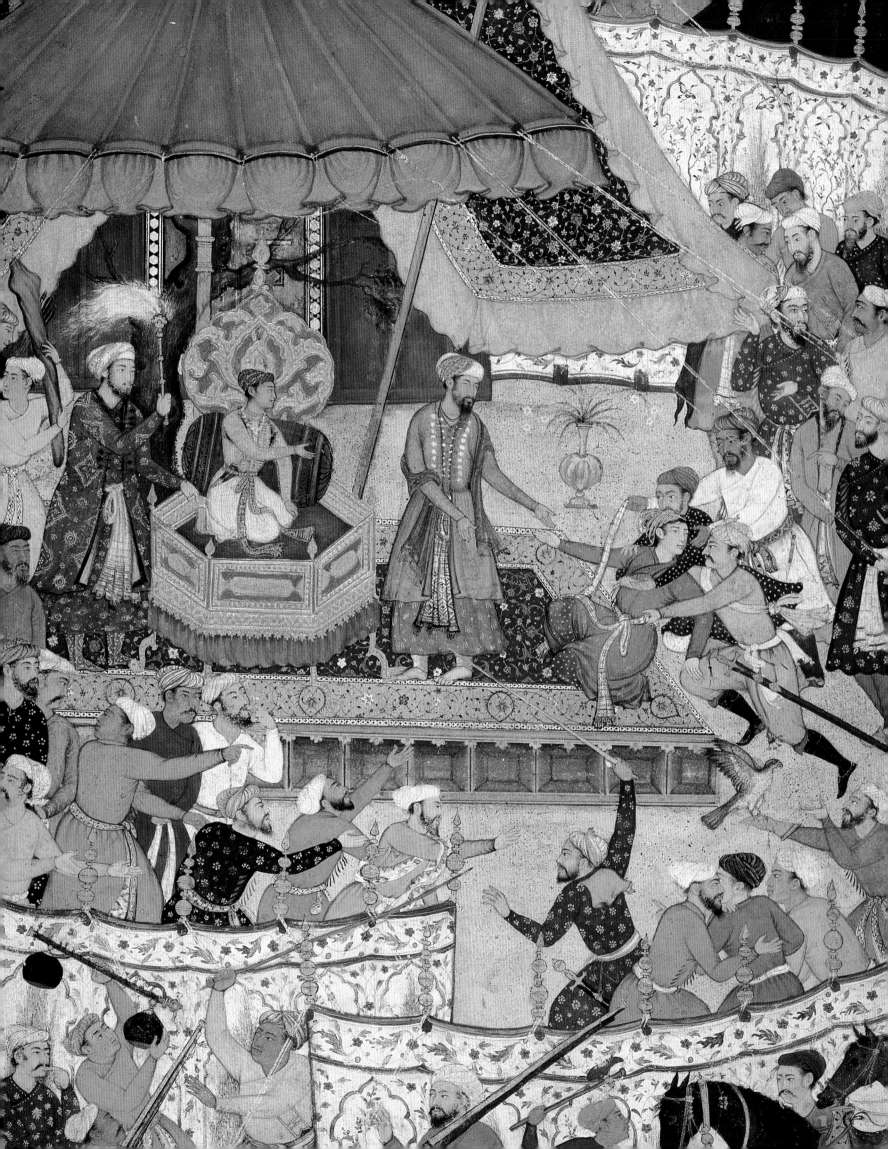

Asia

The longevity of tradition in Chinese art is unparalleled by that of any other culture in the world. From the early Neolithic village settlements of the sixth millennium B.C. to the Cultural Revolution of the later twentieth century, forms have endured changes in government, religion, and the influence of foreign contact. But more than venerability, Chinese artistic traditions are distinguished by the confluence of an integrity of function with a mastery of technology and an elevated aesthetic sensibility. The constant evolution and refinement of ceramic art have kept ancient traditions vital. From early Neolithic vessels, to sophisticated tomb figures such as the horse (p. 38) from the Tang dynasty (618–906), to the exquisite porcelain bowls (p. 41) from the Qing dynasty (1644–1911), formal qualities and technology have changed, but high standards of craftsmanship have remained consistent. Landscape painting, which appeared as early as the fourth century A.D., developed into a fully mature art form by the Song dynasty (960–1279). As seen in the Ming dynasty (1368–1644) painter Xia Chang's *Bamboo-Covered Stream in Spring Rain* (pp. 40–41), the aesthetic is spare yet elegant, featuring an intuitive individualism and a reverence for natural harmony, essential principles in the teachings of Taoism, a spiritual philosophy followed in China for more than two millennia.

The ceramic traditions of Korea evolved from Chinese models, but, as seen in the celadon-glazed, bird-shaped ewer (p. 42) of the Koryo dynasty (918–1392), an understated elegance gives Korean vessels a distinct identity. The peninsula of Korea provided a geographic bridge for the transmission of Chinese culture to the island of Japan. Buddhism, introduced into China from India during the first century A.D., followed this route late in the sixth century, bringing with it artistic techniques that the Japanese rapidly assimilated, as seen in the sculpture of *Nyoirin Kannon* (p. 45) from the Kamakura period (1192–1333), which depicts a Bodhisattva, an enlightened being who brings compassion to humankind. The opulent *Nuihaku* (p. 47) of the Momoyama period (1573–1603) was probably made for an aristocrat and used as a garment for Nō Drama, a theatrical genre exclusive to Japan. The cultural environment forged under the isolationist policies of the Tokogawa Shogunate (1603–1868), and based in urban centers such as Edo (modern-day Tokyo), inspired new subjects that directly reflected Japanese experience. The color woodblock prints of the *ukiyo-e* (pictures of the floating world) tradition portray celebrated courtesans and actors. Landscape images feature well-known sites or popular phenomena, such as Katsushika Hokusai's *Great Wave off Kanagawa* (p. 49). The colorful and delicate approach of Edo printmakers has continued into the modern era, as seen in Onchi Kōshirō's *Sea* (p. 50).

As the wellspring of two of the most influential religions in Asia—Hinduism and Buddhism—the cultural vision of India was shaped and disseminated by faith. Figural sculpture in India developed in close relation to classical dance, as demonstrated in the lithe contours in the figure of the Buddhist protective goddess Yakshi (p. 51) and the eloquent gestures depicted in the Hindu sculpture of Shiva with Uma and Skanda (p. 54). Elements of this sensuous aesthetic traveled with the spread of faith north to Nepal and Tibet, as reflected in the painting of Shiva (p. 56). Examples of stone and bronze sculpture from Cambodia, Thailand, and Vietnam display the more formal monumentality characterizing the sculpture of Southeast Asia. Hinduism, as well as Islam, reached as far as the islands of Indonesia, where the vitality of Indian influence may be observed in the rotund proportions and curving trunk of Ganesha (p. 63), the Hindu deity of auspicious beginnings. Across these diverse nations, works of art chart a common vision of faith and deep cultural connections.

Basawan and Shankar.
Illustration from the *Akbarnama*
(detail). See page 55.

China

Sheath with a Bird and Dragon

Chinese, Western Han dynasty,
2nd/1st cen. B.C.

Jade (nephrite); 10.6 x 5.7 x 0.5 cm
(4⅛ x 2¼ x⅛ in.)
Through prior gifts of Mrs. Chauncey
B. Borland, Lucy Maud Buckingham
Collection, Emily Crane Chadbourne,
Mary Hooker Dole, Edith B.
Farnsworth, Mrs. Mary A. B.
MacKenzie, Mr. and Mrs. Chauncey B.
McCormick, Fowler McCormick, Mrs.
Gordon Palmer, Grace Brown Palmer,
Chester D. Tripp, Russell Tyson, H. R.
Warner, Joseph Winterbotham, and Mr.
and Mrs. Edward Ziff, 1987.141

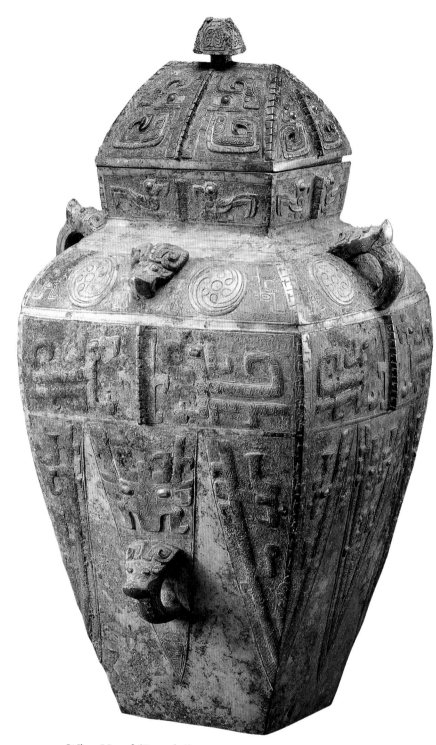

Wine Vessel (Fanglei)

Chinese, Shang dynasty,
12th/11th cen. B.C.

Bronze; h. 45.1 cm (17¾ in.);
diam. 24.8 cm (9¾ in.)
Lucy Maud Buckingham Collection,
1938.17

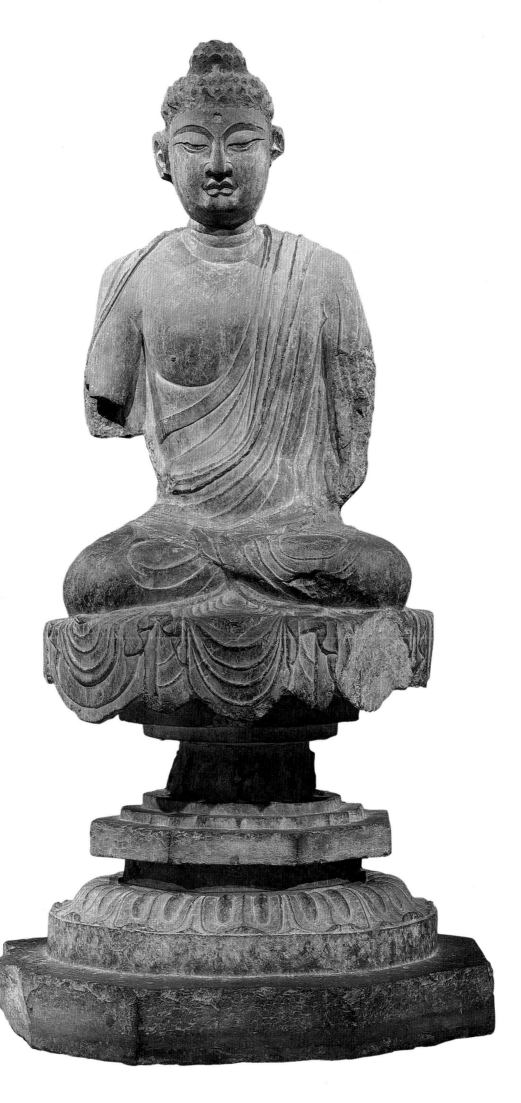

Buddha

Chinese, Tang dynasty, 725/750

Limestone with traces of polychromy;
217.5 x 111 x 111 cm
(85⅝ x 43¹¹⁄₁₆ x 43¹¹⁄₁₆ in.)
Lucy Maud Buckingham Collection,
1930.83

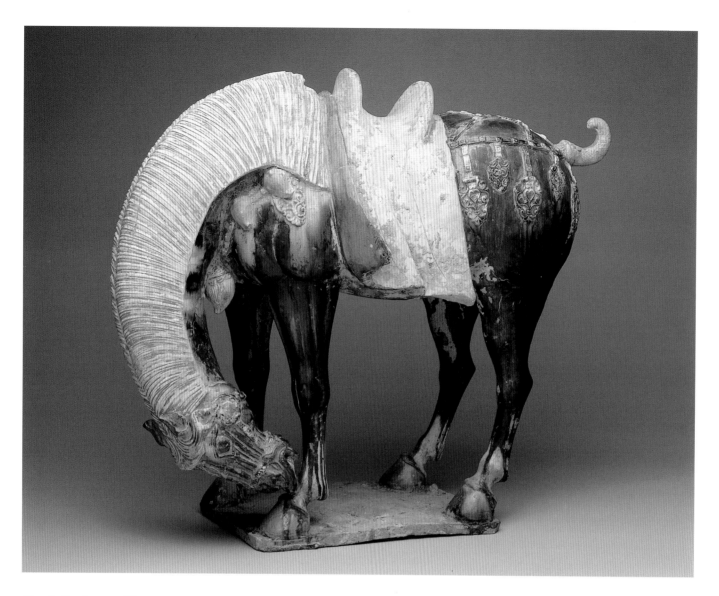

Tomb Sculpture: Horse

Chinese, Tang dynasty,
first half of 8th cen.

Buff earthenware with three-color
(*sancai*) lead glazes and molded
decoration; 62.9 x 78 x 30.8 cm
(24¾ x 30¾ x 12⅛ in.)
Gift of Russell Tyson, 1943.1136

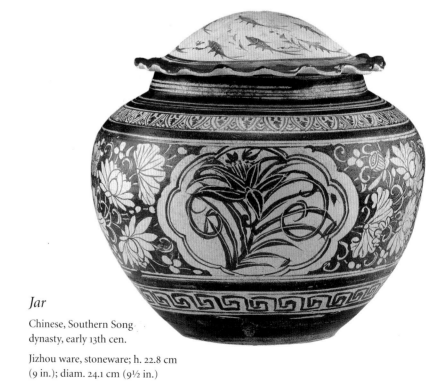

Jar

Chinese, Southern Song
dynasty, early 13th cen.

Jizhou ware, stoneware; h. 22.8 cm
(9 in.); diam. 24.1 cm (9½ in.)
Restricted gift of the Rice Foundation,
1990.118 a–b

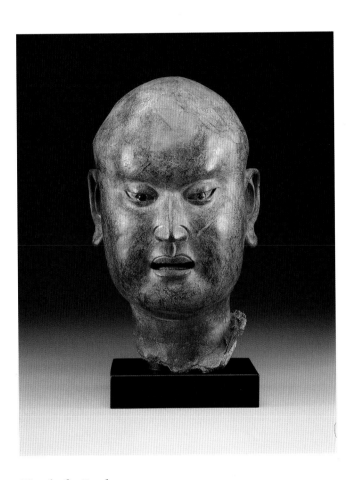

Head of a Luohan

Chinese, Northern Song, Liao,
or Jin dynasty, c. 11th/12th cen.

Hollow dry lacquer; 28.6 x 18 x 20 cm
(11¼ x 7⅛ x 7⅞ in.)
Gift of The Orientals, 1928.259

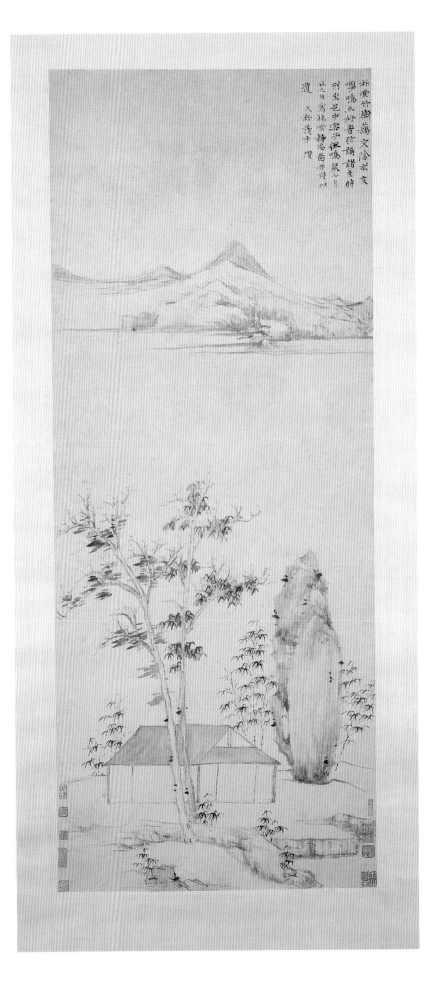

Ni Zan

(Chinese; 1306–1374)

*Poetic Thoughts in a
Forest Pavilion*, c. 1371

Hanging scroll; ink on paper;
124 x 50.5 cm (48⅞ x 19⅞ in.)
Kate S. Buckingham Endowment;
restricted gift of the E. Rhodes
and Leona B. Carpenter
Foundation, 1996.432

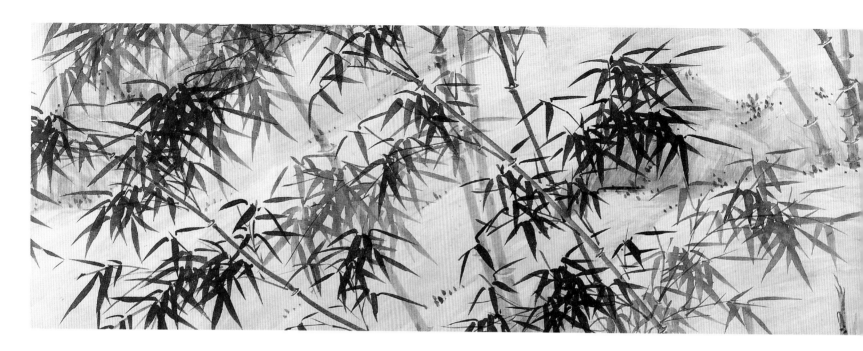

Xia Chang

(Chinese; 1388–1470)

Bamboo-Covered Stream in Spring Rain (detail), 1441

Handscroll; ink on paper;
41.3 x 1500 cm (16¼ x 600 in.)
Kate S. Buckingham Endowment,
1950.2

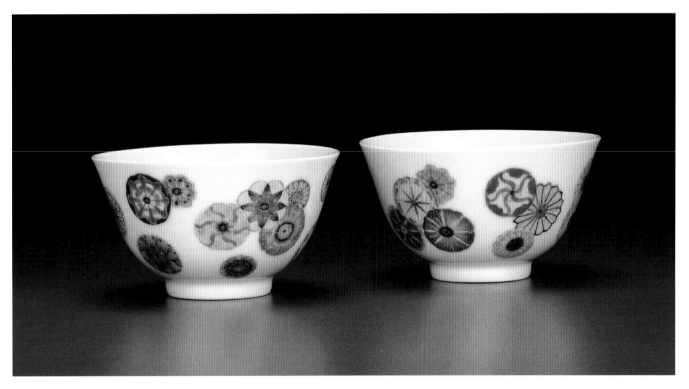

Pair of Bowls

Chinese, Qing dynasty, mark and
period of Yongzheng (1723/35)

Porcelain with underglaze blue and
overglaze enamel (*doucai*) decoration;
h. 5.6 cm (2³⁄₁₆ in.); diam. 10.2 cm (4 in.)
(each)
Gift of Henry C. Schwab, 1941.701a–b

Korea

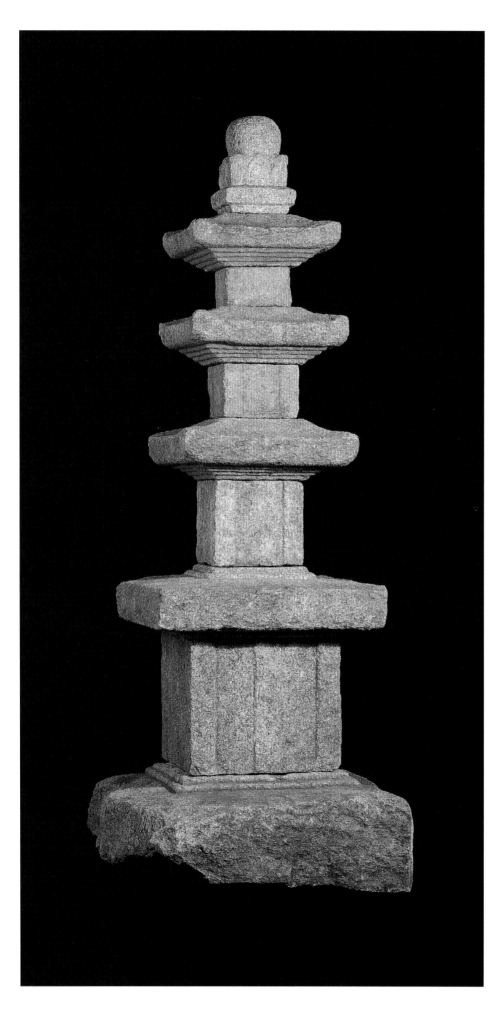

Buddhist Pagoda

Korean, late Unified Silla/early Koryo
dynasty, 9th/10th cen.

Granite; 180 x 70 x 77 cm
(70⅞ x 27 9/16 x 30 5/16 in.)
Gift of Masao Kato, 1989.88

Bird-shaped Ewer

Korean, Koryo dynasty, 12th cen.

Stoneware with celadon glaze and
incised decoration; 21.4 x 13.3 x 18 cm
(8 7/16 x 5¼ x 7 1/16 in.)
Bequest of Russell Tyson, 1964.1213

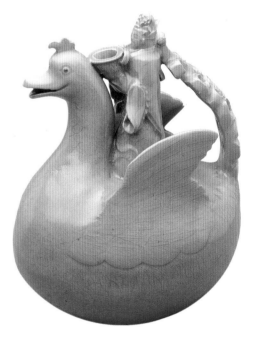

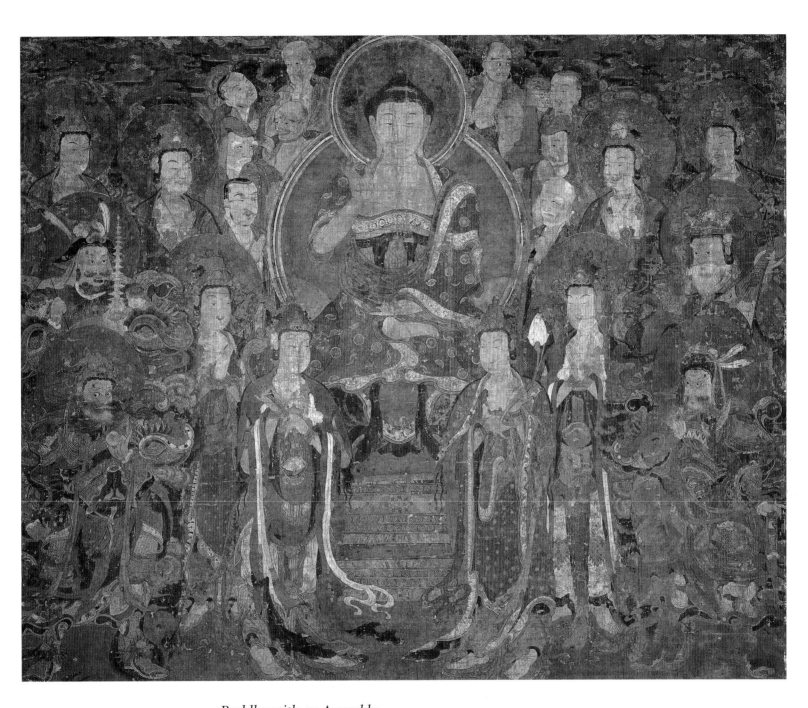

Buddha with an Assembly

Korean, Choson dynasty, 16th cen.

Mounted and framed scroll;
ink, colors, and gold on silk; 168.8 x
208.3 cm (66½ x 82 in.)
Samuel M. Nickerson Endowment,
1921.33

Japan

Legends of the Yūzū Nembutsu (details)

Japanese, Kamakura period, late 13th cen.

Handscroll; ink, colors, and gold on paper; 30.5 x 1176.9 cm (12 x 463⅜ in.)
Kate S. Buckingham Endowment, 1956.1256

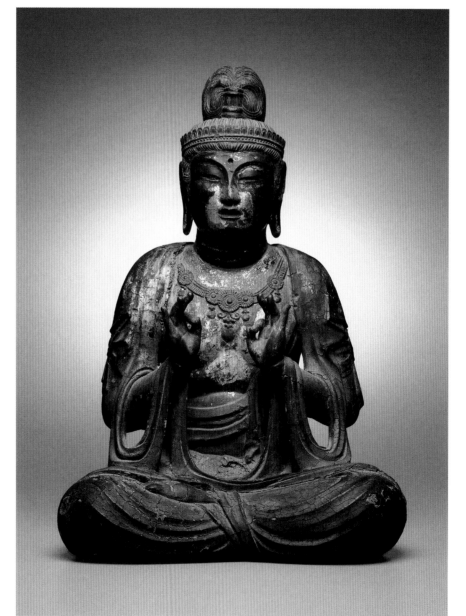

Seated Bodhisattva

Japanese, Nara period, c. 775

Wood core and dry lacquer with traces of gold leaf; 61 x 43.2 x 32.3 cm (24 x 17 x 12¾ in.)
Kate S. Buckingham Endowment, 1962.356

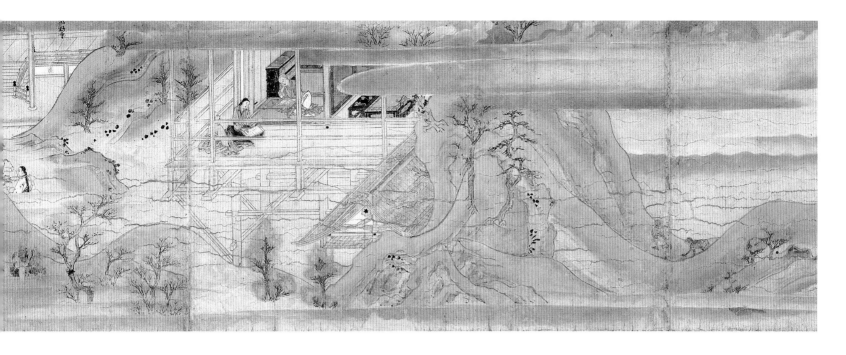

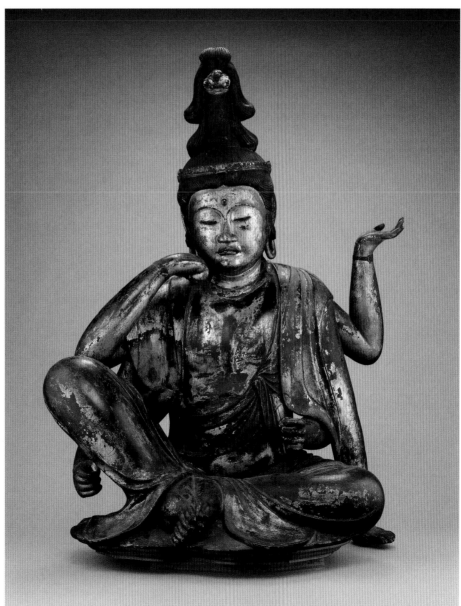

Jewel-holding, Wheel-turning Avalokiteshvara (Nyoirin Kannon)

Japanese, Kamakura period, early 14th cen.

Wood with lacquer and gilding; 66 x 47 x 39.2 cm (26 x 18½ x 15⁷⁄₁₆ in.) Kate S. Buckingham Endowment, 1995.274

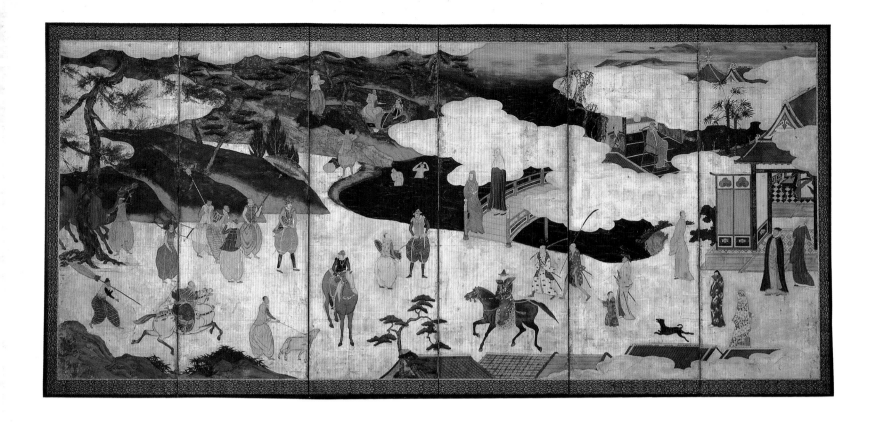

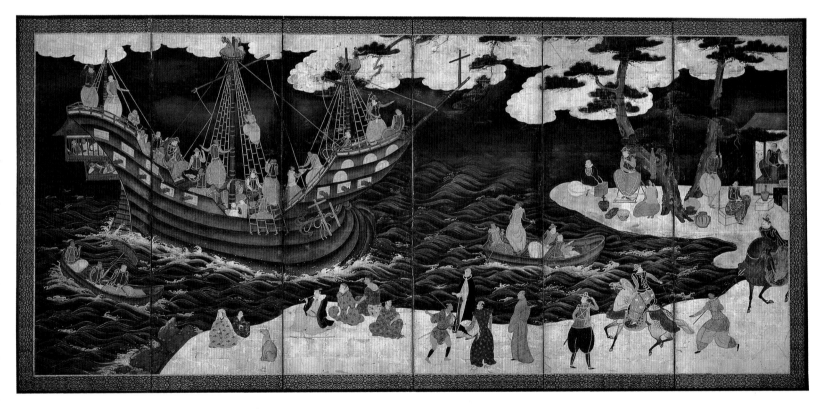

Southern Barbarians
(Namban)

Japanese, Momoyama period,
late 16th cen.

Pair of six-panel screens; ink, colors,
and gold on paper; 152.4 x 363.8 cm
(60 x 143¼ in.) (each)
Robert Allerton Endowment,
1965.400–401

Nō Drama Robe (Nuihaku)

Japanese, Momoyama period, 16th cen.

Silk, plain weave; patterned with resist
dyeing, impressed gold leaf, and
embroidered with silk in satin, single
satin, surface satin, and stem stitches;
couching; 160.6 x 133.1 cm
(63¼ x 52⅜ in.)
Restricted gift of Mrs. Charles H.
Worcester, 1928.814

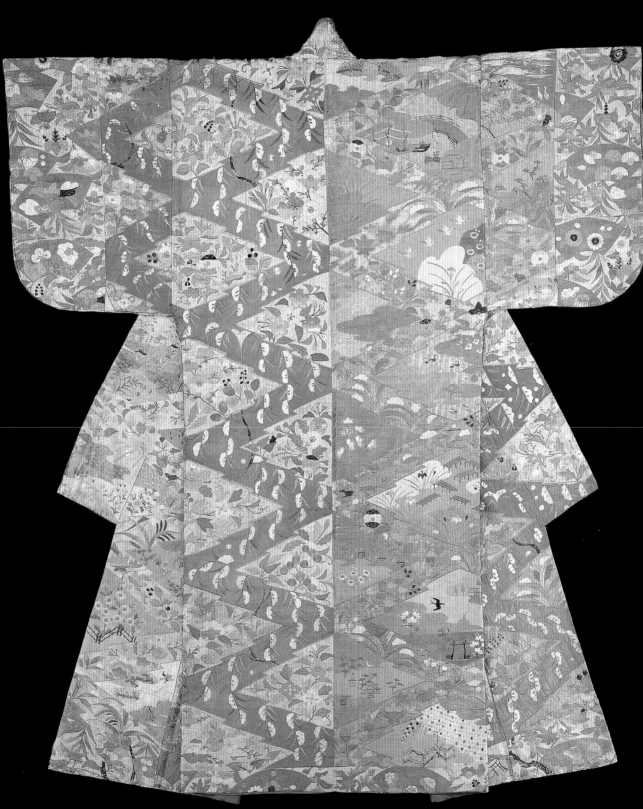

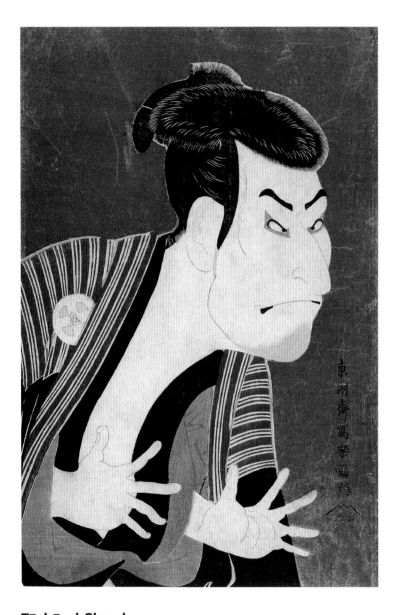

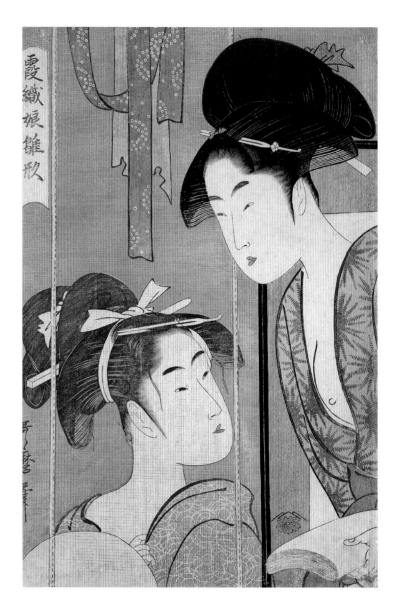

Tōshūsai Sharaku
(Japanese; active 1794–95)

*Otani Oniji III as the
Manservant Edohei in the
Play "The Chosen Wife's
Multicolored Leadrope,"* 1794

Color woodblock print; 37.5 x 24.8 cm
(14¾ x 9¾ in.)
Clarence Buckingham Collection,
1934.207

Kitagawa Utamaro
(Japanese; 1753–1806)

Mosquito Net (Kaya), from
the series *Model Young
Women Woven in Mist*,
1794/95

Color woodblock print; 38.6 x 25.5 cm
(15¼ x 10 in.)
Clarence Buckingham Collection,
1930.412

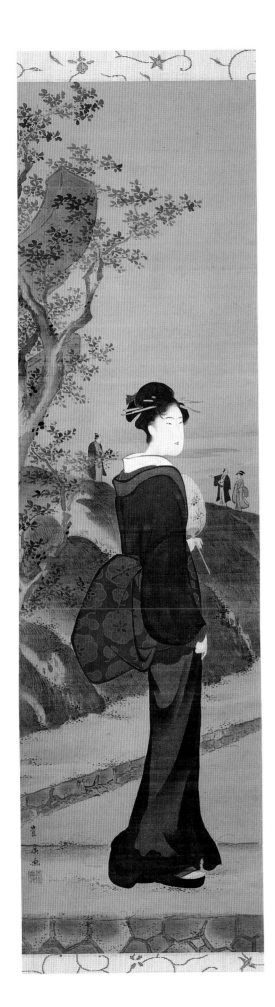

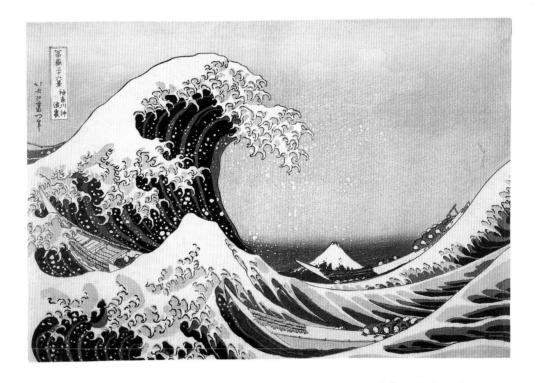

Katsushika Hokusai
(Japanese; 1760–1849)

The Great Wave off Kanagawa, from the series *Thirty-six Views of Mount Fuji,* c. 1831

Color woodblock print; 25.6 x 37.5 cm (10⅛ x 14¾ in.)
Clarence Buckingham Collection, 1925.3245

Utagawa Toyohiro
(Japanese; 1774–1829)

Bijin at the Mimeguri Shrine, 1804/18

Hanging scroll; ink, colors, and gold on silk; 91.4 x 26 cm (36 x 10¼ in.)
Gift of Margaret O. Gentles, 1969.641

Onchi Kōshirō

(Japanese; 1891–1955)

The Sea, 1937

Triptych of woodblock prints;
ink and colors on paper; 89 x 139.5 cm
(35 x 55 in.)
Mr. and Mrs. Hubert Fisher Fund,
1998.127

India

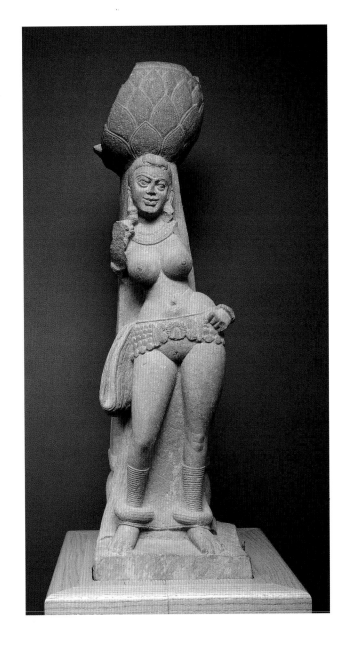

The Birth and First Seven Steps of the Buddha

Pakistani (ancient Gandhara), Kushan period, 2nd/3rd cen.

Gray schist; 27.3 x 52.1 x 10.8 cm (10¾ x 20½ x 4¼ in.)
Samuel M. Nickerson Endowment, 1923.315

Yakshi

Indian, Mathura, Kushan period, 2nd cen.

Red sandstone; 85 x 29.2 x 28 cm (33½ x 11½ x 11 in.)
Kate S. Buckingham Endowment, 1995.260

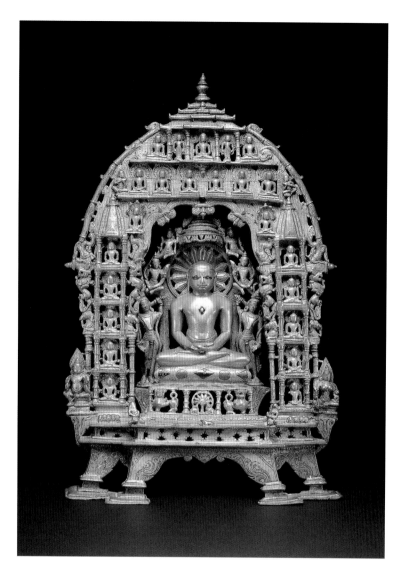

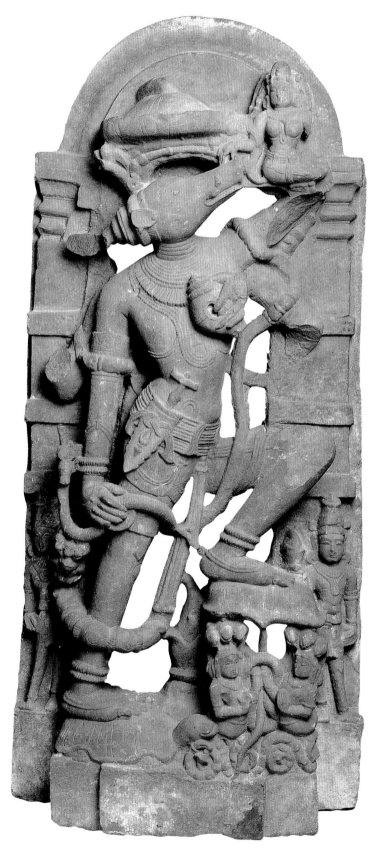

*Shrine with the Jain
Tirthankara Rishabhanatha*

Eastern Indian, 1089

Brass with copper and silver inlay;
50.8 x 34 x 19.5 cm (20 x 13⅜ x 7⅝ in.)
Kate S. Buckingham Endowment,
1995.261

*Boar Avatar of
Vishnu* (Varaha)

Indian, Rajasthan, c. 1100

Red sandstone; 132.1 x 58.5 x 29.3 cm
(52 x 23 x 11½ in.)
Gift of Marilynn Alsdorf, 1997.707

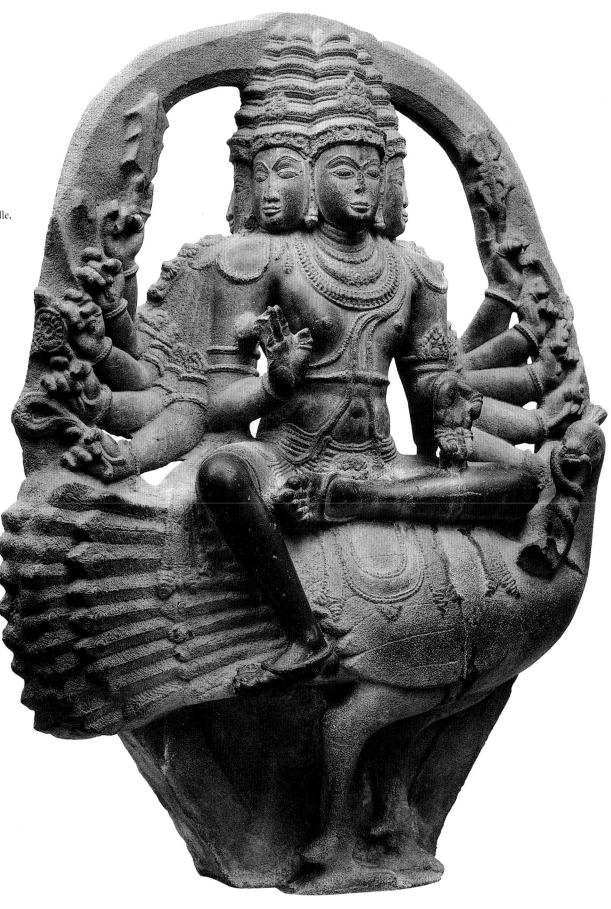

The Divine General Shanmukha

Indian, Andhra Pradesh, Madanapalle, Ganga period, 12th cen.

Granite; 150.5 x 121 x 39 cm
(59¼ x 47⅝ x 15⅜ in.)
Gift of Silvain and Arma Wyler, 1962.203

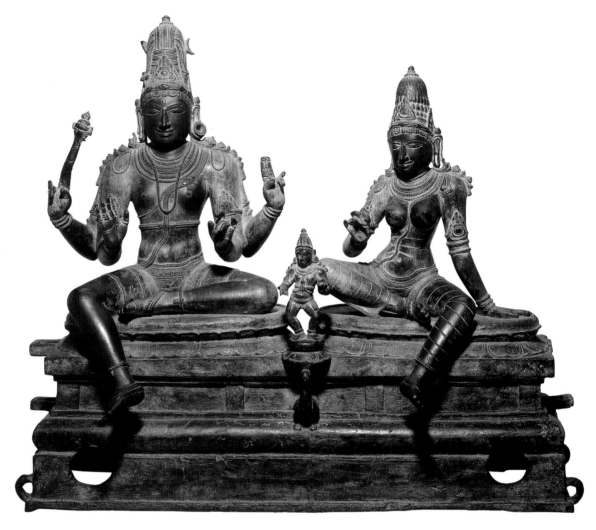

Shiva with Uma and Skanda (Somaskanda)

Indian, Tamil Nadu, c. 1400

Bronze; 62.6 x 75 x 31.4 cm (24¹¹⁄₁₆ x 29½ x 12⅜ in.)
Robert Allerton Endowment, 1966.334

Women Worshipping Ganesha

Indian, Himachal Pradesh, Pahari, Kangra, c.1800

Opaque watercolor and gold on paper; 20 x 30 cm (7⅞ x 11⅞ in.)
Gift of Mr. and Mrs. James W. Alsdorf, 1968.690

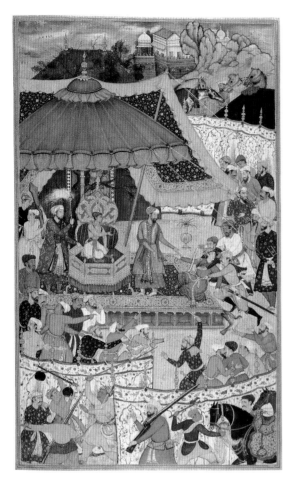

Basawan
(Indian; active late 16th cen.) (designer)
Shankar
(Indian; active late 16th cen.) (painter)

Illustration from the
Akbarnama, 1590/95

Watercolor and gold on paper;
20 x 14.4 (7⅞ x 5⅝ in.)

Lucy Maud Buckingham Collection,
1919.898

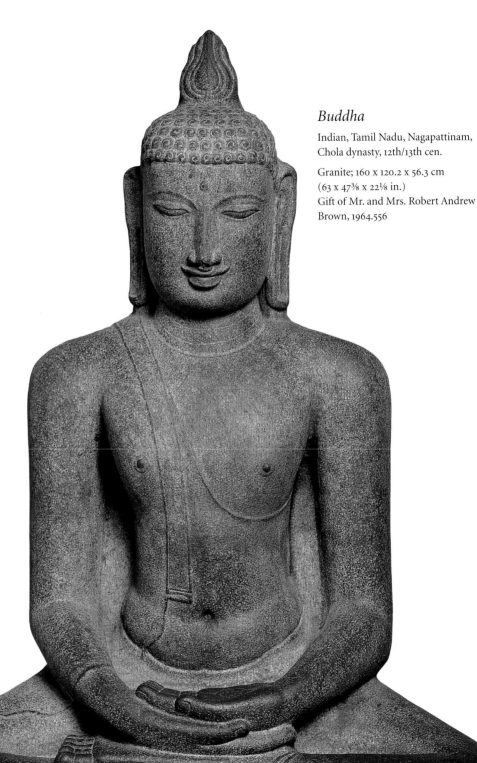

Buddha

Indian, Tamil Nadu, Nagapattinam,
Chola dynasty, 12th/13th cen.

Granite; 160 x 120.2 x 56.3 cm
(63 x 47⅜ x 22⅛ in.)
Gift of Mr. and Mrs. Robert Andrew
Brown, 1964.556

The Himalayas

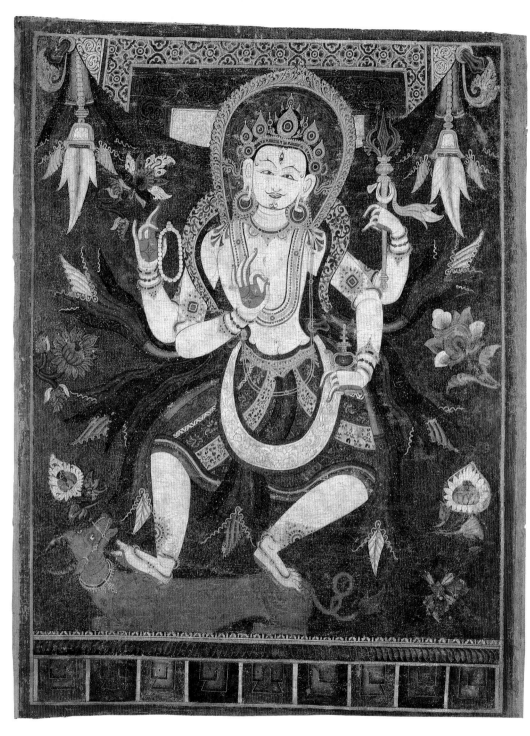

Shiva

Nepalese, 16th cen.

Pauba; ink and colors on cotton;
95 x 71 cm (37⅜ x 28 in.)
Kate S. Buckingham Endowment,
1995.268

Woman under a Tree

Nepalese, 14th/15th cen.

Terracotta; 30 x 19.8 x 9.4 cm
(11¹³⁄₁₆ x 7¹³⁄₁₆ x 3¹⁄₁₆ in.)
Gift of Paul Walter in honor of
Dr. Pratapaditya Pal, 1995.465

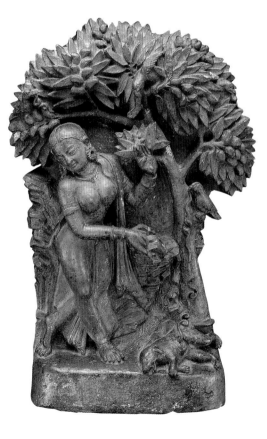

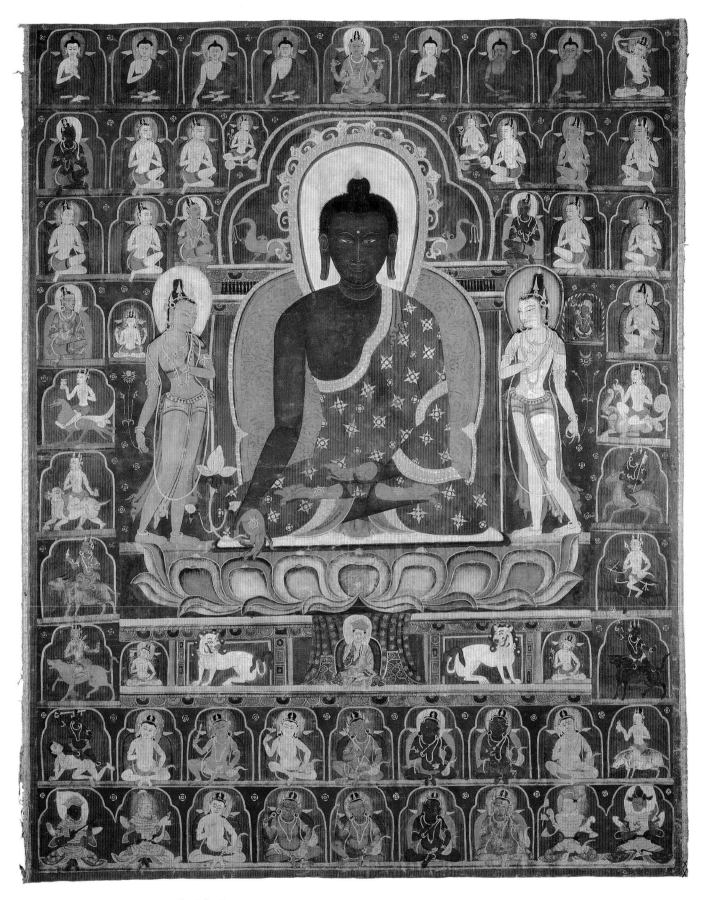

Bhaishajyaguru,
the Buddha of Healing

Tibetan, 14th cen.

Thanka; ink, colors, and gold on
cotton; 104.1 x 82.6 cm (41 x 32½ in.)
Kate S. Buckingham Endowment,
1996.29

Phurbu Deity

Central Tibetan, 16th cen.

Copper repoussé; 43.1 x 24.8 x 10.3 cm
(17 x 9¾ x 4¹⁄₁₆ in.)
Restricted gift of Thomas J. Pritzker,
1996.652

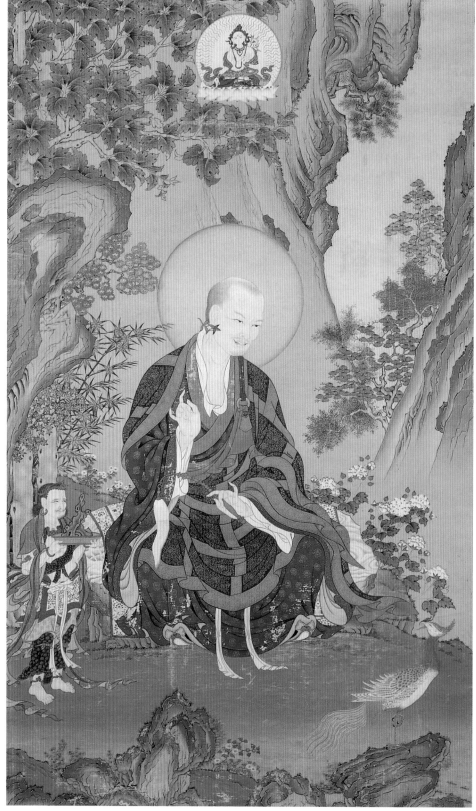

The Arhat Vanavasin in a Landscape

Eastern Tibetan, c. 1700

Thanka; ink, colors, and gold on
cotton; 102 x 61.5 cm (40⅛ x 24¼ in.)
Alsdorf Foundation, Margaret O.
Gentles, Frederick and Natalie
Goodkin, Samuel M. Nickerson, and
Russell Tyson funds; Ardith Lauerman
Endowment, 1997.54

Southeast Asia

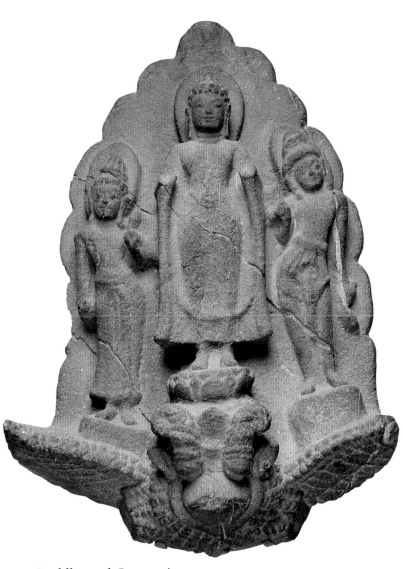

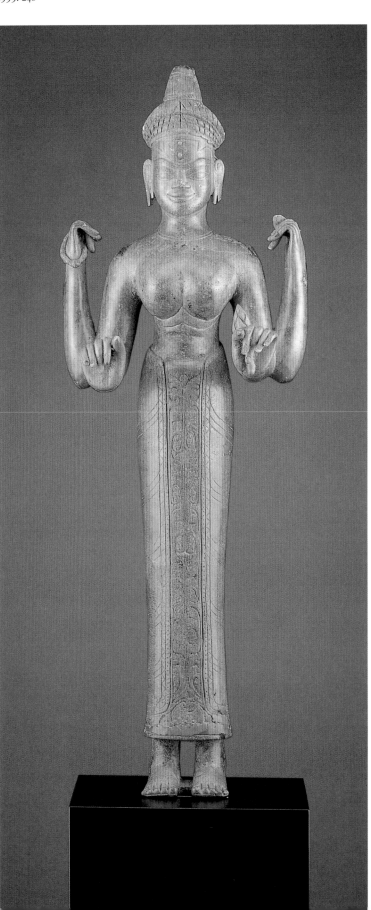

Androgynous Form of Shiva
(Ardhanarishvara)

Cambodian, Khmer, pre-Angkorean
period, 7th/8th cen.

Bronze; 43.1 x 13 x 10 cm
(17 x 5⅛ x 3¹⁵⁄₁₆ in.)
Kate S. Buckingham Endowment,
1995.266

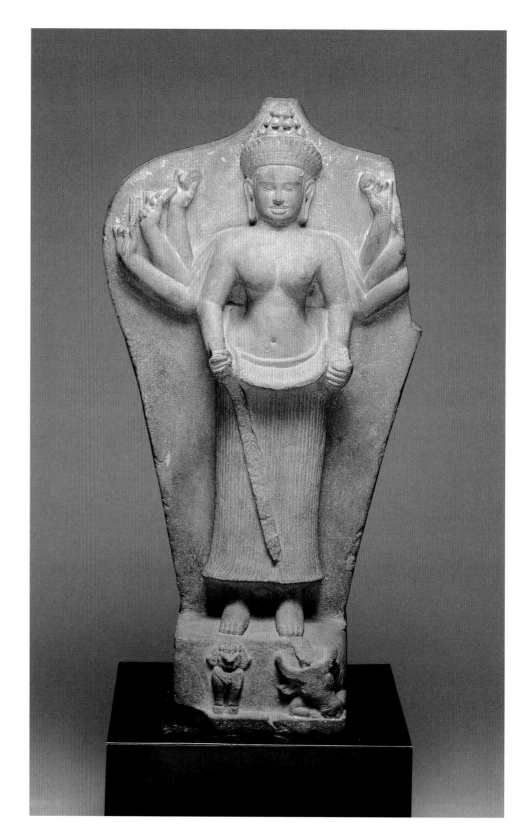

*Durga, Slayer of the Buffalo
Titan* (Durga
Mahishasuramardini)

Cambodian, Khmer, Koh Ker period,
late 10th cen.

Sandstone; 67.1 x 38.5 x 21 cm
(26⅞ x 15⅛ x 8¼ in.)
Kate S. Buckingham Endowment, 1996.32

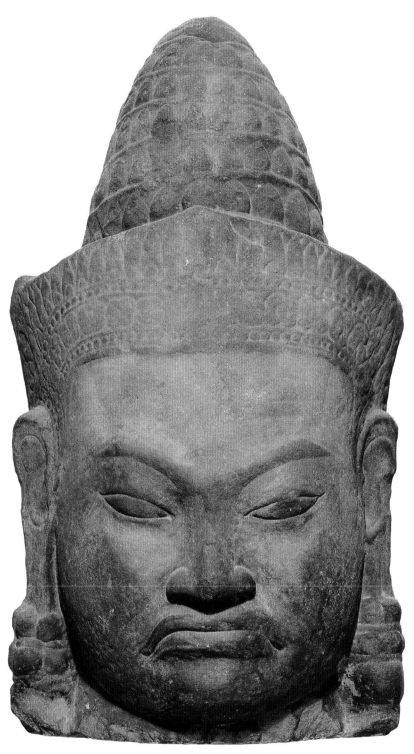

Head of a God

Cambodian, Angor Thom, Khmer,
late 12th/early 13th cen.

Sandstone; 85 x 46.3 x 44 cm
(34¼ x 18⁵⁄₁₆ x 17⁵⁄₁₆ in.)
Samuel M. Nickerson Endowment,
1924.41

Deified Shaivite

Cambodian or Vietnamese, Khmer,
early 13th cen.

Bronze with ancient lead repairs;
65.8 x 20.8 x 17.8 cm (25⅞ x 8³⁄₁₆ x 7 in.)
Gift of Marilynn Alsdorf, 1998.752

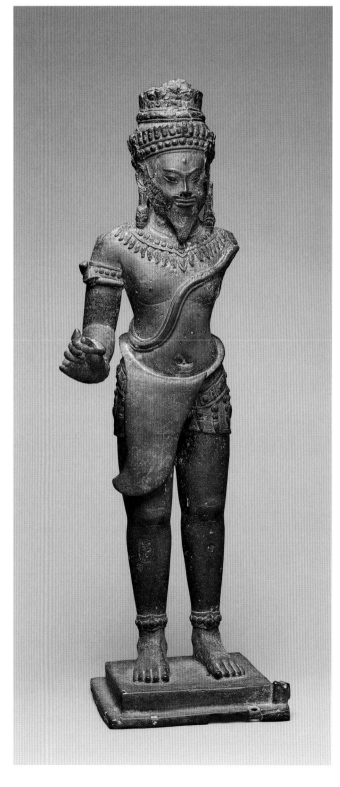

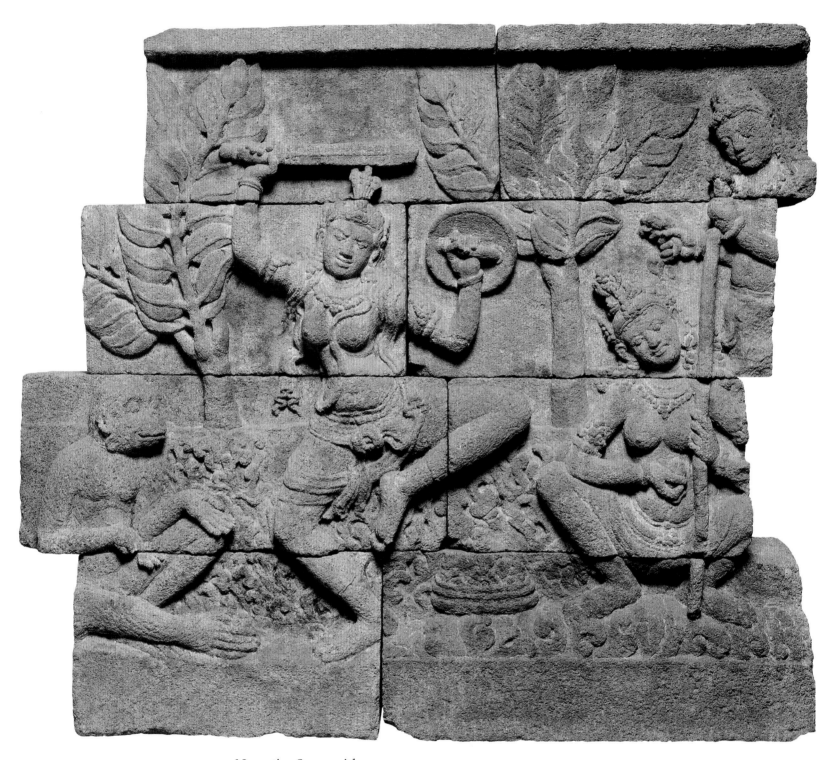

Narrative Scene with a Dancing Goddess Accompanied by a Monkey and Two Attendants

Indonesian, Central Java, 9th cen.

Andesite (volcanic stone); 100 x 114.5 x 19.6 cm (39⅜ x 45⅟₁₆ x 7¹¹⁄₁₆ in.)
Kate S. Buckingham Endowment, 1995.243

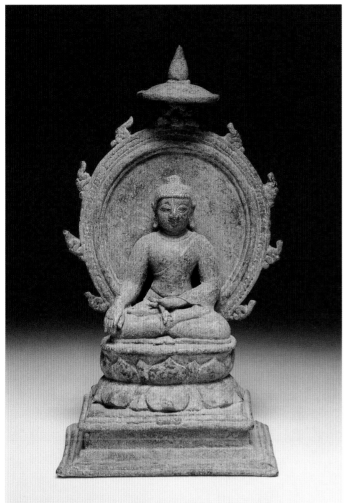

The Transcendental Buddha Akshobhya

Indonesian, Central Java, 9th cen.

Bronze; 17.5 x 10.2 x 9 cm
(6⅞ x 4 x 3½ in.)
Russell Tyson Endowment, 1982.1447

Ganesha

Indonesian, Central Java, 9th/10th cen.

Andesite (volcanic stone); 74.4 x 52 x
31.2 cm (29⁵⁄₁₆ x 20⁷⁄₁₆ x 12¼ in.)
Gift of Mrs. Christian H. Aall in honor
of her parents, Helen and Glen Sample,
1996.673

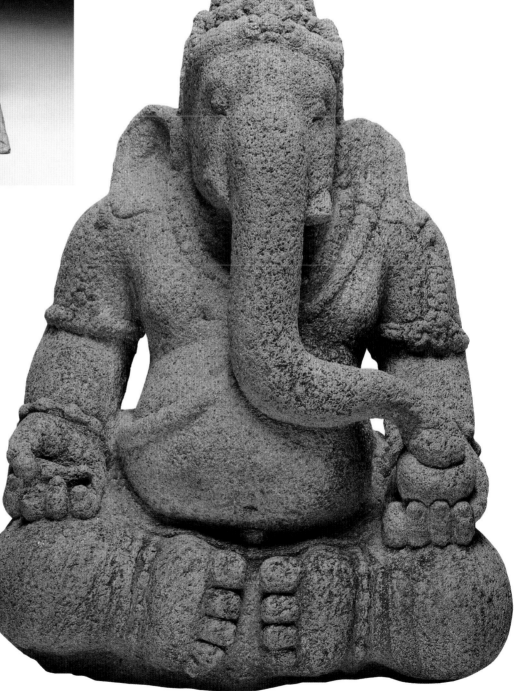

The Near East

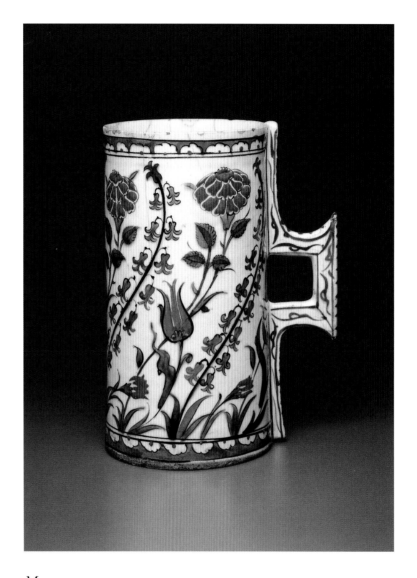

Mug

Turkish (Ottoman Empire), Iznik,
second half of 16th cen.

Earthenware with underglaze painted
decoration; h. 19.6 cm (7⅝ in.);
diam. 10.7 cm (4¼ in.)
Mary Jane Gunsaulus Collection,
1913.342

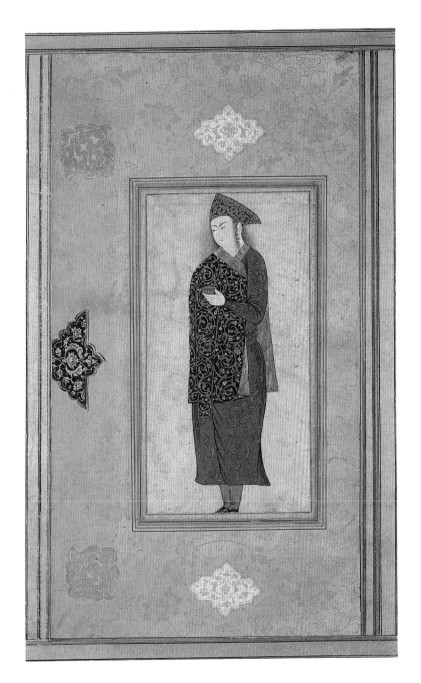

Portrait of a Young Prince

Persian, Isfahan, 1600/30

Ink and color on paper;
16.5 x 10.2 cm (6½ x 4 in.)
Gift of Mrs. Everett McNear, 1975.512

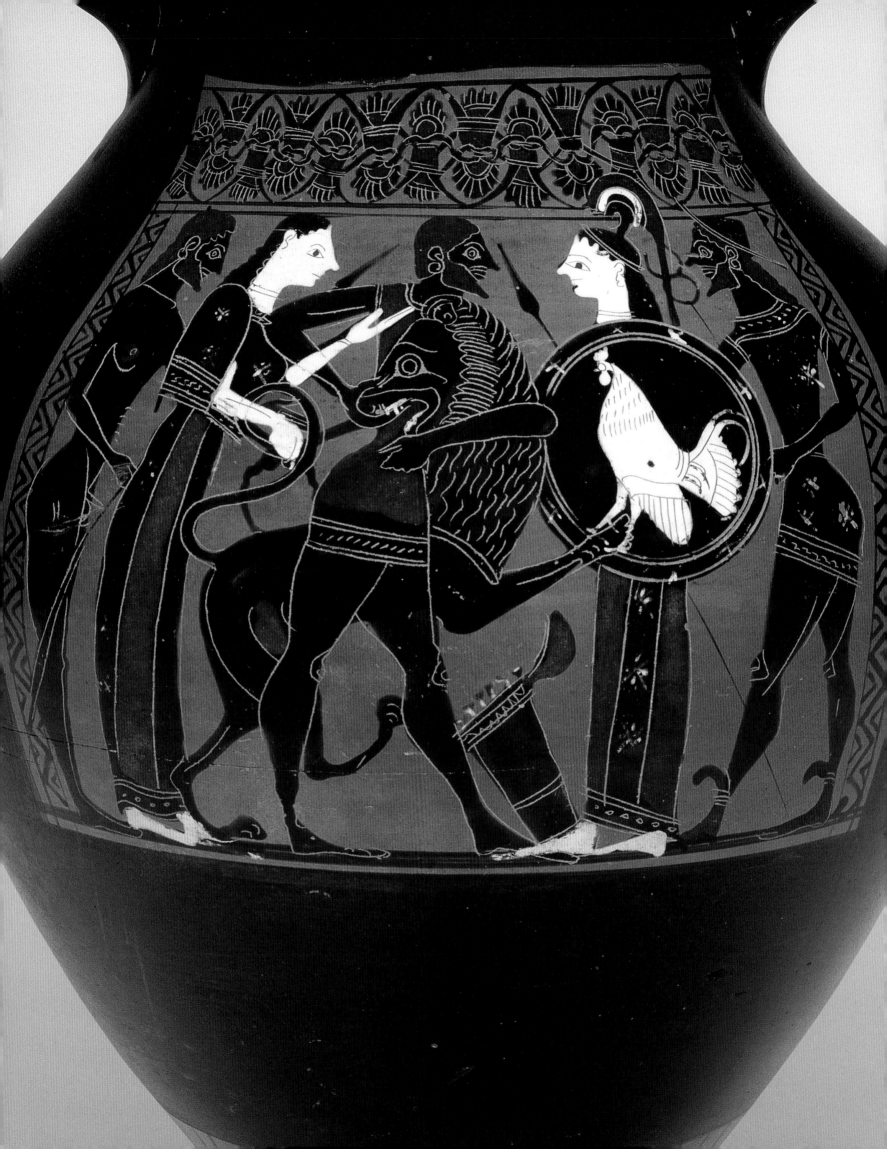

Egypt, Greece, and Rome: these three ancient civilizations have left a grand legacy of history, myth, philosophy, and art. In the late nineteenth century, when the Art Institute was founded, works of art from these civilizations played a significant role in shaping museum collections. Archeological investigations during the previous century—including the discovery of the ruins of Pompeii in 1748 and the primary documentation of ancient monuments from Egypt following Napoleon's invasion of that land in 1798—stimulated an unprecedented fascination in Europe and America with the ancient past. For Chicagoans, who had recently witnessed their city consumed in the flames of the Great Chicago Fire of 1871, ancient objects also symbolized cultural endurance, in their power to survive the ravages of time and bridge old and new worlds across centuries. Today, the art of the ancient world, as seen in the Art Institute's ancient art collection, continues to inspire and fascinate contemporary viewers.

The Ancient Mediterranean World

Regional differences were a significant element in the growth of these ancient cultures surrounding the Mediterranean Sea. The Nile River, with its annual cycle of floodwaters, was the matrix for ancient Egyptian culture and history, inspiring the idea of perpetual renewal. This notion was integral to the Egyptian view of existence, as seen in the culture's complex burial practices. For example the spectacular mummy case of Paankhenamun (p. 68) features imagery of funerary rituals. The wall fragment from the tomb of Amenhemhet and his wife, Hemet (p. 68), portrays what was believed to happen after such funerary rites: a priest and his wife, who holds a lotus blossom, the symbol of rebirth, are surrounded by offerings gathered to nourish the couple through eternity.

Comprised of city-states spreading across a diverse geographic region of mountains, islands, and seacoasts, ancient Greece's identity was shaped by shared ideas rather than singular rule. The taut and economical representation of a female figure from the Cyclades (p. 70), created during the early Bronze Age (c. 3000–2000 B.C.), represents one of the earliest examples of artistic activity in the Aegean region. This tradition of understated beauty is continued in the wine container (p. 71), which was made in Athens at the apex of the Classical Era (c. 450–400 B.C.). Art historian Sir John Beazley noted a similarly elegant, idealized rendering of women decorating another vessel, which led him to identify this and other vases as being by the same hand. Because the artist's identity is unknown, Beazley called him the Chicago Painter, named for the museum's vase.

In ancient Italy, competing cultures with distinct languages and political aims of individual destiny led to diverse traditions of artistic production. The south was settled by Greek cities, while, by the end of the seventh century B.C., most of the fertile northern region was ruled by the Etruscans, master metalworkers who made works of delicate craftsmanship such as the hand mirror (p. 72). Originally a small settlement on the Tiber River, Rome expanded its power throughout the Italian peninsula, defeating the Etruscan city-states and eventually controlling the entire Mediterranean region. It developed a cosmopolitan vision through its conquests of surrounding areas, as seen in the Roman reproduction of a famed Greek statue, the *Aphrodite of Knidos* (p. 73). However, Rome's cultural preference for verism endured in sculpted portraiture (see p. 72), a tradition that sought to capture the personality of the individual portrayed, offering museum-goers a connection to a culture very distant from their own. Indeed, whether through their humanity, their beauty, or their artistry, the Art Institute's objects from the ancient Mediterranean world continue to captivate and speak to modern-day viewers.

Painter of Tarquinia RC 3984.
Storage Jar (Amphora) (detail).
See page 71.

Ancient Egypt

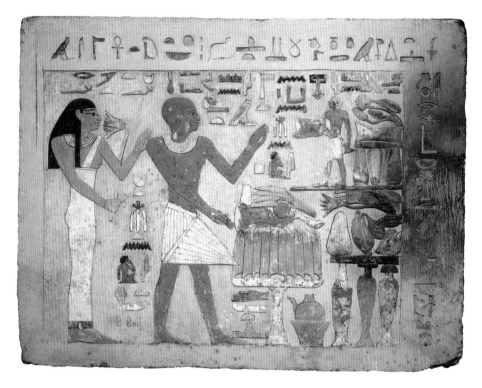

*Wall Fragment from the
Tomb of Amenemhet and
His Wife, Hemet*

Egyptian, Middle Kingdom, Twelfth
Dynasty (c. 1991/1784 B.C.)

Limestone and pigment; 30.6 x 41.7 x
6.3 cm (12⅛ x 16⅞ x 2⅜ in.)
Museum Purchase Fund, 1920.262

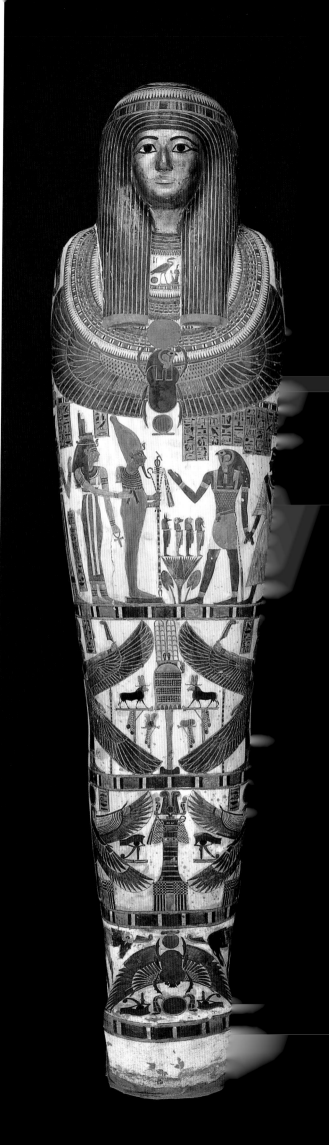

*Mummy Case of
Paankhenamun*

Egyptian, Twenty-second Dynasty,
c. 945/715 B.C.

Cartonnage (gum, linen, and papyrus),
gold leaf, and pigment; 170.2 x 43.2 x
31.7 cm (67 x 17 x 12½ in.)
William M. Willner Fund, 1910.238

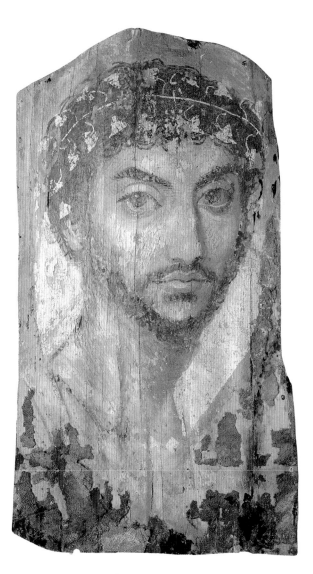

Mummy Portrait

Egyptian, Roman period, 2nd cen.

Encaustic (wax and pigment) on wood;
36.8 x 22 x 3.5 cm (14½ x 8¹¹⁄₁₆ x 1⅜ in.)
Gift of Mrs. Emily Crane Chadbourne,
1922.4798

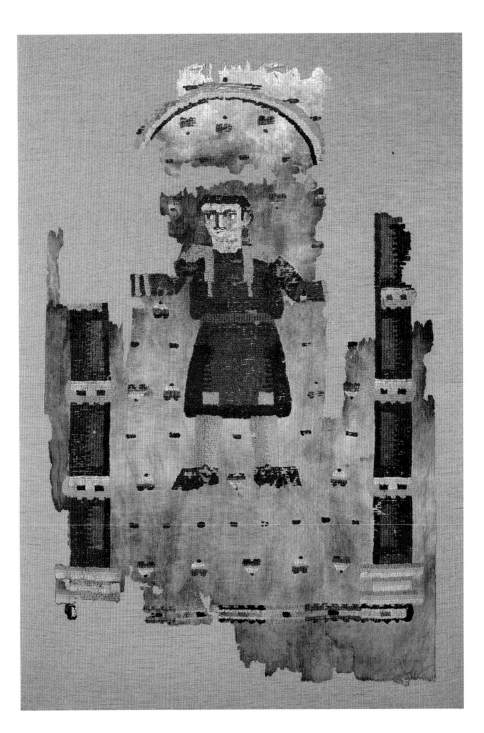

Portion of Hanging with Warrior

Egyptian, Coptic, 5th/6th cen.

Linen and wool, plain weave with
uncut weft pile and embroidered linen
pile formed by variations in back and
stem stitches; 136.5 x 88.3 cm
(53¾ x 34¾ in.)
Grace R. Smith Textile Endowment,
1982.1578

Ancient Greece

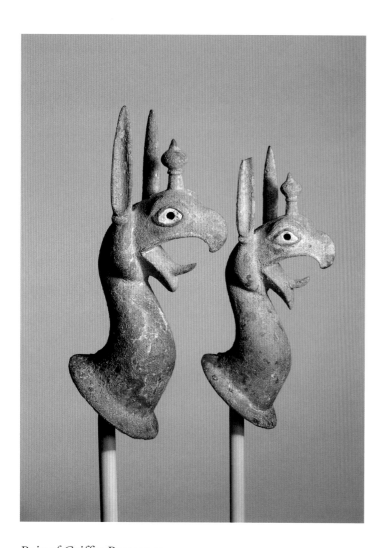

Pair of Griffin Protomes

Greek, late 7th/early 6th cen. B.C.

Bronze with bone or ivory inlay;
20 x 7 x 8.9 cm (7⅞ x 2¾ x 3½ in.)
Katherine K. Adler Endowment,
1994.38.1–2

Female Figure

Greek, Cycladic Islands (probably from
the island of Keros), early Bronze Age,
2600/2400 B.C.

Marble; 39.6 x 11.5 x 5 cm
(15¹¹⁄₁₆ x 4⁹⁄₁₆ x 1¹⁵⁄₁₆ in.)
Katherine K. Adler Endowment, 1978.115

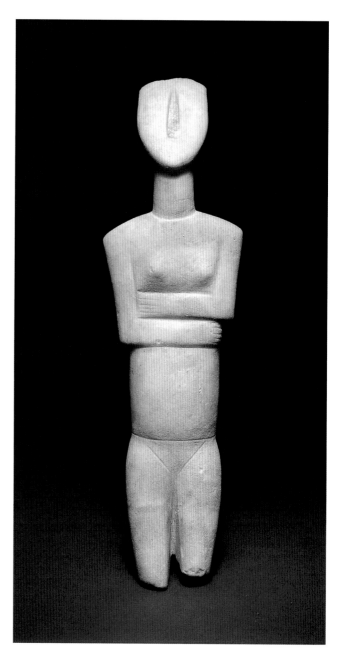

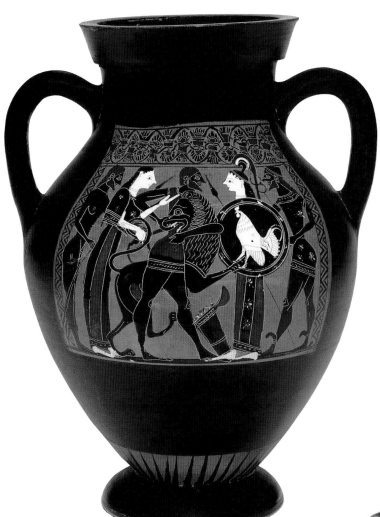

Painter of Tarquinia
RC 3984

(Greek; active mid-to-late-6th cen. B.C.)

Storage Jar (Amphora)
550/525 B.C.

Earthenware; 28.2 x 21.1 x 19.1 cm
(11⅟₁₆ x 8⅗₁₆ x 7½ in.)
Katherine K. Adler Endowment, 1978.114

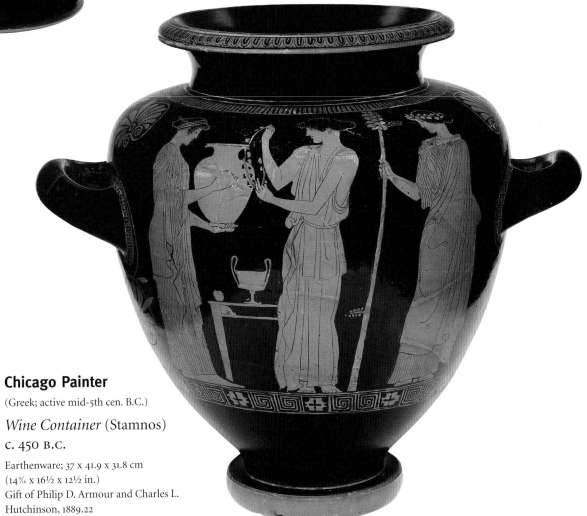

Chicago Painter

(Greek; active mid-5th cen. B.C.)

Wine Container (Stamnos)
C. 450 B.C.

Earthenware; 37 x 41.9 x 31.8 cm
(14⅗₁₆ x 16½ x 12½ in.)
Gift of Philip D. Armour and Charles L.
Hutchinson, 1889.22

Ancient Italy

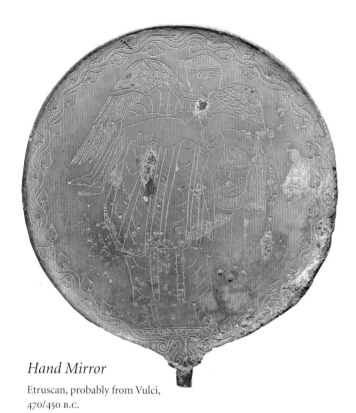

Hand Mirror

Etruscan, probably from Vulci,
470/450 B.C.

Bronze; h. 16.9 cm (6 11/16 in.);
diam. 15.2 cm (6 in.)
Katherine K. Adler Endowment,
1984.1341

Head of Hadrian

Roman, 2nd cen.

Marble; 36 x 27.5 x 27.3 cm
(14 3/16 x 10 13/16 x 10 3/4 in.)
Katherine K. Adler Endowment,
1979.350

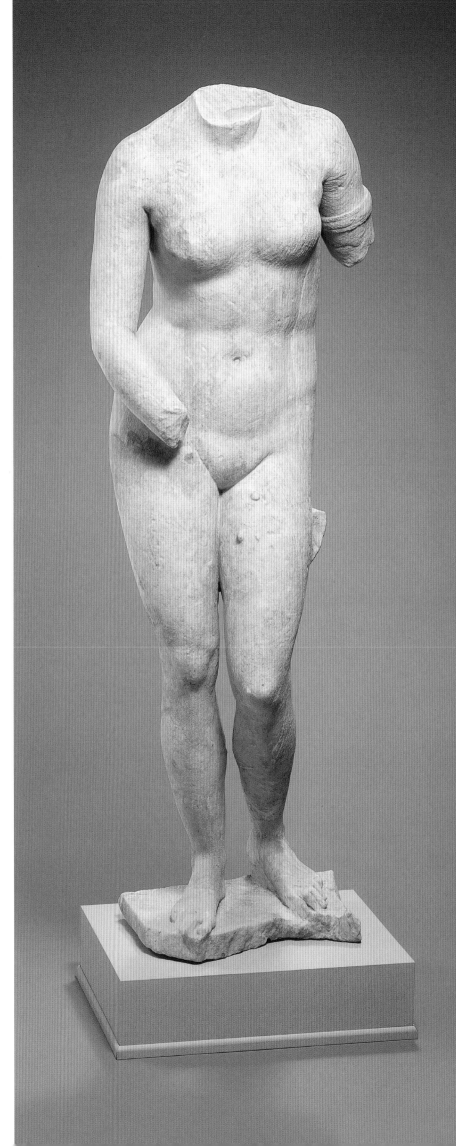

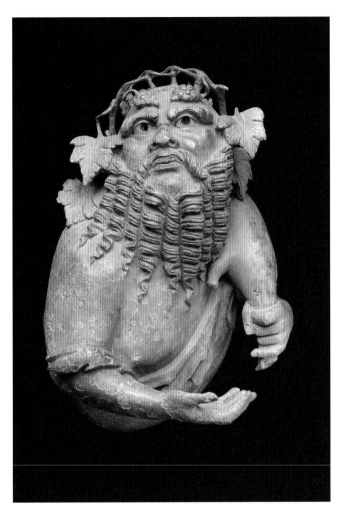

Bust of Silenus

Roman, 1st cen. B.C./1st cen. A.D.

Bronze with traces of silver inlay;
18.7 x 16.2 x 8.9 cm (7⅜ x 6⅜ x 3½ in.)
Katherine K. Adler Endowment,
1997.554.2

*Statue of the Aphrodite of
Knidos*

Roman, 2nd cen.

Copy after 4th cen. B.C. Greek
original by Praxiteles
Marble; 168 x 58.4 x 35.6 cm
(66⅛ x 23 x 14 in.)
Katherine K. Adler Endowment,
Harold L. Stuart and Wirt D. Walker
funds, 1981.11

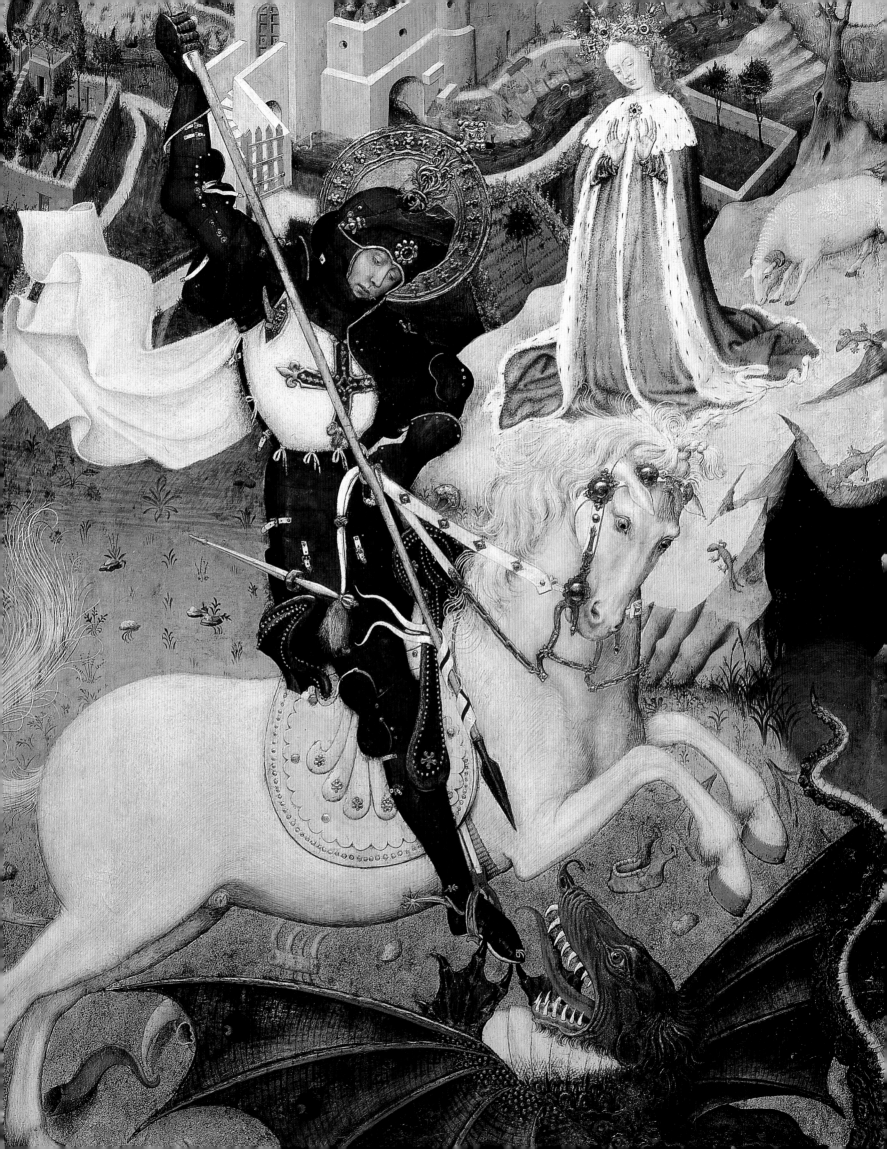

Over the span of a millennium in Europe, from the fifth through the fifteenth centuries, Roman Catholic churches functioned as more than sanctuaries for the Christian faith. After the collapse of Roman imperial authority in the West, the Church survived as a bastion of sacred knowledge and art. The first centuries of the era witnessed tumultuous change, as tribal communities from northern and eastern regions migrated across the continent. But by the eleventh century, stable centers of power began to emerge, laying the foundation for new European nations. The single, unifying force in this transformation was Christianity, as leaders turned to the Church for validation of their power, offering in return military protection and generous patronage. For the duration of the era, religious buildings became treasure-houses, constructed as a testament to enduring belief and furnished with sublimely crafted objects that, according to the German monk Theophilus, gave the faithful a vision of "something of the likeness of the paradise of God."

The Middle Ages

The magnificent churches of the high medieval era (including the regional Romanesque styles of the eleventh and twelfth centuries and the French and International Gothic styles of the late twelfth through the fifteenth centuries) were designed to inspire and instruct, as well as to house the celebration of the Christian religion. Sculpture, conceived as an integral part of architectural design, gave dramatic force to sacred messages. This is evident in the poignant yet dignified expression of the head of an apostle or prophet (p. 76), a fragment of a columnar figure that might have been carved for a portal at the Cathedral of Notre Dame, Paris. In the belief that material richness would guide the pious mind to reflect upon the radiance of heaven, sacred objects were often made of precious metals. Crafted of hammered silver, the chasse of Saint Adrian (p. 76) resembles a miniature tomb. Its form and the relief panels that adorn it explicitly illustrate Adrian's dismemberment, suggesting that the chasse was made to house a relic of the martyred saint.

Lavish liturgical items enhanced the celebration of mass. Participants donned ceremonial garments to conduct the service, and intricately embroidered vestments, such as the museum's cope (p. 87)—a superb example of late *opus anglicanum* (English needlework), featuring silk-and-gilt thread on cut velvet—were stored in church treasuries after being used in the ceremonies. As the most sacred space in the church, the chancel received the most elaborate decoration, allowing benefactors to demonstrate their devotion. The presence of the Montoya coat of arms on the side borders of the retable and altar frontal (p. 86), one of the finest surviving masterworks of Spanish textile arts, reveals that it was a gift from Pedro de Montoya, Bishop of Osma, to the Cathedral of Burgo de Osma. An important fragment from the magnificent gift given by the Duke of Burgundy to the monastic foundation of the Chartreuse de Champol, Dijon, at the end of the fourteenth century, the powerfully expressive *Christ Crucified* (p. 81) was carved by Jacques de Baerze as the focal point of a winged altarpiece illustrating the Passion and Calvary. These images of Christ's suffering held a universal message for Christians. Whether depicted in the monumental form of the tempera-and-gilt altar cross by the Master of the Bigallo Crucifix (p. 77), or on the modest scale of the print *The Road to Calvary* (p. 87) by the Master of the Amsterdam Cabinet, the salvation gained through divine sacrifice was recognized as a greater reward than earth's material treasures.

Bernardo Martorell. *Saint George Killing the Dragon* (detail). See page 82.

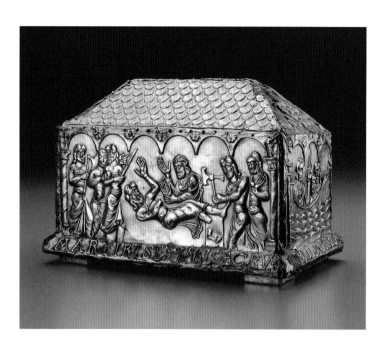

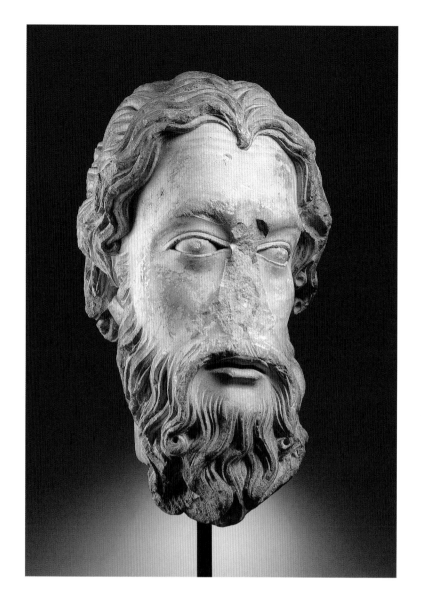

Chasse of Saint Adrian

Spanish, 1100/35

Repoussé silver on oak core;
16.2 x 25.4 x 14.5 cm (6⅜ x 10 x 5¾ in.)
Kate S. Buckingham Endowment,
1943.65

Head of Apostle or Prophet

French, c. 1200

Limestone; 44.2 x 26.5 x 26.8 cm
(17⅟₁₆ x 10⁷⁄₁₆ x 10⁹⁄₁₆ in.)
Lucy Maud Buckingham Collection,
1944.413

*Virgin and Child Enthroned
with the Archangels Raphael
and Gabriel* (left wing),
*Christ on the Cross between
the Virgin and Saint John
the Evangelist* (right wing)

Latin Kingdom of Jerusalem, 1275/85

Tempera on panel; left wing: 38 x
29.5 cm (14ⁱⁱⁱ⁄₁₆ x 11⅝ in.); right wing:
38 x 29.5 cm (14¹⁵⁄₁₆ x 11⅝ in.)
Mr. and Mrs. Martin A. Ryerson
Collection, 1933.1035

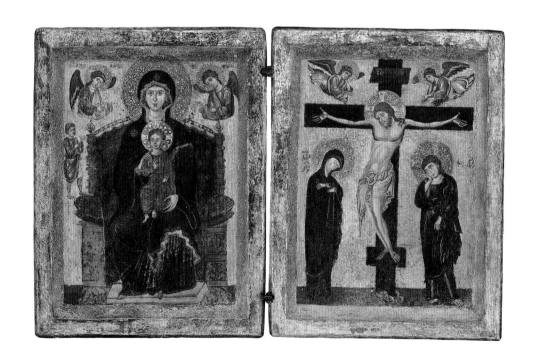

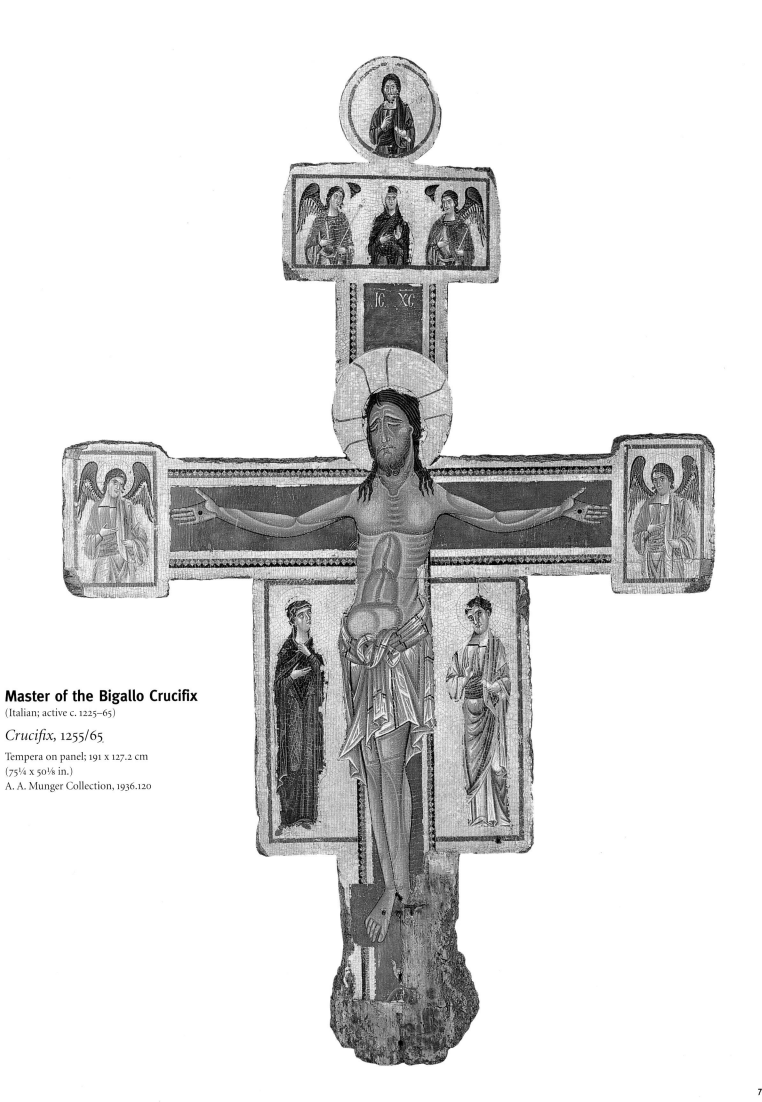

Master of the Bigallo Crucifix
(Italian; active c. 1225–65)

Crucifix, 1255/65

Tempera on panel; 191 x 127.2 cm
(75¼ x 50⅛ in.)
A. A. Munger Collection, 1936.120

The Ayala Altarpiece

Spanish, 1396

Tempera on panel; 253.4 x 639.5 cm
(99¾ x 251¾ in.); altar frontal:
85.1 x 259.1 cm (33½ x 102 in.)
Gift of Charles Deering, 1928.817

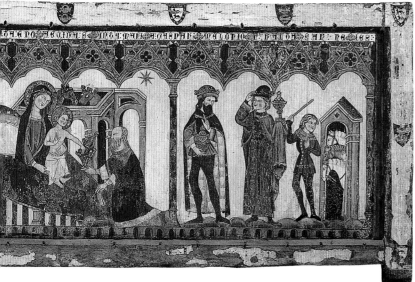

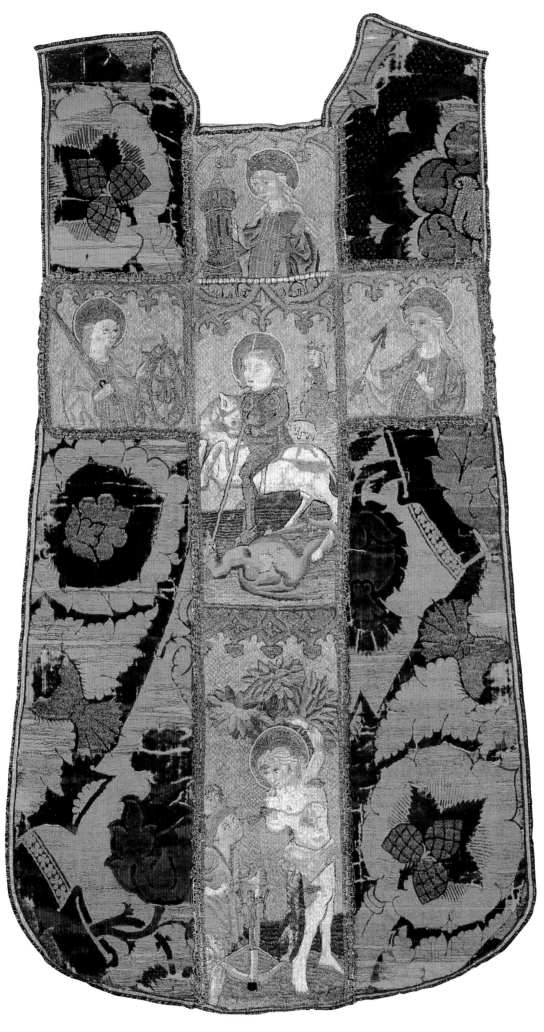

Chasuble Front with Orphrey Cross

Chasuble: Italian, Florence, 15th cen.

Orphrey Cross: Bohemian or German, first half of 15th cen.

Chasuble: silk, plain weave with silk facing wefts, twill interlacings of secondary binding warps and gilt-metal-strip-wrapped silk facing wefts forming weft loops in areas, cut, pile-on-pile voided velvet; orphrey cross: linen, plain weave; embroidered with silk and gilt-and-silvered-animal-substrate-wrapped linen in bullion, outline, satin, and split stitches; laid work, couching, and padded couching; edged with woven fringe and tapes; chasuble: 126.6 x 70.5 cm (49⅞ x 27¾ in.); orphrey cross: 112 x 57.7 cm (44 x 22¾ in.) Grace R. Smith Textile Endowment, 1980.615

Two Fragments

Spanish, 15th cen.

Silk, satin weave with plain interlacings
of secondary binding warps and
patterning wefts; fragment a:
51.5 x 18.6 cm (20¼ x 7⅝ in.);
fragment b: 53.6 x 27.2 cm (21⅛ x
10¾ in.)
Restricted gift of the Needlework and
Textile Guild, 1945.216a–b

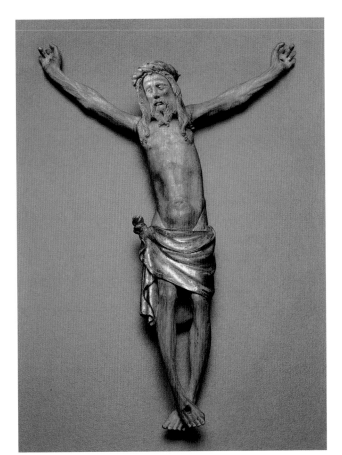

Jacques de Baerze
(Netherlandish; active c. 1383–92)

Christ Crucified, c. 1390

Walnut; 27.9 x 18.3 x 5.2 cm
(11 x 7³⁄₁₆ x 2¹⁄₁₆ in.)
Gift of Honoré Palmer, 1944.1370

Bernardo Martorell
(Spanish; c. 1400–1452)

*Saint George Killing
the Dragon*, 1430/35

Tempera on panel; 155.3 x 98 cm
(61⅛ x 38⅜ in.)
Gift of Mrs. Richard E.
Danielson and Mrs. Chauncey
McCormick, 1933.786

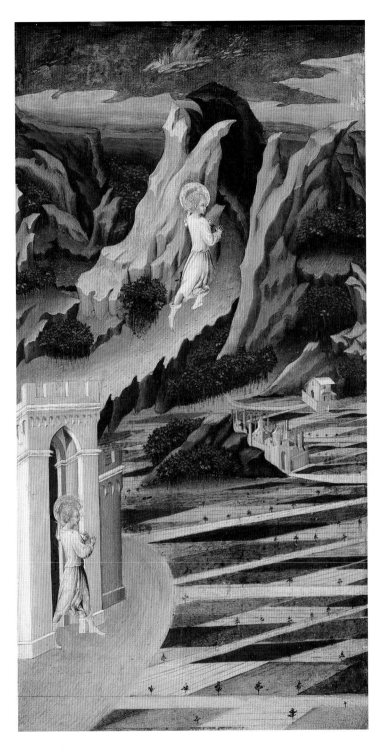

Giovanni di Paolo

(Italian; active c. 1417–82)

Saint John the Baptist Entering the Wilderness, 1455/60

Tempera on panel; 68.5 x 36.2 cm (27 x 14¼ in.); painted surface: 66.3 x 34 cm (26⅛ x 13⅜ in.) Mr. and Mrs. Martin A. Ryerson Collection, 1933.1010

Giovanni di Paolo

(Italian; active c. 1417–82)

The Head of Saint John the Baptist Brought before Herod, 1455/60

Tempera on panel; 68.5 x 40.2 cm (27 x 15¹³⁄₁₆ in.); painted surface: 66.1 x 38.1 cm (26½ x 15 in.) Mr. and Mrs. Martin A. Ryerson Collection, 1933.1015

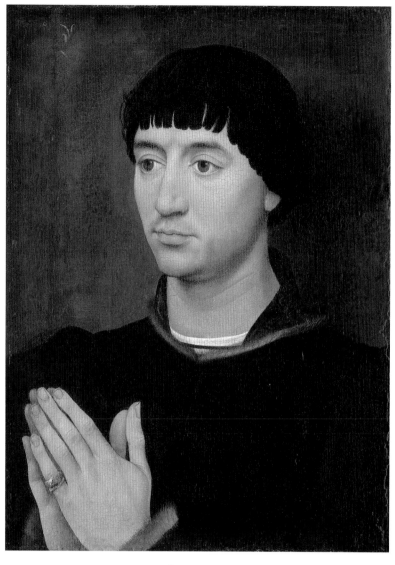

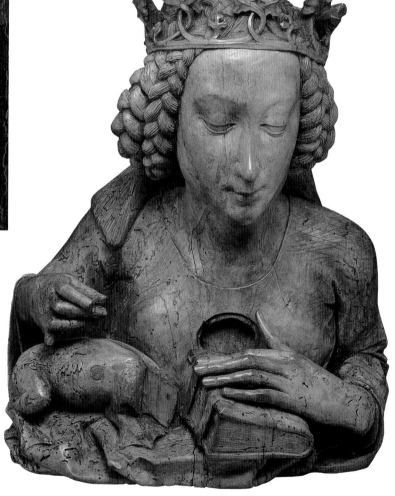

Rogier van der Weyden and Workshop

(Netherlandish; 1399/1400–1464)

Jean Gros, c. 1460

Oil and tempera on panel;
38.6 x 28.6 cm (15⅛ x 11¼ in.)
Mr. and Mrs. Martin A. Ryerson
Collection, 1933.1051

Nicolaus Gerhaert and Workshop

(German; active 1462–73)

Bust of Saint Margaret of Antioch, 1465/70

Walnut; 50.8 x 43.8 x 28 cm
(20 x 17¼ x 11⅛ in.)
Lucy Maud Buckingham
Collection, 1943.1001

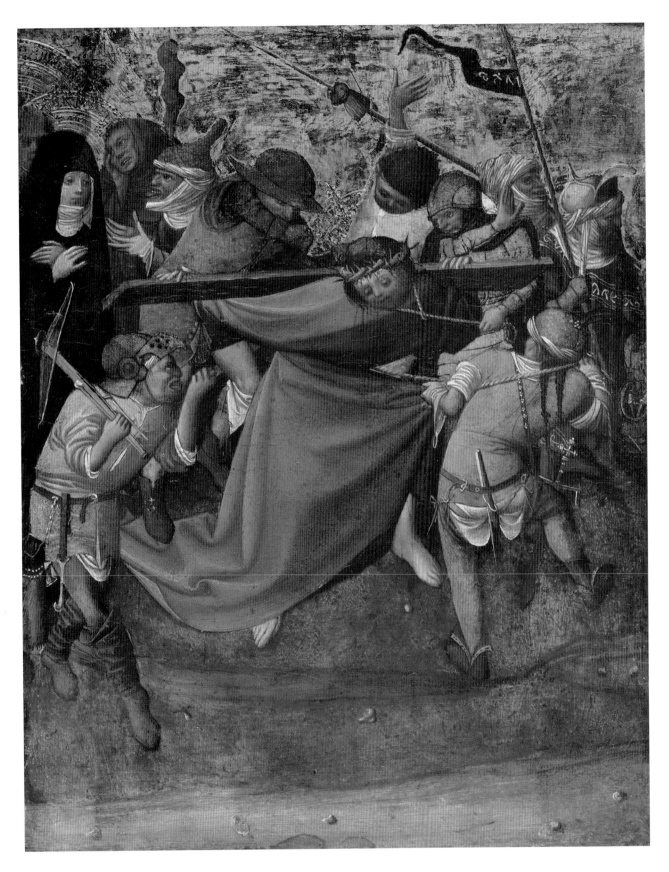

Master of the Worcester Panel

(German; active c. 1420–35)

Christ Carrying the Cross, 1420/25

Tempera on panel; 23.8 x 18.8 cm (9⅜ x 7⅜ in.)
Charles H. and Mary F. S. Worcester
Collection, 1947.79

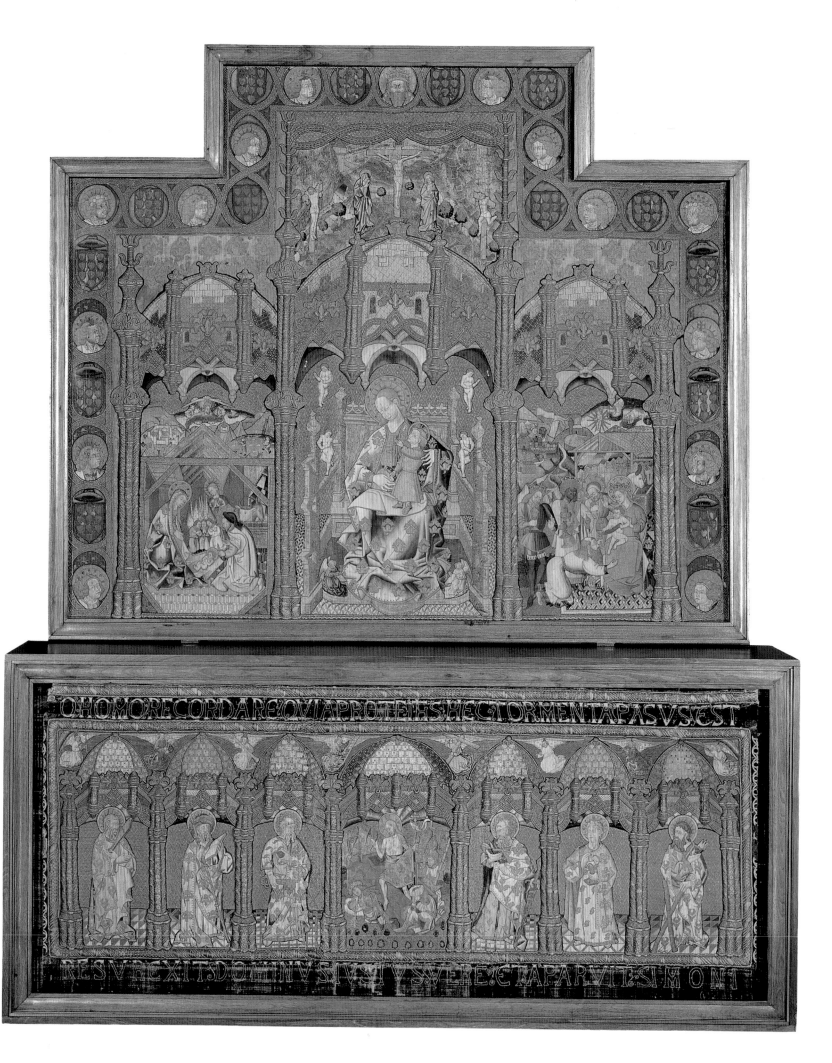

Retable Depicting the Madonna and Child, Nativity, and Adoration of the Magi; Altar Frontal Depicting the Resurrection and Six Apostles

Spanish, Burgo de Osma, c. 1468

Linen, plain weave; appliquéd with linen and silk, plain weaves; and silk, plain weave, cut solid velvet; retable: embroidered with silk floss and creped yarns, and gilt-and-silvered-metal-strip-wrapped silk in a variety of stitches; laid work, couching, and padded couching; seed pearls and spangles; altar frontal: embroidered with linen, silk, and gilt-metal-strip-wrapped silk in satin and split stitches; laid work, couching, and padded couching; spangles; retable: 165.2 x 200.8 cm (65 x 79 in.); altar frontal: 88.8 x 202.3 cm (35 x 79⅝ in.) Gift of Mrs. Chauncey McCormick and Mrs. Richard Ely Danielson, 1927.1779a–b

Master of the Amsterdam Cabinet

(German or Netherlandish; active c. 1465–1500)

The Road to Calvary, 1475/80

Drypoint on ivory laid paper; sheet: 13 x 19.4 cm (5⅛ x 7⅝ in.) Clarence Buckingham Collection, 1958.299

Cope

English, late 15th/early 16th cen.

Silk, broken warp chevron twill weave, cut voided velvet; appliquéd with linen, plain weave; embroidered with silk and gilt-metal-strip-wrapped silk in satin and split stitches; laid work, couching, and padded couching; spangles; 144 x 291.1 cm (56¾ x 114⅝ in.) Grace R. Smith Textile Endowment, 1971.312a

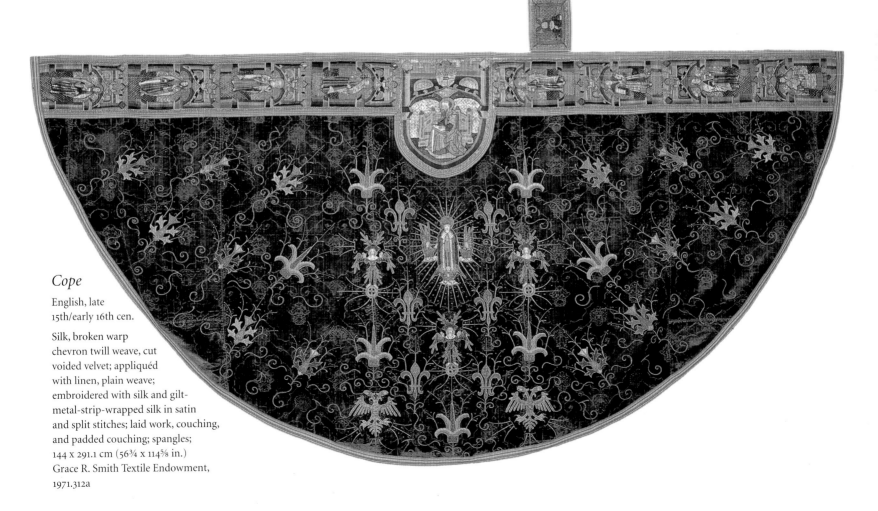

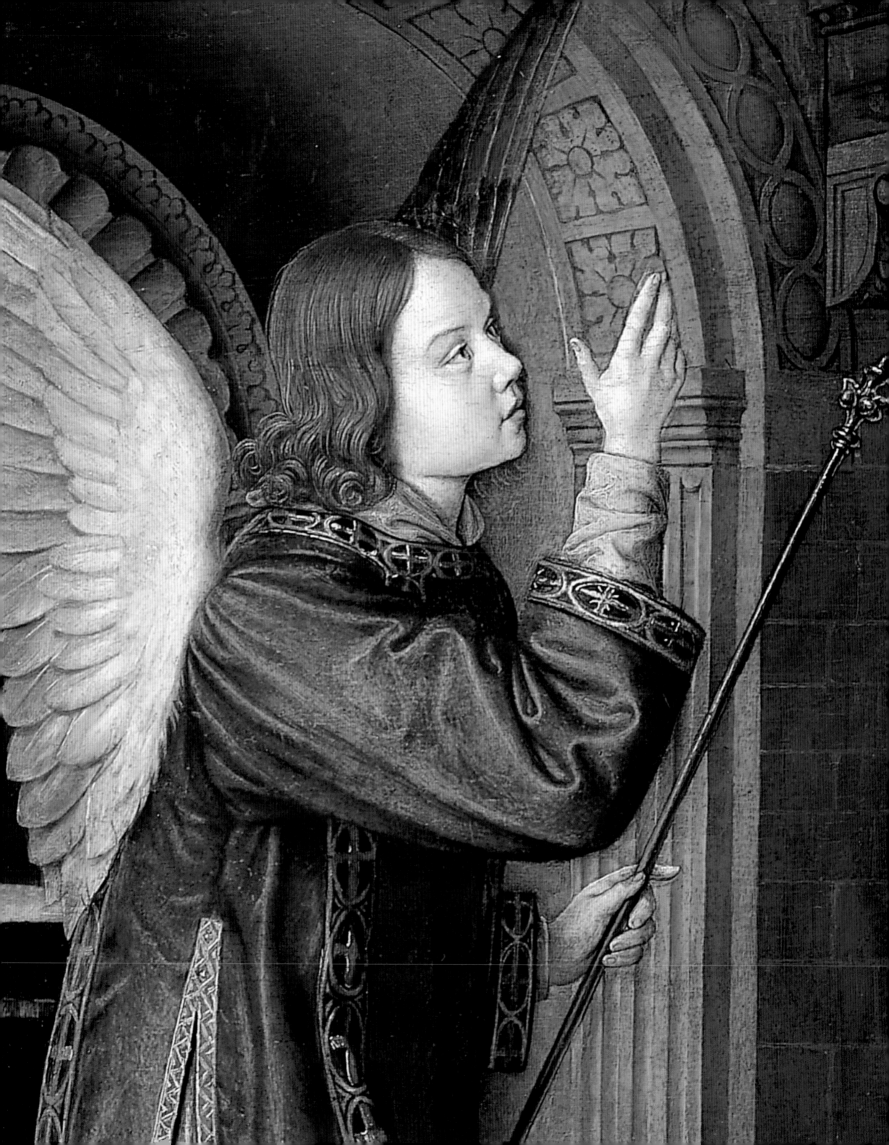

As a passionate advocate of classical learning, the Italian poet and philosopher Petrarch imagined a future in which Latin scholars would revive the wonders of antiquity and "walk back into the pure radiance of the past." He and his followers called their self-conscious embrace of Rome's ancient heritage a *rinascita*, heralding the rebirth of classical values and a new emphasis on individual human experience. The modern use of the term Renaissance, meant to designate the intellectual interest in classical antiquity that originated in Italy in the fourteenth century and culminated during the sixteenth century's pan-European embrace of humanism, reflects Petrarch's legacy. The Renaissance signified a new vision for the arts, reflecting not only aspirations toward classical ideals but also engagement in the known and natural world.

Italy provided artists with a plethora of architectural and sculptural models. In the monumental setting of Gian Francesco de' Maineri's wash drawing *Sacrificial Scene* (p. 90), the arches reveal the artist's knowledge of Roman prototypes, and serve to convey the illusion of depth and space.

The Renaissance

The portrayal by Renaissance artists of the human body also followed antique examples and is therefore characterized by a sense of dignity and a revival of classical proportions. Through careful attention to anatomy, as seen in the hand drawn by Raphael (p. 91), artists gained a command of physical expression that mirrors the force, weight, and mobility they observed in life. In Correggio's *Virgin and Child with the Young Saint John the Baptist* (p. 98), the gentle gestures of Mary suggest the humanity of her divine role, a nurturing mother caring tenderly for vulnerable children. Correggio's softly veiled landscape—as well as the naturalistic grace of his execution— reflects the influence of his older contemporary Leonardo da Vinci, while his subject suggests the tender depictions of the Madonnas painted by Raphael during his early career in Florence. Concern with the naturalistic depiction of human anatomy arose in northern countries as well, but with a difference: works such as Lucas Cranach the Elder's portrayals of Adam and Eve (p. 94) tempered the classical ideal with a more realistic observation of detail and a strong sense of decorative pattern. Throughout Europe, the splendor once reserved for liturgical objects in the Middle Ages now also enriched secular entertainment, as seen in the superb metalwork in pageant and sporting armor (see pp. 96–97).

The exchange of ideas between courts and centers of learning throughout Europe prompted the exchange of artistic styles. The tapestry depicting the Annunciation (p. 93), commissioned by the Gonzagas, the ruling family of Mantua, is believed to be based on a design by the Italian master Andrea Mantegna. It was executed by weavers, brought to the court from France or Flanders, who were internationally known for their preeminence in the technique. In 1580 Hans Fugger, banker to the Holy Roman Emperor, contracted Alessandro Vittoria, an outstanding Venetian sculptor, to produce the magnificent bronze relief depicting the Annuciation (p. 100), intended for an altarpiece displayed in his family's chapel in the German city of Augsburg. Many artists traveled to Italy, seeking commissions or the opportunity to learn from the works praised in Giorgio Vasari's *Lives of the Most Excellent Painters, Sculptors, and Architects* (Florence, 1550), an early history of art that looked back at the great achievements of individual masters. Before settling in Spain, Domenico Theotokópoulos (El Greco) spent time in Venice, and the range of responsive expression and use of luminous color in his visionary *Assumption of the Virgin* (p. 99) bear witness to the powerful influence of the Italian tradition.

Jean Hey (The Master of Moulins).
The Annunciation (detail).
See page 92.

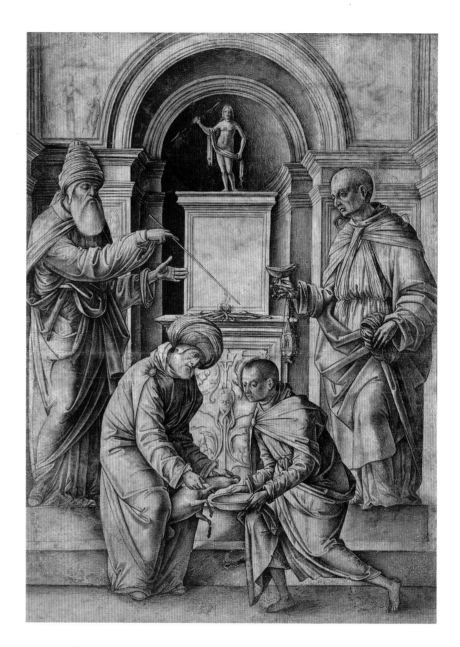

Pisanello (Antonio Pisano)

(Italian; c. 1395–c. 1455)

Bow Case and Quiver of Arrows (verso), 1438

Pen and brown ink on ivory laid paper; 19 x 26.6 cm (7½ x 10½ in.)
Margaret Day Blake Collection, 1961.331

Gian Francesco de' Maineri

(Italian; active 1489–1506)

Sacrificial Scene, 1489/90

Pen and black ink with brush and gray and brown wash, heightened with lead white (partially oxidized), on cream laid paper, edge mounted to cream wove card; 41.8 x 30 cm (16⅜ x 11¹⅜ in.)
Regenstein Collection, 1989.686

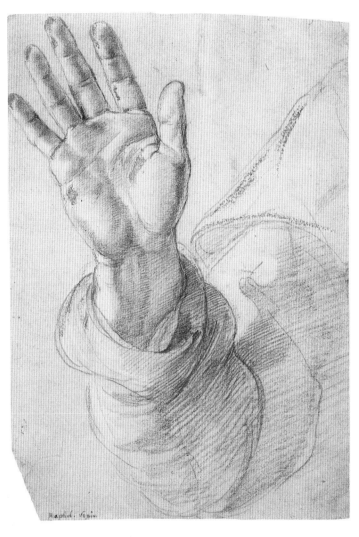

Raphael (Raffaello Sanzio)
(Italian; 1483–1520)

Upraised Right Hand, with Palm Facing Outward (study for *Saint Peter*), 1518/20

Black chalk, heightened with white chalk and lead white (partially oxidized), over stylus underdrawing, on cream laid paper; 28.6 x 19.7 cm (11¼ x 7¾ in.)
Leonora Hall Gurley Memorial Collection, 1993.248.1813

Correggio (Antonio Allegri)
(Italian; c. 1489/94–1534)

Saint Benedict Gesturing to the Left (study for *The Coronation of the Virgin*), 1520/23

Red chalk on cream laid paper prepared with pink wash, laid down on cream laid card; 15.5 x 11.9 cm (6⅟₁₆ x 4⁷⁄₁₆ in.)
Gift of Anne Searle Bent, 1996.337

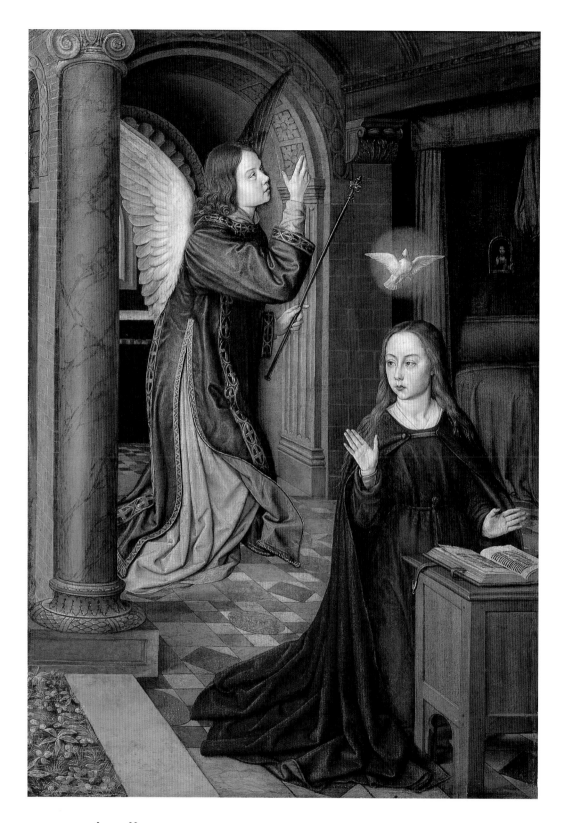

**Jean Hey
(The Master of Moulins)**
(French; active c. 1490–1510)

The Annunciation, c. 1500

Oil on panel; 73.7 x 50.8 cm (29 x 20 in.)
Mr. and Mrs. Martin A. Ryerson
Collection, 1933.1062

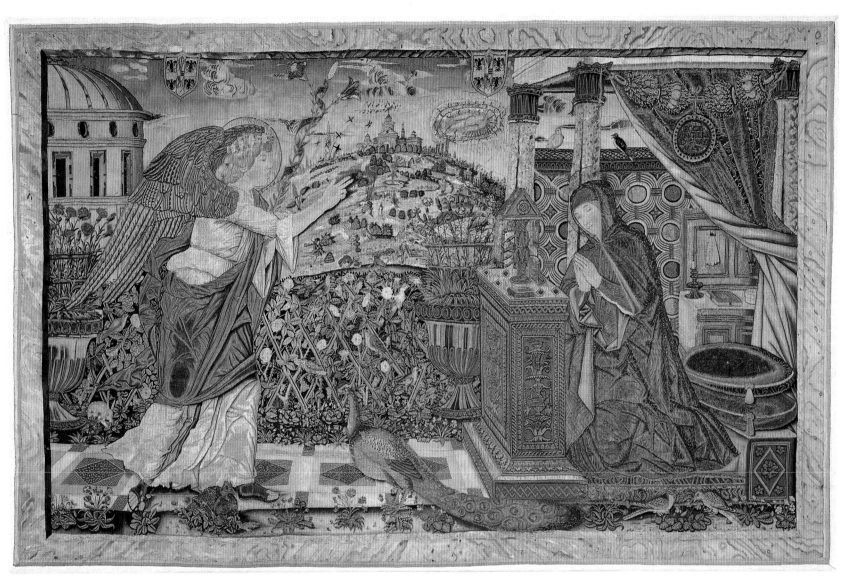

Andrea Mantegna

(Italian; 1431–1506) (attrib.), or artists at
court of Mantua (designer)

*Hanging Depicting the
Annunciation,* 1469/1519

Inscription: *A[ve] G[ratia] P[lena]
Ecce Ancilla D[omini] F[iat] M[ihi]
S[ecundum] T[uum]* ("Hail full of grace;
Behold the handmaid of the Lord;
Be it unto me according Thy word")
Wool, silk, and gilt-and-silvered-metal-
strip-wrapped silk, slit, dovetailed, and
interlocking tapestry weave;
114.6 x 178.8 cm (45⅛ x 70⅜ in.)
Bequest of Mr. and Mrs. Martin A.
Ryerson, 1937.1099

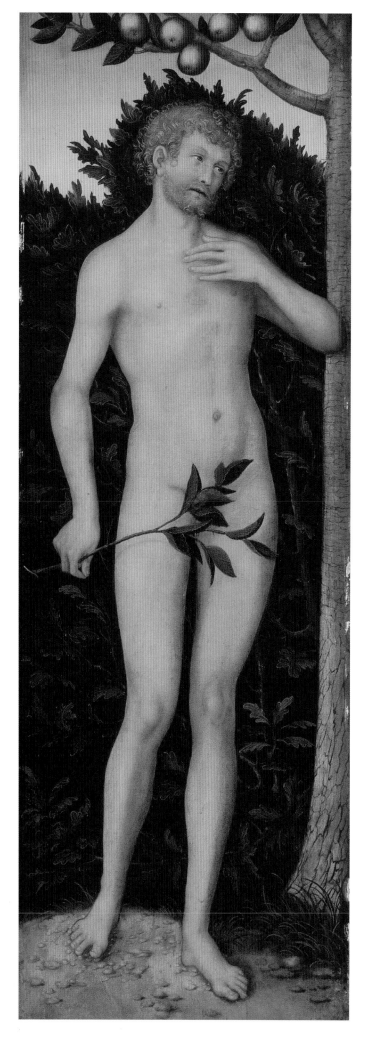
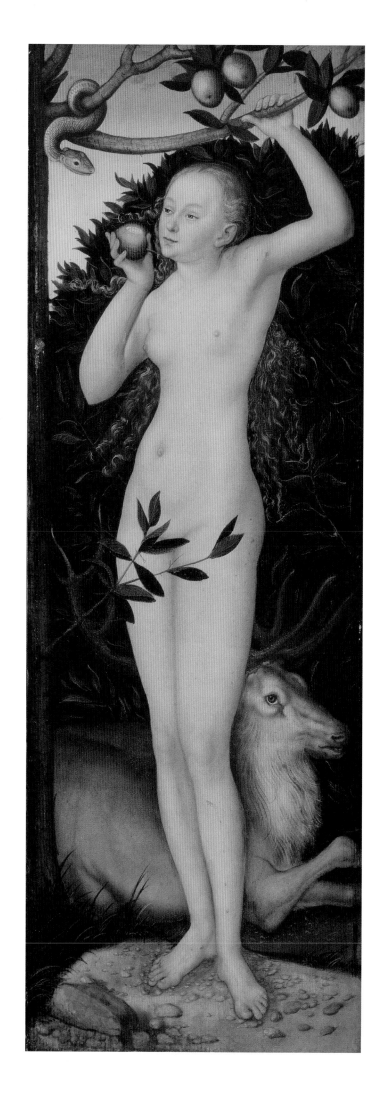

Giovanni Battista Moroni

(Italian; 1520/24–1578)

Gian Lodovico Madruzzo,
1551/52

Oil on canvas; 199.8 x 116 cm
(78⅝ x 45⅝ in.)
Charles H. and Mary F. S. Worcester
Collection, 1929.912

Lucas Cranach the Elder

(German; 1472–1553)

Adam, c. 1530

Oil on panel; 107.5 x 36.5 cm
(42⁵⁄₁₆ x 14⁵⁄₁₆ in.)
Charles H. and Mary F. S. Worcester
Collection, 1935.294

Lucas Cranach the Elder

(German; 1472–1553)

Eve, c. 1530

Oil on panel; 107.6 x 36.4 cm
(42⅜ x 14⁵⁄₁₆ in.)
Charles H. and Mary F. S. Worcester
Collection, 1935.295

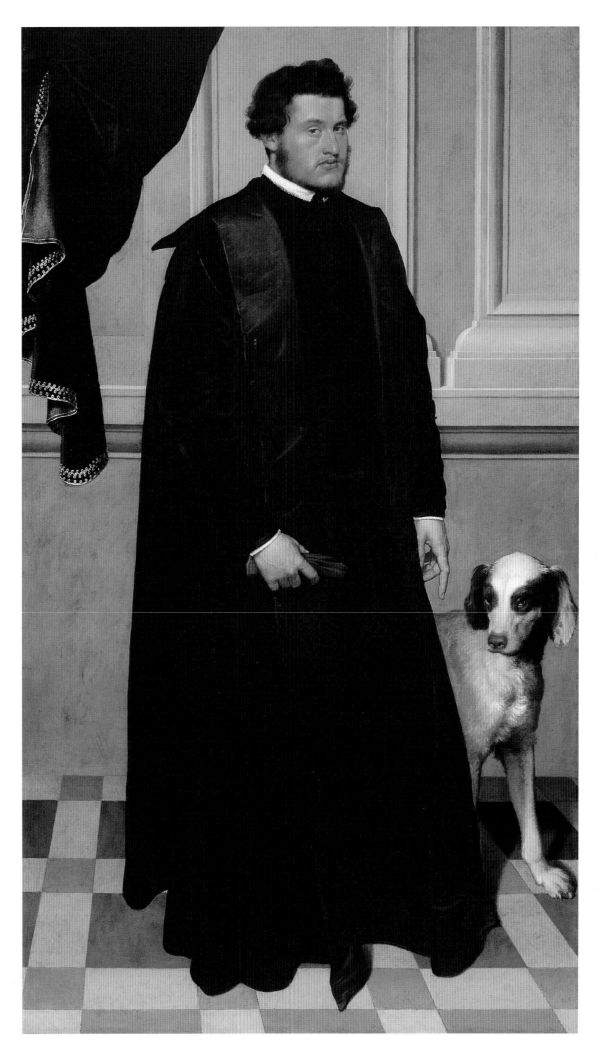

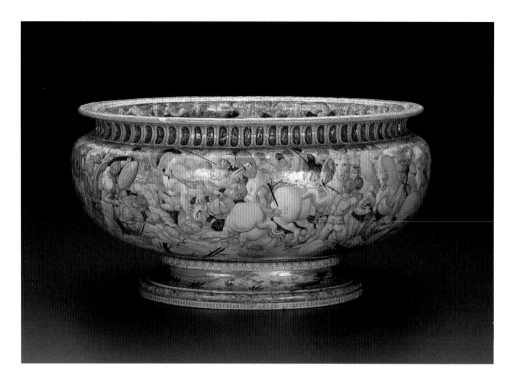

Francesco Durantino
(Italian; active 1543–53)

Wine Cistern, 1553

Tin-glazed earthenware (maiolica);
26 x 51.4 x 41.3 cm (10¼ x 20¼ x 16¼ in.)
Anonymous fund, 1966.395

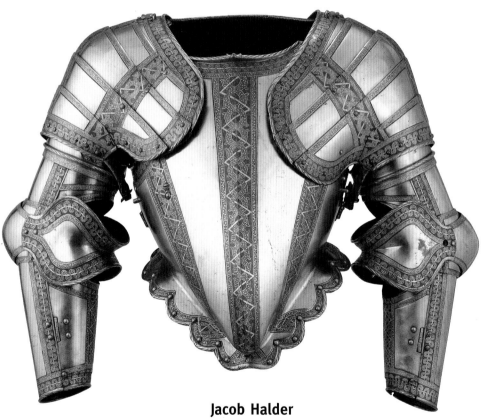

Jacob Halder
(English; active 1576–1608) (attrib.)

Portions of Armor, c. 1590

Etched and gilded steel with iron, brass,
and leather; cuirass with pauldrons:
54 x 63.5 x 39.4 cm (21¼ x 25 x 15½ in.);
arm defenses: l. 50.8 cm (20 in.) (each)
George F. Harding Collection,
1982.2241a–h

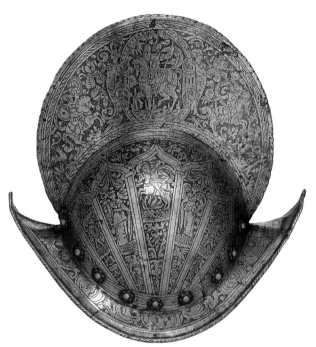

Comb Morion

Northern Italian, probably Brescia,
c. 1590

Etched steel with brass and leather;
35.6 x 34. 3 x 21.6 cm (14 x 13½ x 8½ in.)
George F. Harding Collection, 1982.2192

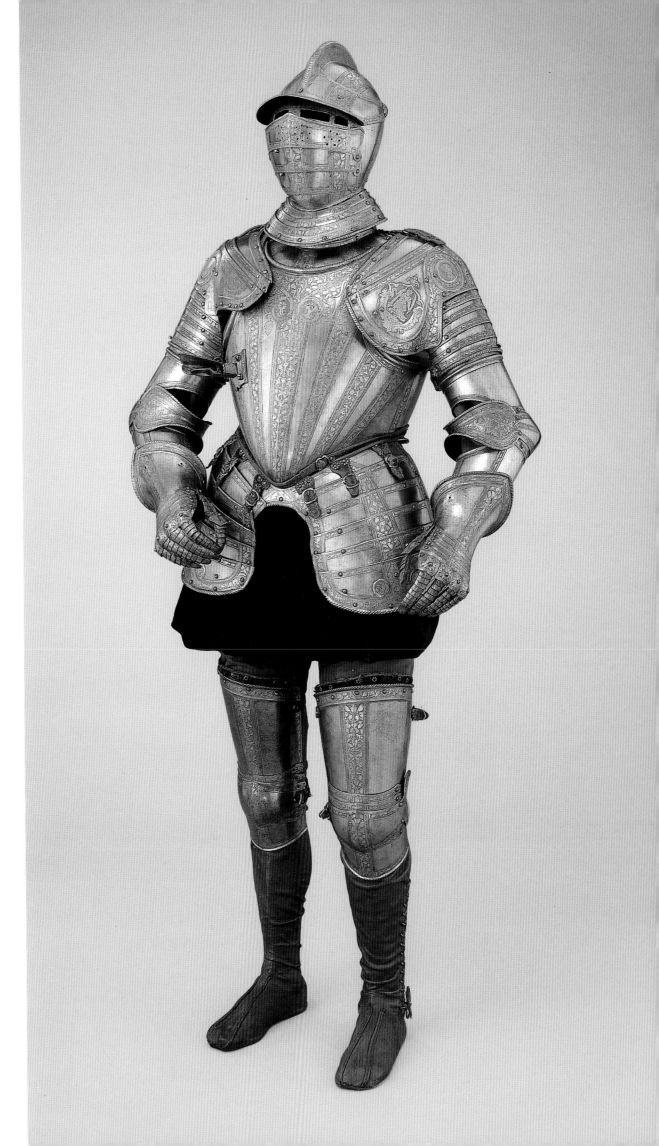

Three-Quarter Armor

Italian, Milan, 1570/80

Chiseled, etched, and gilded steel with
brass, leather, and velvet; helmet:
40.6 x 25.4 x 38.1 cm (16 x 10 x 15 in.);
cuirass with pauldrons and tassets:
63.5 x 49.5 x 40.6 cm (25 x 19½ x 16 in.);
arm defenses with gauntlets: 90.2 x
22.9 x 22.9 cm (35½ x 9 x 9 in.) (each);
leg defenses: 35.6 x 27.9 x 17.8 cm (14 x
11 x 7 in.) (each)
George F. Harding Collection,
1982.2102a–s

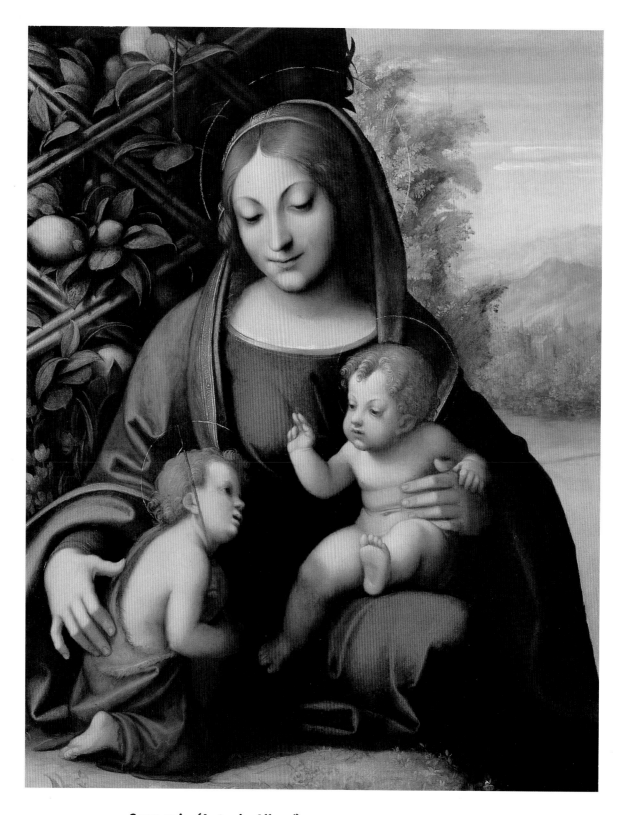

Correggio (Antonio Allegri)
(Italian; c. 1489/94–1534)

*Virgin and Child with the
Young Saint John the Baptist,*
c. 1515

Oil on panel; 64.2 x 50.2 cm
(25¼ x 19¾ in.)
Clyde M. Carr Fund, 1965.688

El Greco (Domenico Theotokópoulos)
(Spanish, b. Greece; 1541–1614)

The Assumption of the Virgin, 1577

Oil on canvas; 401.4 x 228.7 cm
(158 x 90 in.)
Gift of Nancy Atwood Sprague
in memory of Albert Arnold
Sprague, 1906.99

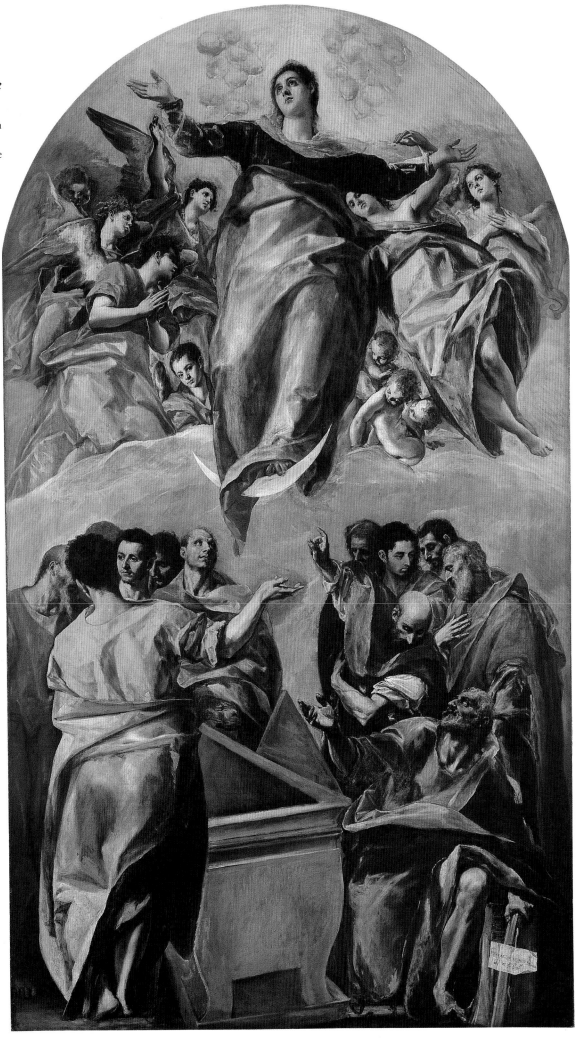

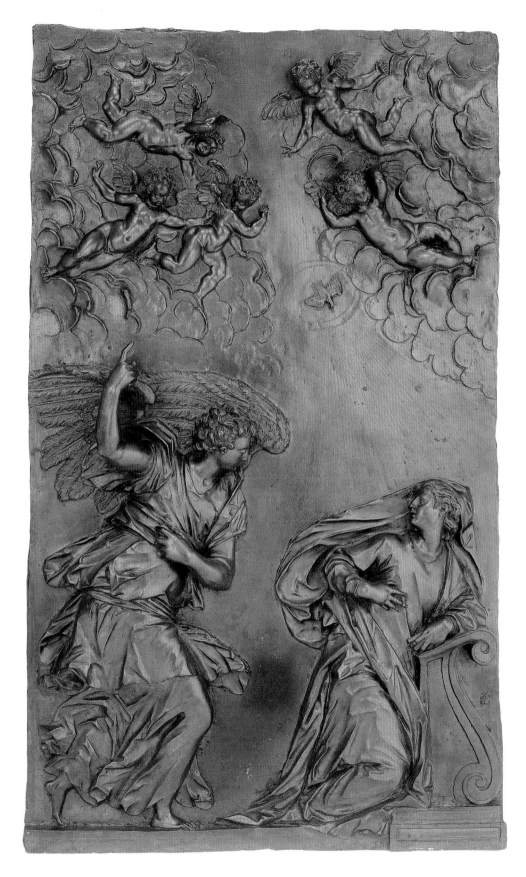

Alessandro Vittoria

(Italian; 1525–1608)

The Annunciation, 1580/85

Bronze; 97.8 x 61.6 cm (38½ x 24¼ in.)
Edward E. Ayer Fund, 1942.249

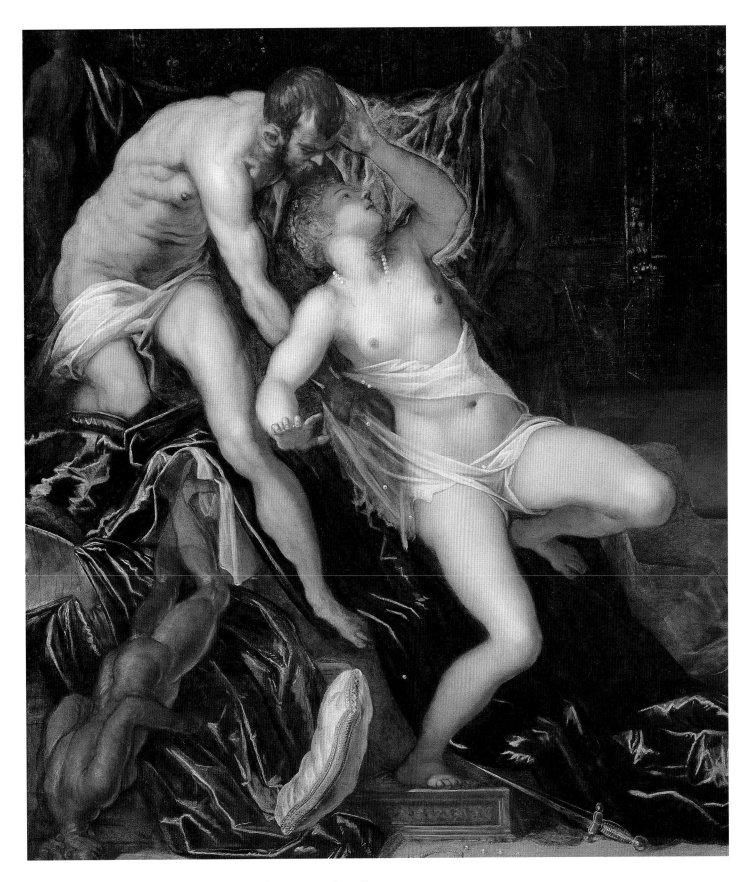

Tintoretto (Jacopo Robusti)
(Italian; 1518–1594)

Tarquin and Lucretia, 1580/90

Oil on canvas; 175 x 151.5 cm (68⅞ x 59⅝ in.)
The Art Institute of Chicago Purchase Fund,
1949.203

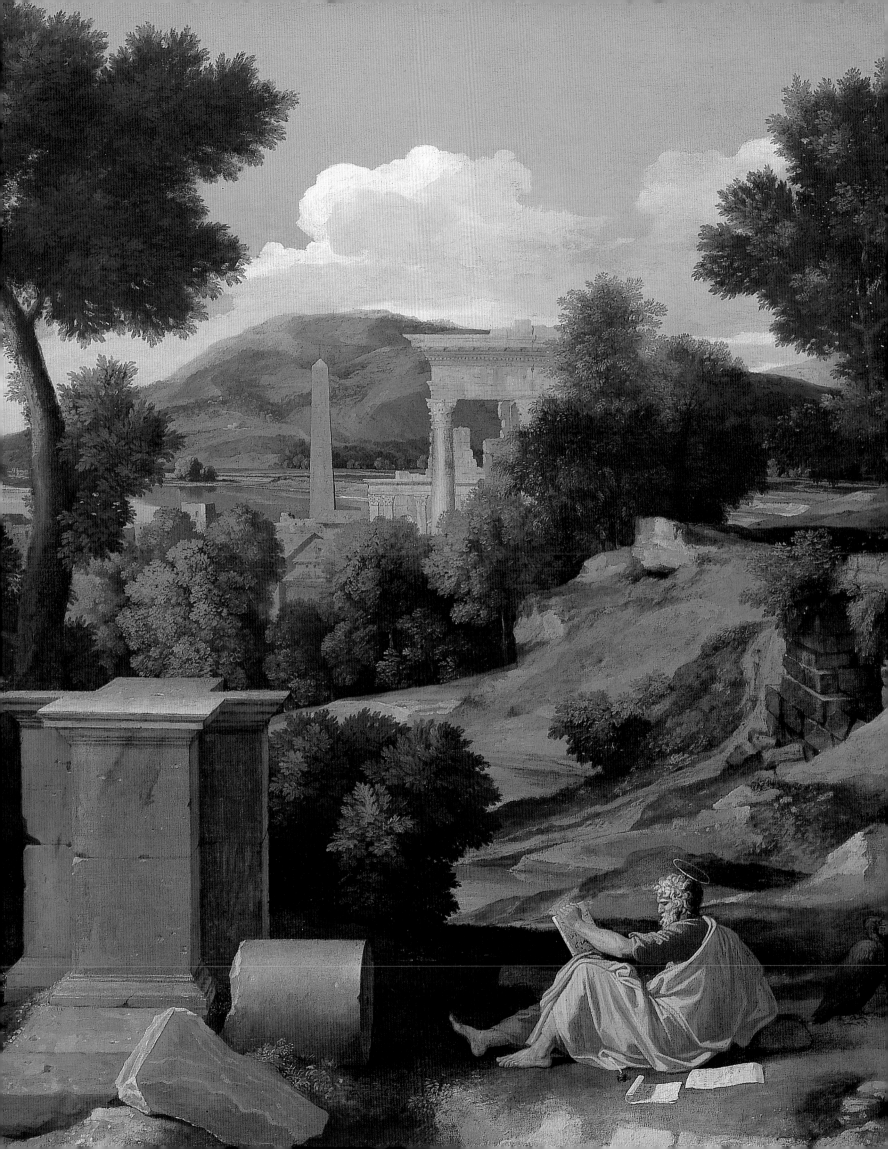

During the seventeenth century, the nations of Europe experienced dynamic social change. King-doms consolidated, dominated by strong monarchs who claimed absolute power and expanded their domains through annexation and colonization. But in some regions, the divine right of kings led to revolution, with the Dutch Republic winning formal independence from the Spanish rulers of the Low Countries in 1648, and the British deposing their king, Charles I, in 1649. The religious reformation of the previous century established Protestantism in much of Northern Europe. In response the Roman Catholic Church, supported by loyal nobility, mounted a Counter-Reformation, an ambitious campaign of heightened piety, church construction, and active conversion. The voyages of exploration in pursuit of new trade routes brought great wealth to Europe, as well as territories with colonial outposts in what was defined as the "New World." The resulting economic growth led to the rise of an affluent middle class, changing the balance of the social structure. The arts of the era mirrored the complexity of these develop-ments, and exhibited the spirit of the age in their energy, confidence, and command.

The Seventeenth Century in Europe

The term "Baroque," commonly used to designate the arts of seventeenth-century Europe, derives from the Portuguese *barroco* (literally: large, irregularly shaped pearl) and implies an ornate or excessive display. But the word *bravura*—suggesting skill, style, and daring—is perhaps more apt. Although diverse in form and aesthetic, the arts of the seventeenth century appeal to the viewer with an emotional intensity, as seen in the lively facial expression of Francesco Mochi's *Bust of a Youth* (p. 112). The humanistic legacy could still be seen in the emphasis on physical beauty, but artists such as Peter Paul Rubens (see p. 109) and Bartolomeo Manfredi (see p. 105) added a dynamic mobility that energized idealized forms. Dramatic contrasts of brilliant illumination and deep shadow, known as tenebrism, height-ened the mood of deep spirituality, whether in Francisco de Zurbarán's expression of Counter-Reformation piety in his *Crucifixion* (p. 110) or in a more personal testament of faith such as Rembrandt van Rijn's etching *Entombment* (p. 119). Rather than excess, the era admired mastery, as seen in Claude Lorrain's subtle but commanding evocation of mood and place in his drawing *Panorama from the Sasso* (p. 118).

The expansion of trade to world markets led artists to explore new materials and absorb new influences. Goods not manufactured in Europe, such as porcelain—a fine, white, translucent ceramic that Western technology could not yet reproduce—were eagerly imported or imitated, as in the Delft vase and cover (p. 120), which was made in Holland but decorated with fantastic motifs inspired by Chinese porcelain. Carved ivory, inlaid into ebony, creates the sumptuous appearance of the Augsburg cabinet (p. 115); this exotic material was also used to embellish swords, daggers, and firearms, as seen in the pair of flintlock pistols (p. 120). While the influx of rare materials expanded the European notion of desirable treasure, there was also a rising appreciation for the bounty of home, expressed in closely observed still lifes of fruits, game, and vegetables, such as those painted by Juan Sánchez Cotán (see p. 106) and Frans Snyders (see p. 107). With the entire world as its repertory, seventeenth-century European art displayed an expansive vision, ranging from the exotic, apparent in the lion and elephant portrayed with their trainers in the French tapestry *The Tamers* (Les Dompteurs) (p. 121), to the mundane, seen in Rembrandt's seemingly effortless *Female Nude Seated on Stool* (p. 118).

Nicolas Poussin. *Landscape with Saint John on Patmos* (detail). See page 116.

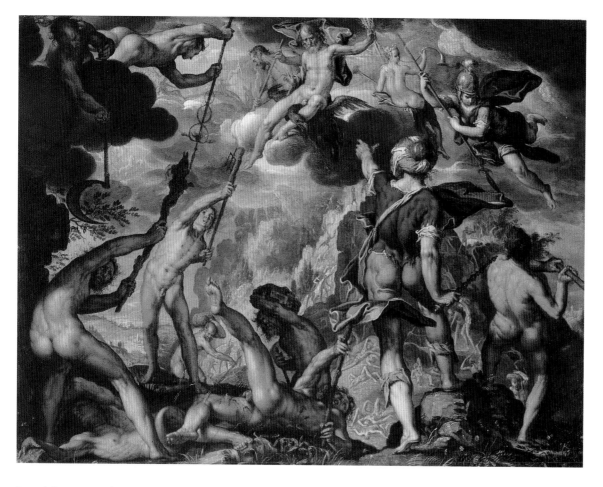

Joachim Antonisz. Wtewael
(Dutch; c. 1566–1638)

The Battle between the Gods and the Titans, c. 1600

Oil on copper; 15.6 x 20.3 cm
(6⅛ x 8 in.)
Through prior acquisition of the
George F. Harding Fund, 1986.426

Cushion Cover
(one of a pair)

English, 1601

Linen, plain weave; embroidered with
silk, linen, and wool in long-armed
cross stitches; edged with woven fringe;
49.5 x 52.8 cm (19½ x 20¾ in.)
Robert Allerton Endowment, 1989.149

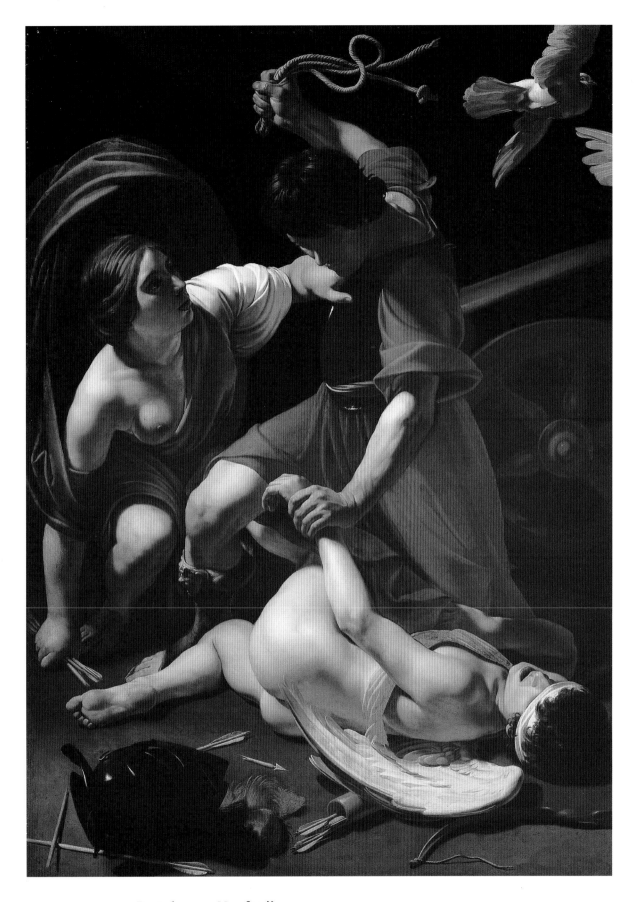

Bartolomeo Manfredi

(Italian; 1582–after 1622)

Cupid Chastised, 1605/10

Oil on canvas; 175.3 x 130.6 cm
(69 x 51⅜ in.)
Charles H. and Mary F. S. Worcester
Collection, 1947.58

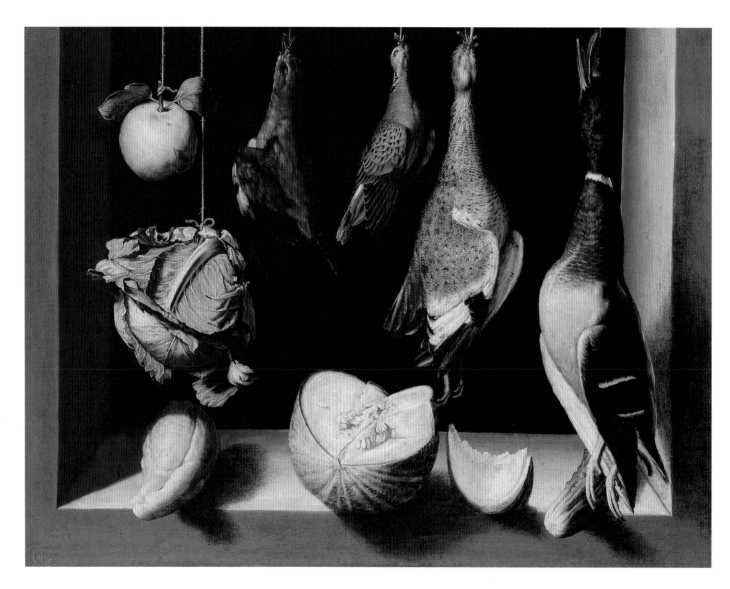

Juan Sánchez Cotán
(Spanish; 1560–1627)

Still Life with Game Fowl,
c. 1602

Oil on canvas; 67.8 x 88.3 cm
(26⅝ x 34¾ in.)
Gift of Mr. and Mrs. Leigh B. Block,
1955.1203

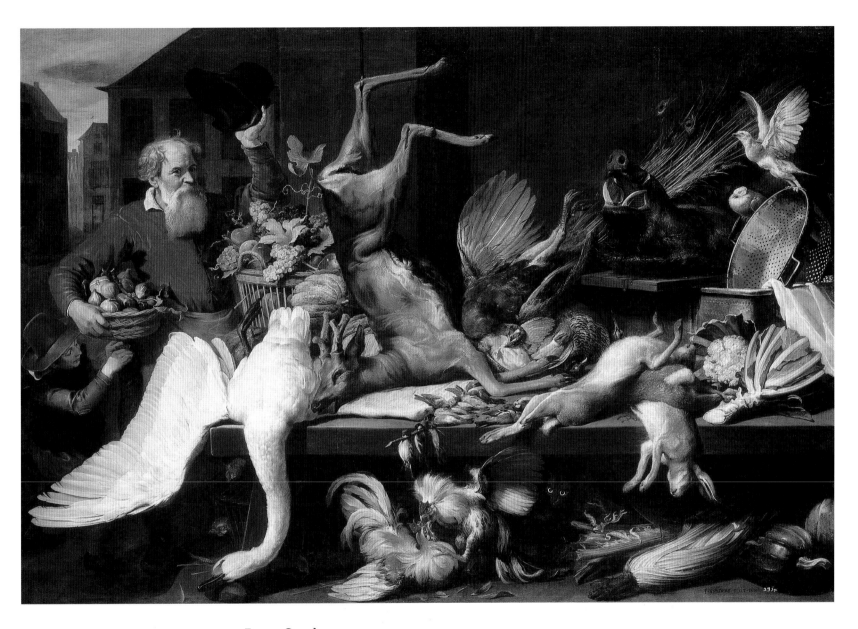

Frans Snyders

(Flemish; 1579–1657)

*Still Life with Dead Game,
Fruits, and Vegetables in a
Market,* 1614

Oil on canvas; 212.1 x 308.6 cm
(83½ x 121¼ in.)
Charles H. and Mary F. S. Worcester
Collection, 1981.182

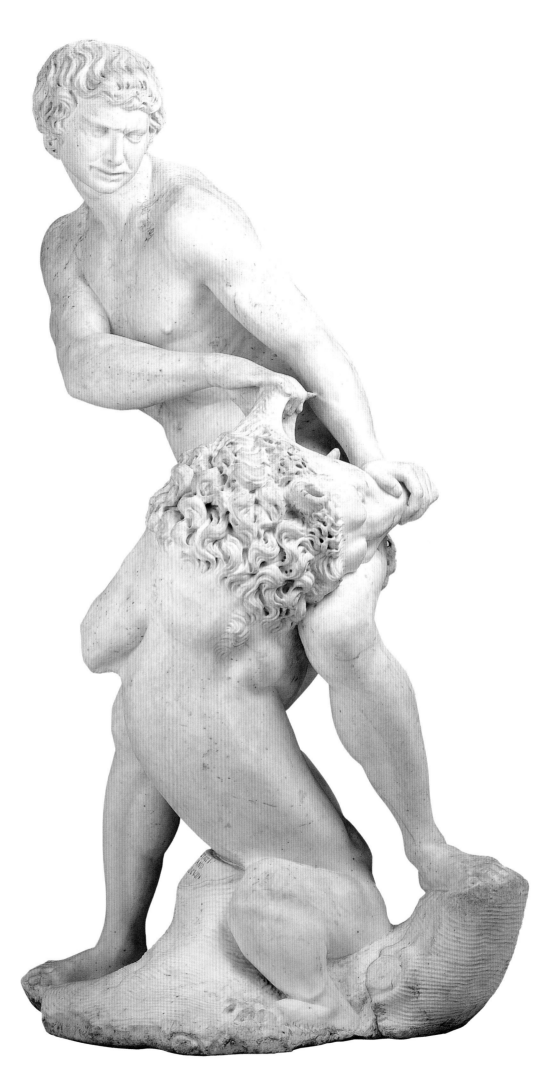

Cristoforo Stati

(Italian; c. 1556–1619)

Samson and the Lion,
1604–1607

Marble; 210.8 x 110.5 x 81.9 cm
(83 x 43½ x 32¼ in.)
Chester D. Tripp Endowment, 1997.335

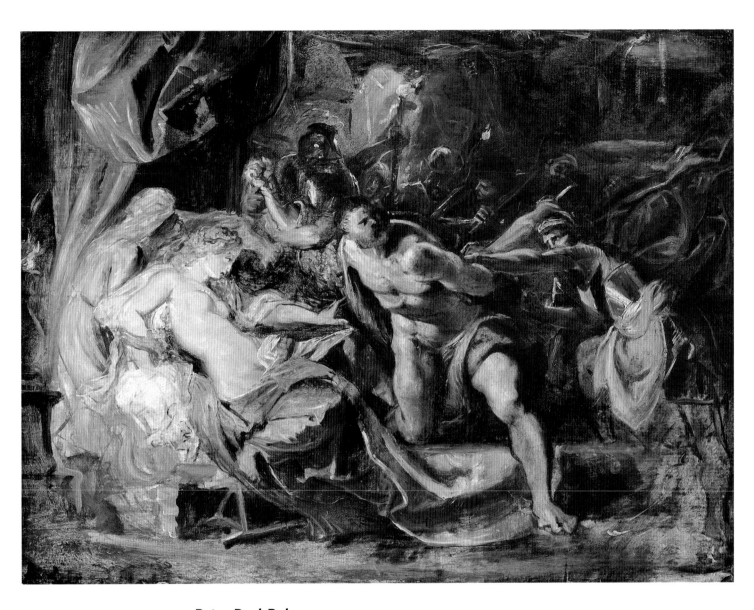

Peter Paul Rubens
(Flemish; 1577–1640)

The Capture of Samson,
1609/10

Oil on panel; 50.4 x 66.4 cm
(19¾ x 26⅛ in.)
Robert A. Waller Memorial Fund,
1923.551

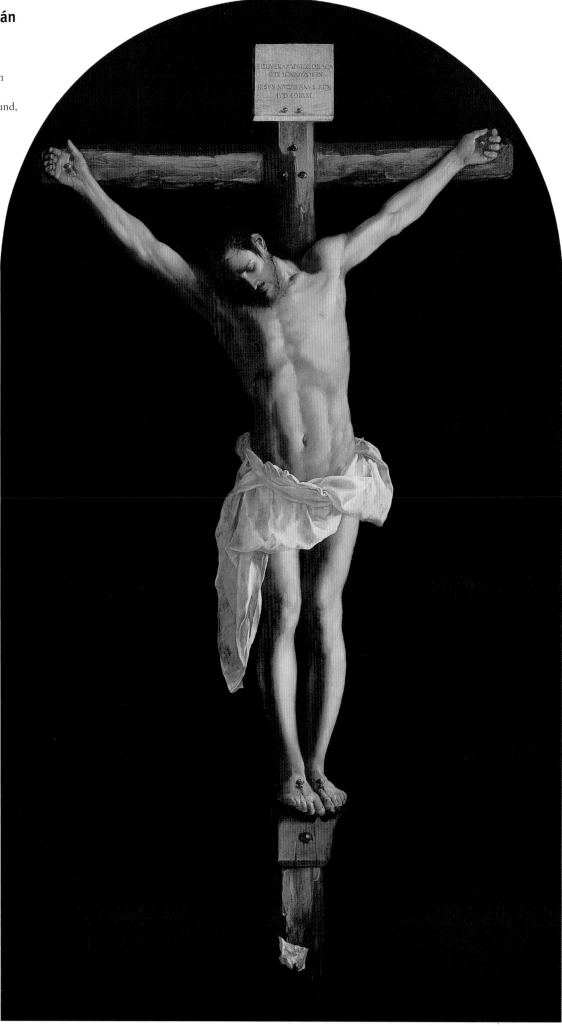

Francisco de Zurbarán
(Spanish; 1598–1664)

The Crucifixion, 1627

Oil on canvas; 290.3 x 165.5 cm
(114⅜ x 65 3/16 in.)
Robert A. Waller Memorial Fund,
1954.15

Jusepe de Ribera

(Spanish; 1591–1652)

Penitent Saint Peter, 1628/32

Oil on canvas; 126 x 97 cm
(49 ⁹⁄₁₆ x 38 ³⁄₁₆ in.)
Mrs. Golabelle Macomb Finn Fund,
with additional support from friends of
the European Painting Department,
Mrs. James W. Alsdorf, Mrs. Edward
McCormick Blair, Mr. and Mrs. Gerald
Gidwitz, Josephine and John J. Louis,
Jr., the Otto L. and Hazel T. Rhoades
Fund and Mrs. George B. Young; L. L.
and A. S. Coburn Endowment, 1993.60

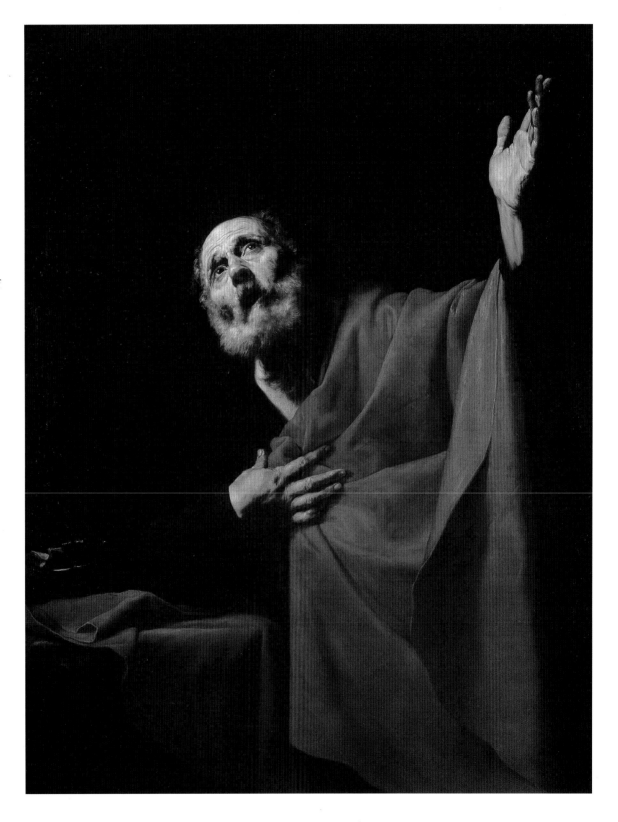

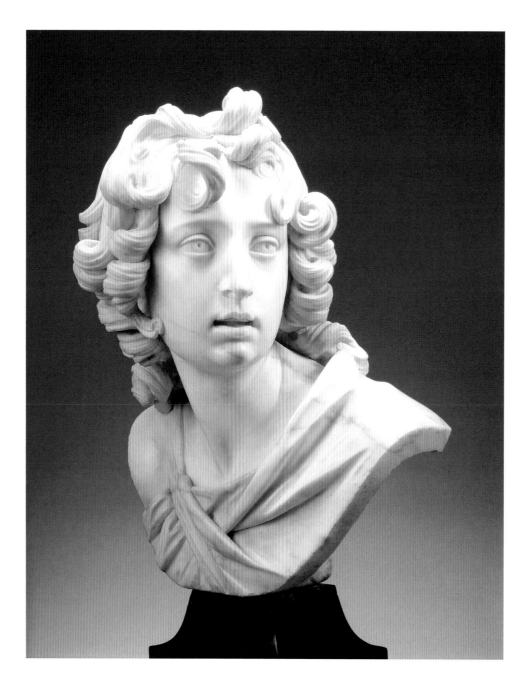

Francesco Mochi
(Italian; 1580–1654)

Bust of a Youth (possibly
Saint John the Baptist),
c. 1630

Marble; 40.5 x 33 x 29 cm
(16 x 13 x 11⁷⁄₁₆ in.) (without base)
From the collection of the Estate of
Federico Gentili di Giuseppe.
Restricted gift of Mrs. Harold T. Martin
through the Antiquarian Society;
European Decorative Arts Purchase
funds; Major Acquisitions Centennial
Endowment; and through prior gift of
Arthur Rubloff, 1989.1

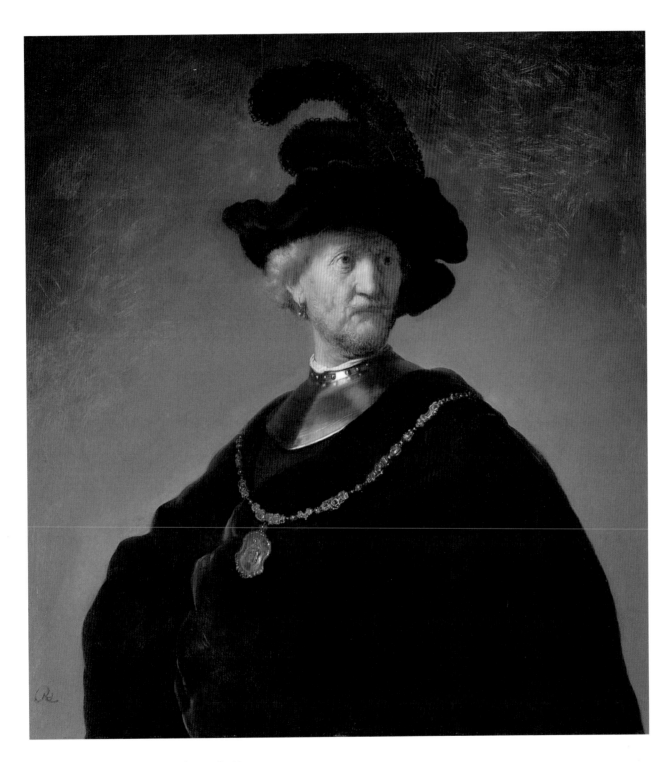

**Rembrandt Harmensz.
van Rijn**
(Dutch; 1606–1669)

*Old Man with a Gold
Chain*, c. 1631

Oil on panel; 83.1 x 75.7 cm
(32¾ x 29¾ in.)
Mr. and Mrs. W. W. Kimball Collection,
1922.4467

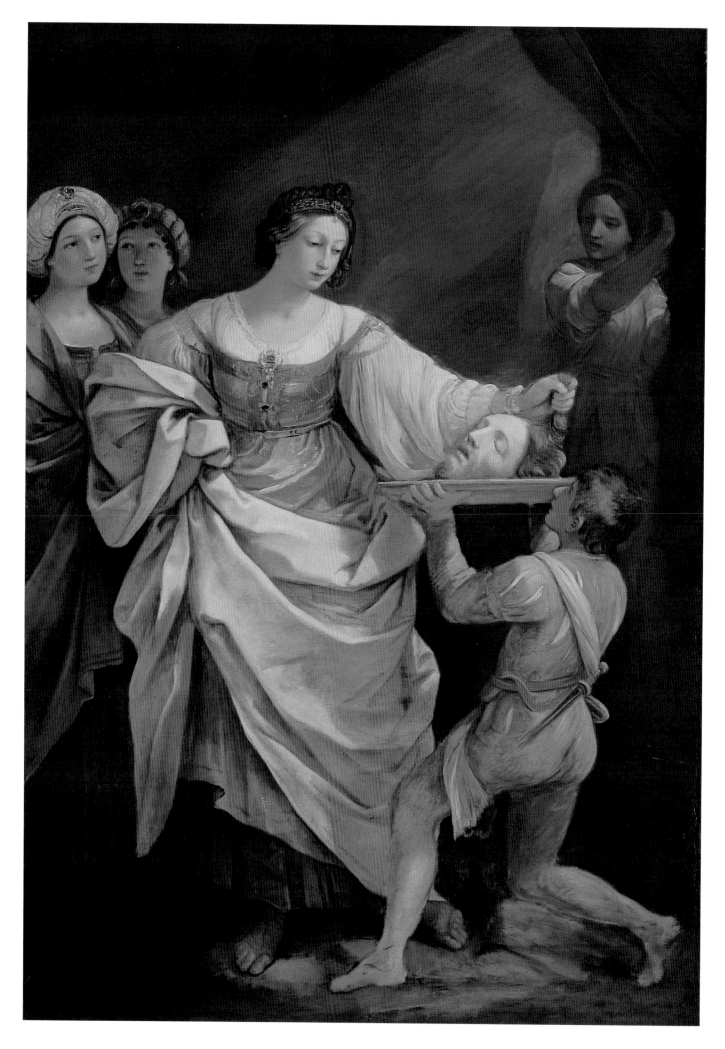

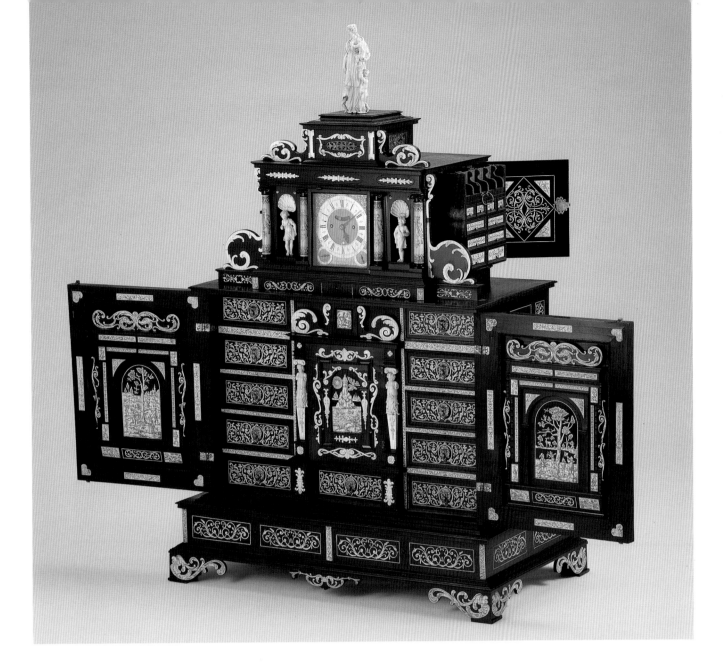

Augsburg Cabinet

German, c. 1640

Ebony, carved and inlaid ivory, stained
and carved wood relief, gilt bronze, and
iron implements; 160 x 110.5 x 64.8 cm
(63 x 43½ x 25½ in.)
Anonymous Purchase Fund, 1970.404

Ferdinando Tacca
(Italian; 1619–1686)

Bireno and Olimpia, 1640/50

Bronze; 37.8 x 38.1 x 20.3 cm
(14⅞ x 15 x 8 in.)
Major Acquisitions Centennial
Endowment, through prior gift of the
George F. Harding Collection, 1993.348

Guido Reni
(Italian; 1575–1642)

*Salome with the Head of
Saint John the Baptist,*
1639–40

Oil on canvas; 248.5 x 224.8 cm
(97¾ x 88½ in.)
Louise B. and Frank H. Woods Fund,
1960.3

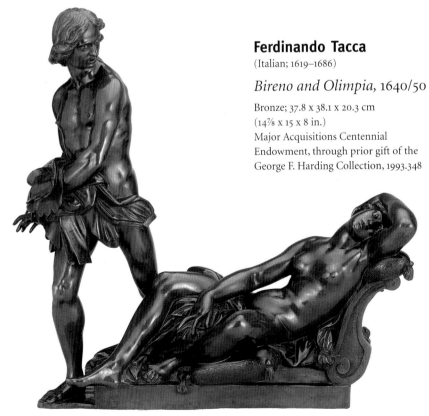

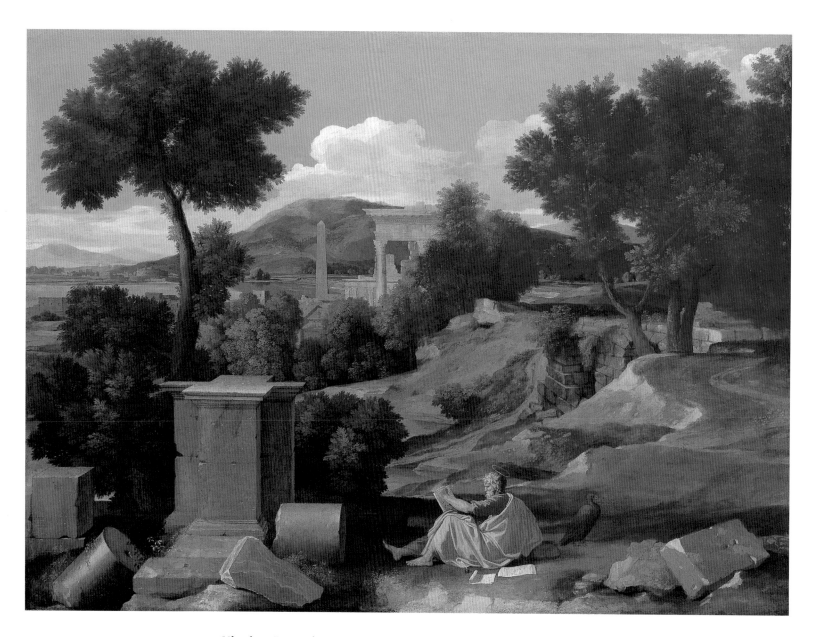

Nicolas Poussin
(French; 1594–1665)

Landscape with Saint John on Patmos, 1640

Oil on canvas; 100.3 x 136.4 cm
(39½ x 53⅝ in.)
A. A. Munger Collection, 1930.500

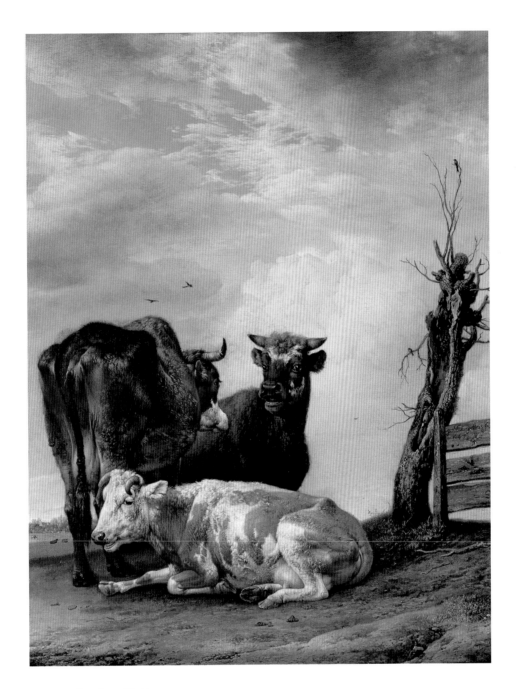

Paulus Potter

(Dutch; 1625–1654)

*Two Cows and a Young Bull
beside a Fence in a Meadow,*
1647

Oil on panel; 49.5 x 37.2 cm
(19½ x 14¾ in.)
In loving memory of Harold T. Martin
from Eloise W. Martin, wife, and Joyce
Martin Brown, daughter; Charles H. and
Mary F. S. Worcester Collection; Lacy
Armour Endowment; through prior gift
of Frank H. and Louise B. Woods,
1997.336

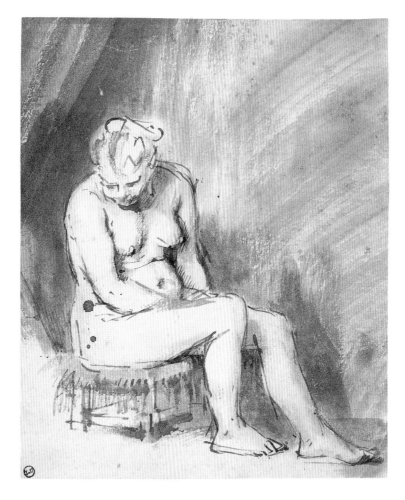

Rembrandt Harmensz. van Rijn
(Dutch; 1606–1669)

Female Nude Seated on a Stool, 1658/61

Pen and brown ink, and brush and brown wash, on ivory laid paper, laid down on cream laid card; 21.2 x 17.4 cm (8¼ x 6⅞ in.)
Clarence Buckingham Collection, 1953.38

Claude Lorrain (called Claude Gellée)
(French; 1600–1682)

Panorama from the Sasso, 1649

Pen and brown ink, with brush and brown wash and white gouache, and white chalk, over black chalk and traces of graphite, on cream laid paper; 16.8 x 41 cm (6⅝ x 16⅛ in.)
Helen Regenstein Collection, 1980.190

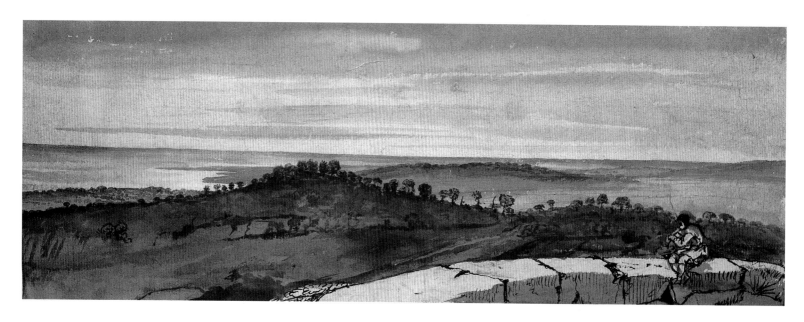

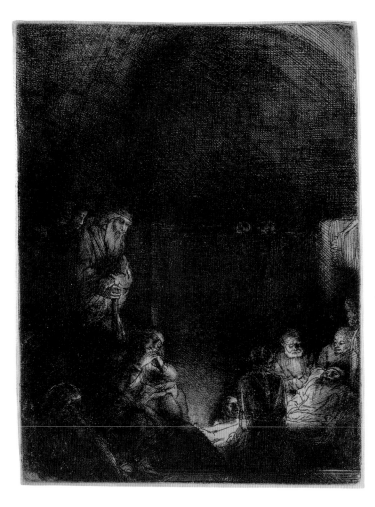

**Rembrandt Harmensz.
van Rijn**

(Dutch; 1606–1669)

Entombment, c. 1654

Etching with drypoint and burin,
printed on vellum (second state of
four); plate: 20.6 x 15.7 cm (8⅛ x 6³⁄₁₆ in.)
Clarence Buckingham Collection,
1997.419

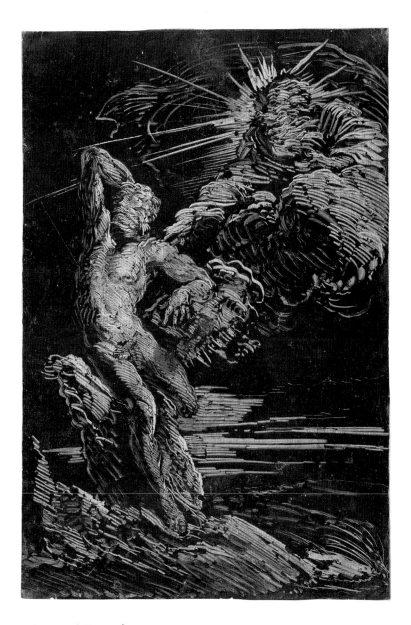

**Giovanni Benedetto
Castiglione**

(Italian; c. 1609–1664)

The Creation of Adam, c. 1642

Monotype in black on ivory laid paper,
edge mounted to cream laid paper;
30.3 x 20.3 cm (11⅞ x 8³⁄₁₆ in.)
Gift of an anonymous donor; restricted
gifts of Dr. William D. and Sara R. Shorey
and Mrs. George B. Young, 1985.1113

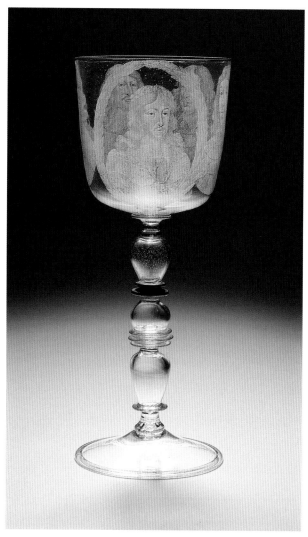

Georg Schwanhardt the Elder

(German; 1601–1667) (attrib.)

Goblet, c. 1660

Glass; h. 36.7 cm (14⅞ in.); diam. 14.6 cm (5¾ in.)
Gift of Julius and Augusta N. Rosenwald, 1927.1255

Pair of Ivory-Stocked Flintlock Pistols

Dutch, Maastricht, 1660/65

Steel, ivory, and brass; l. 45.6 cm (17¹⁵⁄₁₆ in.) (each); length of barrel: 26.7 cm (10½ in.) (each)
George F. Harding Collection, 1982.2324a–b

Vase and Cover

Dutch, Delft, 1665/80

Attributed to The Greek A (De Grieksche A) Factory
Tin-glazed earthenware; h. 57.7 cm (22¾ in.); diam. 39.7 cm (15⅝ in.)
Anonymous gift in honor of Eloise W. Martin; Eloise W. Martin Fund, 1998.515a–b

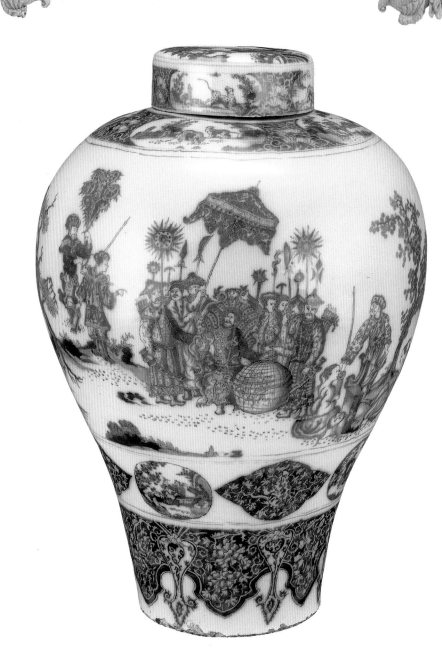

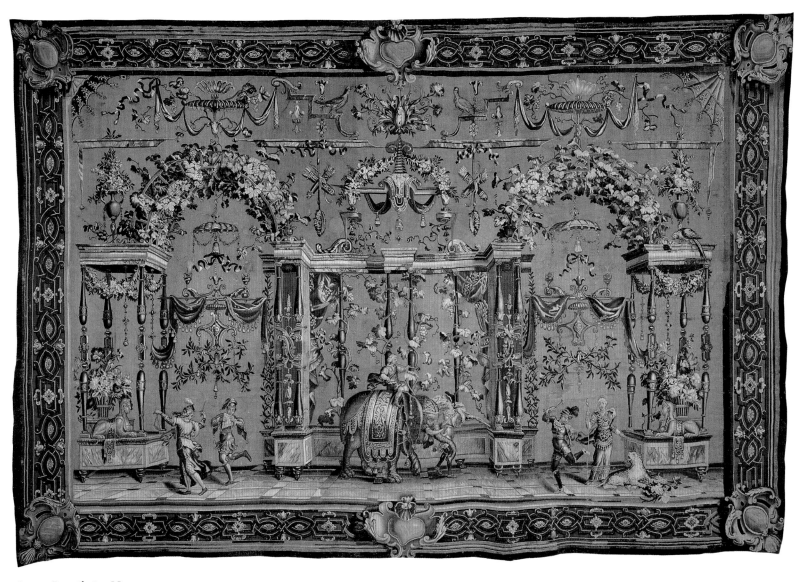

Jean Baptiste Monnoyer

(French; 1636–1699) in the style of Jean
Bérain I (French; 1640–1711)

Hanging Entitled *The
Tamers (Les Dompteurs)*
from the *Grotesques* series,
late 17th/early 18th cen.

Woven at the Beauvais Tapestry
Manufactory under Philippe Behagle
(French; 1641–1705)
Wool and silk, slit and double
interlocking tapestry weave;
457.7 x 309.8 cm (180¼ x 122 in.)
Robert Allerton Income Fund, 1956.101

Rebecca Stonier Plaisted

(English; 17th century)

*Casket Depicting Scenes
from the Old Testament*,
1668

Silk, satin weave; embroidered with
silk and silk-wrapped-metal purl
in a variety of stitches; laid work,
couching, and padded couching;
French and Turkey knots; applied
areas of linen, plain weave; and silk
fringe; seed pearls, coral beads, and
mica; edged with woven tape;
39 x 38.3 x 29 cm (15⅜ x 15 x 11½ in.)
Restricted gift of Mrs. Chauncey B.
Borland and Mrs. Edwin A. Seipp,
1959.337

The Eighteenth Century in Europe

A radical change in philosophy transformed Europe in the eighteenth century. Scientific inquiry into the natural world had revealed consistent patterns, leading to the conclusion that life in nature was governed by rational principles. This idea was articulated by writers across Europe, including John Locke in Britain, Immanuel Kant in Germany, and Jean Jacques Rousseau in France. By extending rationalism to social structures and individual existence, the new attitude presented liberal challenges to the old orders of church and state. The Age of Enlightenment, as cultural historians have come to call the era, redefined the human experience; as rational beings, men and women were now thought to possess the capacity to shape their own destinies, and the arts reflected this quest for self-determination in a world rooted in reason rather than in faith.

Throughout most of the eighteenth century, the social classes remained stratified, and aristocratic circles channeled their wealth into private indulgence. The artists employed by the French monarchy developed an elegant style known as the Rococo (derived from the French word *rocaille*, or stone debris, referring to a popular rock-and-shell architectural ornament). Distinctive for its wit and refinement, the style had its roots in the sumptuous aesthetic of the previous century, but is lighter in form and more playful in spirit. An emphasis on personal pleasure is clearly demonstrated in the era's luxury textiles, including elegant hangings such as the tapestry *Autumn*, woven after a design by Charles Le Brun at the Gobelins Manufactory (p. 126), and in exquisite accessories, such as the lace cravat end featuring the monogram of Louis XIV (p. 124). Giovanni Battista Tiepolo's portrayal of the figures in *Rinaldo Enchanted by Armida* (p. 132) is indicative of a shift among painters during this era: Tiepolo preferred delicate over strongly contrasting hues, and grace over energy. Meanwhile, works such as François Boucher's provocatively titled painting *Are They Thinking about the Grape?* (p. 133) played to the popularity of suggestive subjects among sophisticated patrons of the day.

Outside of court circles, rising literacy and greater ease of travel expanded a man or woman's sense of place in the wider world. Italy, regarded as the artistic capital of Europe, was the preferred destination on the Grand Tour, a cultural expedition considered the finishing touch for a genteel education. Francesco Guardi's *Garden of the Palazzo Contarini dal Zaffo* (p. 142) represents the kind of souvenir view avidly collected by tourists of the time. Archeological excavations at Pompeii, the ancient Roman city buried in 79 A.D. by the eruption of Mount Vesuvius, renewed an interest in the study of Greek antiquities, resulting in a new taste for the Neoclassical style and in landscapes featuring ruins, such as Hubert Robert's *Fountains* (p. 143). Trade continued to expand, bringing more imported goods to Europe that enhanced the quality of life. New beverages—tea, coffee, and chocolate—became fashionable, as did elegant serving sets, such as the tea service (p. 125) by Matthäus Bauer II. The early years of the century saw the first European porcelain, with Meissen, Du Paquier, and, later, Sèvres becoming the leading manufactories. The artists and designers employed by these firms used exotic styles appropriated from Asia, as seen in the fantastic adaptation of Indian form in the elephant candelabrum vase (p. 131), or in examples of furniture, such as the chinoiserie of David Roentgen's secretary desk (p. 139). But works such as the self-portraits by Joseph Wright of Derby and Jean Baptiste Siméon Chardin (see p. 135) capture the true spirit of the age. Self-aware and self-confident, they affirm the sentiments of British poet Alexander Pope, who declared: "Know then thyself, presume not God to scan/ The proper study of mankind is man."

Matthäus Bauer II. *Tea Service* (detail). See page 125.

Cravat End with Monogram of Louis XIV

Belgian, Brussels, 1700/15

Linen, bobbin part-lace of a type known as "Brussels";
32.1 x 41.7 cm (12⅝ x 16⅜ in.)
Restricted gift of Mr. and Mrs. John V. Farwell III, 1987.334

Bedcover

English, c. 1720

Cotton, plain weave; embroidered with silk in back, cross, herringbone, individual satin, satin, star, and stem stitches; laid work, couching, and French knots;
155.9 x 147.8 cm (61⅜ x 58⅛ in.)
Restricted gift of Mr. and Mrs. John V. Farwell III, 1985.84a

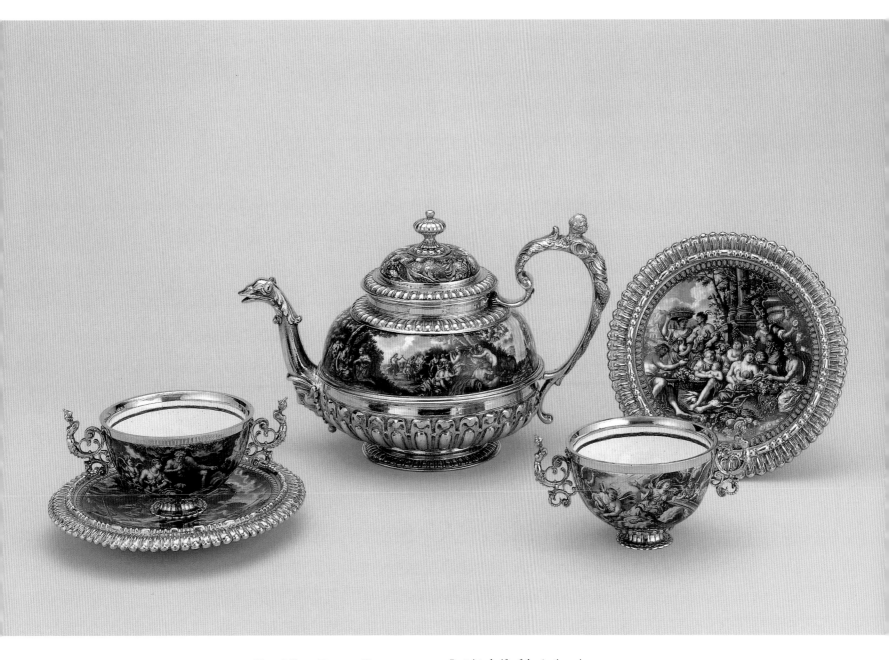

Matthäus Bauer II

(German; c. 1653–1728) (goldsmith)

Tea Service, C. 1700

Cast, embossed, and chased silver-gilt with enamels on copperplate; teapot: 14. 5 x 23 x 14 cm (5¹¹⁄₁₆ x 9¹⁄₁₆ x 5½ in.); bowl (air): 6.4 x 12.1 x 8.3 cm (2½ x 4¾ x 3¼ in.); bowl (fire): 5.2 x 12.4 x 8.3 cm (2⁵⁄₁₆ x 4⁷⁄₈ x 3¼ in.); saucers: h. 2.3 cm (¹⁵⁄₁₆ in.); diam. 14.5 cm (5¹¹⁄₁₆ in.) (each)

Restricted gift of the Antiquarian Society; Pauline Seipp Armstrong and Charles R. and Janice Feldstein endowments; through prior acquisitions of Mrs. Josephine P. Albright, Mr. I. D. Berg in memory of Alice Kimpton Berg, Estate of Maribel G. Blum, Mrs. Elizabeth Peabody Boulon, Dr. and Mrs. William C. Brown, Bequest of Hans G. Cahen, Mrs. Richard T. Crane, Jr., Mrs. Stanley Keith, Mrs. John L. Kellogg, the Marion E. Merrill Trust, Mr. and Mrs. Morton G. Neumann, Russell Tyson, Mrs. Joseph L. Valentine, and others, 1999.45.1–3a, b

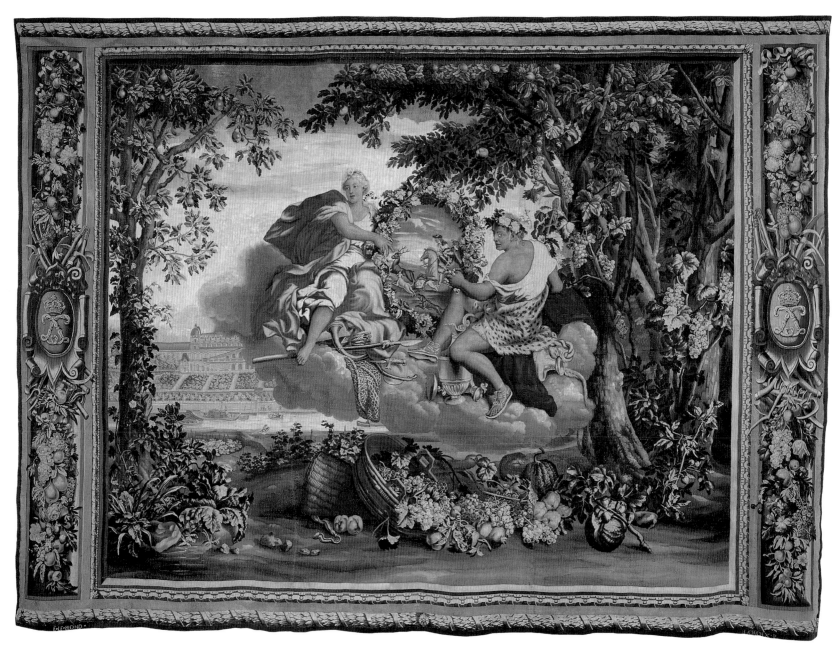

Charles Le Brun

French; 1619–1690 (designer)

Hanging Entitled *Autumn,*

C. 1710

Woven by Etienne Claude Le Blond
(French; c. 1700–1751) and Jean de La
Croix (French; active 1662–1712) at the
Gobelins Tapestry Manufactory, Paris
Wool and silk, slit and double
interlocking tapestry weave;
378.8 x 531.8 cm (149⅛ x 209⅜ in.)
Gift of the Hearst Foundation, Inc., in
memory of William Randolph Hearst,
1954.260

Antoine Watteau

(French; 1684–1721)

The Old Savoyard, c. 1715

Red and black chalk, with stumping,
on buff laid paper, pieced at bottom
edge, laid down on cream wove card,
laid down on cream board;
36 x 22.4 cm (14¼ x 8⅞ in.)
Helen Regenstein Collection, 1964.74

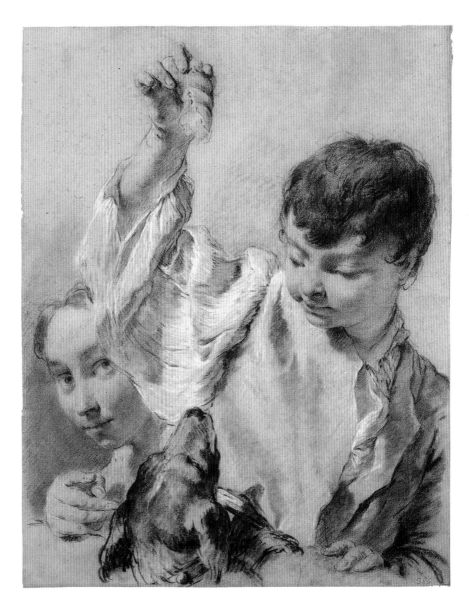

Giovanni Battista Piazzetta

(Italian; 1682–1754)

*Boy (Giacomo) Feeding a
Dog,* 1738/39

Black chalk with stumping, and with
traces of charcoal, heightened with
touches of white chalk, on blue-gray
paper (discolored to cream),
laid down on cream wood-pulp board;
53.4 x 43.2 cm (21⅛ x 17⁄₁₆ in.)
Helen Regenstein Collection, 1971.326

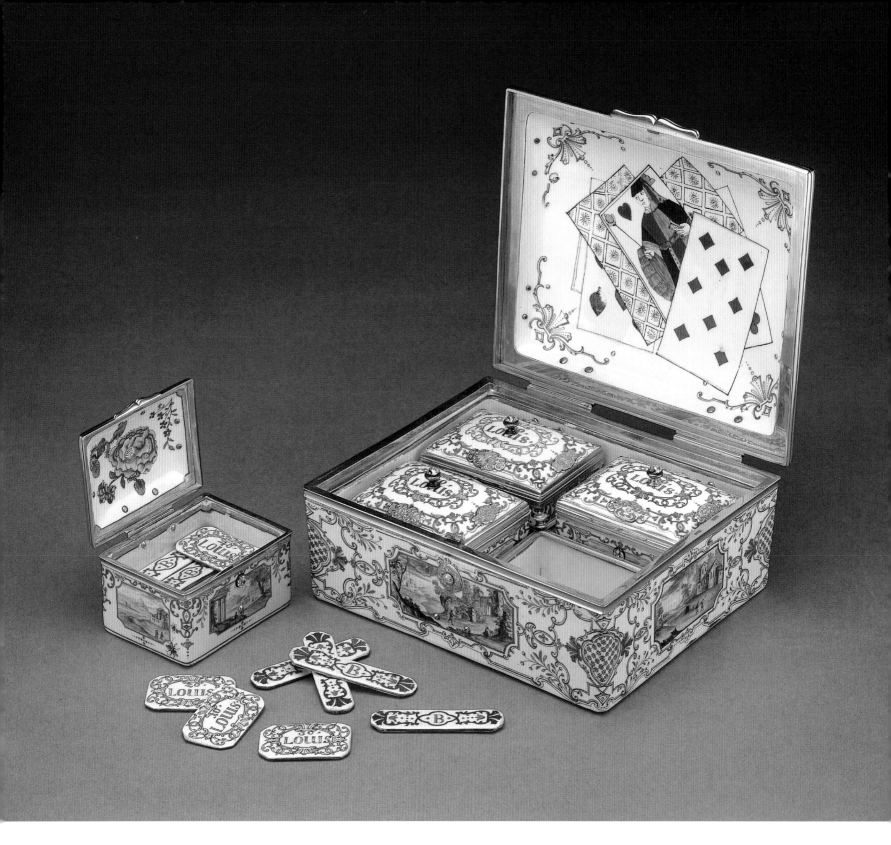

Gaming Set

Austrian, 1735/40

Manufactured by Du Paquier Porcelain
Manufactory, Vienna
Hard-paste porcelain with enamels,
gold mounts, and diamonds; gaming box:
8.1 x 16.8 x 14.8 cm (3³⁄₁₆ x 6⅝ x 5¹³⁄₁₆ in.);
counter boxes: 5.7 x 7 x 5.9 cm (2¼ x 2¾ x
2⁵⁄₁₆ in) (each); counter lengths: 3.8 and
5.7 cm (1½ and 2¼ in.) (each)
Eloise W. Martin Fund; Richard T. Crane,
Jr., and Mrs. J. Ward Thorne endowments;
through prior gifts of the Antiquarian
Society, 1993.349

Johann Joachim Kändler

(German; active 1731–75)

Centerpiece and Stand with Pair of Sugar Casters and Oil or Vinegar Cruet, c. 1737

Manufactured by Meissen Porcelain Manufactory

Hard-paste porcelain with enamels, gilding, and chased and engraved gilt-metal mounts; bowl: 28 x 44.4 x 25.4 cm (11 x 17½ x 10 in.); stand: 15.2 x 66 x 50.8 cm (6 x 26 x 20 in.); sugar caster (a): 19.5 x 7.5 x 7.3 cm (7¹¹⁄₁₆ x 2¹⁵⁄₁₆ x 2⅞ in.); sugar caster (b): 19.4 x 6.4 x 7.5 cm (7⅝ x 2½ x 2¹⁵⁄₁₆ in.); cruet: 21.3 x 14.6 x 7.3 cm (8⅜ x 5¾ x 2⅞ in.)
Tureen and stand: Atlan Ceramic Club, Buckingham Luster and Decorative Arts Purchase Funds, 1958.405; sugar casters: the Robert Allerton, R. T. Crane, Jr., Mrs. Edward I. Rothschild, Louise D. Smith, and Edward Byron Smith Charitable funds, 1984.1228–29; cruet: Gift of Mr. and Mrs. Samuel Grober in honor of Ian Wardropper and Ghenete Zelleke, 1998.504a–b

Giuseppe Gricci

(Italian; active 1743–59) (attrib.)

Ewer and Basin, c. 1745

Manufactured by Capodimonte Porcelain Manufactory, Naples
Soft-paste porcelain with enamels and gilding; ewer: 30.5 x 14.3 x 21.6 cm (12 x 5⅝ x 8½ in.); basin: 16.5 x 38.7 x 34.3 cm (6½ x 15¼ x 13½ in.)
Gift of Mr. and Mrs. Robert Norman Chatain in memory of Professor Alfred Chatain, 1957.490

Jean Pierre Latz

(French; c. 1691–1754)

Wall Clock, 1735/40

Movement by Francis Bayley, Ghent
Oak with tortoiseshell and kingwood
veneer, brass inlay, gilt bronze, and
glass; musical movement; 147.3 x 52.3 x
36.4 cm (58 x 20⅝ x 14⅜ in.)
Ada Turnbull Hertle Endowment,
1975.172

Franz Anton Bustelli
(Swiss; active 1753–63)

Mourning Madonna, 1756/58

Manufactured by Nymphenburg
Porcelain Manufactory
Hard-paste porcelain; 30.6 x 17.1 x
12.2 cm (12⅛ x 6¾ x 4¹³⁄₁₆ in.)
Gift of the Antiquarian Society through
the Mrs. Harold T. Martin Fund,
1986.1009

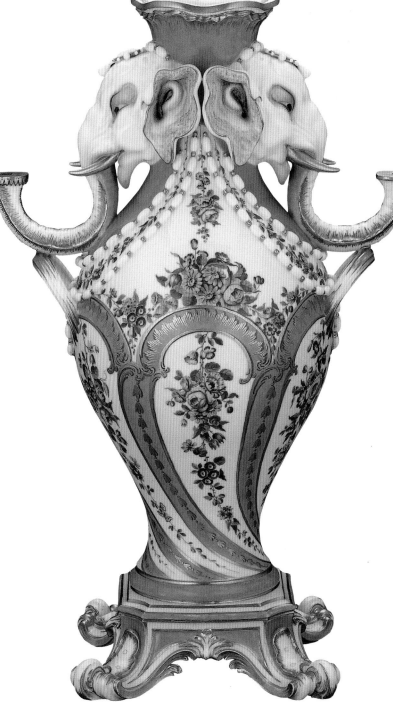

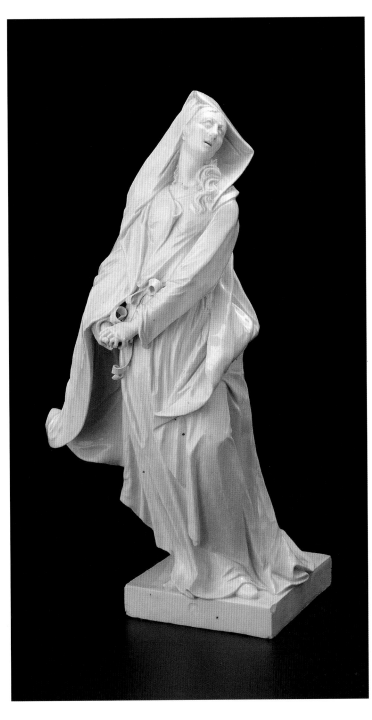

Jean Claude Duplessis
(French; active 1745/48–74) (attrib.)
Pierre Louis Philippe Armand
(French; active 1758–81) (painter)

Elephant Candelabrum Vase
(Vase à tête d'eléphant), 1757/58

Manufactured by Sèvres Porcelain
Manufactory
Soft-paste porcelain with polychrome
enamels and gilding; 39.1 x 25.7 x 15.9 cm
(15⅜ x 10⅛ x 6¼ in.)
The Joseph Maier and Arthur Lewis Liebman
Memorial; gift of Kenneth J. Maier, M.D.,
1986.3446

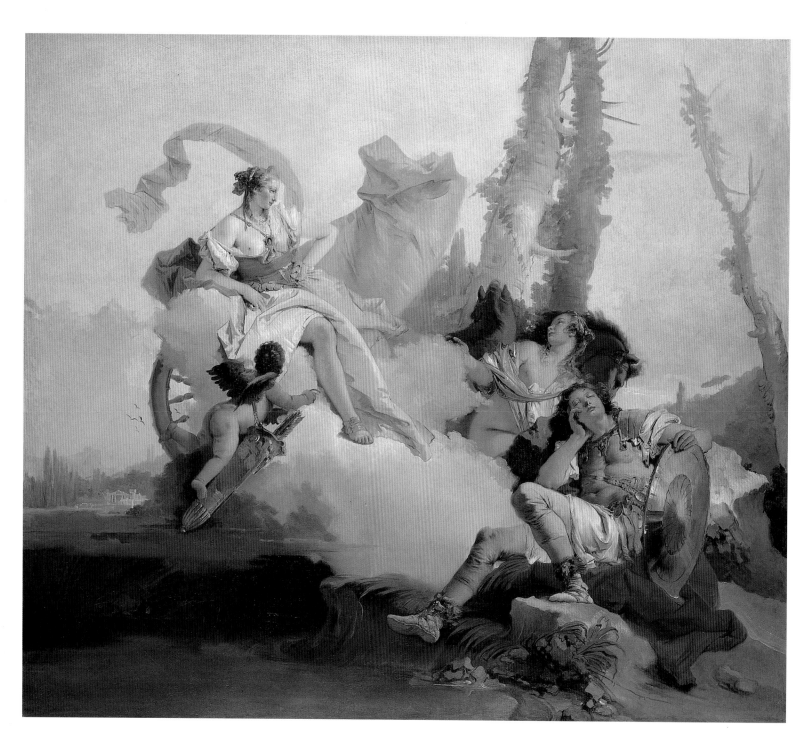

Giovanni Battista Tiepolo
(Italian; 1696–1770)

*Rinaldo Enchanted by
Armida,* 1742/45

Oil on canvas; 187.5 x 216.8 cm
(73¹¹⁄₁₆ x 85⅜ in.)
Bequest of James Deering, 1925.700

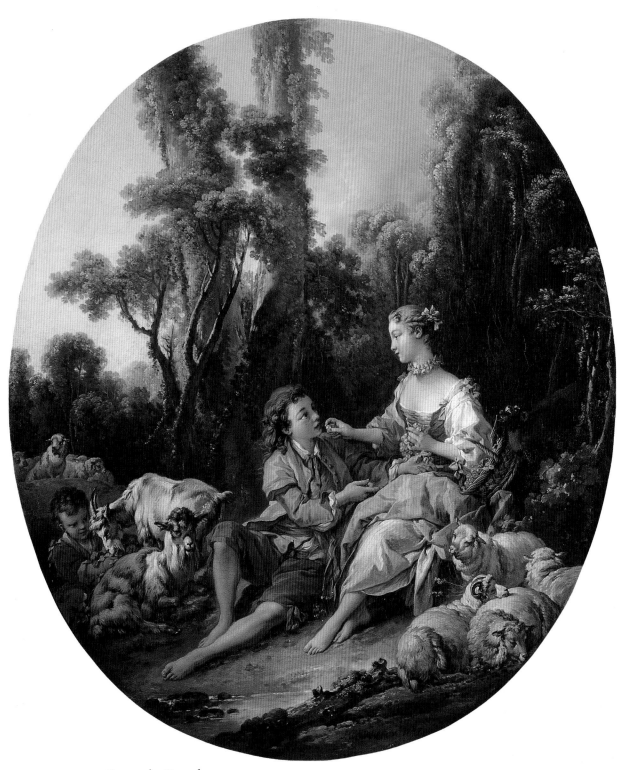

François Boucher

(French; 1703–1770)

Are They Thinking about the Grape? (Pensent-ils au raisin?), 1747

Oil on canvas; 80.8 x 68.5 cm
(31¾ x 27 in.)
Martha E. Leverone Endowment,
1973.304

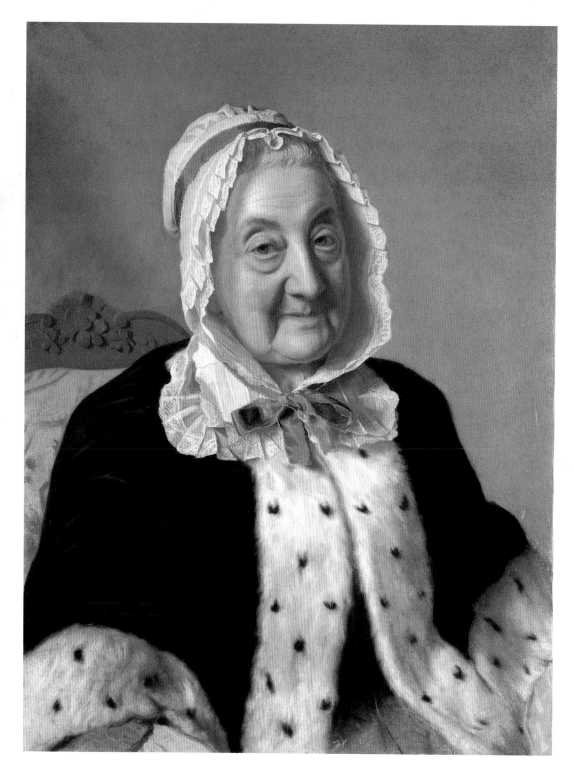

Jean Etienne Liotard
(Swiss; 1702–1789)

*Portrait of Marthe Marie
Tronchin*, 1758/61

Pastel and stumping on vellum;
62.4 x 47.3 cm (24⁹⁄₁₆ x 18⅝ in.)
Clarence Buckingham Collection,
1985.252

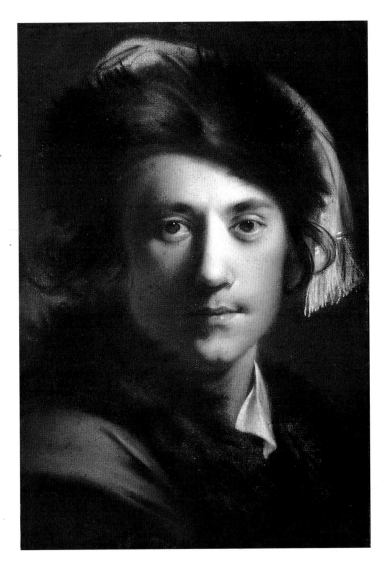

Joseph Wright of Derby
(English; 1734–1797)

Self-Portrait in a Fur Cap,
1765/68

Monochrome pastel (*en grisaille*)
on gray-blue paper; 42.5 x 29.5 cm
(16¾ x 11⅝ in.)
Clarence Buckingham Collection,
1990.141

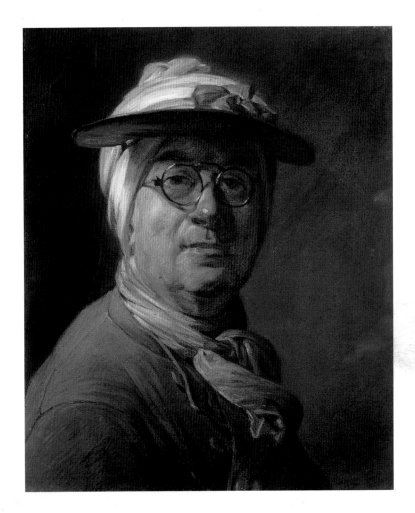

**Jean Baptiste Siméon
Chardin**
(French; 1699–1779)

Self-Portrait with a Visor,
c. 1776

Pastel on blue laid paper mounted on
canvas; 45.7 x 37.4 cm (17⅜ x 14⅛ in.)
Clarence Buckingham Collection and
Harold Joachim Memorial Fund,
1984.61

Joshua Reynolds

(English; 1723–1792)

Lady Sarah Bunbury Sacrificing to the Graces, 1763–65

Oil on canvas; 242.6 x 151.5 cm (95½ x 59¾ in.)
Mr. and Mrs. W. W. Kimball Collection, 1922.4468

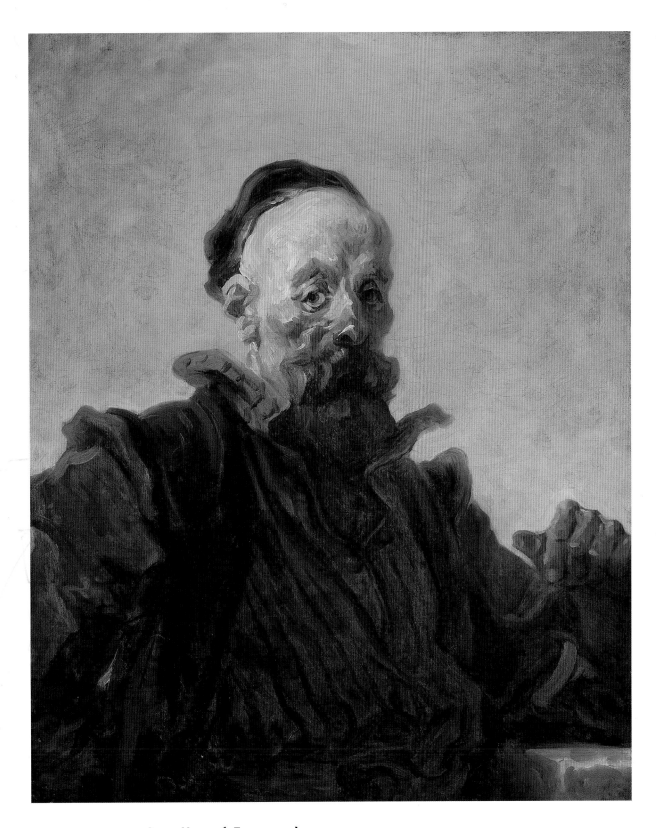

Jean Honoré Fragonard
(French; 1732–1806)

Portrait of a Man, 1768/70

Oil on canvas; 80.3 x 64.7 cm
(31⅝ x 25½ in.)
Gift of Mary and Leigh Block in honor
of John Maxon, 1977.123

Jean François Dapcher

(French; 1721–1780)

Tureen and Stand, 1773/74

Silver with repoussé, cast and applied
and chased decorations; 34.5 x 50 x
49.2 cm (13⅝ x 19¹⁄₁₀ x 19⅜ in.)
Buckingham Fund, 1958.510a–d

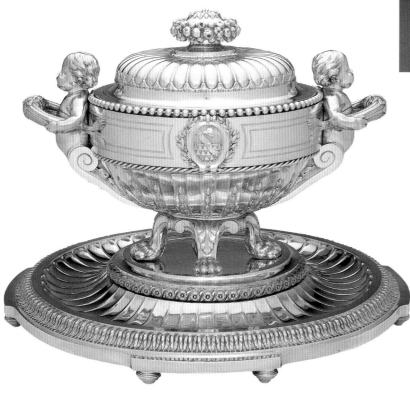

Clodion (Claude Michel)

(French; 1738–1814)

Vase, 1766

Marble; 36.4 x 19.9 x 18.3 cm
(14⅜ x 7¹³⁄₁₆ x 7¹⁄₁₆ in.)
George F. Harding Collection by
exchange; Harold L. Stuart Fund,
1987.55

David Roentgen
(German; 1743–1807)

Secretary Desk, c. 1775

Walnut, inlay of a variety of woods,
and ormolu mounts; bottom:
106.4 x 137.8 x 61.3 cm
(41⅞ x 54¼ x 24⅛ in.);
top: 150.5 x 139.1 x 36.8 cm
(59¼ x 54¾ x 14½ in.)
Gift of Count Pecci-Blunt,
1954.21

William Vile
(English; 1700/1705–1767)(attrib.)

Cabinet on a Stand, c. 1761

Mahogany, ebony, and holly; 120.7 x
48.3 x 38.1 cm (47½ x 19 x 15 in.)
Eloise W. Martin Fund; Gladys
Anderson, Tillie C. Cohn, and Mary
Louise Stevenson endowments, 1993.155

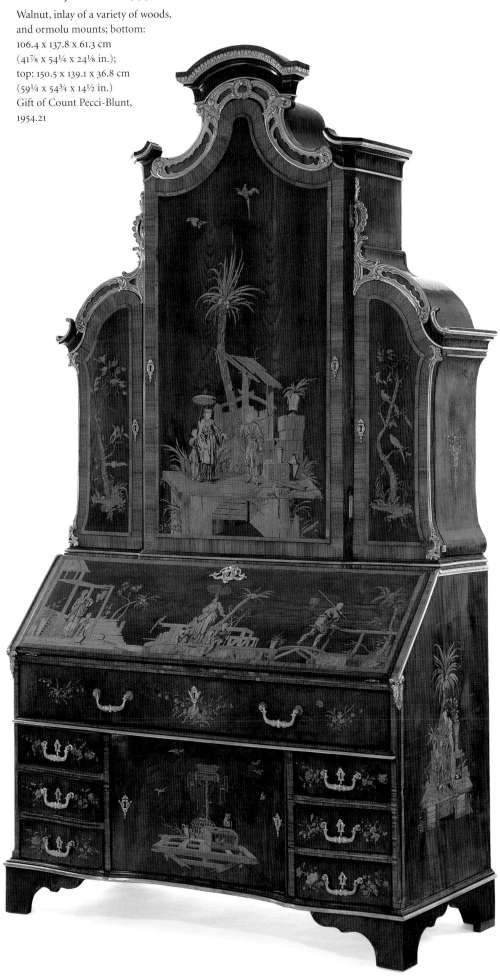

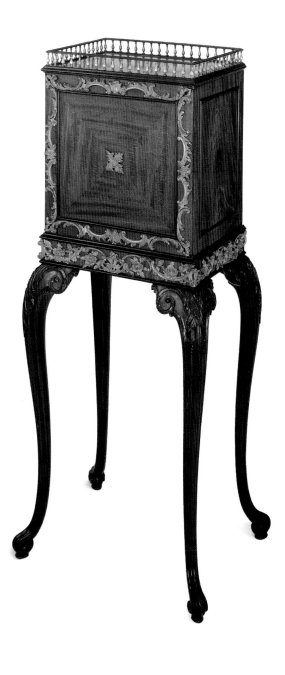

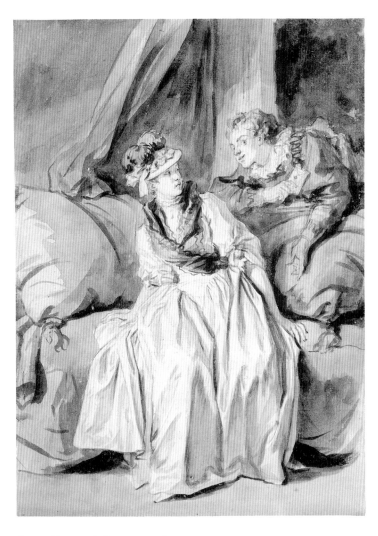

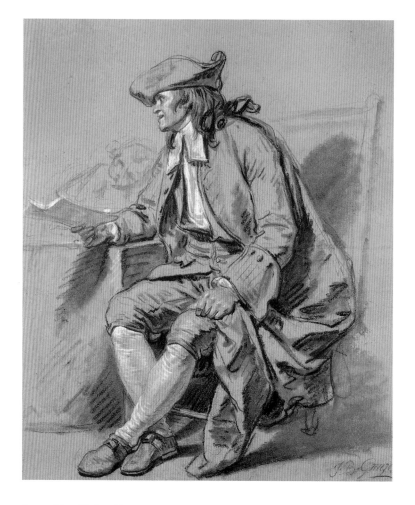

Jean Honoré Fragonard
(French; 1732–1806)

The Letter or *The Spanish Conversation,* c. 1778

Brush and brown ink and brush and brown wash, with graphite, on ivory laid paper; 39.9 x 29 cm (15¹¹/₁₆ x 11⁷/₁₆ in.)
Margaret Day Blake Collection, 1945.32

Jean Baptiste Greuze
(French; 1725–1805)

The Notary, c. 1761

Black chalk with stumping, with red chalk, heightened with white chalk, on tan laid paper, laid down on card; 52.6 x 43.5 cm (20¹¹/₁₆ x 17⅛ in.)
Wirt D. Walker Endowment, 1999.2

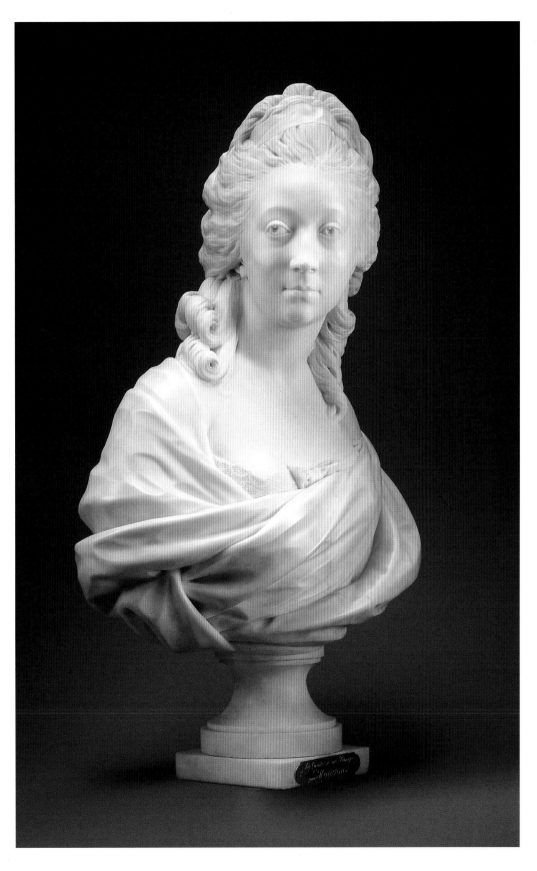

Jean Antoine Houdon

(French; 1741–1828)

Bust of Anne Marie Louise Thomas de Domageville de Sérilly, Comtesse de Pange, 1780

Marble; 89.9 x 48.6 x 35.2 cm (35⅜ x 19⅛ x 13⅞ in.)
Through prior acquisitions of the George F. Harding Collection; the Lacy Armour, Harry and Maribel G. Blum Foundation, Richard T. Crane, Jr., and European Decorative Arts Purchase endowments; Eloise W. Martin and European Decorative Arts Purchase funds; restricted gifts of the Woman's Board in honor of Gloria Gottlieb and Mrs. Eric Oldberg; through prior acquisitions of Robert Allerton, the Antiquarian Society through the J. S. Landon Fund, Mary and Leigh Block, Mr. and Mrs. Robert Andrew Brown, Miss Janet Falk, Brooks and Hope B. McCormick, Mr. and Mrs. Joseph Regenstein, Sr., Mrs. Florene Schoenborn, and the Solomon A. Smith Charitable Trust, 1996.79

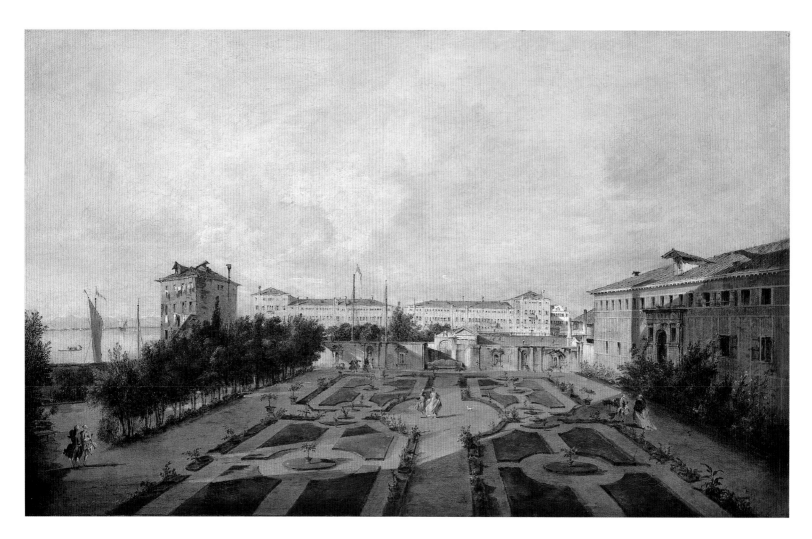

Francesco Guardi
(Italian; 1712–1793)

The Garden of the Palazzo Contarini dal Zaffo, late 1770s

Oil on canvas; 48 x 78 cm (19 x 30⅝ in.)
Gift of the Marion and Max Ascoli
Fund, 1991.112

Hubert Robert
(French; 1733–1808)

The Fountains, 1787/88

Oil on canvas; 255.3 x 221.2 cm
(100½ x 88⅛ in.)
Gift of William C. Hibbard, 1900.385

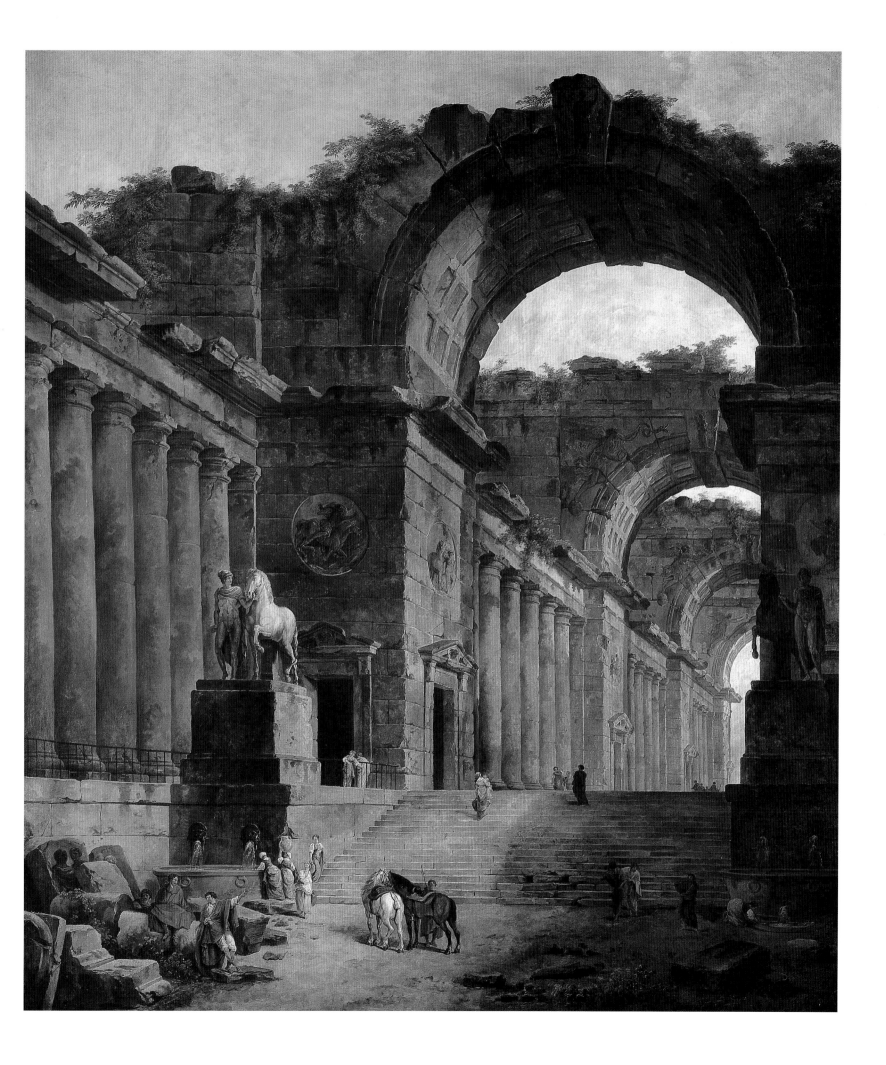

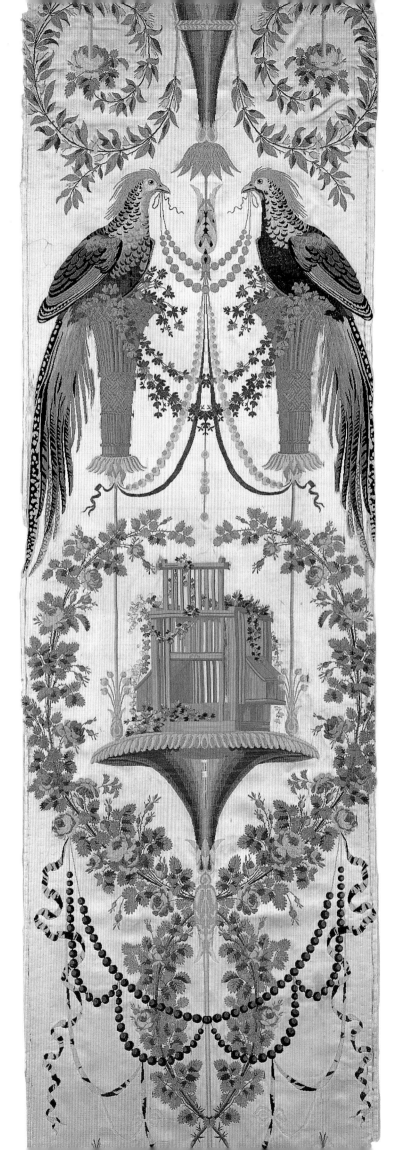

Jean Démosthène Dugourc
(French; 1749–1825)

Panel Entitled *The Pheasants*
(detail), from the *Verdures of
the Vatican* series, 1783/89

Woven and produced by Camille
Pernon & Cie, Lyon
Silk, satin weave with plain interlacings
of secondary binding warps and
brocading wefts; embroidered with silk
in chain (tambour work) and satin
stitches; 242.5 x 44.5 cm (95¼ x 17½ in.)
Restricted gift of Mrs. Chauncey B.
Borland, 1945.12

Panel Entitled *A Visit to
the Camp* (detail)

English, c. 1785

After drawings by Henry Bunbury
(English; 1750–1811) and engravings by
William Dickenson (English; 1746-
1823) and Thomas Watson
(English; 1743 or 1748–1781)
Cotton, plain weave; copperplate
printed; 90.9 x 70.4 cm (35¾ x 27¾ in.)
Gift of Emily Crane Chadbourne,
1952.585a

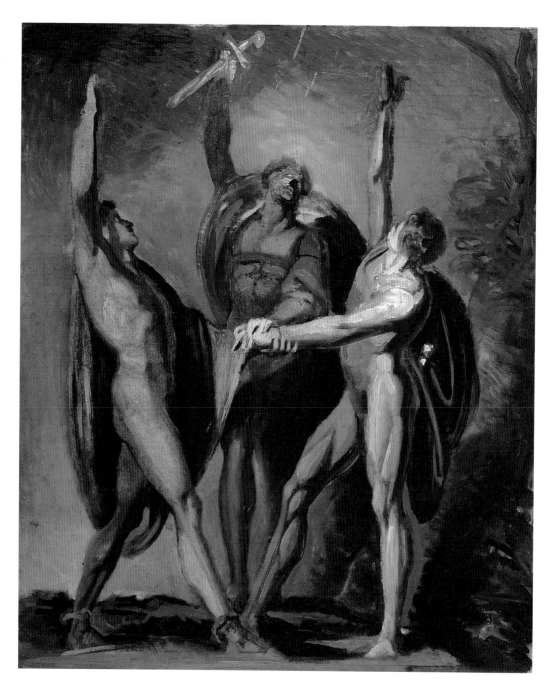

Henry Fuseli
(Swiss; 1741–1825)

Sketch for *The Oath on
the Rütli*, 1779/81

Oil on canvas; 74 x 63.2 cm
(29⅛ x 24⅞ in.)
Anonymous gift, 1980.170

**Francisco José
de Goya y Lucientes**
(Spanish; 1746–1828)

Boy on a Ram, 1786/87

Oil on canvas; 127.2 x 112.1 cm
(50⅟₁₆ x 44⅛ in.)
Gift of Mr. and Mrs. Brooks
McCormick, 1979.479

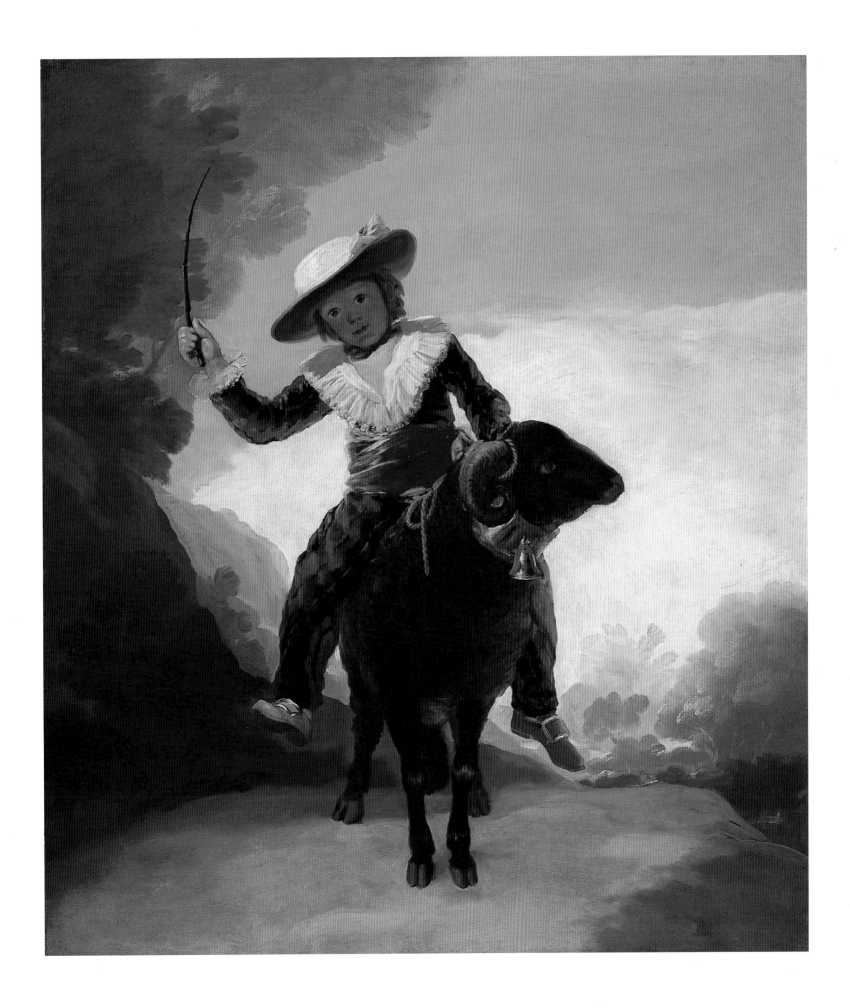

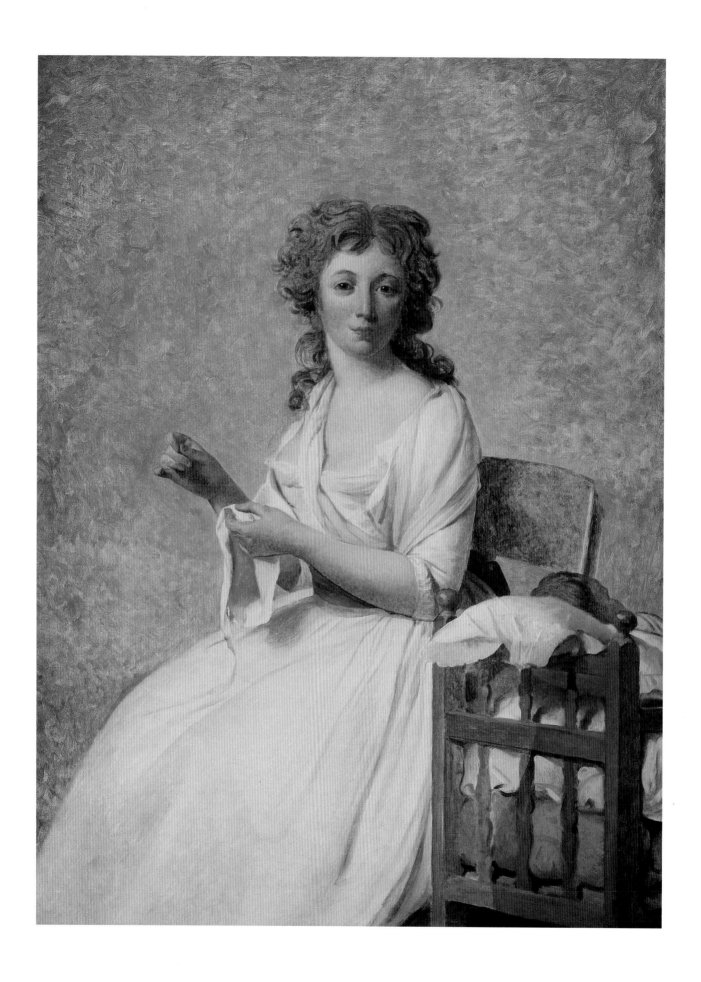

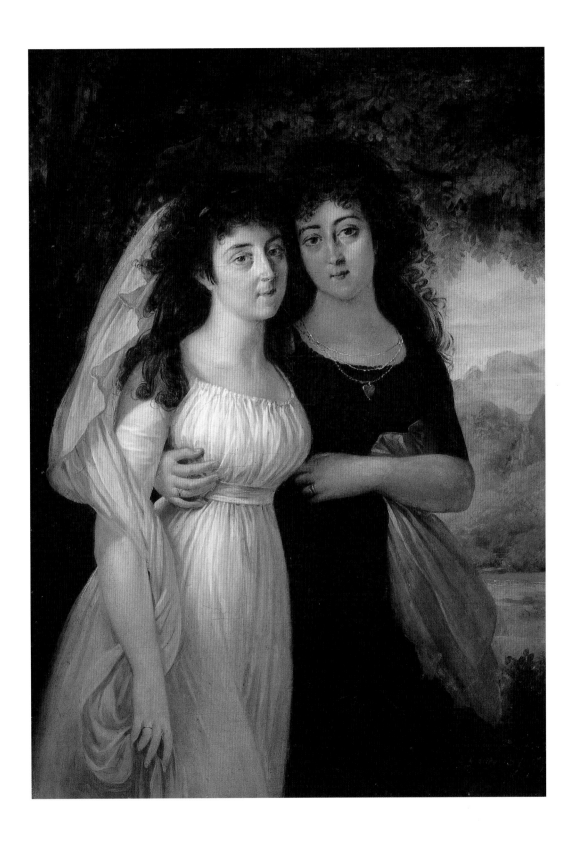

Antoine Jean Gros
(French; 1771–1835)

Portrait of the Maistre Sisters, 1796

Oil on canvas; 43.2 x 31.2 cm
(17 x 12¼ in.)
Charles H. and Mary F. S. Worcester
Collection, 1990.110

Jacques Louis David
(French; 1748–1825)

Madame de Pastoret and Her Son, mid-1791/mid-1792

Oil on canvas; 129.8 x 96.6 cm
(51⅛ x 38 in.)
Clyde M. Carr Fund and Major
Acquisitions Endowment, 1967.228

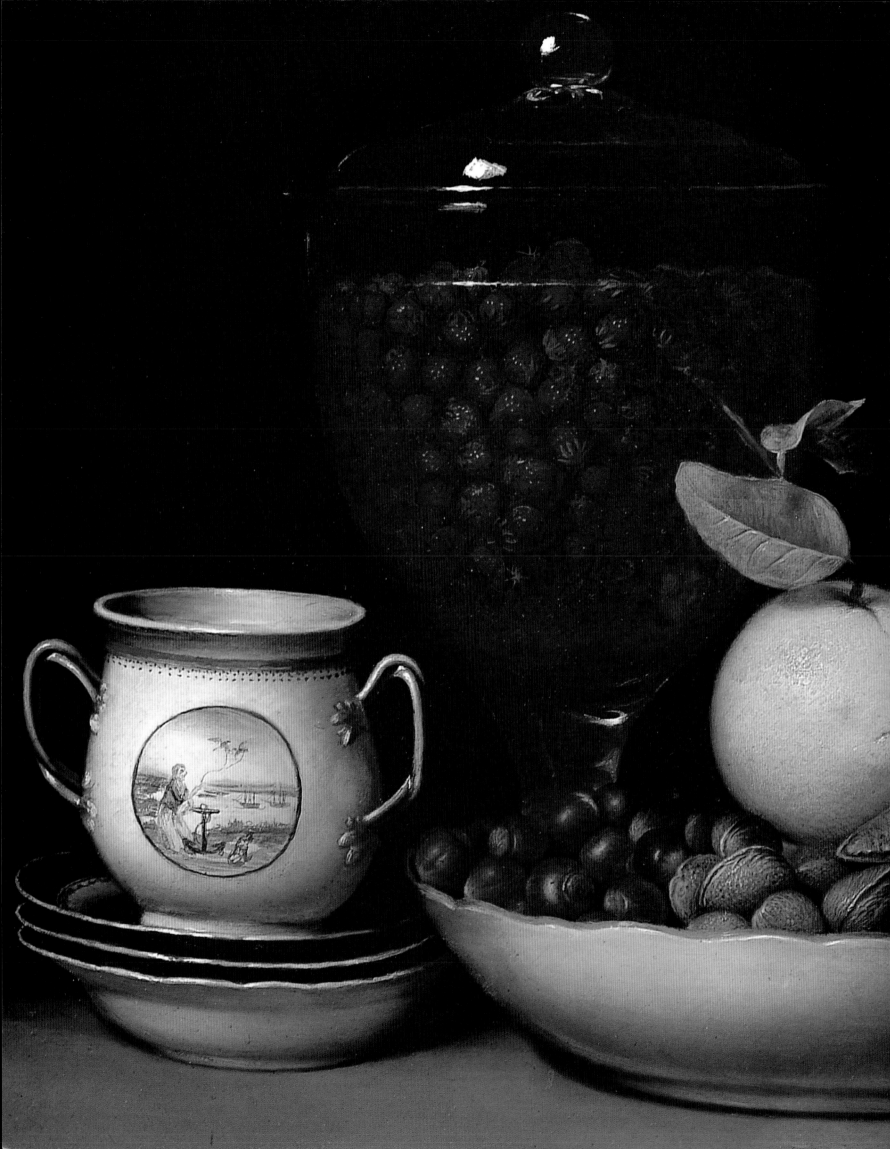

The Eighteenth and Nineteenth Centuries in the United States

The demands of life in the first settlements in North America left little time for the creation of luxury goods, but by the early eighteenth century, rising affluence transformed the colonies, instilling a sense of permanence and a pride of place. This sense of identity was still bound to Europe, and objects made in the colonies reflect these ties. Cornelius Kierstede's tankard (p. 152) combines the techniques of English silversmithing with elements of the Dutch Baroque style, speaking to the heritage of New York City, Kierstede's birthplace. The emigration of foreign artists perpetuated such old-world influence. John Smibert served an apprenticeship in London before moving to the colonies, while John Singleton Copley trained under his British stepfather. Conventions of traditional European portraiture—elegant dress and posture—can be seen in these artists' depictions of prominent Bostonians (see pp. 153, 154–55, respectively).

European influence endured after the 1776 War of Independence. Imported pattern books continued to introduce continental styles and motifs such as the Neoclassical decoration of the card table (p. 161) by the French émigré Charles Honoré Lannuier. Strong vernacular traditions evolved simultaneously: self-taught artists such as John Ritto Penniman (see p. 157) and Joshua Johnson (see p. 158) brought a fresh vision to their portraits of the land and its inhabitants, while domestic objects such as the bedcover (p. 156) added color to modest interiors. As the young republic gained a sense of its own power, portraits of extraordinary Americans, such as William Rush's terracotta bust of Andrew Jackson (p. 160) and Samuel J. Miller's daguerreotype of Frederick Douglass (p. 162), express the sitters' sense of purpose rather than more traditional qualities such as wealth and position. The land itself became an emblem of identity. From the natural wonders of the northeastern states portrayed in Thomas Cole's *Distant View of Niagara Falls* (p. 164), to the rugged forests of California's Mendocino River West seen in Carleton Watkins's photograph (p. 172), American artists paid tribute to a terrain that was being transformed, preserving a nostalgic view of the rapidly disappearing wilderness.

Expansion also involved unification, which, in the case of the American indigenous population and the ante-bellum South, proved bloody and destructive. The powerful image of newfound liberty seen in John Quincy Adams Ward's *Freedman* (p. 162) marks the end of the country's institution of slavery. After the nation recovered from the Civil War, it forged its place in world commerce and culture. Entrepreneurial endeavors brought great wealth into new hands, ushering in a luxurious mode of living, portrayed as the Gilded Age in the novels of Edith Wharton and Henry James. Many American painters of this generation pursued their education abroad; some, such as Mary Cassatt (see pp. 176–77) and James McNeill Whistler (see p. 170), became expatriates, while others, such as Winslow Homer (see pp. 166, 173, 180) and William Merritt Chase (see p. 167), chose to lead their careers at home, developing American responses to European aesthetic advances such as Realism and Impressionism. Major cities also flourished at this time, making urban space a valuable commodity. Architects began to build upward; new towers of commerce demanded engineering advances such as elevators and fireproofed iron-and-steel construction. Coupled with bold developments in aesthetic design, as seen in the magnificent decoration of Dankmar Adler and Louis Sullivan's Trading Room for the Chicago Stock Exchange (p. 178), American architects took their place as innovators on the international stage, just as the United States moved toward world leadership in technological advancements and industrial power.

Raphaelle Peale.
Still Life—Strawberries, Nuts, &c.
(detail). See page 160.

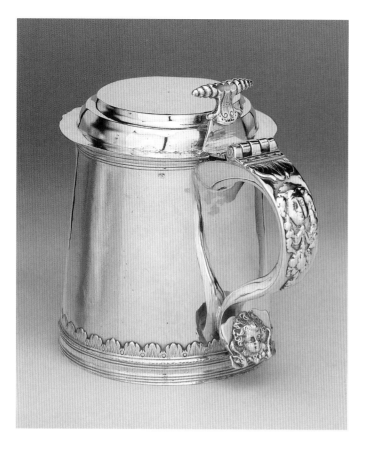

Cornelius Kierstede
(American; 1675–1757)

Tankard, 1698/1722

Silver; 16.5 x 19.4 cm (6½ x 7⅝ in.)
(at base)
Gift of the Antiquarian Society through
the Mr. and Mrs. Edwin A. Seipp Fund,
1946.220

John Townsend
(American; 1732–1809) (attrib.)

Bureau Table, 1780/90

Mahogany with maple, chestnut,
and white pine; 86.6 x 93.4 x 58 cm
(34⅛ x 36¾ x 20 in.)
Gift of Jamee J. and Marshall Field,
1984.1387

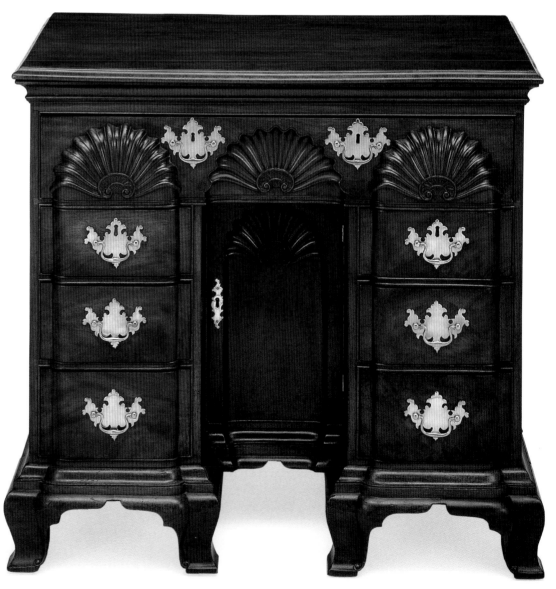

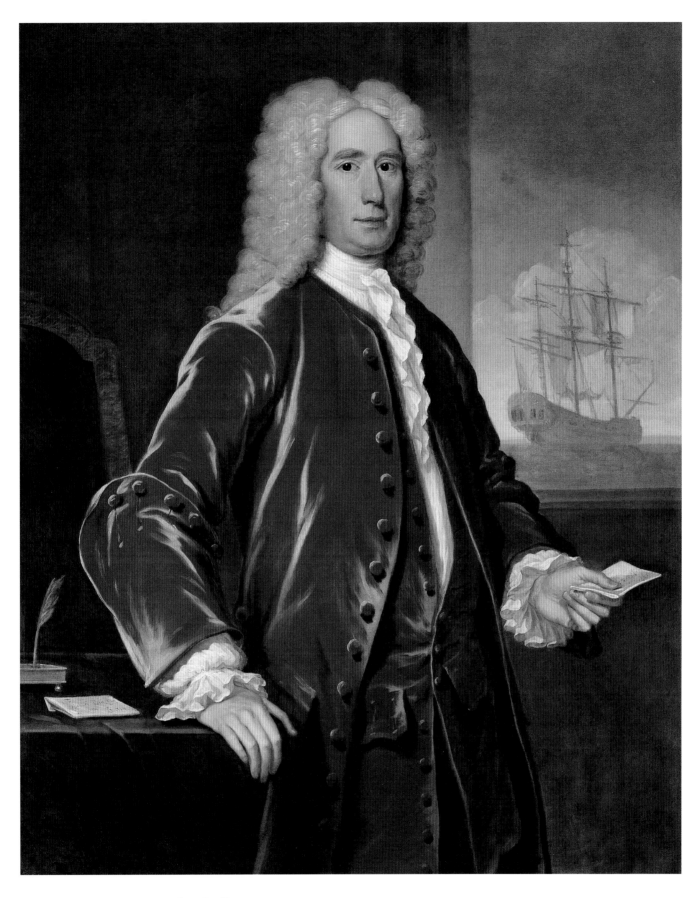

John Smibert
(American, b. Scotland; 1688–1751)

Richard Bill, 1733

Oil on canvas; 127.6 x 102.2 cm
(50¼ x 48¼ in.)
Friends of American Art Collection,
1944.28

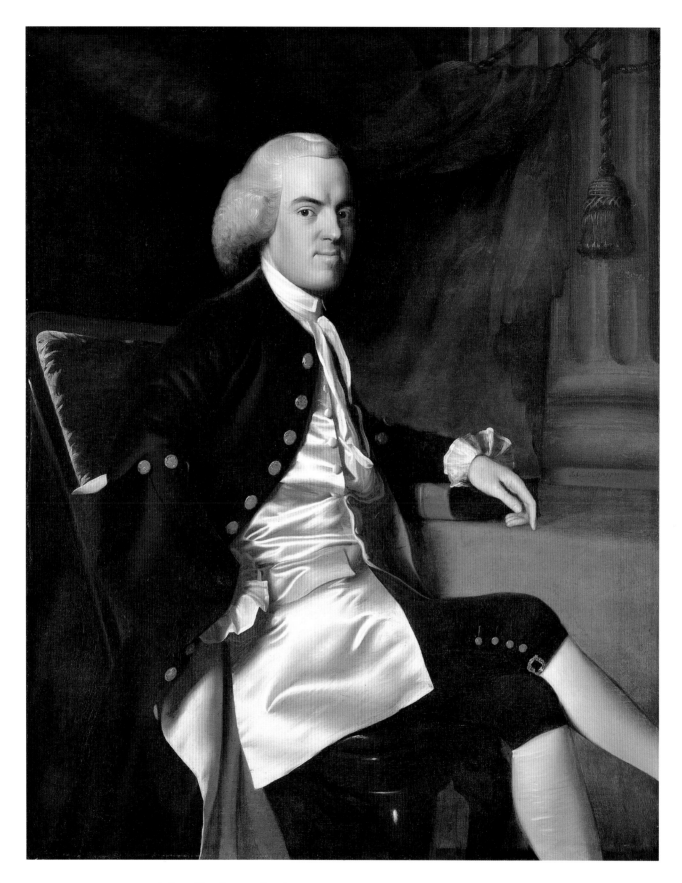

John Singleton Copley
(American; 1738–1815)

Daniel Hubbard, 1764

Oil on canvas; 127.2 x 100.8 cm
(50⅛ x 39¹¹⁄₁₆ in.)
The Art Institute of Chicago Purchase
Fund, 1947.27

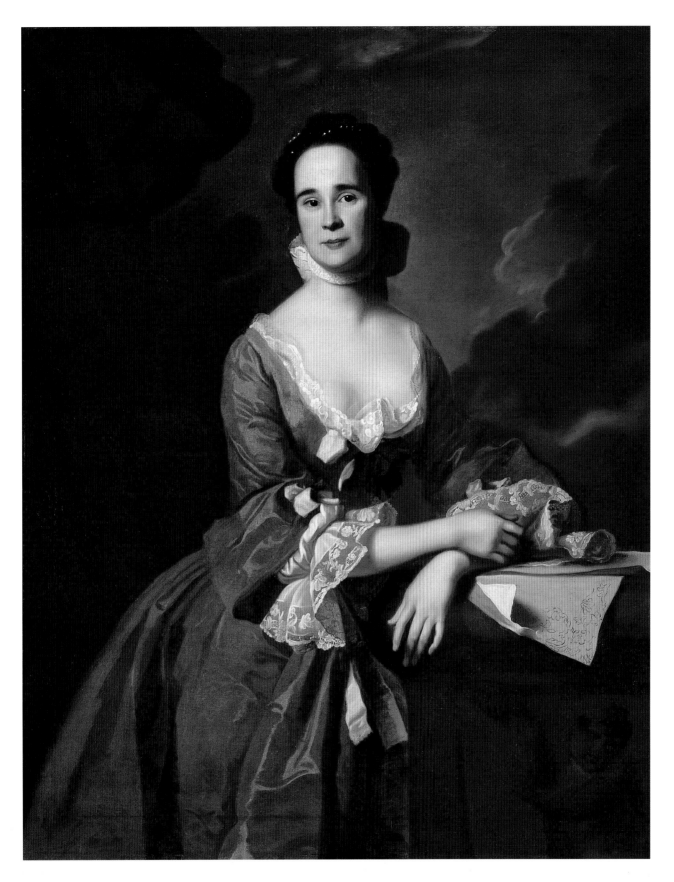

John Singleton Copley
(American; 1738–1815)

Mrs. Daniel Hubbard
(Mary Greene), c. 1764

Oil on canvas; 127.6 x 100.9 cm
(50¼ x 39¾ in.)
The Art Institute of Chicago Purchase
Fund, 1947.28

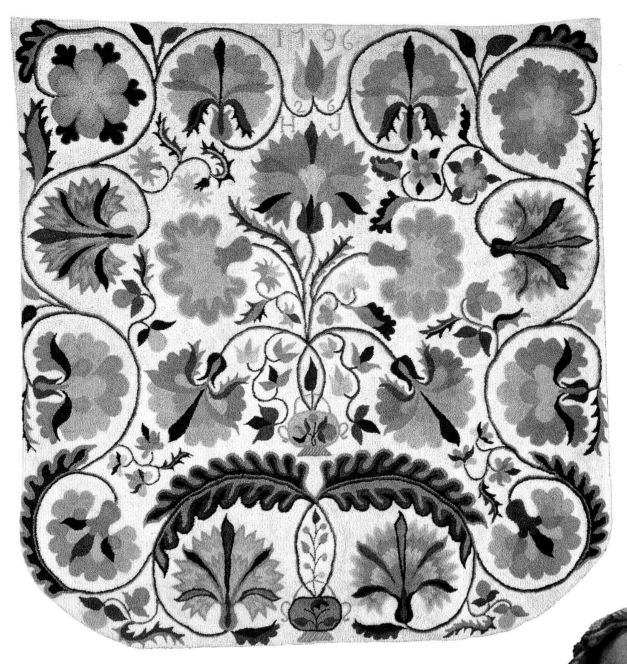

Hannah Johnson
(American; 1770–1848)

Bed Rugg, 1796

Wool, plain weave; embroidered with
wool yarns in looped running stitches,
cut to form pile; 249.4 x 246.1 cm
(98¼ x 97 in.)
Gift of the Needlework and Textile
Guild, 1944.27

Female Bust

American, 1800/30

White pine;
36.8 x 25.4 x 17.2 cm
(14½ x 10 x 6¾ in.)
George F. Harding Collection,
1982.1175

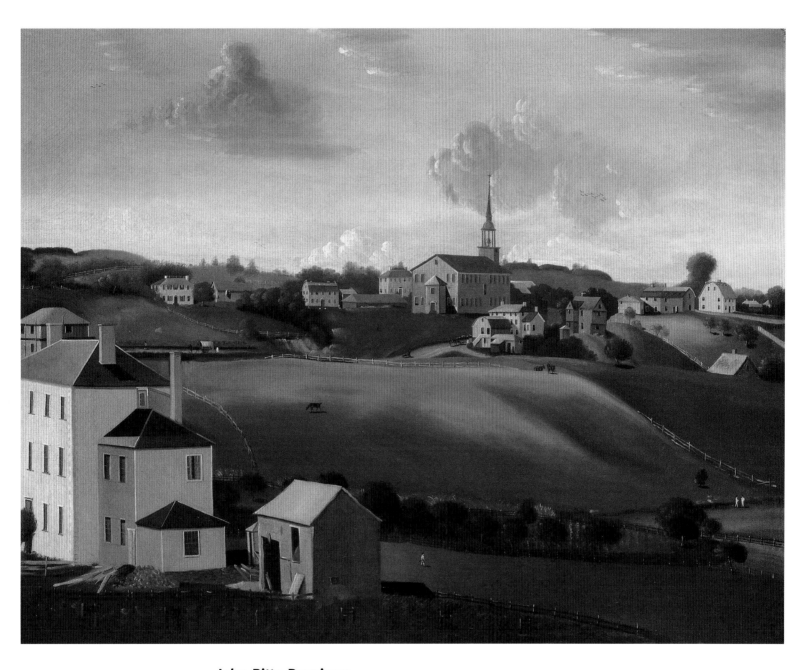

John Ritto Penniman
(American; c. 1782–1841)

*Meetinghouse Hill, Roxbury,
Massachusetts,* 1799

Oil on canvas; 73.6 x 94 cm (29 x 37 in.)
Centennial Year Acquisition and the
Centennial Fund for Major
Acquisitions, 1979.1461

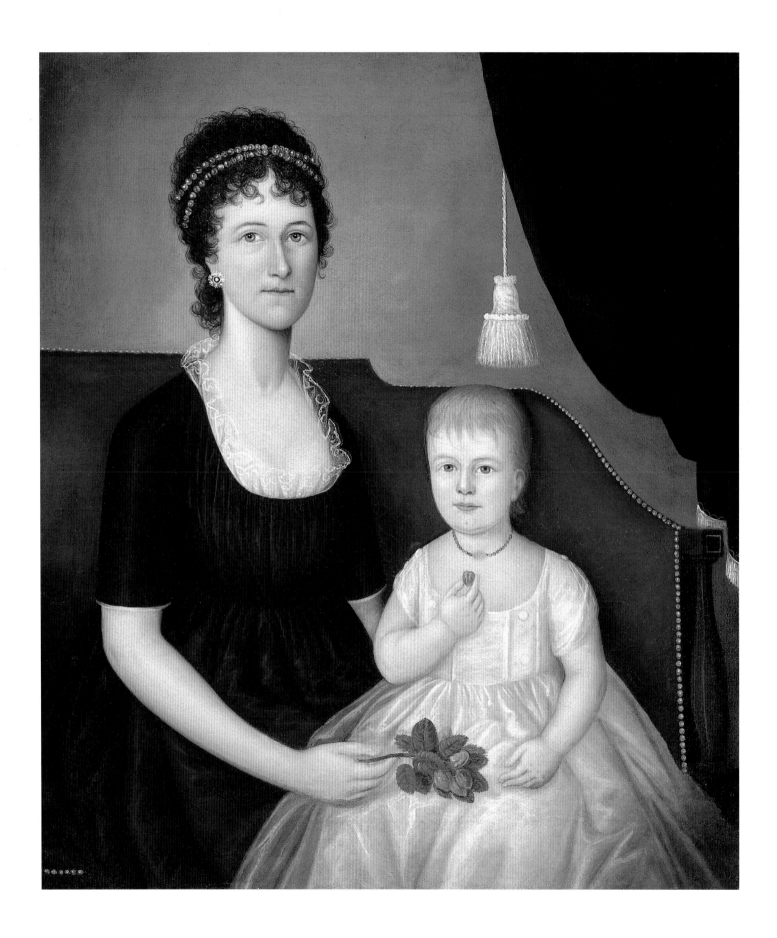

Thomas Sully
(American, b. England; 1783–1872)

Mrs. Klapp
(Anna Milnor), 1814

Oil on canvas; 92.1 x 71.5 cm
(36¼ x 28⅛ in.)
Gift of Annie Swan Coburn to the
Mr. and Mrs. Lewis L. Coburn
Memorial Collection, 1950.1362

Joshua Johnson
(American; c. 1770–after 1825)

Mrs. Andrew Bedford
Bankson and Son, Gunning
Bedford Bankson, 1803/1805

Oil on canvas; 81.3 x 71.1 cm
(38 x 32 in.)
Restricted gifts of Robin and Timm
Reynolds and Mrs. Jill Zeno; Bulley &
Andrews, Mrs. Edna Graham, Love
Galleries, Mrs. Eric Oldberg, Ratcliffe
Foundation, and Mr. and Mrs. Robert
O. Delaney funds; Walter Aitken, Dr.
Julian Archie, Mr. and Mrs. Perry
Herst, Jay W. McGreevy, John W. Puth,
Stone Foundation, and Mr. and Mrs.
Frederick G. Wacker endowments;
through prior acquisitions of the
George F. Harding Collection and
Ruth Helgeson, 1998.315

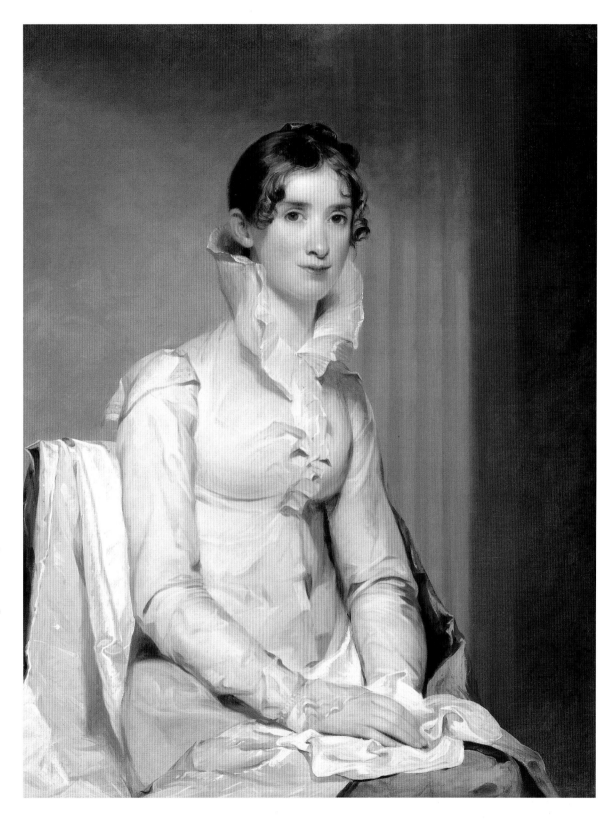

Raphaelle Peale
(American; 1774–1825)

*Still Life—Strawberries,
Nuts, &c.,* 1822

Oil on wood panel; 41.1 x 57.8 cm
(16⅜ x 22¾ in.)
Gift of Jamee J. and Marshall Field,
1991.100

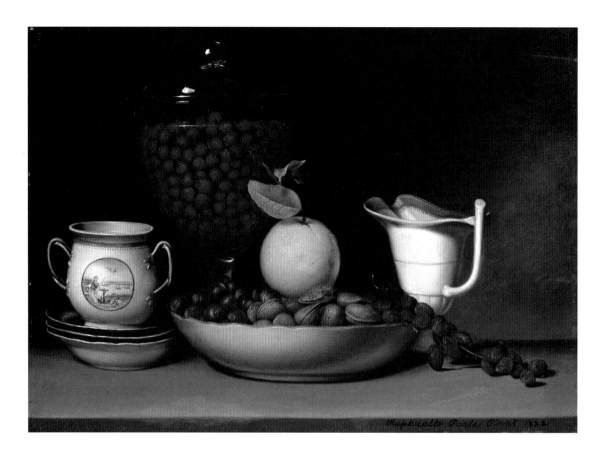

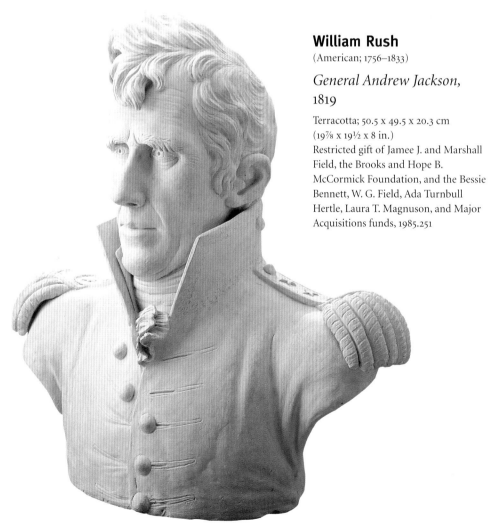

William Rush
(American; 1756–1833)

General Andrew Jackson,
1819

Terracotta; 50.5 x 49.5 x 20.3 cm
(19⅞ x 19½ x 8 in.)
Restricted gift of Jamee J. and Marshall
Field, the Brooks and Hope B.
McCormick Foundation, and the Bessie
Bennett, W. G. Field, Ada Turnbull
Hertle, Laura T. Magnuson, and Major
Acquisitions funds, 1985.251

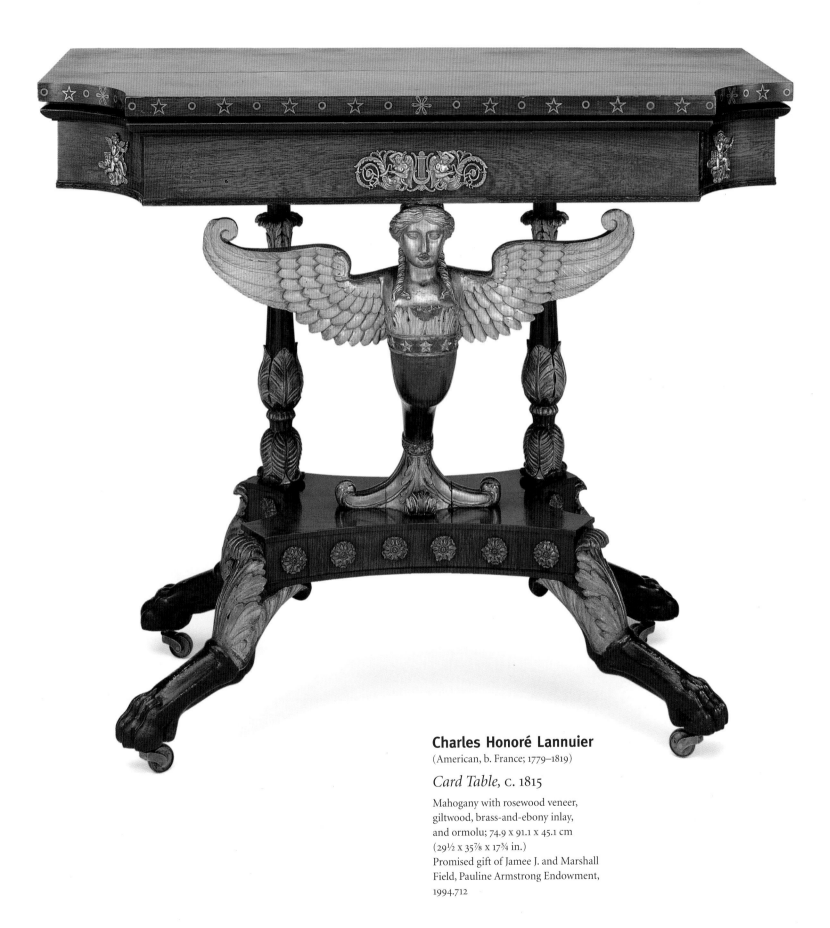

Charles Honoré Lannuier

(American, b. France; 1779–1819)

Card Table, c. 1815

Mahogany with rosewood veneer,
giltwood, brass-and-ebony inlay,
and ormolu; 74.9 x 91.1 x 45.1 cm
(29½ x 35⅞ x 17¾ in.)
Promised gift of Jamee J. and Marshall
Field, Pauline Armstrong Endowment,
1994.712

Randolph Rogers

(American; 1825–1892)

Nydia, the Blind Flower Girl of Pompeii, modeled 1855–56, carved 1858

Marble; 139.7 x 63.5 x 61 cm (55 x 25 x 24 in.)
Bequest of Mrs. Uri Balcom, 1896.77

Samuel J. Miller

(American; ?–1888)

Frederick Douglass, 1847/52

Half-plate daguerreotype with case;
14 x 10.6 cm (5½ x 4⅛ in.)
Major Acquisitions Centennial
Endowment, 1996.433

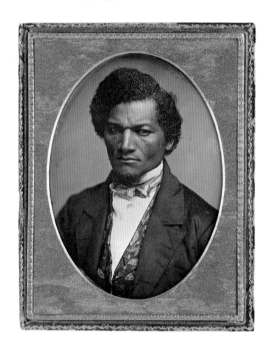

John Quincy Adams Ward

(American; 1830–1910)

The Freedman, modeled 1863

Bronze; 49.9 x 40 x 23.9 cm
(19⅝ x 15¾ x 9⅜ in.)
Roger McCormick
Endowment, 1998.1

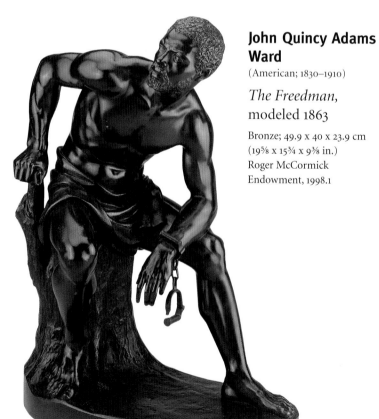

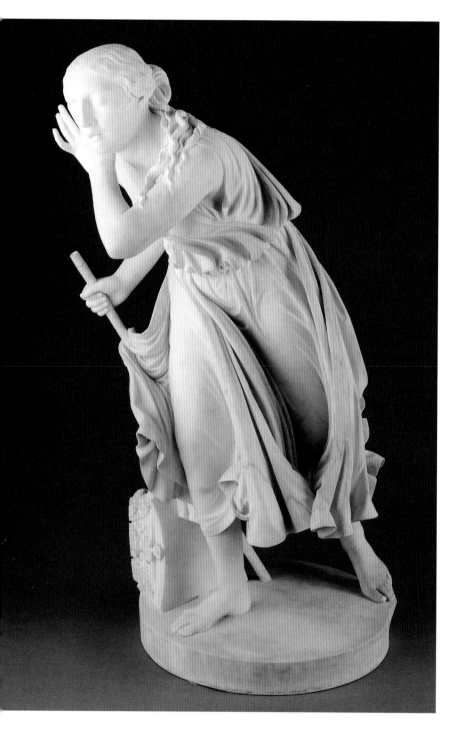

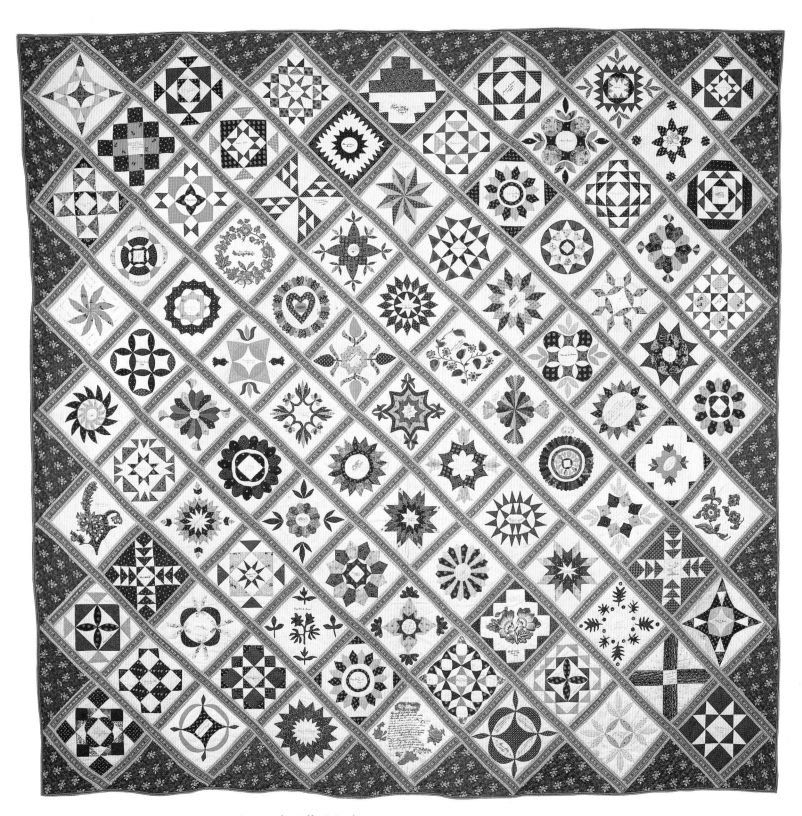

Bedcover for Ella Maria Deacon

American, New Jersey, Mount Holly, 1842

Cotton, plain weaves; pieced and
appliquéd with cotton, plain weaves,
some printed in a variety of techniques,
some glazed; quilted; 264.7 x 272.6 cm
(104⅛ x 107⅜ in.)
Gift of Betsey Leeds Tait Puth, 1978.923

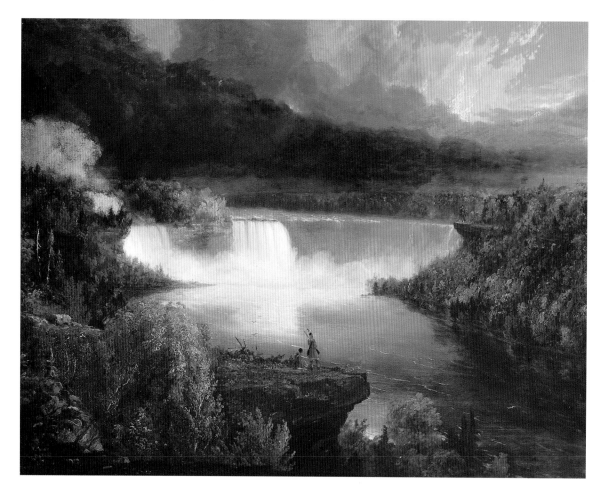

Thomas Cole
(American, b. England; 1801–1848)

Distant View of Niagara Falls, 1830

Oil on panel; 47.9 x 60.6 cm
(18⅞ x 23⅞ in.)
Friends of American Art Collection,
1946.396

Frederic Edwin Church
(American; 1826–1900)

View of Cotopaxi, 1857

Oil on canvas; 62.2 x 92.7 cm
(24½ x 36½ in.)
Gift of Jennette Hamlin in memory of
Mr. and Mrs. Louis Dana Webster,
1919.753

Albert Bierstadt

(American, b. Germany; 1830–1902)

Mountain Brook, 1863

Oil on canvas; 111.8 x 91.4 cm
(44 x 36 in.)
Restricted gift of Mrs. Herbert A.
Vance; fund of an anonymous donor;
Wesley M. Dixon, Jr., Fund and
Endowment; Henry Horner Straus and
Frederick G. Wacker endowments;

through prior acquisitions of various
donors, including Samuel P. Avery
Endowment, Mrs. George A. Carpenter,
Frederick S. Colburn, Mr. and Mrs.
Stanley Feinberg, Field Museum of
Natural History, Mr. and Mrs. Frank
Harding, International Minerals and
Chemicals Corp., Mr. and Mrs. Ralph
Loeff, Mrs. Frank C. Miller, Mahlan D.
Moulds, Mrs. Clive Runnells, Mr. and
Mrs. Stanley Stone, and the Charles
H. and Mary F. S. Worcester Collection,
1997.365

Winslow Homer

(American; 1836–1910)

Croquet Scene, 1866

Oil on canvas; 40.3 x 66.2 cm
(15⅞ x 26¹⁄₁₆ in.)
Friends of American Art Collection;
Goodman Fund, 1942.35

William Merritt Chase
(American; 1849–1916)

A City Park, c. 1887

Oil on canvas; 34.6 x 49.9 cm
(13⅝ x 19⅝ in.)
Bequest of Dr. John J. Ireland, 1968.88

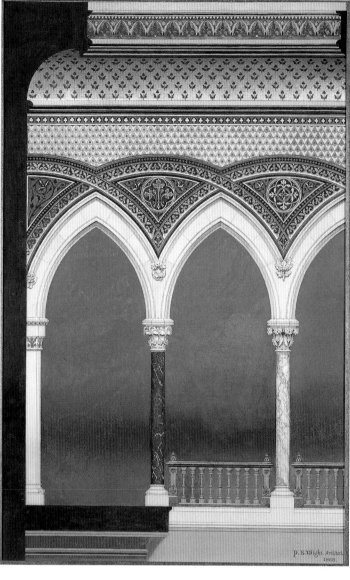

Peter B. Wight

(American; 1838–1925)

Elevation of the Proposed Stenciling for the Central Stairwell of the National Academy of Design, New York, 1868

Gouache, graphite, and watercolor on paper; approx. 50.8 x 35.7 cm (20 x 14⅟₁₆ in.)
Gift of Peter B. Wight, 1992.81.7

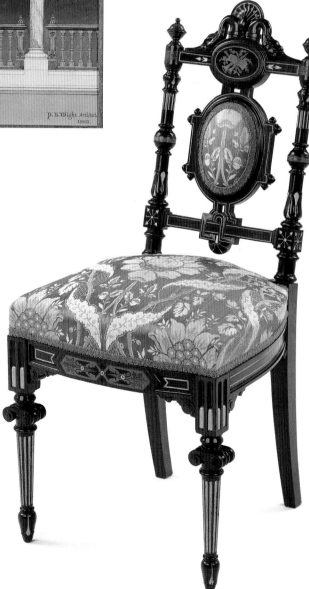

Side Chair

American, 1869/70

Designed and manufactured by Herter Brothers, New York, New York
Rosewood with marquetry of various woods; ivory; 90.5 x 45.7 x 41.9 cm (35⅝ x 18 x 16½ in.)
Wesley M. Dixon, Jr., Endowment, 1988.199

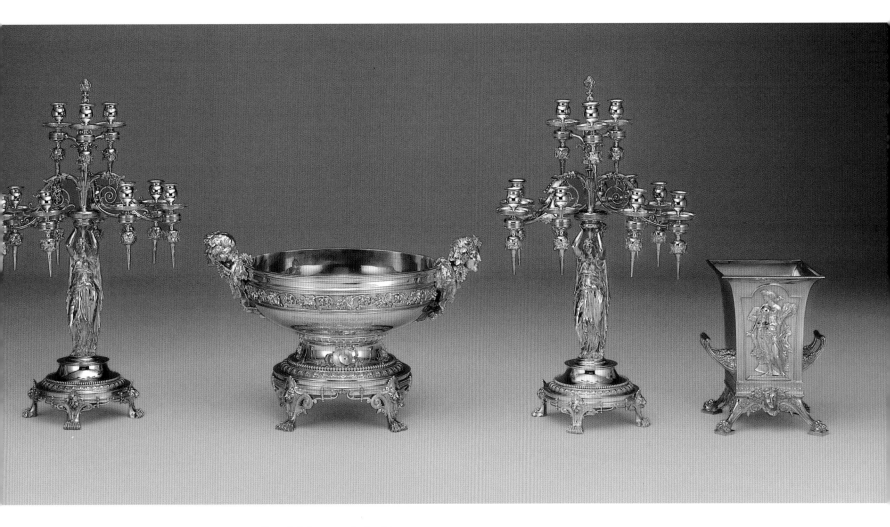

*Candelabra and the Geneva
Tribunal Testimonial Suite*

American, New York, New York, 1873

Designed by Tiffany and Company
Candelabra signed by Eugene J. Soligny
(American; c. 1833–1901)
Silver; punch bowl: h. 41.9 cm (16½ in.);
diam. 67.3 cm (26½ in.); candelabra:
77.4 x 43.2 cm (30½ x 17 in.); wine
coolers: h. 35 cm (13⅜ in.) (each)
Punch bowl and candelabra: Gift of the
Antiquarian Society through the Mr.
and Mrs. William Y. Hutchinson Fund,
1985.221a–c; pair of wine coolers: Gift of
the Antiquarian Society, 1996.15.1–2

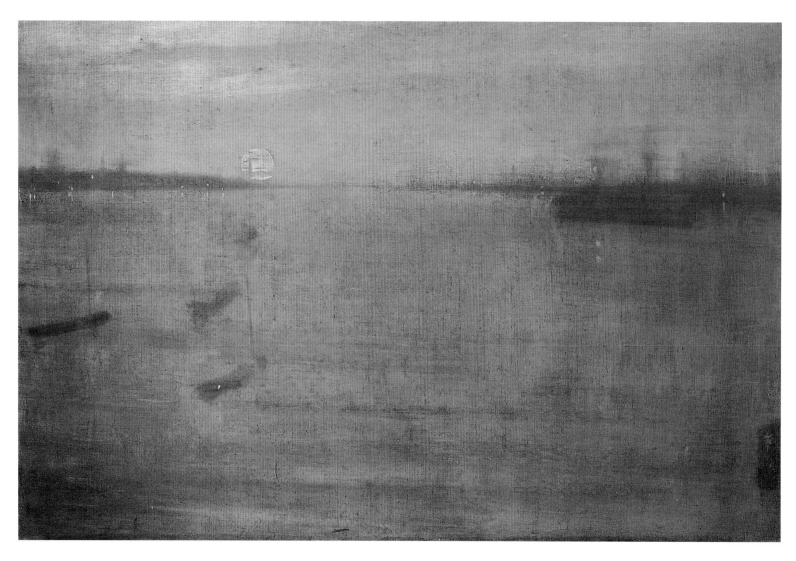

James McNeill Whistler
(American; 1834–1903)

Nocturne: Blue and Gold—
Southampton Water, 1872

Oil on canvas; 50.5 x 76 cm
(19⅞ x 29⁹⁄₁₆ in.)
The Stickney Fund, 1900.52

Martin Johnson Heade
(American; 1819–1904)

York Harbor, Coast of Maine,
1877

Oil on canvas; 38.7 x 76.8 cm
(15¼ x 30¼ in.)
Restricted gift of Mrs. Herbert A. Vance;
Americana, Lacy Armour, and Roger
McCormick endowments; through
prior gifts of Dr. and Mrs. R. Gordon
Brown, Emily Crane Chadbourne,
George F. Harding Collection, Brooks
McCormick and James S. Pennington,
1999.291

Carleton Watkins
(American; 1829–1916)

Mendocino River, from the Rancherie, Mendocino County, California, c. 1863/68

Albumen silver print from
wet-collodion glass negative;
39.9 x 52.5 cm (15¹¹⁄₁₆ x 20¹¹⁄₁₆ in.)
Gift of the Auxiliary Board, 1981.649

John Henry Twachtman
(American; 1853–1902)

Icebound, c. 1889

Oil on canvas; 64.2 x 76.6 cm
(25¼ x 30⅛ in.)
Friends of American Art Collection,
1917.200

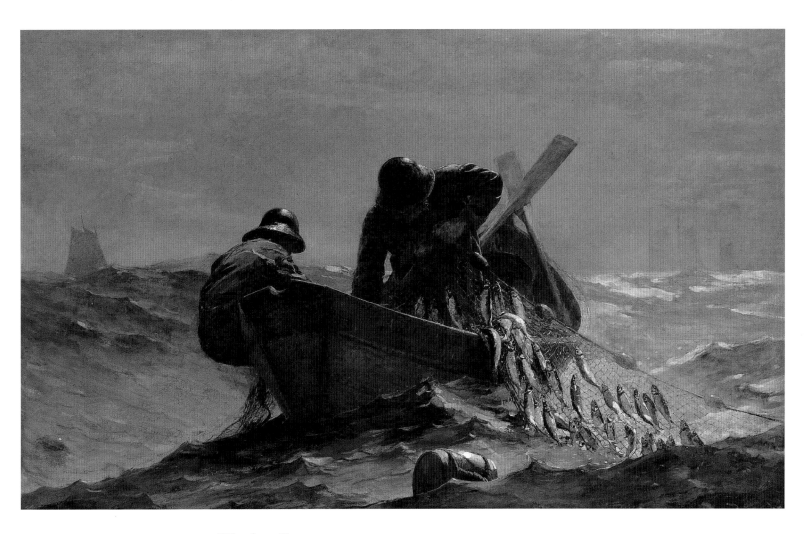

Winslow Homer
(American; 1836–1910)

The Herring Net, 1885

Oil on canvas; 76.5 x 122.9 cm
(30⅛ x 48⅜ in.)
Mr. and Mrs. Martin A Ryerson
Collection, 1937.1039

George Inness

(American; 1825–1894)

The Home of the Heron, 1893

Oil on canvas; 76.2 x 115.2 cm
(30 x 45 in.)
Edward B. Butler Collection, 1911.31

*Fragment Depicting
Children at Play* (detail)

American, Massachusetts, Lowell,
1886/90
Printed and produced by Merrimack
Company
Cotton, plain weave; block and
engraved roller printed; 66 x 48.2 cm
(26 x 19 in.)
Gift of Mrs. Chauncey B. Borland,
1956.159

William Le Baron Jenney
(American; 1832–1907)
William B. Mundie
(Canadian; 1863–1939)

*Elevator Grille from the
Manhattan Building*
(detail), 1889/91

Cast iron and copper-plated cast iron;
226 x 229 x 4 cm (89 x 90¼ x 1⅝ in.)
Gift of the Manhattan Associates,
1981.942–46

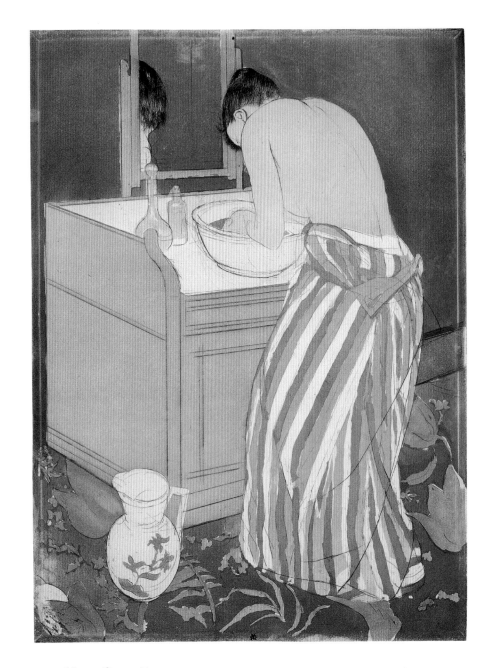

Mary Cassatt
(American; 1844–1926)

The Bath, 1890/91

Drypoint and aquatint from two
plates, on off-white, medium-weight,
moderately textured, laid paper; sheet:
43.2 x 30.5 cm (17 x 12 in.)
Mr. and Mrs. Martin A. Ryerson
Collection, 1932.1281

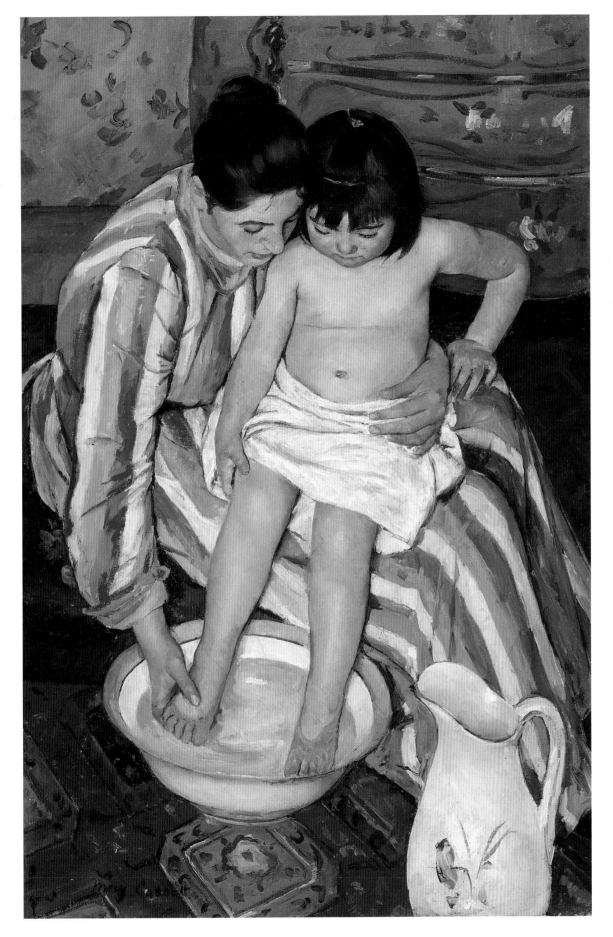

Mary Cassatt
(American; 1844–1926)

The Child's Bath, 1893

Oil on canvas; 100.3 x 66.1 cm
(39½ x 26 in.)
The Robert A. Waller Fund, 1910.2

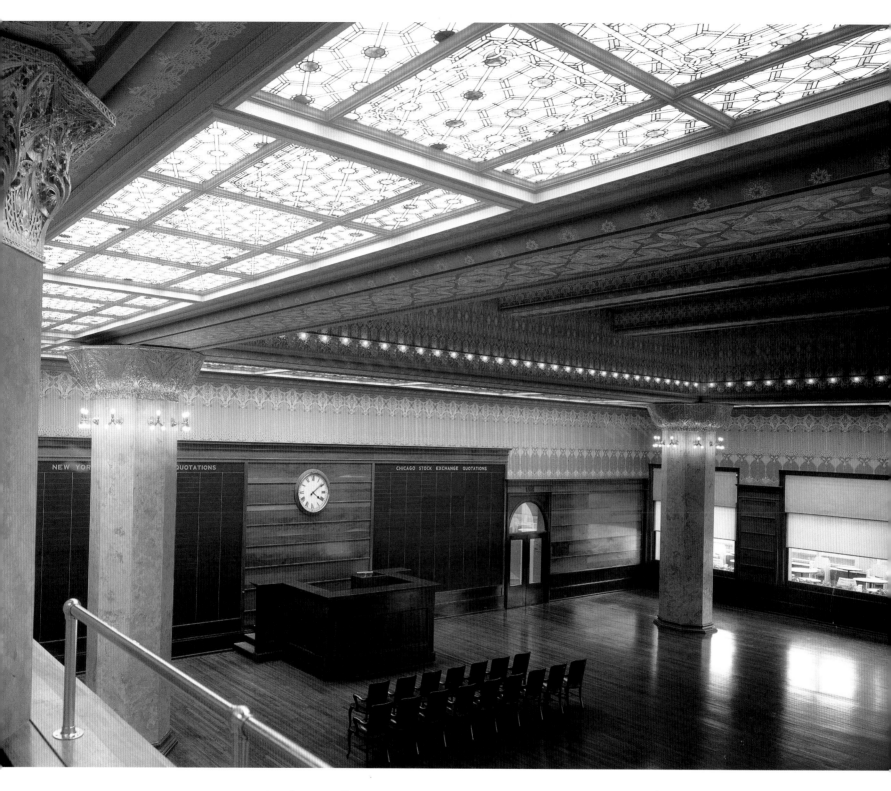

Dankmar Adler
(American; 1844–1900)

Louis H. Sullivan
(American; 1856–1924)

*The Trading Room of the
Chicago Stock Exchange,*
1893–94

Gift of the Three Oaks Wrecking
Company, 1971.922

Augustus Saint-Gaudens
(American, b. Ireland; 1848–1907)

Amor Caritas, modeled 1897,
cast after 1899

Bronze; 131.4 x 80.7 cm (51¾ x 31¾ in.)
Roger McCormick Fund, 1982.211

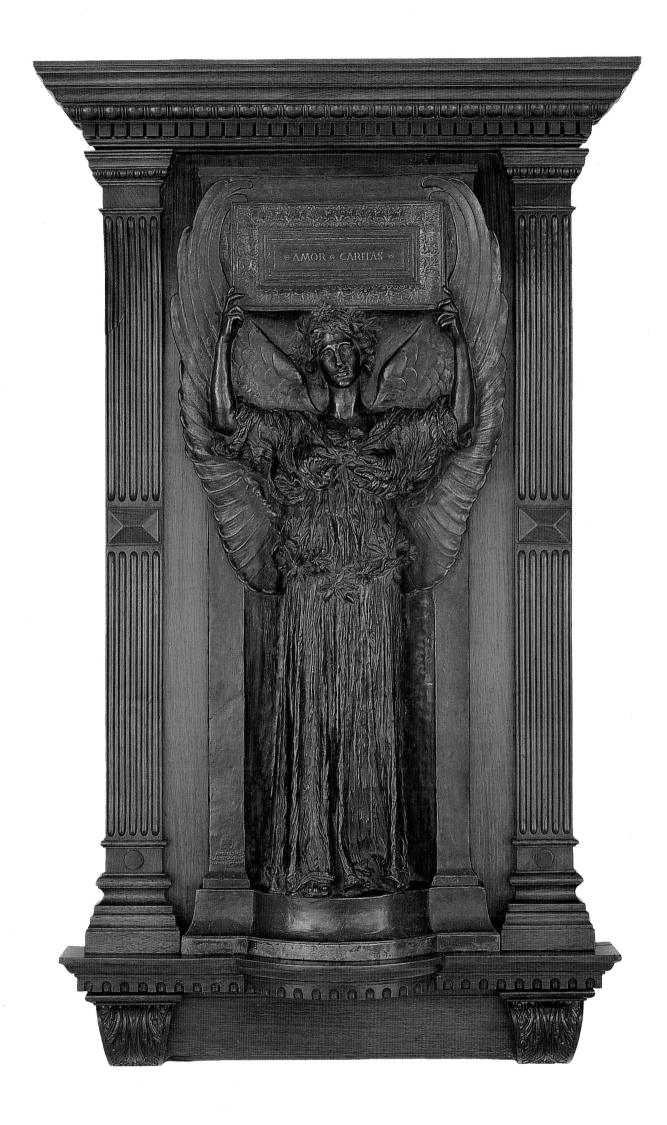

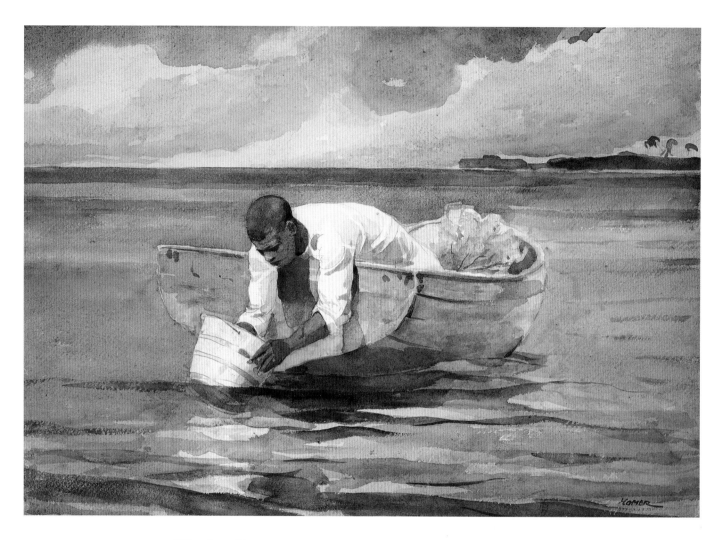

Winslow Homer

(American; 1836–1910)

The Water Fan, 1898/99

Watercolor with graphite on
off-white wove paper; 37.2 x 53.3 cm
(14¾ x 21⅟₁₆ in.)
Gift of Dorothy A., John A., Jr., and
Christopher Holabird in memory of
William and Mary Holabird, 1972.190

Thomas Eakins
(American; 1844–1916)

Mary Adeline Williams,
1899

Oil on canvas; 61 x 50.8 cm
(24 x 20⅛ in.)
Friends of American Art Collection
1939.548

The Nineteenth Century in Europe

Beginning with the French Revolution of 1789 and continuing throughout the nineteenth century, revolution undermined the stability of monarchical governments in Europe. Economic bases changed from agrarian to industrial, leading to drastic shifts in population from country to city. Scientific and political theorists, such as Charles Darwin and Karl Marx, shattered traditional beliefs, while technological advances redefined the role of human labor and the scope of progress. In the face of such change, revival styles emerged in the arts, as seen in the lavish Neoclassicism of the Londonderry vase (p. 186), and in the decorative medievalism of the model chalice (p. 193) by Englishman Augustus Welby Northmore Pugin. But the spirit of restiveness and rebellion that characterized the era also fueled a Romantic attitude in the arts, which asserted the primacy of emotion and experience and helped to validate individual expression.

A pan-European development, Romanticism defied any singularity of style or subject. Liberated from the academic dictates of what to depict, artists chose subjects that varied from Francisco Goya's depiction of heroism in everyday life (p. 185) to Eugène Delacroix's visions of distant lands and exotic tales (see p. 188). The passionate spirit of these works is counterbalanced by a meditative—almost mystical—reverence toward nature, as seen in Caspar David Friedrich's mountain scene (p. 184). John Constable (see p. 190) and Jean François Millet (see pp. 196 and 198), among others, took inspiration from ordinary rural landscapes and those who worked the land. Inventions such as the portable easel and the collapsible paint tube allowed them to work out-of-doors, recording their impressions from direct observation rather than relying upon sketches and memory to re-create the image of nature in the studio. The invention of photography made this connection even more immediate, and many pioneers of this technology, such as William Henry Fox Talbot (see p. 194) and Gustave Le Gray (see p. 195), chose nature as one of their most important subjects.

By mid-century in France, proponents of a new and adamant realism in the arts challenged the idealized aesthetics that had endured for centuries. In contrast to the controlled and conventional mode of painting taught in the official academies, artists such as Gustave Courbet (see p. 192) and Edouard Manet (see pp. 197 and 199) employed flat, bold brushwork and strong color contrasts to suggest direct observation. Poet and critic Charles Baudelaire urged painters to depict the epic, vital quality of contemporary existence and to recognize "how great and poetic we are in our cravats and patent-leather boots," goals achieved in Gustave Caillebotte's *Paris Street; Rainy Day* (p. 204). Embracing the rapidly changing world, Edgar Degas (see pp. 203, 213, 223), Claude Monet (see pp. 202 and 205), Pierre Auguste Renoir (see pp. 206–207), and others employed such techniques as broken brush strokes, bright palettes, and cropped compositions to capture the sensations of atmosphere, light, and movement. Exhibited in a series of eight independent exhibitions from 1874 to 1886, their work was dismissed by conservative critics as unfinished, merely an impression. The daring approach of the Impressionists inspired further experimentation, with a subsequent generation of artists translating optical experience into a controlled visual language that evoked solidity and permanence, as seen in the meticulous dots and color dashes of Georges Seurat (see p. 211) and considered compositions of Paul Cézanne (see pp. 218, 222, 230). At the same time, artists Paul Gauguin (see pp. 209, 216, 220–21), Vincent van Gogh (see pp. 209, 214–15), and Gustave Moreau (see p. 219) drew upon their inner vision to express emotional and spiritual realms. By the close of the century, the past no longer provided an expressive template for the present; challenges to traditional form and content lay the foundation for the art of the next century.

Henri Marie Raymond de Toulouse-Lautrec. *At the Moulin Rouge* (detail). See page 217.

Caspar David Friedrich
(German; 1774–1840)

Statue of the Madonna in the Mountains, 1804

Brush and black ink and gray wash, with graphite, on cream wove paper; 24.4 x 38.2 cm (9⅝ x 15⅛ in.)

Francisco José de Goya y Lucientes
(Spanish; 1746–1828)

Landscape with Waterfall, before 1810

Etching and burnished aquatint on ivory laid paper (working proof); 16.6 x 28.5 cm (6⁹⁄₁₆ x 11¼ in.) Clarence Buckingham Collection, 1974.16

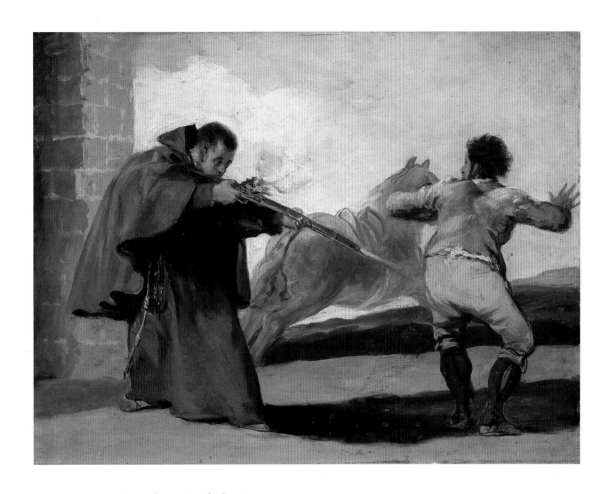

**Francisco José de Goya
y Lucientes**
(Spanish; 1746–1828)

*Friar Pedro Shoots
El Maragato as His Horse
Runs Off,* c. 1806

Oil on panel; 29.2 x 38.5 cm (11½ x 15⅝ in.)
Mr. and Mrs. Martin A. Ryerson
Collection, 1933.1075

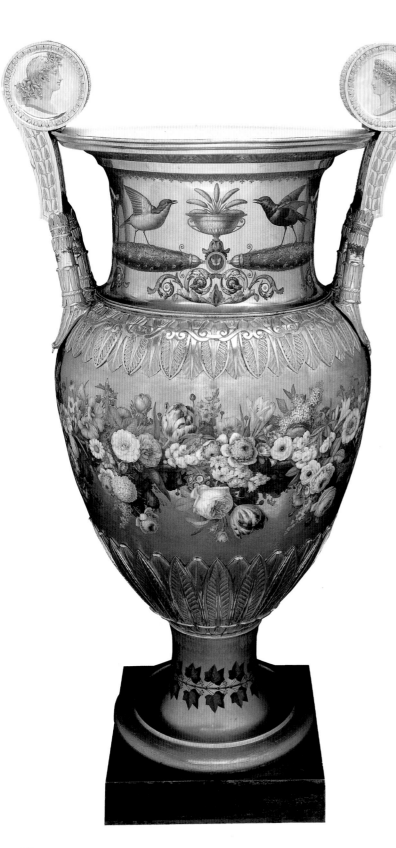

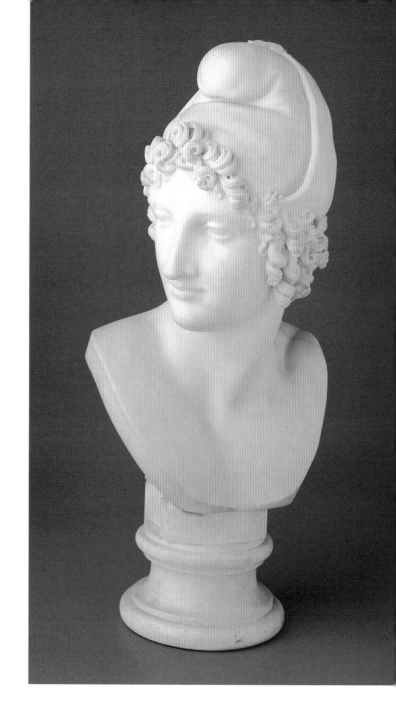

Charles Percier
(French; 1764–1838)

Alexandre Théodore Brongniart
(French; 1739–1813)

The Londonderry Vase, 1813

Manufactured by Sèvres Porcelain Manufactory
Hard-paste porcelain with polychrome enamels, gilding, and gilt-bronze mounts; approx. 137.2 x 82.6 x 61.5 cm (54 x 32½ x 24¼ in.)
Harry and Maribel G. Blum Foundation, and Harold L. Stuart funds, 1987.1

Antonio Canova
(Italian; 1757–1822)

Bust of Paris, 1809

Marble; 66 x 30.5 x 27.9 cm
(26 x 12 x 11 in.)
Harold Stuart Fund; restricted gift of Mrs. Harold T. Martin, 1984.530

Jean Auguste Dominique Ingres
(French; 1780–1867)

Amédée-David, Marquis de Pastoret, 1823–26

Oil on canvas; 103 x 83.5 cm
(40½ x 32¾ in.)
Estate of Dorothy Eckhart Williams; Robert Allerton, Bertha E. Brown, and Major Acquisitions endowments, 1971.452

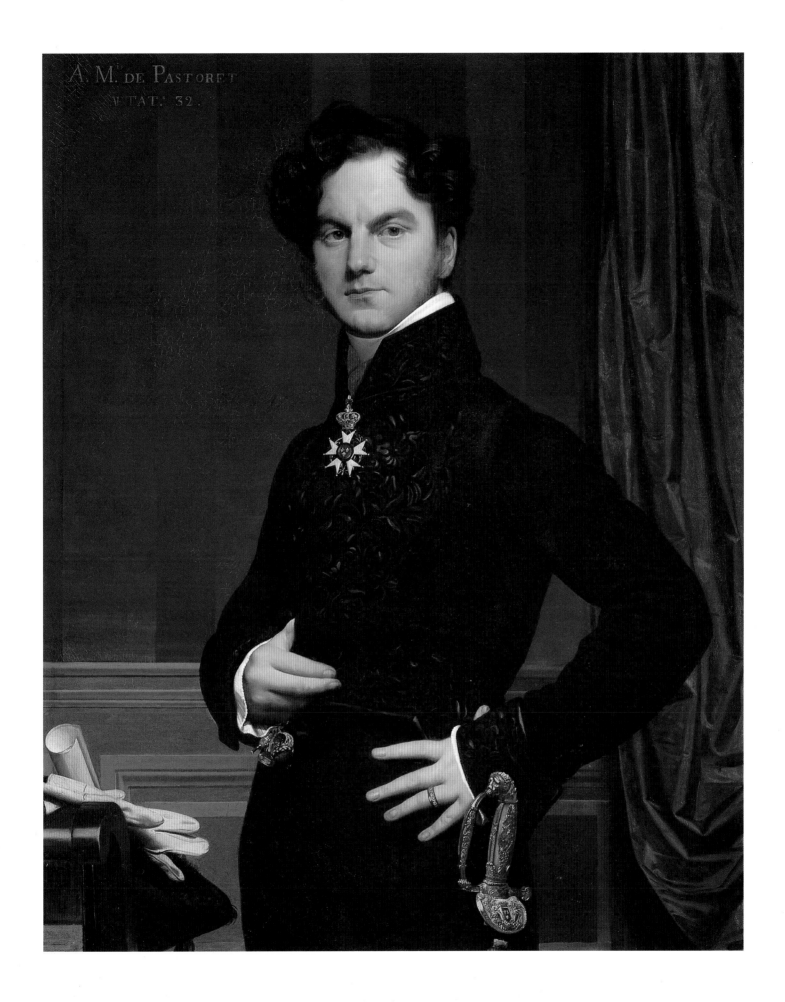

A. M.ᵉ ᴅᴇ Pastoret
ᴀ̈ᴛᴀᴛ. 32.

187

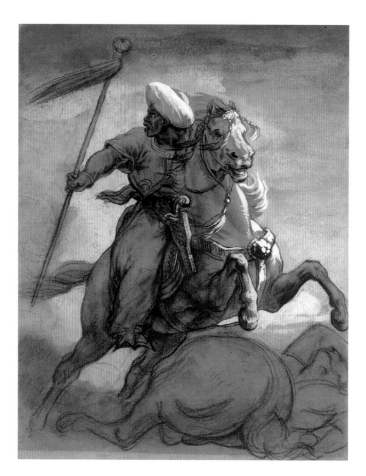

Théodore Géricault
(French; 1791–1824)

Haitian Horseman,
c. 1818

Brush and brown wash, heightened
with white gouache over black chalk,
with blue wash on brown laid paper;
28 x 22 cm (11 x 8⅝ in.)
Regenstein Collection, 1994.178

Eugène Delacroix
(French; 1798–1863)

*The Combat of the Giaour
and Hassan,* 1826

Oil on canvas; 59.6 x 73.4 cm
(23½ x 28⅞ in.)
Gift of Bertha Palmer Thorne,
Mrs. Rose Movius Palmer, Mr. and
Mrs. Arthur M. Wood, Mr. and
Mrs. Gordon Palmer, 1962.966

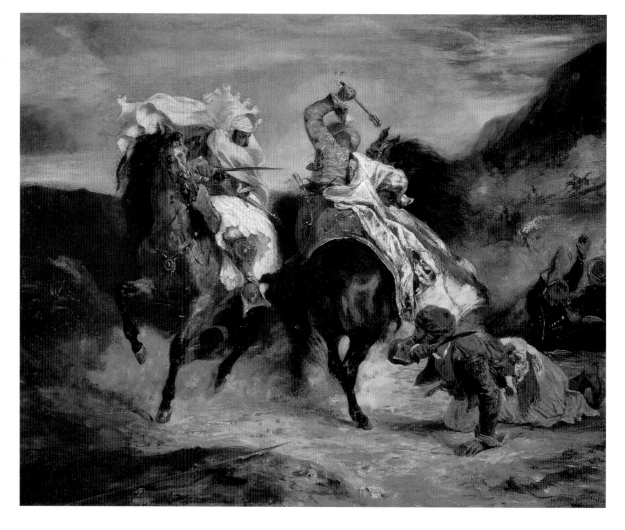

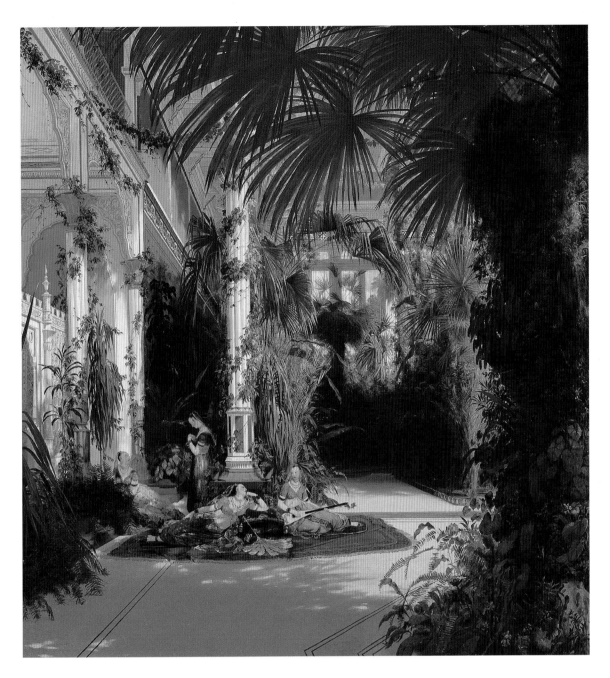

Carl Blechen

(German; 1798–1840)

Interior of the Palmhouse on the Pfaueninsel near Potsdam, 1834

Oil on canvas; 135 x 126 cm (52½ x 50 in.)
Through prior acquisitions of the
George F. Harding Collection; L. L. and
A. S. Coburn and Alexander A. McKay
endowments; through prior gift of
William Wood Prince; through prior
acquisitions of the Charles H. and Mary
F. S. Worcester Endowment, 1996.388

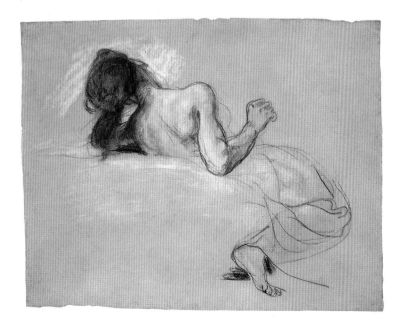

Eugène Delacroix

(French; 1798–1863)

Crouching Woman
(study for *The Death of
Sardanapalus*), 1827

Pastel, with black, red, and white chalks
and touches of blue chalk, over red and
white chalk wash, on tan wove paper;
24.6 x 31.4 cm (9¹¹⁄₁₆ x 12⅜ in.)
Through prior bequest of Mr. and Mrs.
Martin A. Ryerson, 1990.226

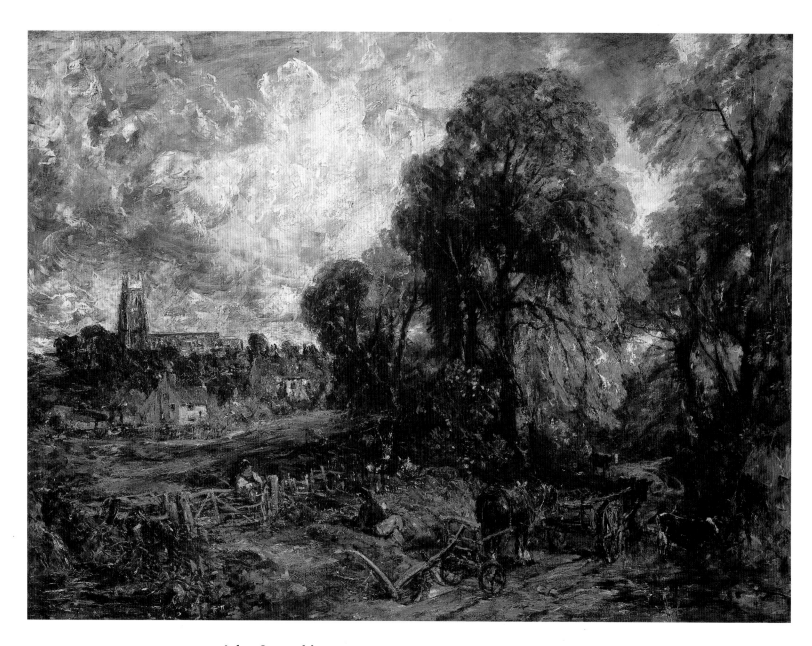

John Constable
(English; 1776–1837)

Stoke-by-Nayland, 1836

Oil on canvas; 126 x 169 cm
(49⅝ x 66½ in.)
Mr. and Mrs. W. W. Kimball Collection,
1922.4453

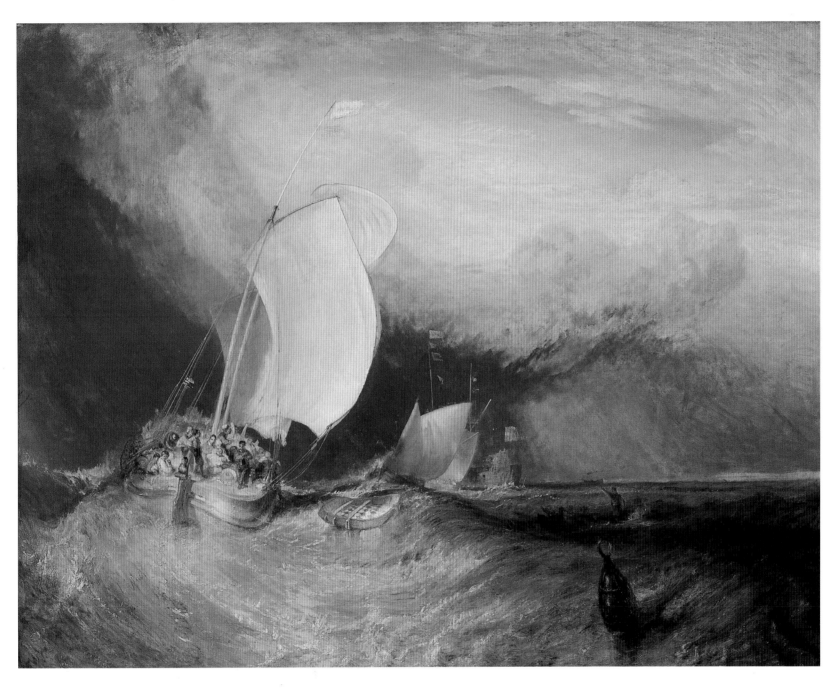

Joseph Mallord William Turner

(English; 1775–1851)

Fishing Boats with Hucksters Bargaining for Fish, 1837/38

Oil on canvas; 174.5 x 224.9 cm
(68¾ x 88½ in.)
Mr. and Mrs. W. W. Kimball Collection,
1922.4472

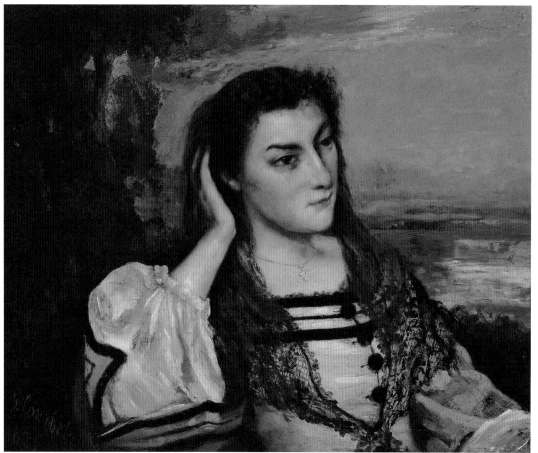

Gustave Courbet

(French; 1819–1877)

Reverie (Portrait of Gabrielle Borreau), 1862

Oil on paper mounted on canvas;
63.5 x 77 cm (25 x 30⁵⁄₁₆ in.)
Joseph Winterbotham Collection,
1987.259

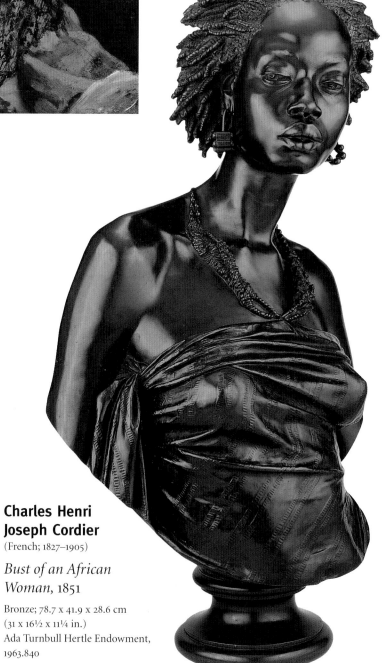

Charles Henri Joseph Cordier

(French; 1827–1905)

Bust of an African Woman, 1851

Bronze; 78.7 x 41.9 x 28.6 cm
(31 x 16½ x 11¼ in.)
Ada Turnbull Hertle Endowment,
1963.840

Dahlia Paperweight

French, c. 1848/55

Manufactured by St. Louis Glass
Factory, St. Louis
Glass with lampwork;
diam. 7.4 cm (2⅞ in.)
Bequest of Arthur Rubloff, 1988.541.580

Patterned Millefiori Paperweight

French, c. 1845/55

Manufactured by L. J. Maës Factory,
Clichy-la-Garenne
Glass with pastry-mold canes;
diam. 7 cm (2¾ in.)
Gift of Arthur Rubloff, 1978.1300

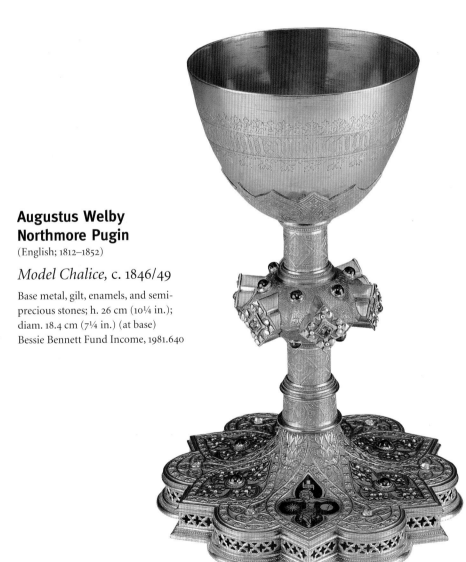

Augustus Welby Northmore Pugin

(English; 1812–1852)

Model Chalice, c. 1846/49

Base metal, gilt, enamels, and semi-
precious stones; h. 26 cm (10¼ in.);
diam. 18.4 cm (7¼ in.) (at base)
Bessie Bennett Fund Income, 1981.640

William Henry Fox Talbot
(English; 1800–1877)

Flowers, Leaves, and Stem,
c. 1838

Photogenic drawing stabilized in
potassium bromide; 22.1 x 18 cm
(8⅞ x 7⅟₁₆ in.)
Edward E. Ayer Endowment in memory
of Charles L. Hutchinson, 1972.325.2

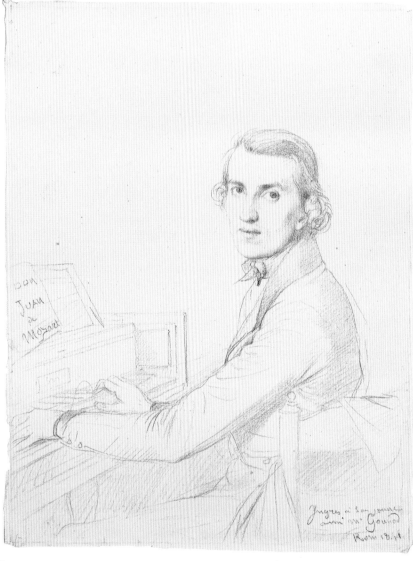

**Jean Auguste Dominique
Ingres**
(French; 1780–1867)

Portrait of Charles Gounod,
1841

Graphite, on ivory wove paper
(discolored to cream);
30 x 23 cm (11⅞ x 9⅛ in.)
Gift of Charles Deering McCormick,
Brooks McCormick, and Roger
McCormick, 1964.77

Julia Margaret Cameron
(English; 1815–1879)

Julia Jackson, c. 1864/65

Albumen silver print from wet-collodion negative; 25 x 18.2 cm
(9¹³⁄₁₆ x 7⅛ in.)
Harriott A. Fox Endowment, 1968.226

Gustave Le Gray
(French; 1820–1882)

*Tree, Forest of
Fontainebleau,* c. 1856

Gold chloride-toned albumen silver
print from wet-collodion glass
negative; 31.4 x 41.6 cm (12⅜ x 16⅜ in.)
Edward E. Ayer Endowment in
memory of Charles L. Hutchinson;
Samuel P. Avery, Wentworth G. Field
Memorial, Maurice D. Galleher, Laura
T. Magnuson, and General Acquisitions
endowments, 1987.54

Jean François Millet

(French; 1814–1875)

Flight into Egypt, c. 1864

Black and brown conté crayon,
with pen and black ink, and traces
of black pastel, over bands of variously
colored gray washes, on cream
wove paper edge-mounted on
laminated wood-pulp board;
31.7 x 40.7 cm (12½ x 16 in.)
Regenstein Collection, 1996.608

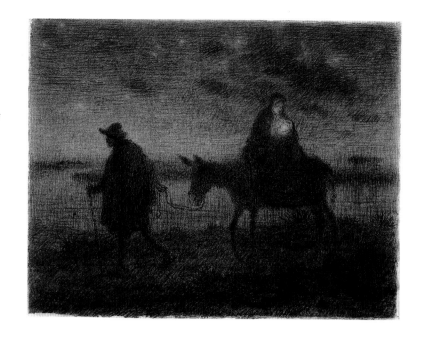

Honoré Daumier

(French; 1808–1879)

Side Show, 1865/67

Pen and black ink and brush and
gray wash with charcoal, on ivory
laid paper (discolored to cream);
51.7 x 36.4 cm (20⁵⁄₁₆ x 14⁵⁄₁₆ in.)
Gift of Mary and Leigh Block,
1988.141.26

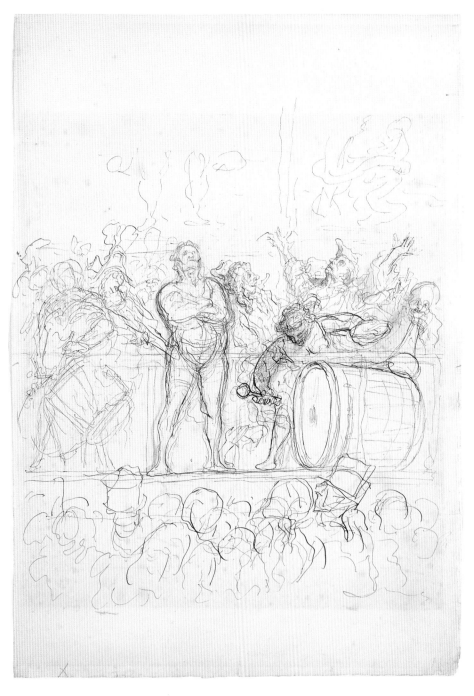

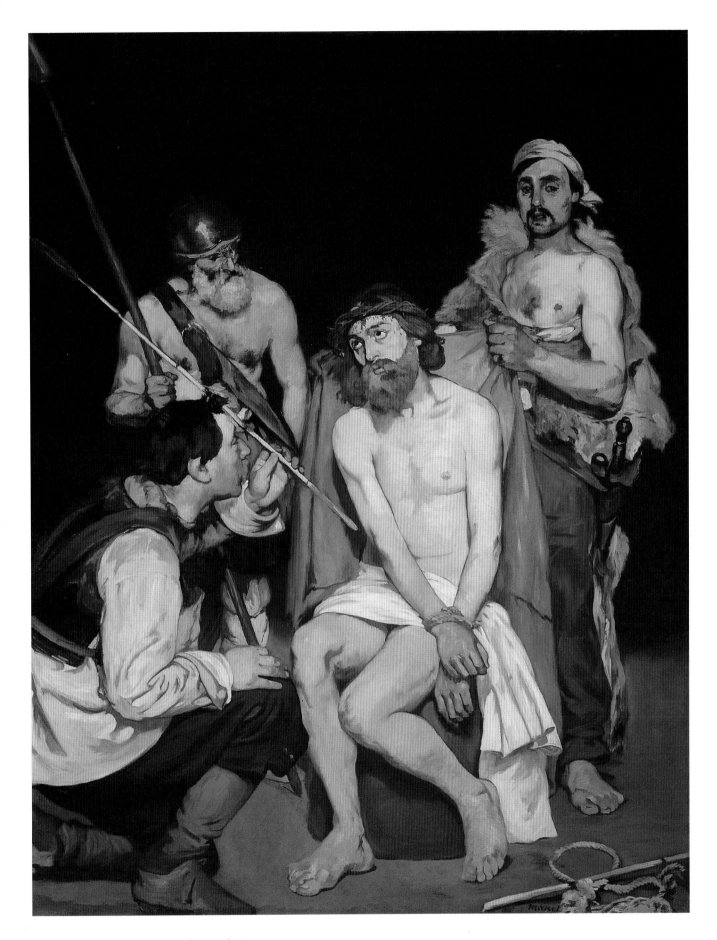

Edouard Manet

(French; 1832–1883)

The Mocking of Christ, 1865

Oil on canvas; 190.8 x 148.3 cm
(74⅞ x 58⅜ in.)
Gift of James Deering, 1925.703

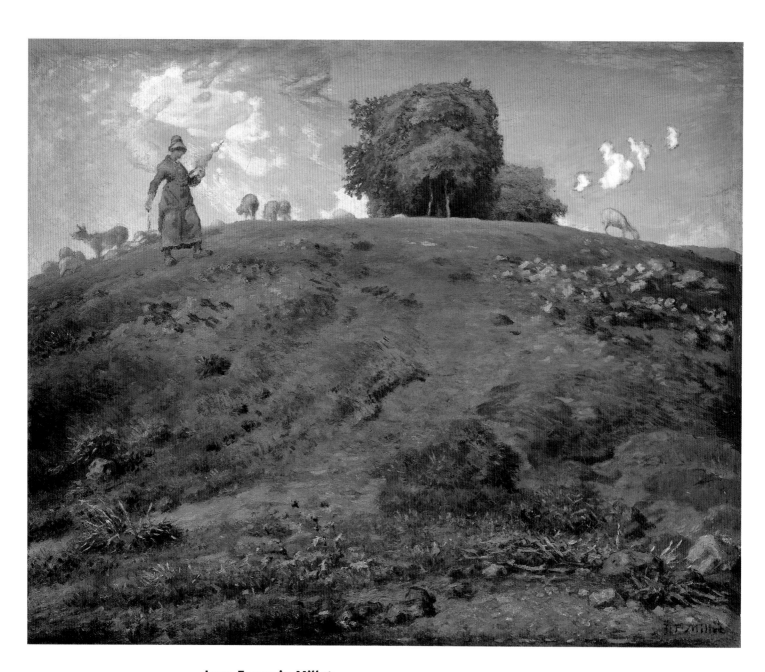

Jean François Millet

(French; 1814–1875)

In the Auvergne, 1866/69

Oil on canvas; 81.5 x 99.9 cm
(32¹⁄₁₆ x 39¼ in.)
Potter Palmer Collection, 1922.414

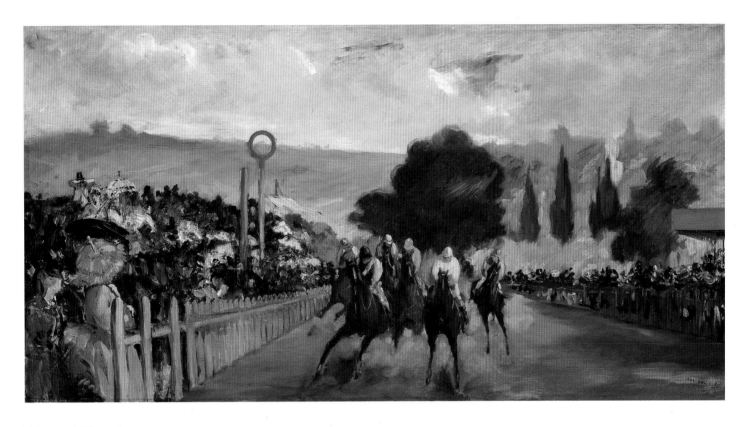

Edouard Manet

(French; 1832–1883)

The Races at Longchamp,
1866

Oil on canvas; 43.9 x 84.5 cm
(17¼ x 33¼ in.)
Potter Palmer Collection, 1922.424

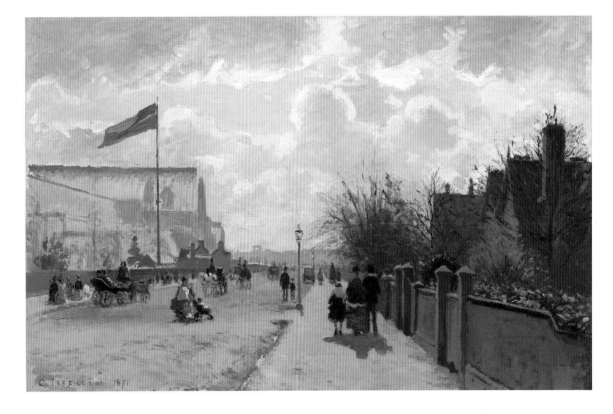

Camille Pissarro

(French; 1830–1903)

The Crystal Palace, 1871

Oil on canvas; 47.2 x 73.5 cm
(19 x 29 in.)
Gift of Mr. and Mrs. B. E. Bensinger,
1972.1164

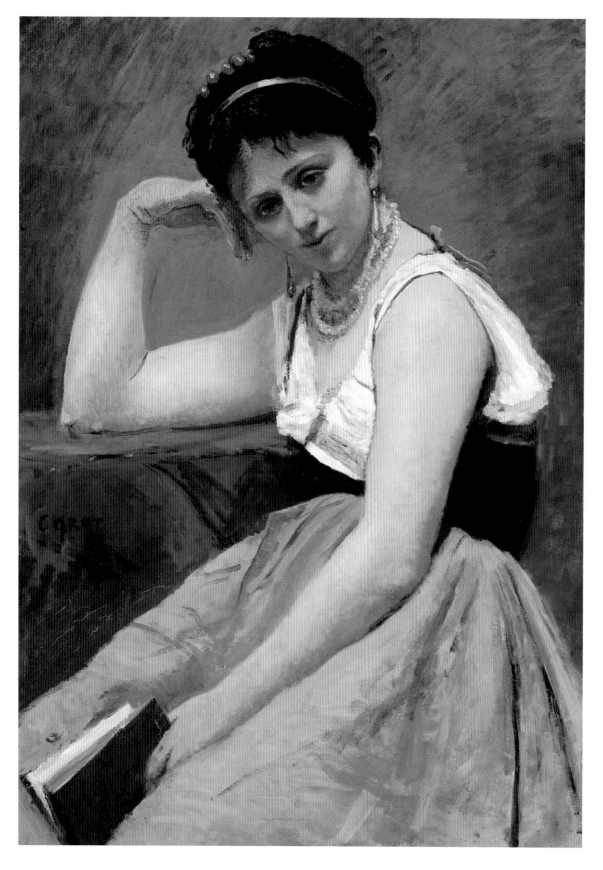

Jean Baptiste Camille Corot

(French; 1796–1875)

Interrupted Reading, c. 1870

Oil on canvas mounted on board;
92.5 x 65.1 cm (36⅕ x 25⅝ in.)
Potter Palmer Collection (Bequest of
Bertha Honoré Palmer), 1922.410

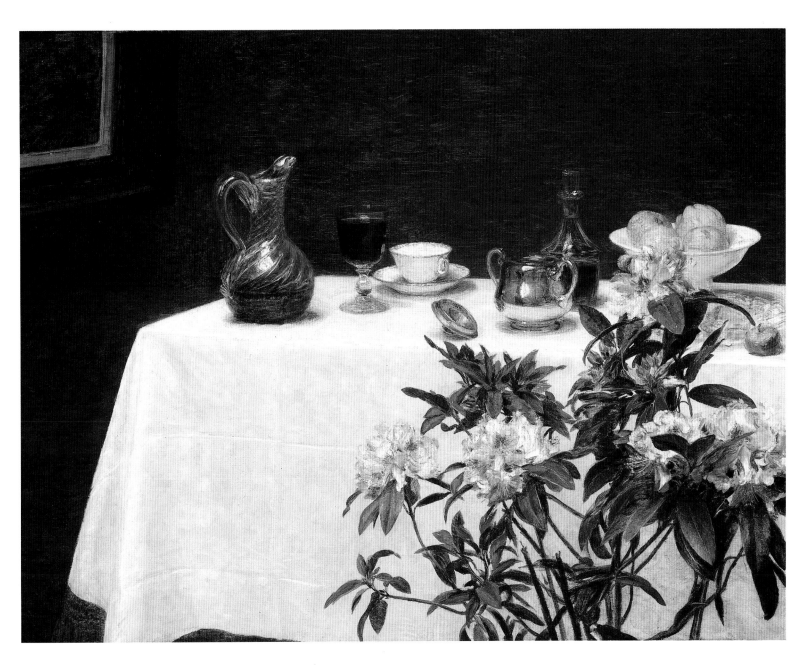

Henri Fantin-Latour

(French; 1836–1904)

Still Life: Corner of a Table,
1873

Oil on canvas; 96.4 x 125 cm
(37 ¹⁵⁄₁₆ x 49 ³⁄₁₆ in.)
Ada Turnbull Hertle Endowment,
1951.226

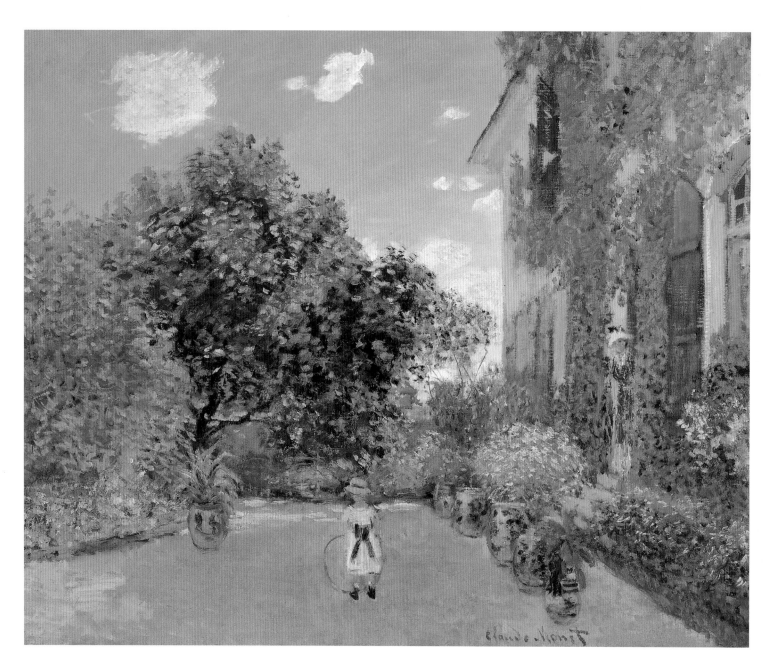

Claude Monet

(French; 1840–1926)

The Artist's House at Argenteuil, 1873

Oil on canvas; 60.2 x 73.3 cm
(23¹¹⁄₁₆ x 28⅞ in.)
Mr. and Mrs. Martin A. Ryerson
Collection, 1933.1153

**Hilaire Germain
Edgar Degas**

(French; 1834–1917)

*Yellow Dancers (In the
Wings),* 1874/76

Oil on canvas; 73.5 x 59.5 cm
(28⅛₆ x 23⅜₆ in.)
Gift of Mr. and Mrs. Gordon Palmer,
Mrs. Bertha Palmer Thorne, Mr. and
Mrs. Arthur M. Wood, and Mrs. Rose
M. Palmer, 1963.923

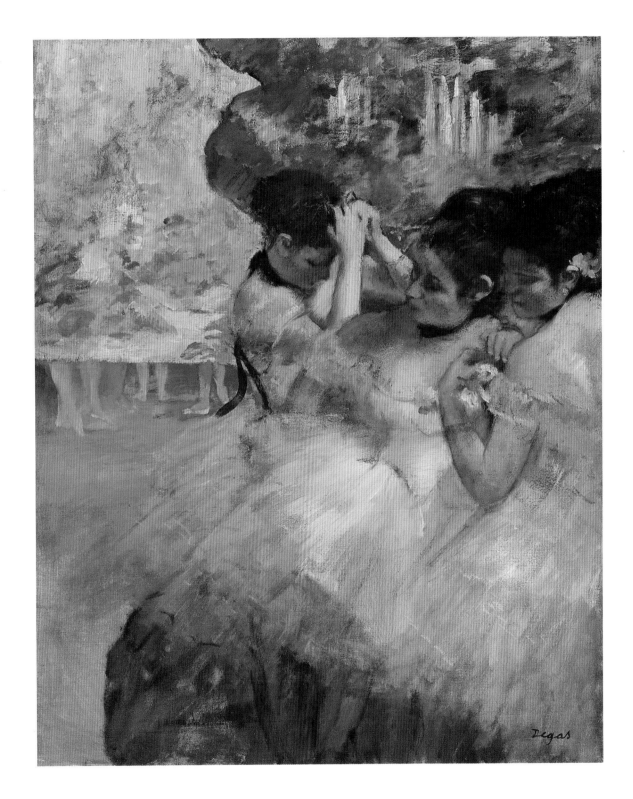

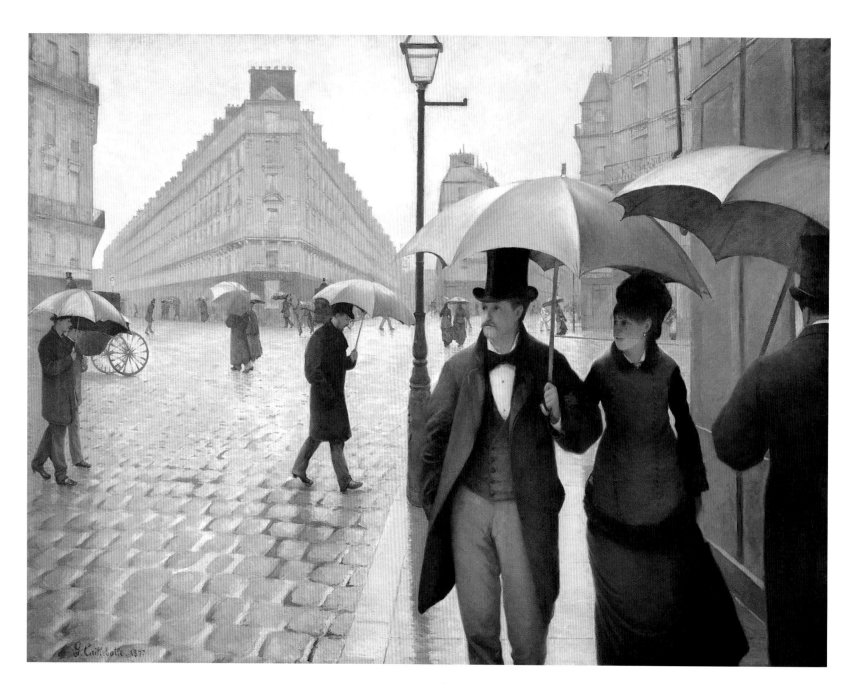

Gustave Caillebotte

(French; 1848–1894)

Paris Street; Rainy Day, 1877

Oil on canvas; 212.2 x 276.2 cm
(83½ x 108¾ in.)
Charles H. and Mary F. S. Worcester
Collection, 1964.336

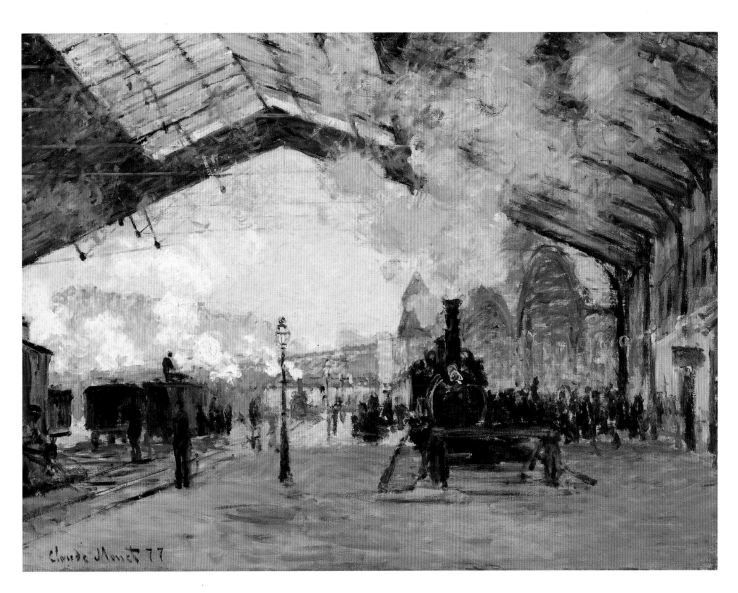

Claude Monet
(French; 1840–1926)

Arrival of the Normandy Train, Gare Saint-Lazare, 1877

Oil on canvas; 59.6 x 80.2 cm
(23½ x 31½ in.)
Mr. and Mrs. Martin A. Ryerson
Collection, 1933.1158

Pierre Auguste Renoir
(French; 1841–1919)

*Acrobats at the Cirque
Fernando (Francisca and
Angelina Wartenberg),* 1879

Oil on canvas; 131.5 x 99.5 cm
(51¾ x 39⅛ in.)
Potter Palmer Collection, 1922.440

Pierre Auguste Renoir
(French; 1841–1919)

*Workers' Daughters on the
Outer Boulevard
(Illustration for Emile Zola's
L'Assommoir),* 1877/78

Pen and brown ink, over black chalk,
on ivory laid paper; 27.5 x 39.9 cm
(10¹¹⁄₁₆ x 15¹¹⁄₁₆ in.)
Regenstein Collection, 1986.420

Pierre Auguste Renoir
(French; 1841–1919)

Two Sisters (On the Terrace),
1881

Oil on canvas; 100.5 x 81 cm
(39⁷⁄₁₆ x 37⅞ in.)
Mr. and Mrs. Lewis Larned Coburn
Memorial Collection, 1933.455

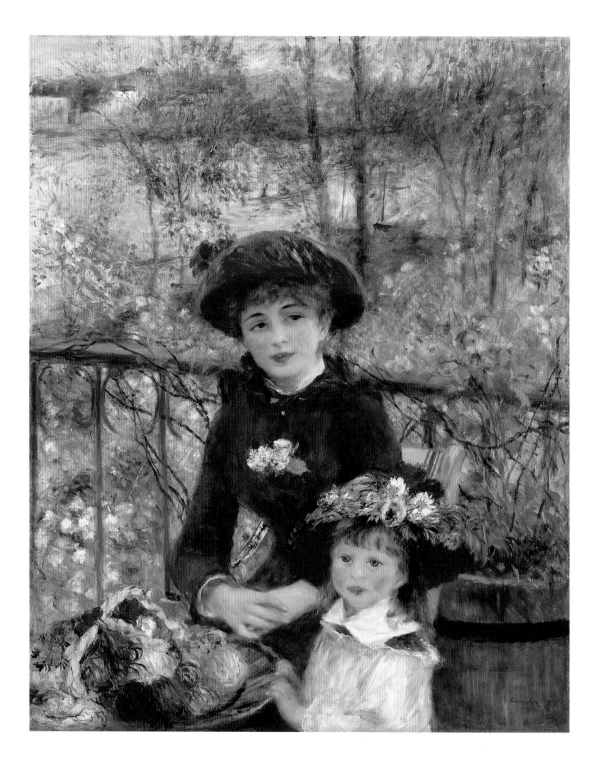

Auguste Rodin

(French; 1840–1917)

Adam, c. 1881

Cast by the Alexis Rudier Foundry,
Paris
Bronze; 198.1 x 76.2 x 75.6 cm
 (78 x 30 x 29¾ in.)
Gift of Robert Allerton, 1924.4

Paul Gauguin

(French; 1848–1903)

The Faun, 1886

Unglazed stoneware with touches
of gold; 47 x 29.8 x 27.3 cm
(18½ x 11¾ x 10¾ in.)
Estate of Suzette Morton Davidson;
Major Acquisitions Centennial
Endowment, 1997.88

Vincent van Gogh

(Dutch; 1853–1890)

The Carrot Puller, 1885

Black chalk, with stumping and
erasing, on cream wove paper;
52.5 x 42.2 cm (20¹¹⁄₁₆ x 16⅝ in.)
Gift of Dorothy Braude Edinburg to
the Harry B. and Bessie K. Braude
Memorial Collection, 1998.697

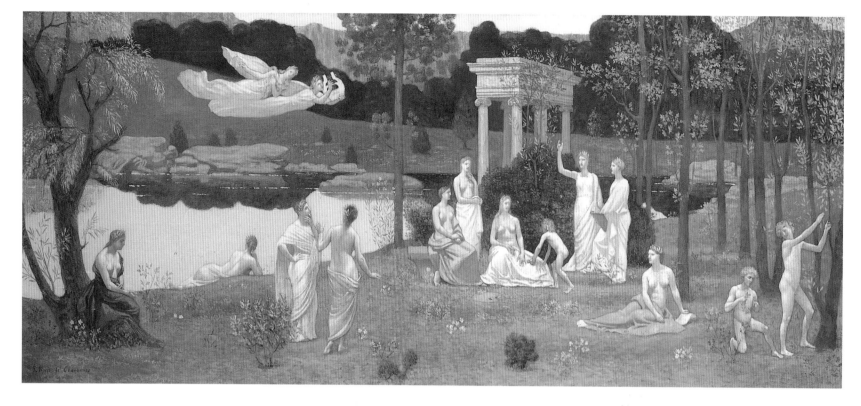

**Pierre Cécile Puvis
de Chavannes**

(French; 1824–1898)

*The Sacred Grove, Beloved
of the Arts and the Muses,*
1884–89

Oil on canvas; 93 x 231 cm
(35⁷⁄₁₆ x 90¹⁵⁄₁₆ in.)
Potter Palmer Collection, 1922.445

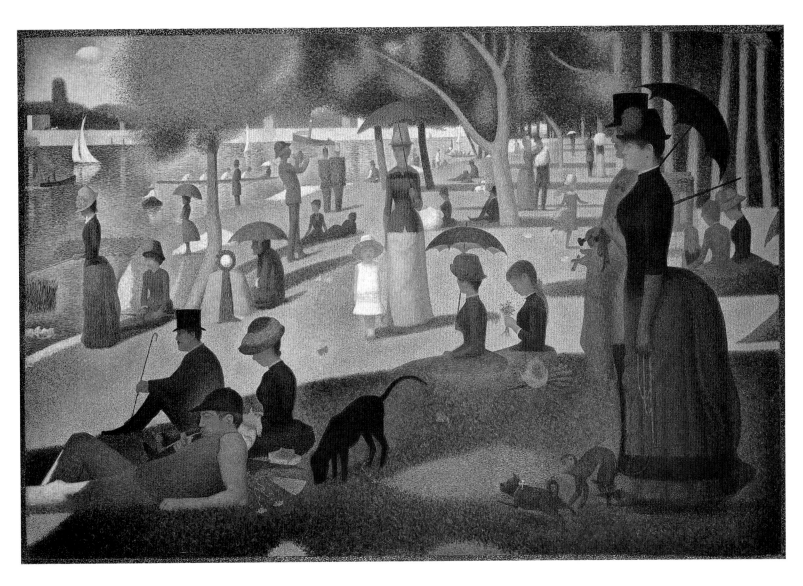

Georges Pierre Seurat

(French; 1859–1891)

A Sunday on La Grande Jatte—1884, 1884–86

Oil on canvas; 207.6 x 308 cm
(81¾ x 121¼ in.)
Helen Birch Bartlett Memorial
Collection, 1926.224

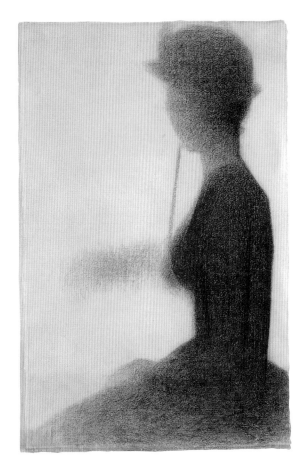

Georges Pierre Seurat

(French; 1859–1891)

Seated Woman with Parasol, 1884

Black conté crayon on ivory laid paper;
47.7 x 31.5 cm (18¹⁵⁄₁₆ x 12⁷⁄₁₆ in.)
Bequest of Abby Aldrich Rockefeller,
1999.7

Berthe Morisot

(French; 1841–1895)

The Garden (Le Jardin),
1882–83

Oil on canvas; 123 x 94 cm
(48⅜ x 36¾ in.)
A Millennium Gift of Sara Lee
Corporation, 1999.363

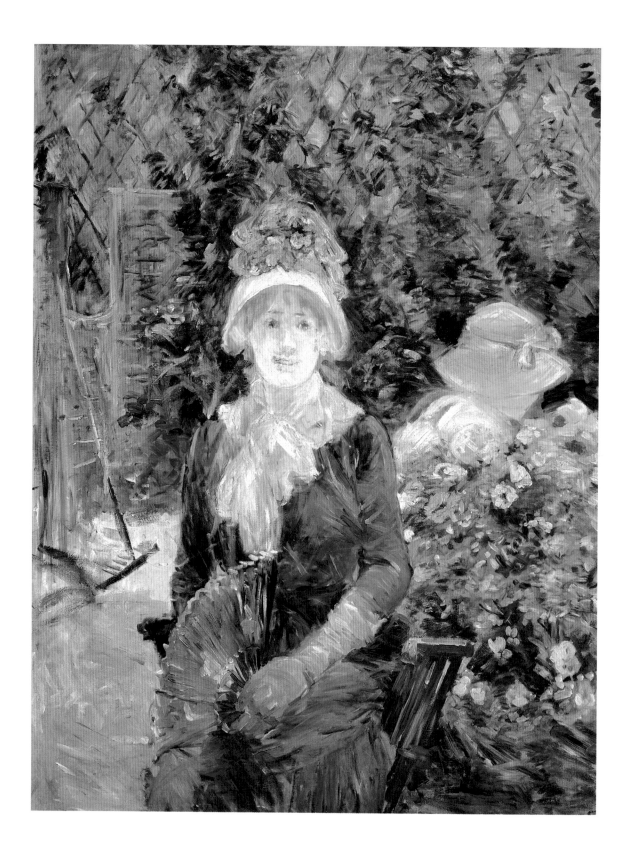

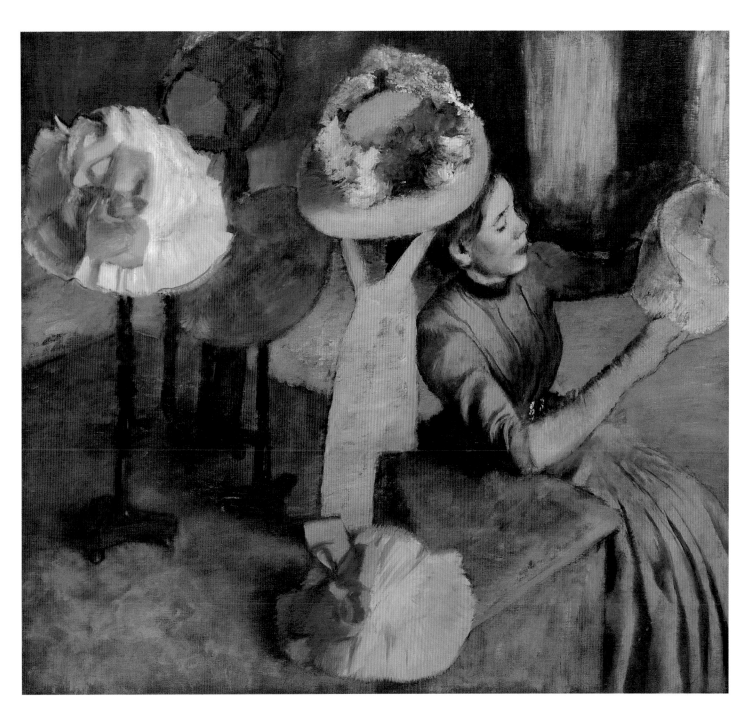

Hilaire Germain Edgar Degas

(French; 1834–1917)

The Millinery Shop, 1884/90

Oil on canvas; 100 x 110.7 cm
(39⅜ x 43 9/16 in.)
Mr. and Mrs. Lewis Larned Coburn
Memorial Collection, 1933.428

Vincent van Gogh
(Dutch; 1853–1890)

Self-Portrait, 1886/87

Oil on mill board mounted on cradled
panel; 41 x 32.5 cm (16⅛ x 13¼ in.)
Joseph Winterbotham Collection,
1954.326

Vincent van Gogh
(Dutch; 1853–1890)

The Bedroom, 1889

Oil on canvas; 73.6 x 92.3 cm
(29 x 36⅝ in.)
Helen Birch Bartlett Memorial
Collection, 1926.417

Paul Gauguin
(French; 1848–1903)

The Arlésiennes (Mistral),
1888

Oil on canvas; 73 x 92 cm
(28¾ x 36⅟₁₆ in.)
Mr. and Mrs. Lewis Larned Coburn
Memorial Collection, 1934.391

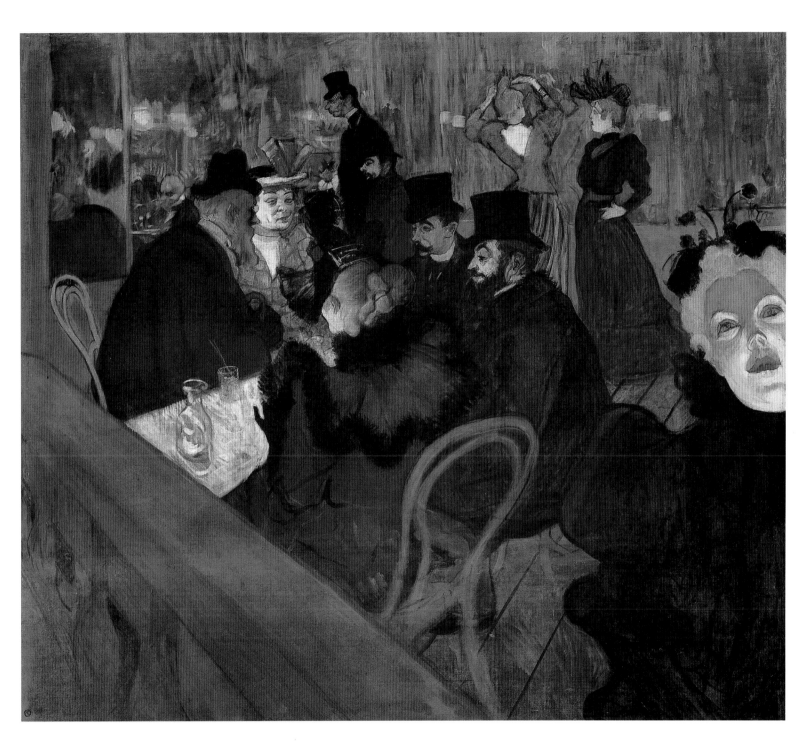

**Henri Marie Raymond
de Toulouse-Lautrec**

(French; 1864–1901)

At the Moulin Rouge,
1892/95

Oil on canvas; 123 x 141 cm
(48⁷⁄₁₆ x 55½ in.)
Helen Birch Bartlett Memorial
Collection, 1928.610

Paul Signac
(French; 1863–1935)

Les Andelys, Côte d'aval,
1886

Oil on canvas; 60 x 92 cm
(23⅝ x 36⅜ in.)
Through prior gift of William
Wood Prince, 1993.208

Paul Cézanne
(French; 1839–1906)

The Bay of Marseilles,
Seen from L'Estaque,
1886/90

Oil on canvas; 80.2 x 100.6 cm
(31⅝ x 39⅝ in.)
Mr. and Mrs. Martin A.
Ryerson Collection, 1933.1116

Gustave Moreau
(French; 1826–1898)

Inspiration, c. 1893

Watercolor and gouache, with pen and
blue ink, over traces of graphite, on
pressed ivory wove paper wrapped on
cardboard; 29 x 19 cm (11⁷⁄₁₆ x 7⁷⁄₁₆ in.)
Restricted gift of Mrs. Wesley M.
Dixon, Jr., 1985.596

Edward Burne-Jones
(English; 1833–1898)

William Morris
(English; 1834–1896)

Hanging Entitled *Pomona,*
designed 1884/85,
manufactured 1898/1918

Woven and produced by Morris &
Company at Merton Abbey Works,
Wimbleton
Cotton, wool, and silk, double
interlocking tapestry weave;
92.9 x 165.1 cm (36½ x 65 in.)
Ida E. Noyes Fund, 1919.792

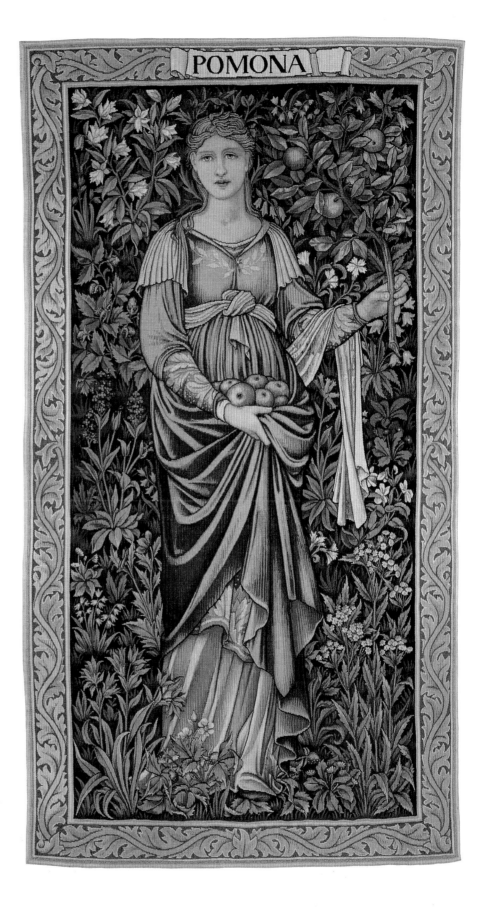

Paul Gauguin
(French; 1848–1903)

Ancestors of Tehamana,
(Merahi Metua no
Tehamana), 1893

Oil on canvas; 76.3 x 54.3 cm
(30⅟₁₆ x 21⅜ in.)
Gift of Mr. and Mrs. Charles Deering
McCormick, 1980.613

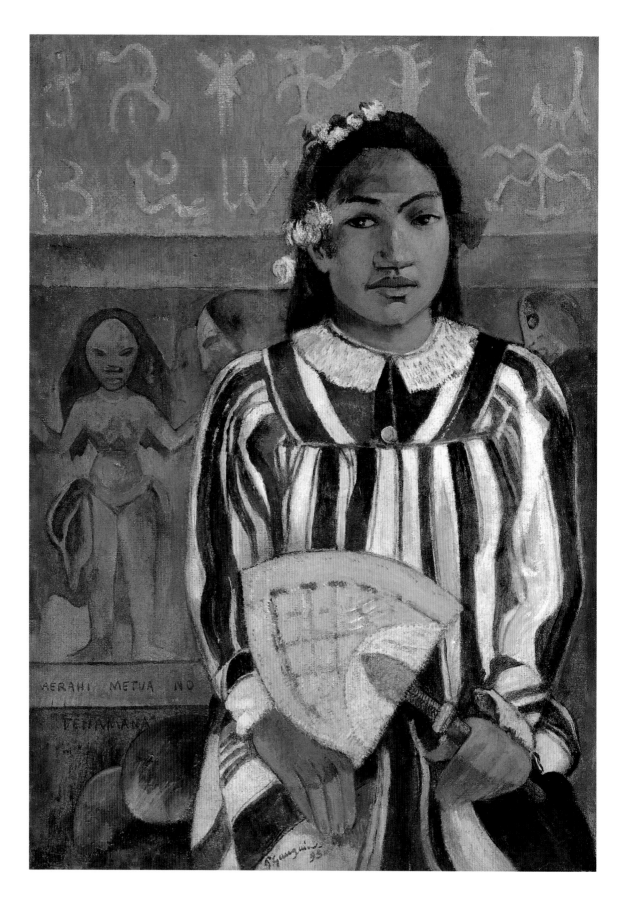

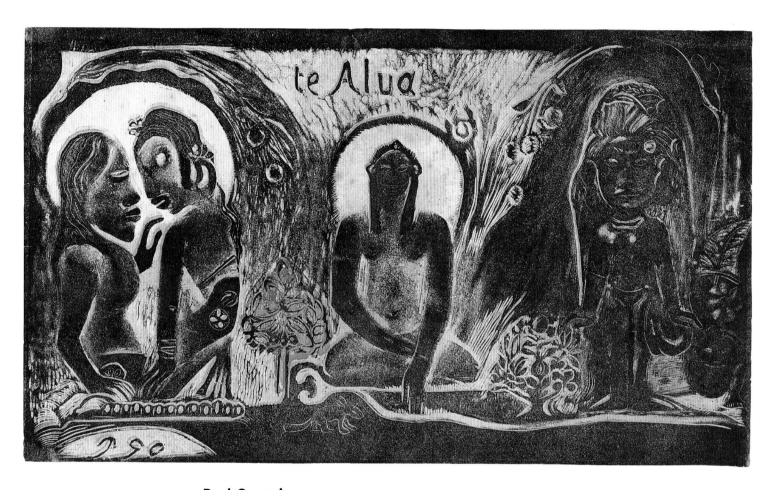

Paul Gauguin
(French; 1848–1903)

The Gods (Te atua), 1893/95

Woodcut printed in black and ochre in
two separate printings from same box-
wood block, slightly off-register, with
touches of red (apparently printed),
green (added by hand), and yellow
liquid media on ivory Japanese paper;
20.3 x 35.2 cm (8 x 13⅞ in.)
Clarence Buckingham Collection,
1948.262

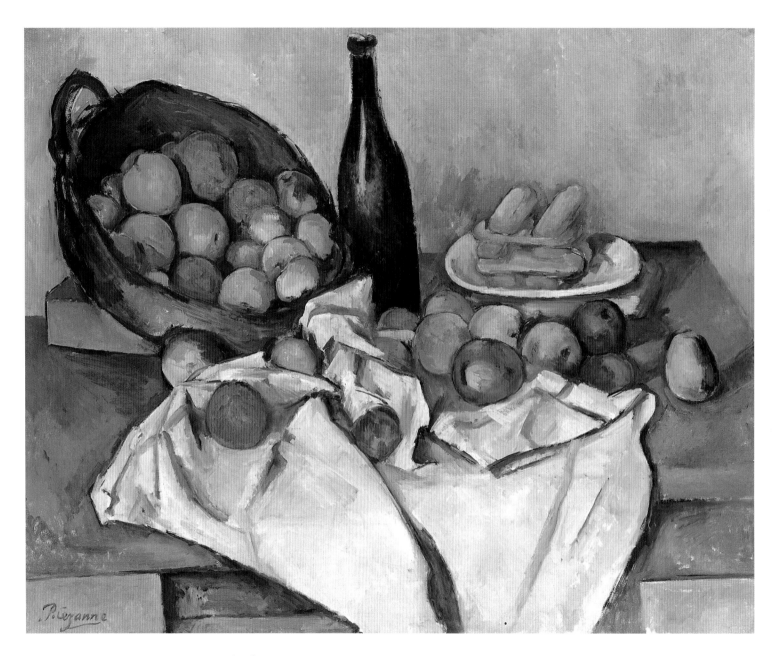

Paul Cézanne
(French; 1839–1906)

The Basket of Apples, c. 1895

Oil on canvas; 65 x 80 cm
(25⁷⁄₁₆ x 31½ in.)
Helen Birch Bartlett Memorial
Collection, 1926.252

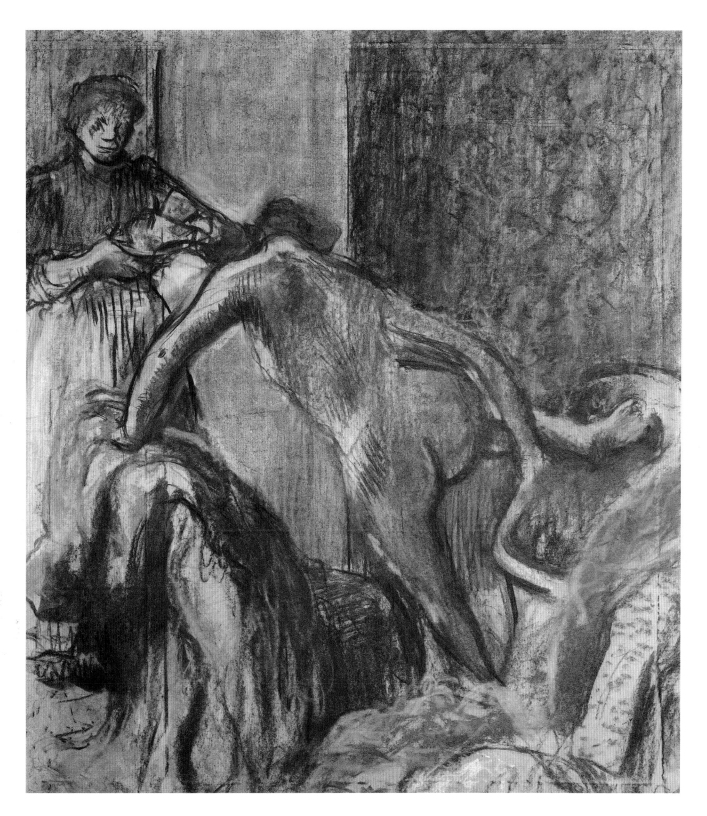

Hilaire Germain Edgar Degas

(French; 1834–1917)

Breakfast after the Bath,
1895/98

Pastel on paper laid down on board;
92 x 81 cm (36½ x 32¼ in.)
A Millennium Gift of Sara Lee
Corporation, 1999.365

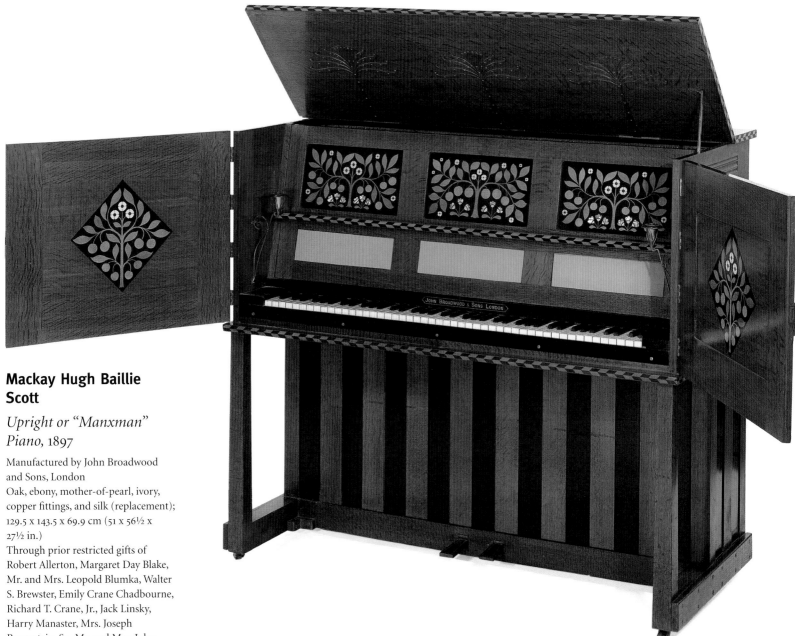

Mackay Hugh Baillie Scott

Upright or "Manxman" Piano, 1897

Manufactured by John Broadwood
and Sons, London
Oak, ebony, mother-of-pearl, ivory,
copper fittings, and silk (replacement);
129.5 x 143.5 x 69.9 cm (51 x 56½ x
27½ in.)
Through prior restricted gifts of
Robert Allerton, Margaret Day Blake,
Mr. and Mrs. Leopold Blumka, Walter
S. Brewster, Emily Crane Chadbourne,
Richard T. Crane, Jr., Jack Linsky,
Harry Manaster, Mrs. Joseph
Regenstein, Sr., Mr. and Mrs. John
Wilson, and Mrs. Henry C. Woods;
through prior acquisition of the
Florene May Schoenborn and Samuel
A. Marx Fund; European Decorative
Arts Purchase Fund, 1985.99

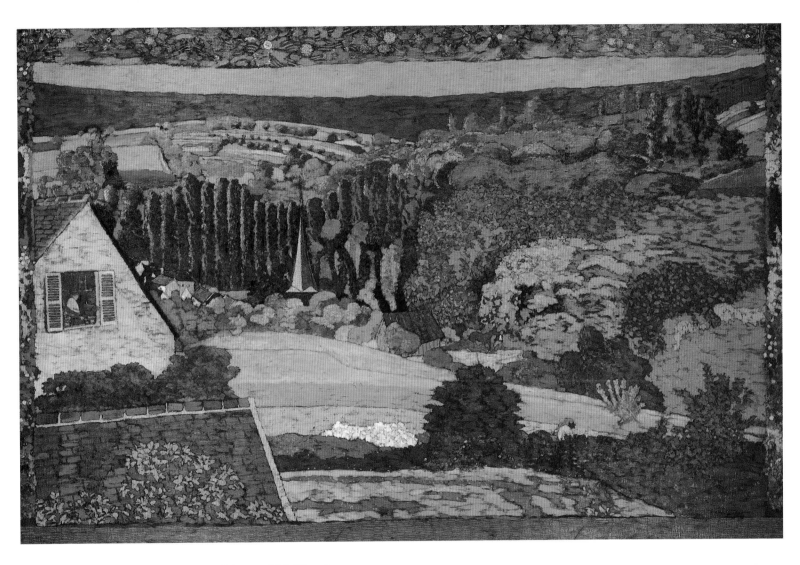

Edouard Vuillard

(French; 1868–1940)

Landscape: Window Overlooking the Woods, 1899

Oil on canvas; 249.2 x 378.5 cm (96⅛ x 149 in.)
L. L. and A. S. Coburn, Martha E. Leverone, and Charles Norton Owen funds; anonymous restricted gift, 1981.77

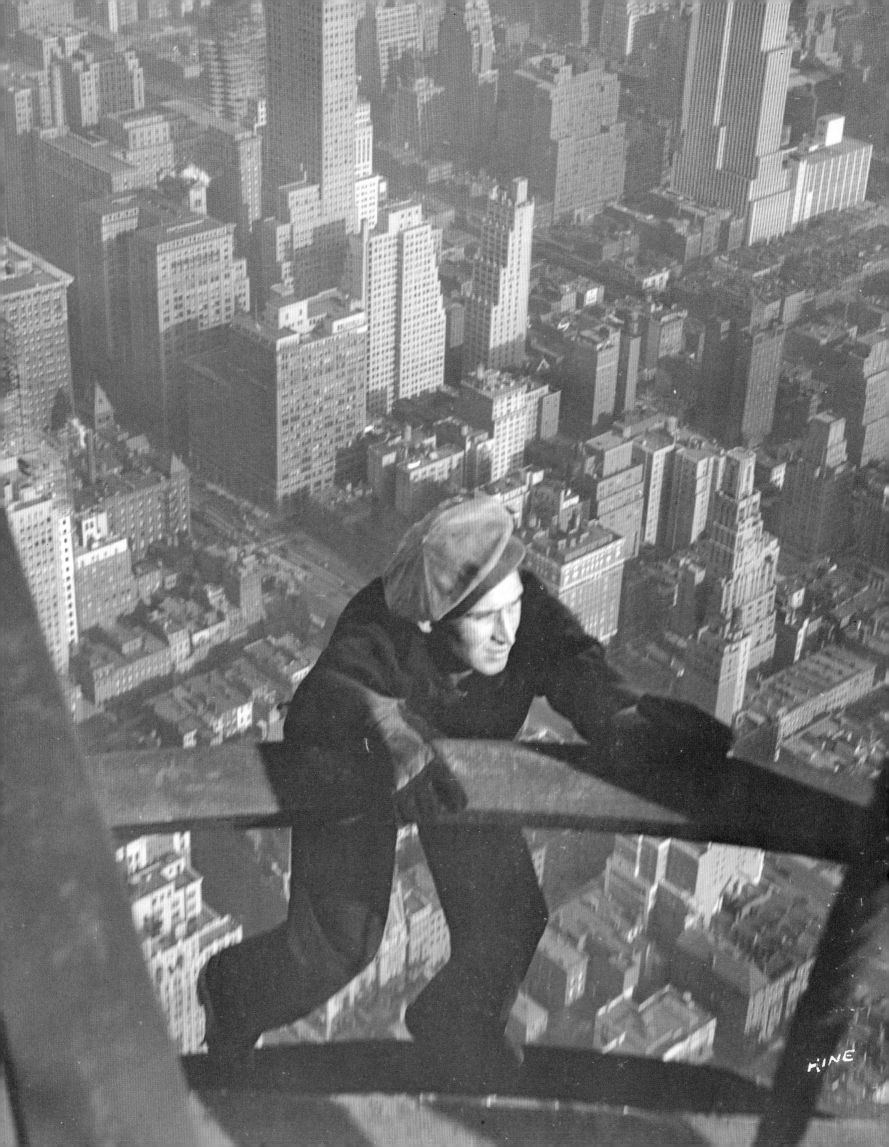

The Twentieth Century
Part 1: 1900–1945

While no single term can fully describe the artistic developments of the twentieth century, the signifier "modernism" encompasses a variety of attempts to forge a connection between artistic practice and the sweeping changes of contemporary life. In the early years of the century, daring formulations in architecture and design appeared throughout Europe, from the boldly geometric Glasgow School aesthetic of Charles Rennie Mackintosh (see p. 232) to the clean, elegant designs of the Wiener Werkstätte (see pp. 232–33). In the American Midwest, the Prairie School, inspired by the organic structures and ornamentation of Louis Sullivan (see pp. 178 and 262), took architecture in totally new directions. The leader of this movement, Frank Lloyd Wright (see pp. 245 and 297), sought to bring the building arts into harmony with nature and, in so doing, looked beyond Europe at Japanese and Meso-American models. Just as the theories of Sigmund Freud and Albert Einstein transformed traditional constructs of mind and matter in the early years of the century, artists revised the objectives of art. For some the search for a new visual language demanded the radical step of giving primacy to the intrinsic elements of painting—color, stroke, and form arranged on a flat surface—over the act of creating an illusion of three-dimensional representation. At the same time that Einstein was formulating his theories on the nature of matter, time, and space, the Cubists repudiated a traditional, consistent, and naturalistic representation of "reality." In *Daniel-Henry Kahnweiler* (p. 243), Pablo Picasso broke down and rearranged the visual elements of his subject so that Kahnweiler is subsumed into a complex arrangement of planes, shapes, and contours presented from several points of view. Other artists adopted a reductive approach to line and form: in his monumental *Bathers by a River* (p. 242), completed during World War I, Henri Matisse used thick, black lines to indicate limbs, faceless ovals to represent heads, and strong patterns of line and color to suggest the outdoor setting, creating a composition whose sobriety suggests the end of Eden.

While some artists, such as Vasily Kandinsky (see p. 248), evolved fully abstract styles as a way to suggest psychological states, others, partly in reaction to the devastation of World War I, actively pursued pure formalism, hoping to inspire a more utopian and stable world. In Holland Piet Mondrian (see p. 259) reduced two- and three-dimensional form to bare essentials—primary colors, straight lines, and flat planes—which he combined into balanced harmonies. The Russian Constructivists advocated the use of static mass or volume and geometric abstraction, as seen in El Lissitsky's *Proun* (p. 258). Representational form nonetheless remained essential to many artists. The German Expressionists (see for example p. 277) evolved a style of strong color and exaggeration to suggest complex psychological states. Delighting in the irrational, Surrealists Joan Miró (see pp. 264–65) and René Magritte (see pp. 279 and 290) employed Freudian psychoanalytic methods—such as the exploration of dreams and free association—to penetrate the subconscious. American artists working early in the century, such as William Glackens (see p. 235) and Henry Ossawa Tanner (see p. 234), deemed figuration essential to the reflection of experience, whether social or spiritual. As the century progressed, scenes of urban life celebrated the nation's modern identity: Lewis Wickes Hine's photograph of the Empire State Building (pp. 226 and 270) dramatically captures the vitality and dizzying verticality of expanding American cities; and Archibald J. Motley's *Nightlife* (p. 284) celebrates the exuberance of the Jazz Age. Yet the frenetic pace of the modern world also created the alienation evident in Edward Hopper's stark *Nighthawks* (p. 285). In rural areas, the industrialization of agriculture and the profound economic depression of the 1930s brought about hardship. Works such as Walker Evans's arresting *Alabama Cotton Tenant Farmer's Wife* (p. 276) depict a harsh reality that challenged the status quo of American life between the two world wars.

Lewis Wickes Hine. *Empire State Building* (detail). See page 270.

Daniel Chester French

(American; 1850–1931)

Truth, 1900

Plaster; 148.6 x 53.3 x 36.8 cm
(58½ x 21 x 14½ in.)
Restricted gift of Brooks McCormick;
Ethel T. Scarborough Fund, 1984.531

Henri Matisse

(French; 1869–1954)

The Serf, 1900–1908

Bronze; 92 x 35 x 33 cm (36¼ x
13¾ x 13 in.)
Edward E. Ayer Endowment
in memory of
Charles L. Hutchinson,
1949.202

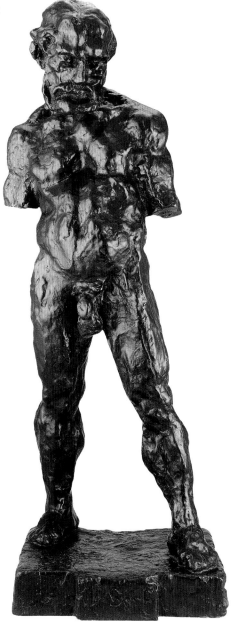

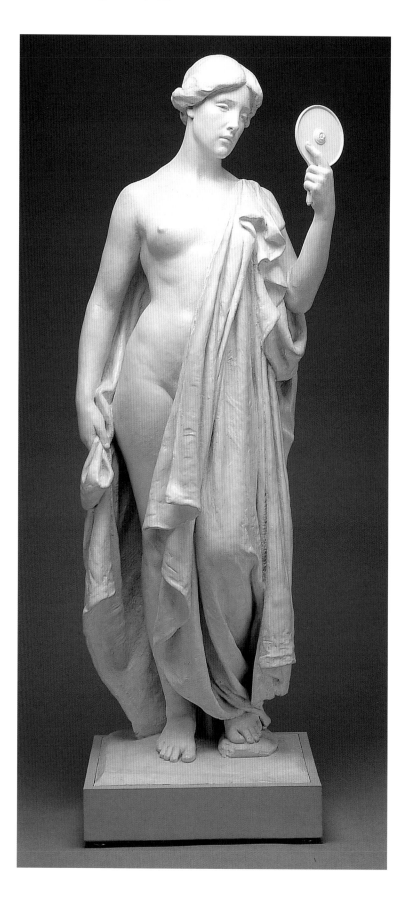

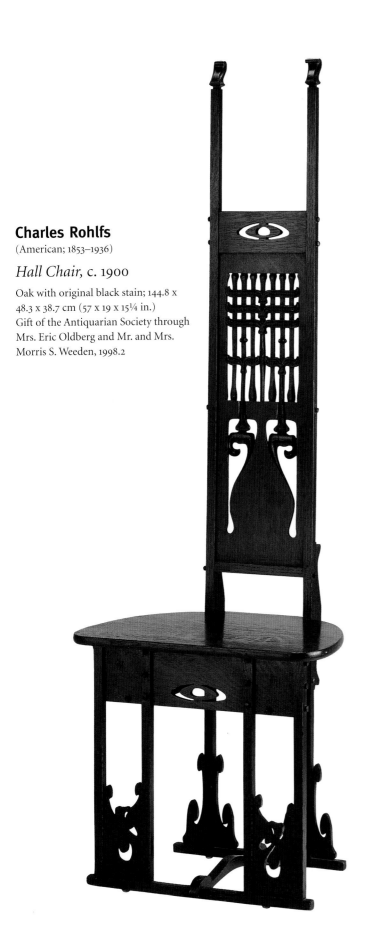

Charles Rohlfs

(American; 1853–1936)

Hall Chair, c. 1900

Oak with original black stain; 144.8 x
48.3 x 38.7 cm (57 x 19 x 15¼ in.)
Gift of the Antiquarian Society through
Mrs. Eric Oldberg and Mr. and Mrs.
Morris S. Weeden, 1998.2

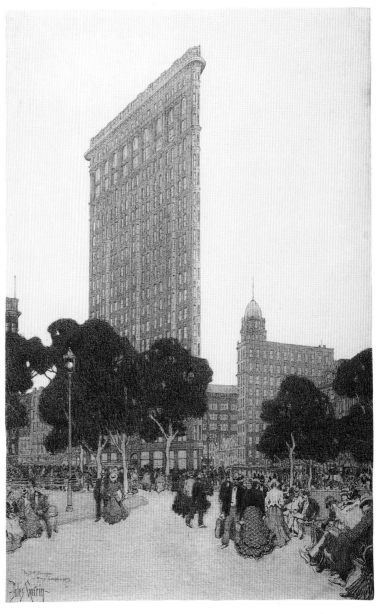

D. H. Burnham and Company

Perspective Rendering of the Flatiron Building, New York,
1902

Rendered by Jules Guérin (American;
1866–1946)
Charcoal and ink wash on underpainted linen; 80 x 50.8 cm (31½ x 20 in.)
Restricted gift of the Thomas J. and
Mary E. Eyerman Foundation, 1983.798

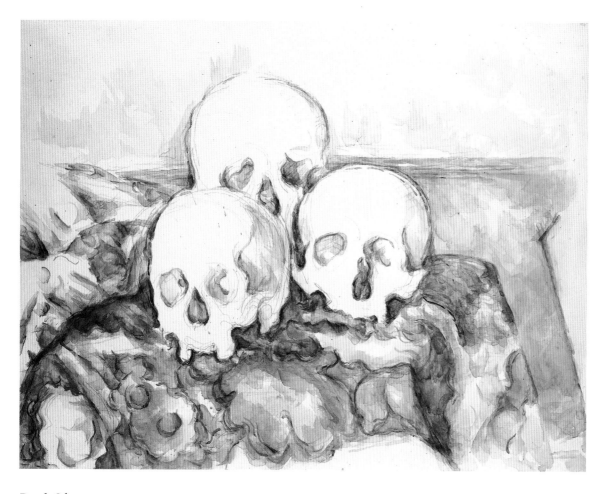

Paul Cézanne

(French; 1839–1906)

The Three Skulls, 1902/1906

Watercolor, with graphite, and touches
of gouache, on ivory wove paper;
47.7 x 63.2 cm (18¾₆ x 24⅞ in.)
Olivia Shaler Swann Memorial
Collection, 1954.183

Edward Steichen

(American, b. Luxembourg; 1879–1973)

*Self-Portrait with Brush and
Palette,* 1902

Gum bichromate print; 26.7 x 20 cm
(10½ x 7⅞ in.)
Alfred Stieglitz Collection, 1949.823

Pablo Picasso

(Spanish; 1881–1973)

The Old Guitarist, 1903/1904

Oil on panel; 122.9 x 82.6 cm
(48⅜ x 32½ in.)
Helen Birch Bartlett Memorial
Collection, 1926.253

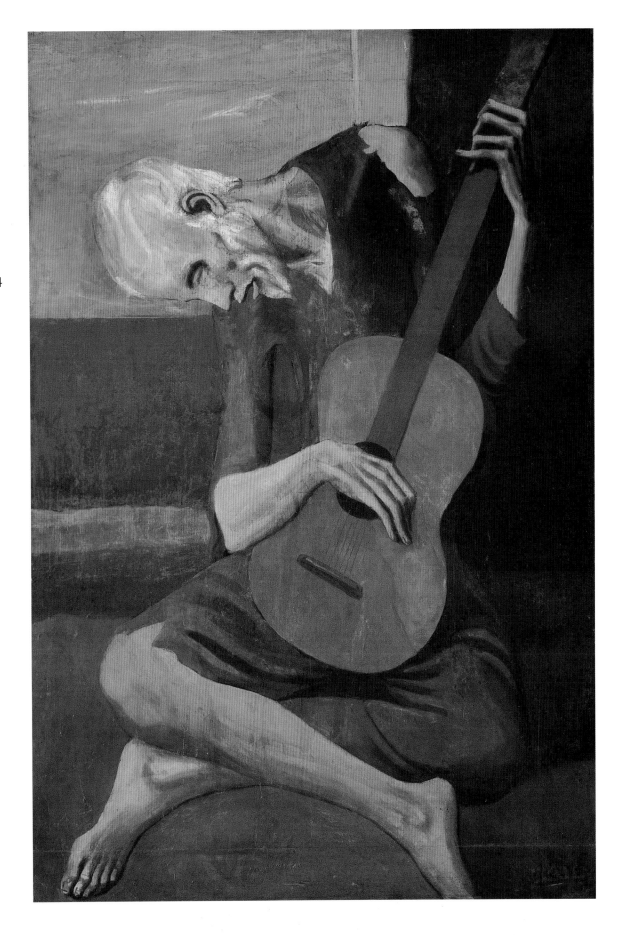

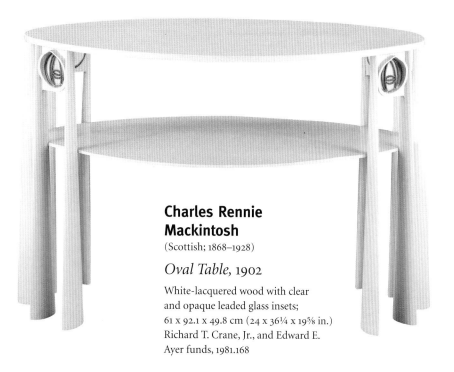

Charles Rennie Mackintosh

(Scottish; 1868–1928)

Oval Table, 1902

White-lacquered wood with clear
and opaque leaded glass insets;
61 x 92.1 x 49.8 cm (24 x 36¼ x 19⅝ in.)
Richard T. Crane, Jr., and Edward E.
Ayer funds, 1981.168

Josef Hoffmann

(Austrian; 1870–1956)

Carl Otto Czeschka

(Austrian; 1878–1960)

Tall-Case Clock, c. 1906

Painted maple with ebony,
mahogany, gilt brass, glass, silver-
plated copper, and clockworks;
179.4 x 46.4 x 30.5 cm
(70⅝ x 18¼ x 12 in.)
Laura Matthews and Mary Waller
Langhorne funds, 1983.37

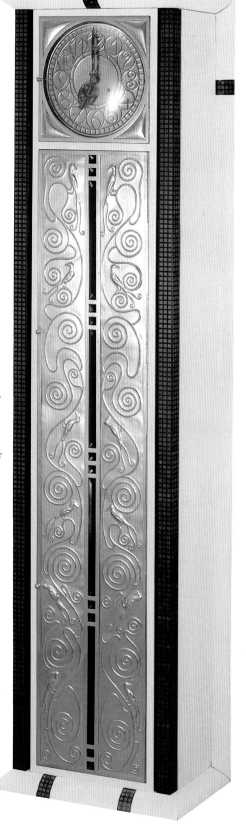

Henry van de Velde

(Belgian; 1863–1957)

Samovar, c. 1902

Manufactured by Theodore Müller,
Weimar
Silvered brass and teak; 37.9 x 28.5 x
23.5 cm (14⅞ x 11¼ x 9¼ in.)
Gift of the Historical Design Collection
and an anonymous donor; Mr. and
Mrs. F. Lee Wendell, European
Decorative Arts Purchase funds;
Edward E. Ayer Endowment in mem-
ory of Charles L. Hutchinson; Bessie
Bennett Endowment; through prior
gifts of Walter C. Clark, Mrs. Oscar
Klein,
Mrs. R. W. Morris, Mrs. I. Newton
Perry; through prior acquisition of
European Decorative Arts Purchase
funds, 1989.154

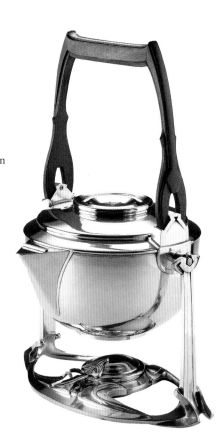

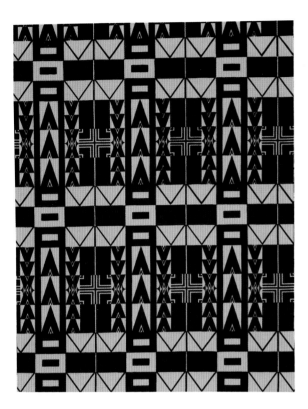

Josef Hoffmann
(Austrian; 1870–1956)

Panel Entitled *Santa Sofia*
(pattern #473) (detail),
1910/12

Printed and produced by the Wiener
Werkstätte
Silk and cotton, plain weave; screen
printed; 135.7 x 114.6 cm (53⅜ x 45⅛ in.)
Gift of Robert Allerton, 1924.217

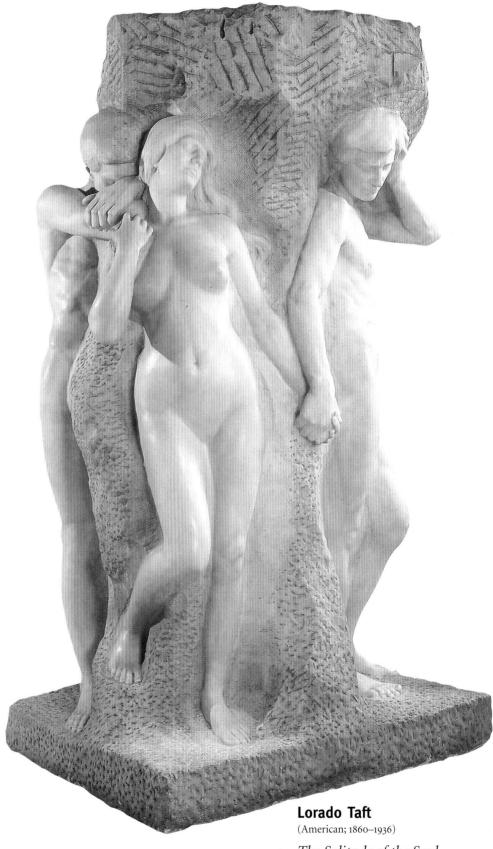

Lorado Taft
(American; 1860–1936)

The Solitude of the Soul,
modeled 1901, sculpted 1914

Marble; 231.1 x 129.5 x 105.4 cm
(91 x 51 x 41½ in.)
Friends of American Art Collection,
1914.739

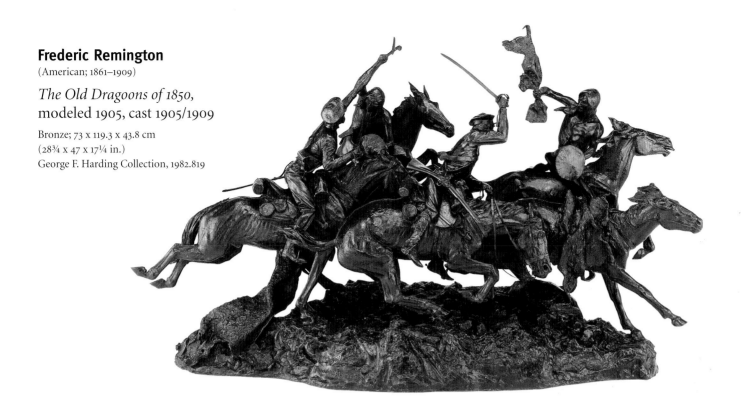

Frederic Remington
(American; 1861–1909)

The Old Dragoons of 1850,
modeled 1905, cast 1905/1909

Bronze; 73 x 119.3 x 43.8 cm
(28¾ x 47 x 17¼ in.)
George F. Harding Collection, 1982.819

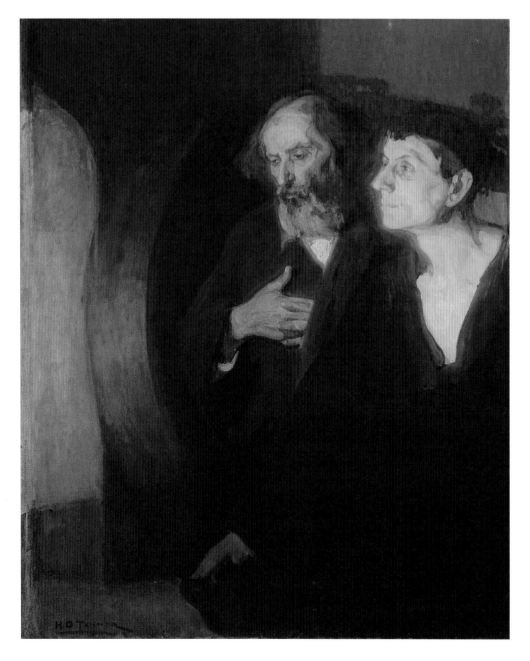

Henry Ossawa Tanner
(American; 1859–1937)

Two Disciples at the Tomb,
c. 1905

Oil on canvas; 129.5 x 106.4 cm
(51 x 41⅞ in.)
Robert A. Waller Fund, 1906.300

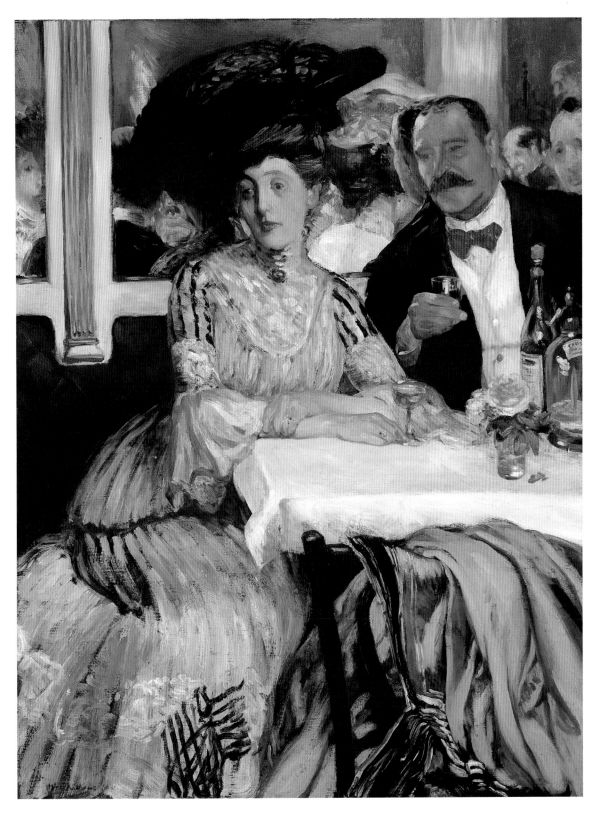

William Glackens
(American; 1870–1938)

At Mouquin's, 1905

Oil on canvas; 121.9 x 99.1 cm
(48 x 39 in.)
Friends of American Art Collection,
1925.295

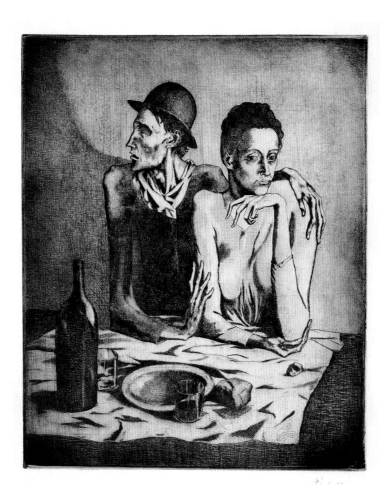

Pablo Picasso

(Spanish; 1881–1973)

The Frugal Repast, 1904

Etching printed in blue-green on ivory
laid paper; 48 x 38 cm (18½ x 15 in.)
Clarence Buckingham Collection,
1963.825

Odilon Redon

(French; 1840–1916)

Flower Clouds, c. 1903

Pastel with touches of stumping,
incising, and brushwork, on blue-gray
wove paper with multicolored fibers
(altered to tan), perimeter mounted
to cardboard; 44.7 x 54.2 cm
(17⁹⁄₁₆ x 21⁵⁄₁₆ in.)
Through prior bequest of Mr. and Mrs.
Martin A. Ryerson, 1990.165

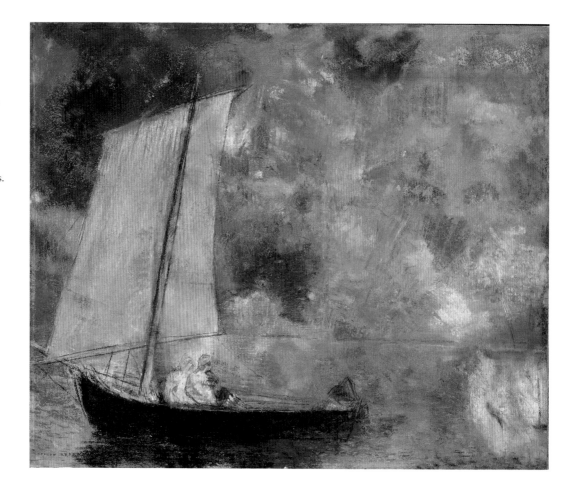

Henri Matisse

(French; 1869–1954)

Nude in a Folding Chair,
c. 1906

Brush with India ink on ivory laid
paper, pieced at top edge; 65.7 x 46.7 cm
(25⅞ x 18⅜ in.)
Gift of Mrs. Potter Palmer, Jr., 1944.576

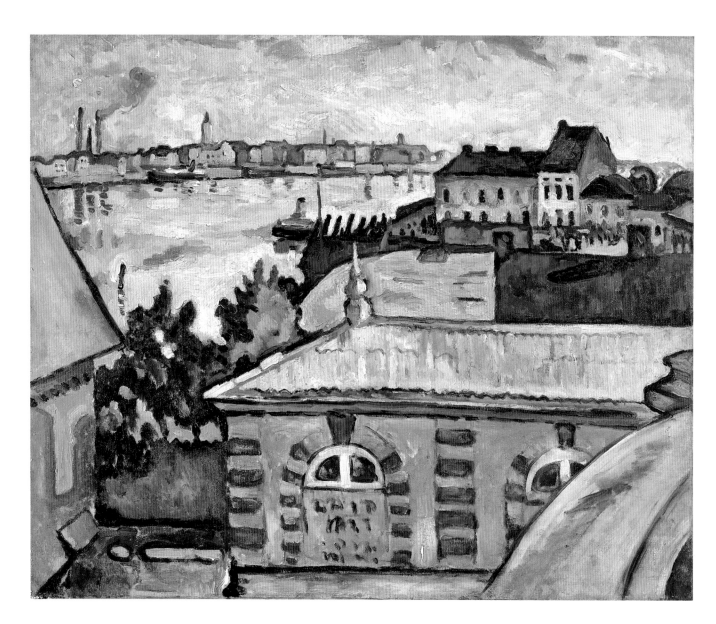

Georges Braque
(French; 1882–1963)

Antwerp, 1906

Oil on canvas; 59.7 x 73 cm
(23¼ x 28½ in.)
A Millennium Gift of Sara Lee
Corporation, 1999.366

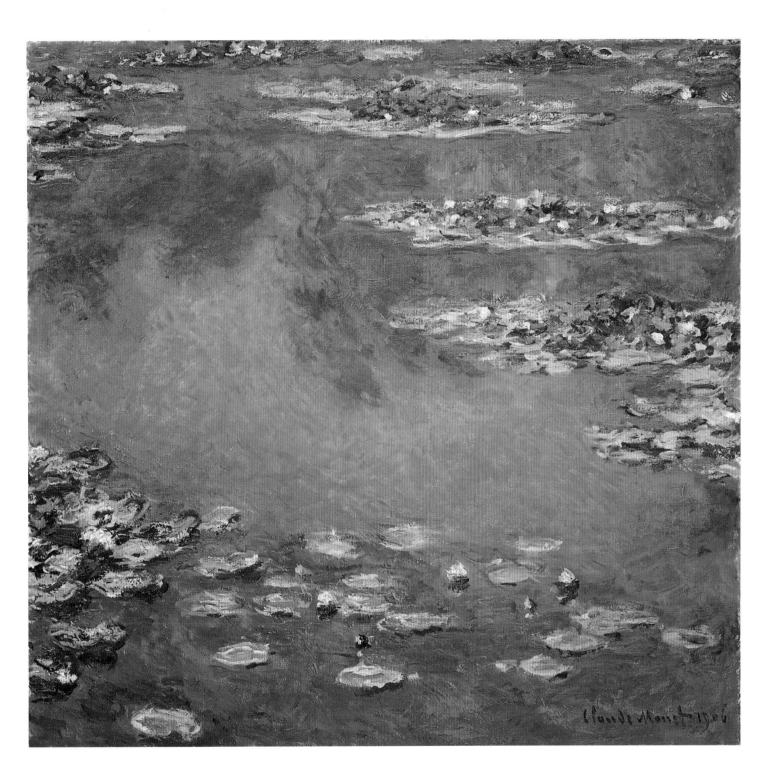

Claude Monet

(French; 1840–1926)

Water Lilies, 1906

Oil on canvas; 87.6 x 92.7 cm
(34½ x 36½ in.)
Mr. and Mrs. Martin A. Ryerson
Collection, 1933.1157

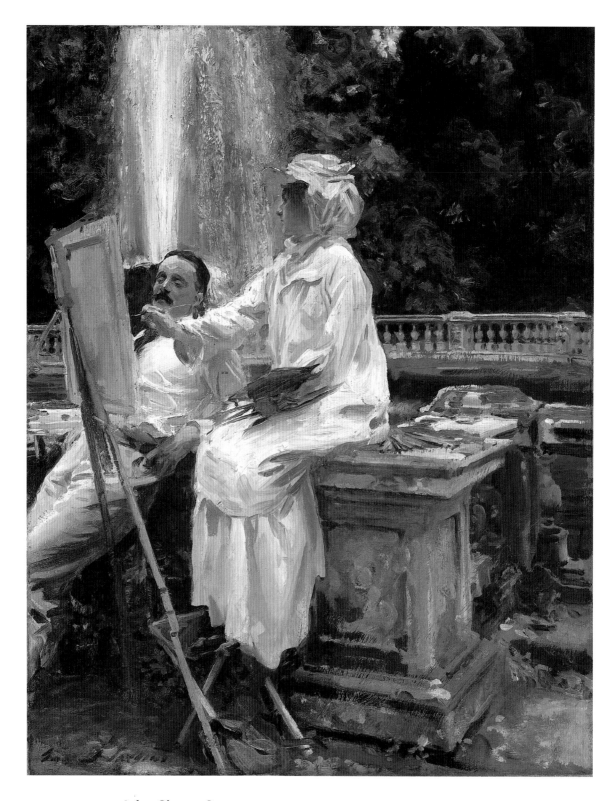

John Singer Sargent
(American, b. Italy; 1856–1925)

*The Fountain, Villa
Torlonia, Frascati, Italy,* 1907

Oil on canvas; 71.4 x 56.5 cm
(28⅛ x 22¼ in.)
Friends of American Art Collection,
1914.57

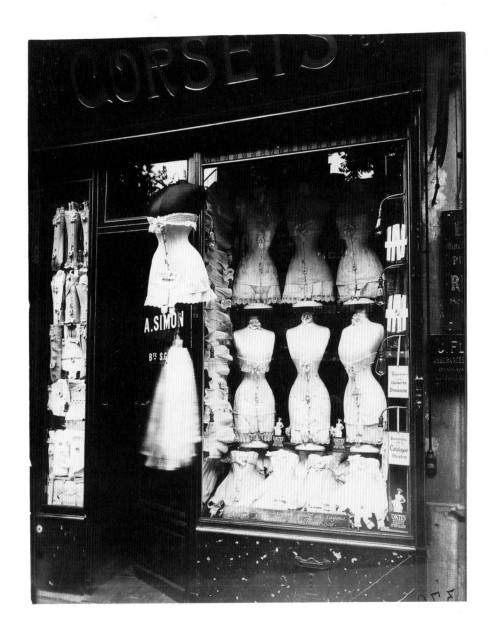

**Jean Eugène Auguste
Atget**
(French; 1856–1927)

*Boulevard de Strasbourg
(Corsets)*, 1912

Gelatin silver printing-out-paper print
from dry-plate negative; 22.9 x 18 cm
(9 x 7 1/16 in.)
Julien Levy Collection, gift of Jean and
Julien Levy, 1975.1130

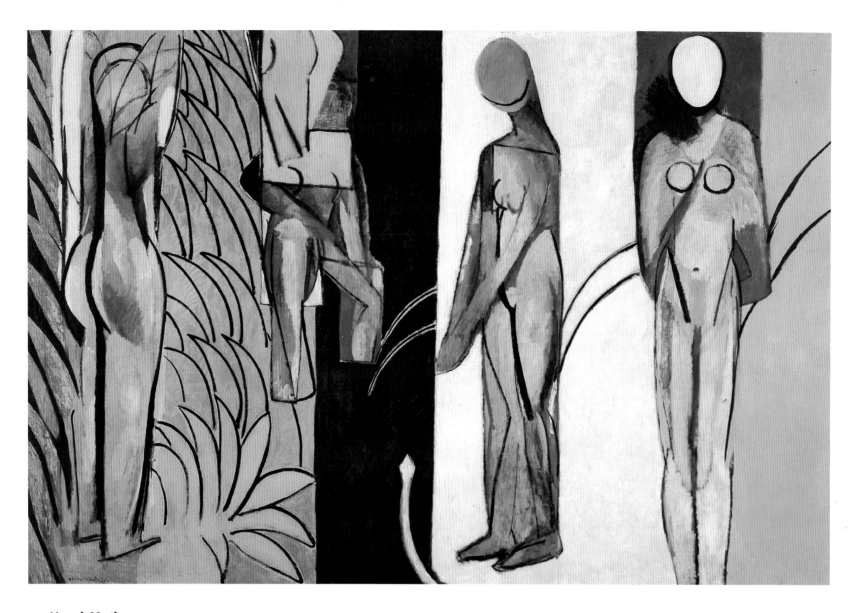

Henri Matisse
(French; 1869–1954)

Bathers by a River, 1909,
1913, and 1916

Oil on canvas; 259.7 x 389.9 cm
(102¼ x 153½ in.)
Charles H. and Mary F. S. Worcester
Collection, 1953.158

Pablo Picasso
(Spanish; 1881–1973)

Head of Fernande Olivier,
1909

Bronze; 41.3 x 27.3 x 25.4 cm
(16⅛ x 10¾ x 10 in.)
Alfred Stieglitz Collection, 1949.584

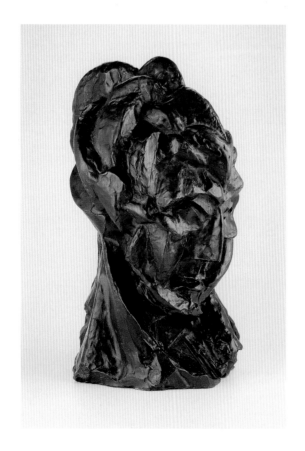

Constantin Brancusi

(French, b. Romania; 1876–1957)

Sleeping Muse, 1910

Bronze; 16.1 x 27.7 x 19.3 cm
(6⅜ x 10¹⁵⁄₁₆ x 7⁹⁄₁₆ in.)
Arthur Jerome Eddy Memorial
Collection, 1931.523

Pablo Picasso

(Spanish; 1881–1973)

Daniel-Henry Kahnweiler,
1910

Oil on canvas; 101.1 x 73.3 cm
(39¹¹⁄₁₆ x 28⅞ in.)
Gift of Mrs. Gilbert W. Chapman, in
memory of Charles B. Goodspeed,
1948.561

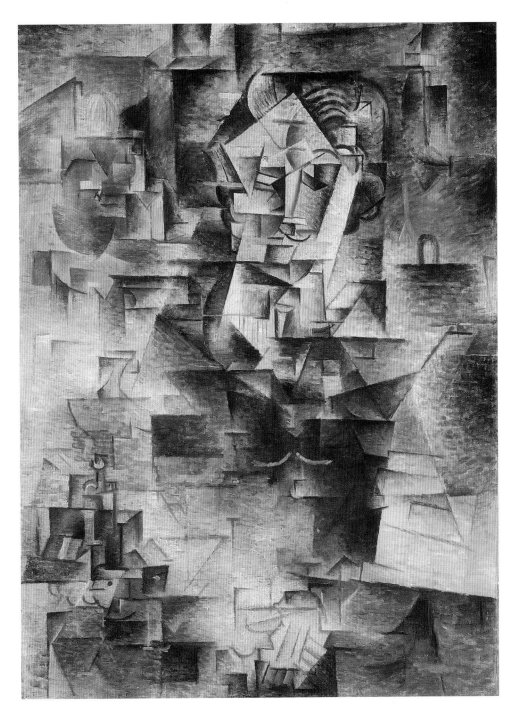

Daniel H. Burnham
(American; 1846–1912) and
Edward H. Bennett
(American; 1874–1954)

*View of Chicago from
Jackson Park to Grant Park*
(detail), 1907, plate 49 from
the *Plan of Chicago*, 1909

Rendered by Jules Guérin
(American; 1866–1946)
Watercolor and graphite on paper;
103.5 x 480 cm (40¾ x 189 in.)
On permanent loan from the City of
Chicago, 2.148.1966

Marion Mahony Griffin

(American; 1871–1962)

Walter Burley Griffin

(American; 1876–1937)

Perspective Rendering of Rock Crest-Rock Glen, Mason City, Iowa, 1912

Lithograph and gouache on green satin;
59 x 201 cm (23¼ x 79⅛ in.)
Gift of Marion Mahony Griffin
through Eric Nicholls, 1988.182

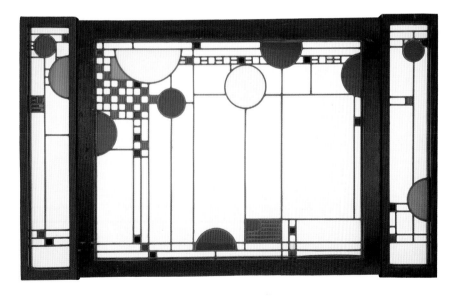

Frank Lloyd Wright

(American; 1867–1959)

Triptych Window from a Niche in the Avery Coonley Playhouse, Riverside, Illinois, 1912

Leaded glass with oak frame; center
panel: 88.9 x 109.2 cm (35 x 43 in.);
side panels: 91.4 x 19.7 cm (36 x 7¾ in.)
(each)
Restricted gift of Dr. and Mrs. Edwin J.
DeCosta and the Walter E. Heller
Foundation, 1986.88

Juan Gris

(Spanish; 1887–1927)

Portrait of Pablo Picasso,
1912

Oil on canvas; 93 x 74.1 cm
(36⅞ x 29¾₆ in.)
Gift of Leigh B. Block, 1958.525

Robert Henri

(American; 1865–1929)

Herself, 1913

Oil on canvas; 81.3 x 66 cm (32 x 26 in.)
Walter H. Schulze Memorial Collection,
1924.912

Marc Chagall

(French, b. Vitebsk, Russia [present-day
Belarus]; 1887–1985)

The Praying Jew, 1923 copy
of 1914 work

Oil on canvas; 116.8 x 84.9 cm
 (46 x 33⅜ in.)
Joseph Winterbotham Collection,
1937.188

Franz Marc

(German; 1880–1916)

The Bewitched Mill, 1913

Oil on canvas; 130.2 x 69.2 cm (51¼ x 27¼ in.)
Arthur Jerome Eddy Memorial Collection, 1931.522

Vasily Kandinsky

(French, b. Russia; 1866–1944)

Improvisation No. 30 (Cannons), 1913

Oil on canvas; 109.9 x 111.1 (43¼ x 43¾ in.)
Arthur Jerome Eddy Memorial Collection, 1931.511

George Bellows
(American; 1882–1925)

Love of Winter, 1914

Oil on canvas; 82.6 x 102.9 cm
(32½ x 40½ in.)
Friends of American Art Collection,
1914.1018

Pierre Bonnard

(French; 1867–1947)

Earthly Paradise, 1916–20

Oil on canvas; 130 x 160 cm
(50¼ x 63 in.)
Estate of Joanne Toor Cummings; Bette
and Neison Harris and Searle Family
Trust endowments; through prior gifts
of Mrs. Henry Woods, 1996.47

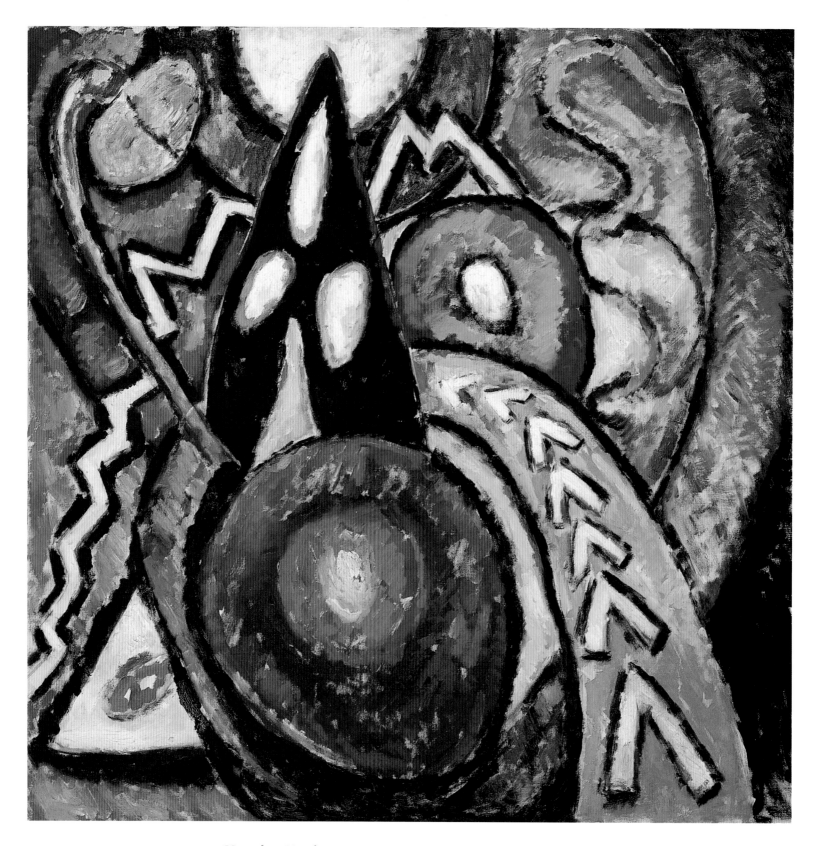

Marsden Hartley
(American; 1877–1943)

Movements, c. 1915

Oil on canvas; 119.7 x 120 cm
(47⅛ x 47¼ in.)
Alfred Stieglitz Collection, 1949.544

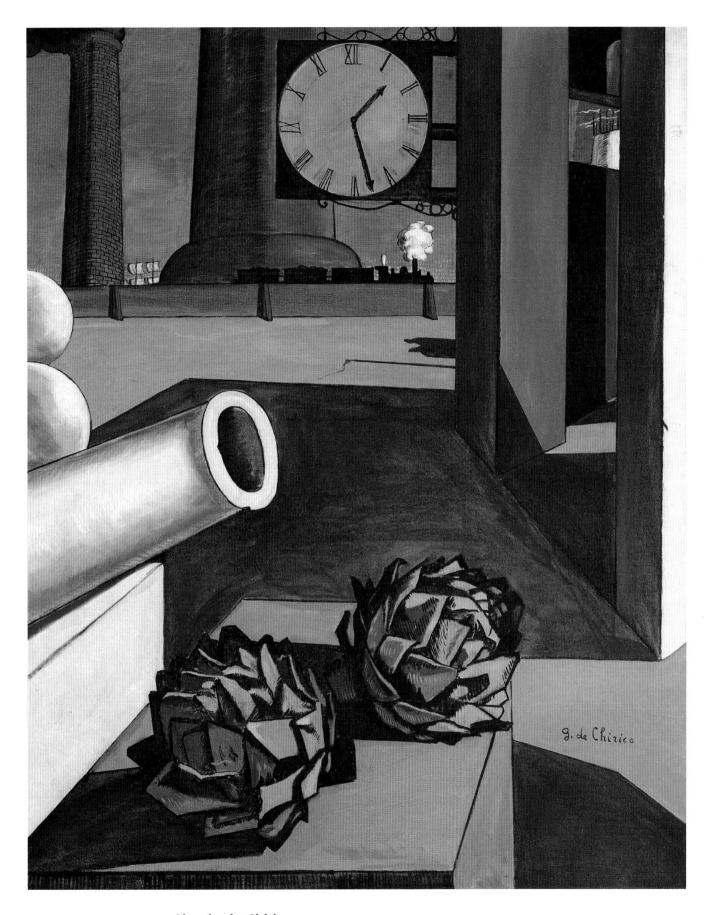

Giorgio de Chirico
(Italian; 1888–1978)

*The Philosopher's
Conquest,* 1914

Oil on canvas; 125.1 x 99.1 cm (49¼ x 39 in.)
Joseph Winterbotham Collection, 1939.405

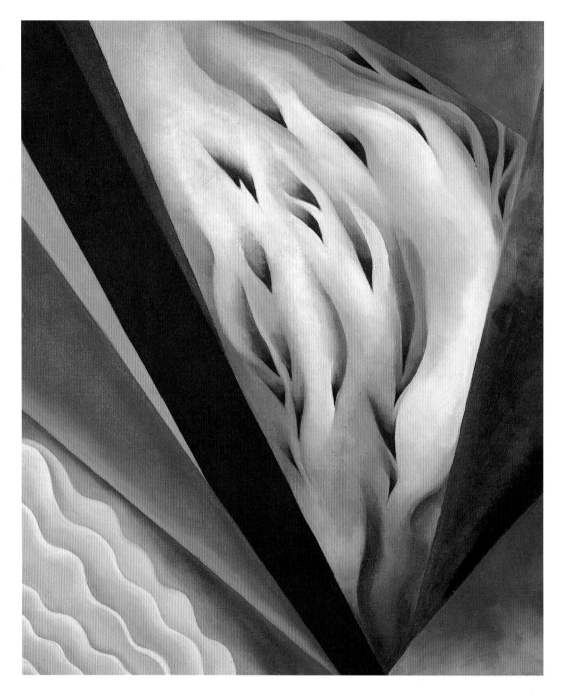

Georgia O'Keeffe

(American; 1887–1986)

Blue and Green Music, 1919

Oil on canvas; 58.4 x 48.3 cm
(23 x 19 in.)
Alfred Stieglitz Collection, gift of
Georgia O'Keeffe, 1969.835

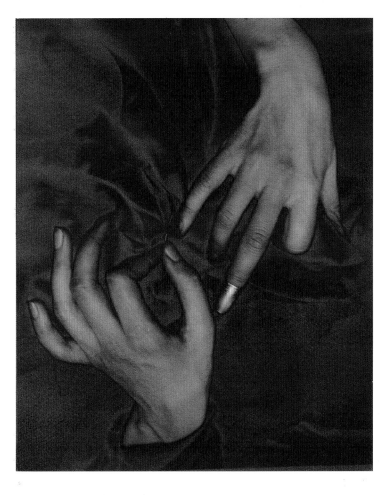

Alfred Stieglitz

(American; 1864–1946)

Georgia O'Keeffe, 1920

Solarized palladium print, treated by
Edward Steichen; 25.1 x 20.2 cm
(9⅞ x 8 in.)
Alfred Stieglitz Collection, 1949.745

Constantin Brancusi

(French, b. Romania; 1876–1957)

Golden Bird, 1919/20

Bronze, stone, and wood; 217.8 x 30 x
30 cm (85¾ x 11¾ x 11¾ in.) (with base)
Partial gift of the Arts Club of Chicago;
restricted gift of various donors;
through prior bequest of Arthur
Rubloff; through prior restricted gift
of William Hartmann; through prior
gifts of Mr. and Mrs. Carter H.
Harrison, Mr. and Mrs. Arnold H.
Maremont through the Kate Maremont
Foundation, Woodruff J. Parker, Mrs.
Clive Runnells, Mr. and Mrs. Martin A.
Ryerson, and various donors, 1990.88

Jacobus W. G. (Japp) Gidding

(Dutch; 1887–1955)

Carpet, 1920/25

Cotton, jute, and wool, plain weave
with secondary binding warps tying
chenille facing wefts forming cut
surface pile; 297.6 x 196 cm
(117¼ x 77⅛ in.)
Restricted gift of Mr. and Mrs. Robert
Hixon Glore in honor of Robert
Hixon Glore, Jr., 1986.990

Mariano Fortuny y Madrazo

(Spanish; 1871–1949)

Border (detail), 1920/30

Printed and produced by the Società Anonima Fortuny, Venice
Cotton, twill weave; printed in the Fortuny system; 895.1 x 31.8 cm (352½ x 12½ in.)

Gift of Vera Megowan, 1981.99

Jacques Emile Ruhlmann

(French; 1879–1933)

Corner Cabinet (Etat d'angle encoignure), 1916/22

Amboyna, ebony, and ivory veneer on oak and mahogany carcass; 127.3 x 82.9 x 52 cm (50⅛ x 32⅝ x 20½ in.)
Restricted gifts of Mrs. James W. Alsdorf, Mrs. T. Stanton Armour, Mrs. DeWitt W. Buchanan, Jr., Mrs. Henry M. Buchbinder, Mrs. Robert O. Delaney, Mrs. Harold T. Martin, Manfred Steinfeld, Mrs. Edgar J. Uihlein; Mrs. T. Stanton Armour, Mr. and Mrs. Robert O. Delaney, Mr. and Mrs. Fred Krehbiel, and Mrs. Eric Oldberg funds; Mrs. Pauline S. Armstrong, Harry and Maribel G. Blum, Richard T. Crane, Jr. Memorial, Mr. and Mrs. Fred Krehbiel, Mary Waller Langhorne, and European Decorative Arts endowments; through prior acquisitions of the Antiquarian Society, European Decorative Arts Purchase Fund, Howard Van Doren Shaw, and Mr. and Mrs. Martin A. Ryerson, 1997.694

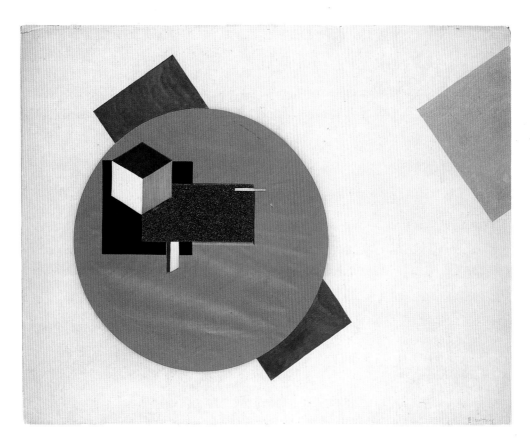

El Lissitsky (Lazar Markowich)

(Russian; 1890–1941)

Proun, 1920

Collage of various papers, with brush and black gouache and silver metallic paint, over graphite on cream wove paper, laid down on wood-pulp board; 29.9 x 37.8 cm (11¾ x 14⅞ in.) Gift of Dorothy Braude Edinburg to the Harry B. and Bessie K. Braude Memorial Collection, 1998.733

Charles Demuth

(American; 1883–1935)

Business, 1921

Oil on canvas; 50.8 x 61.6 cm (20 x 24³⁄₁₆ in.) Alfred Stieglitz Collection, 1949.529

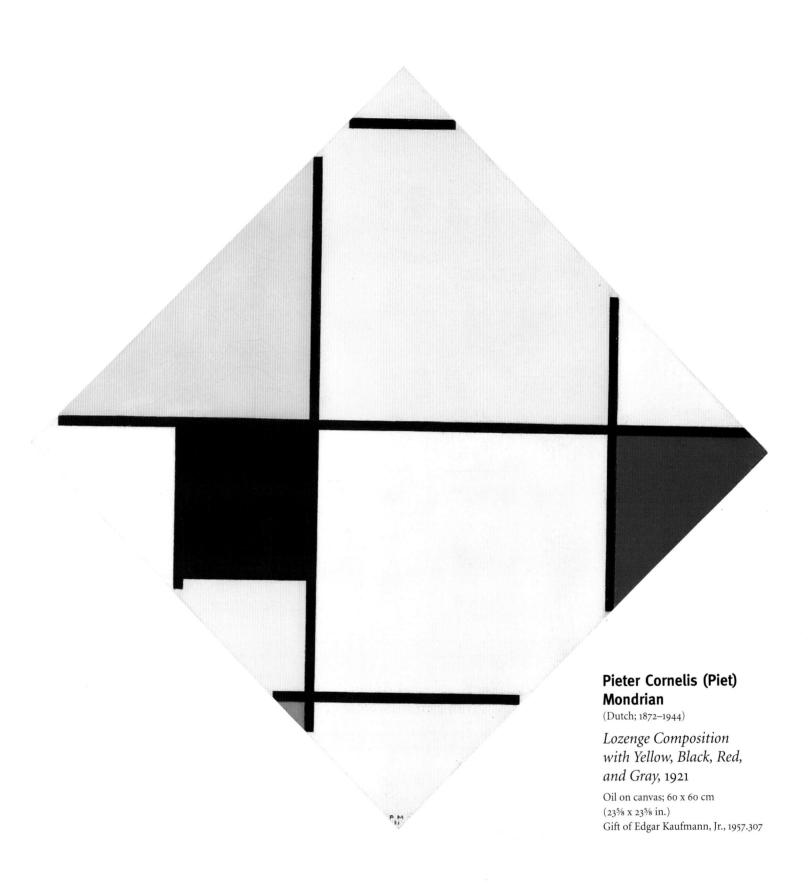

Pieter Cornelis (Piet) Mondrian

(Dutch; 1872–1944)

Lozenge Composition with Yellow, Black, Red, and Gray, 1921

Oil on canvas; 60 x 60 cm
(23⅝ x 23⅝ in.)
Gift of Edgar Kaufmann, Jr., 1957.307

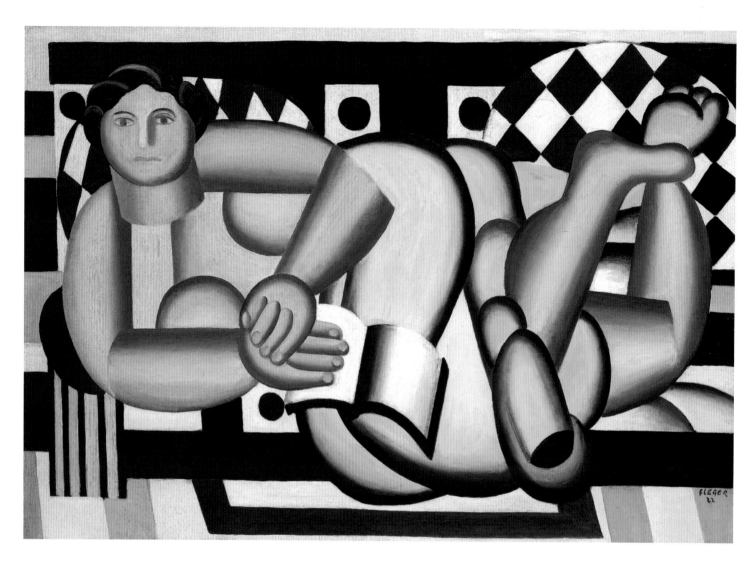

Fernand Léger

(French; 1881–1955)

Reclining Woman, 1922

Oil on canvas; 64.5 x 92 cm
(25½ x 36¼ in.)
A Millennium Gift of Sara Lee
Corporation, 1999.369

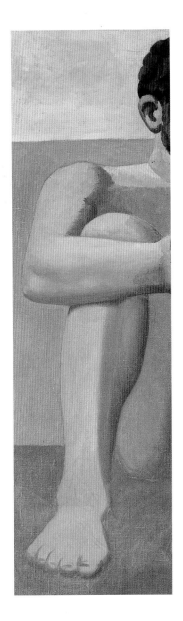

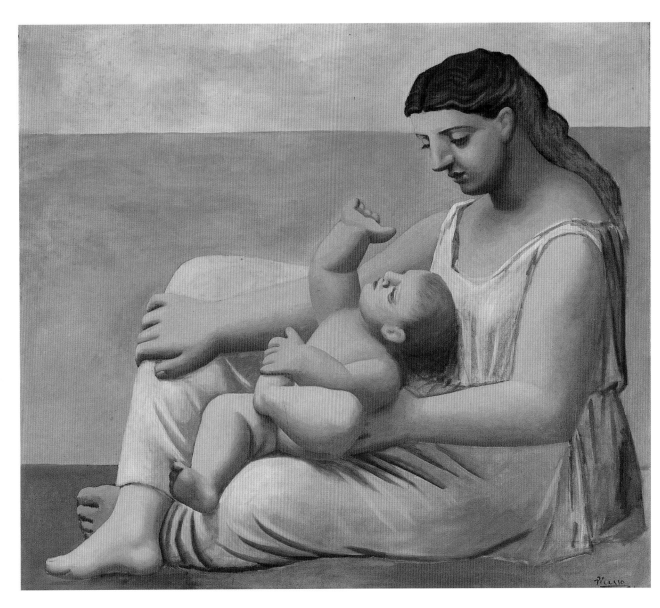

Pablo Picasso

(Spanish; 1881–1973)

Mother and Child
(with fragment), 1921

Oil on canvas; 142.9 x 172.7 cm
(56¼ x 68 in.); fragment: 143.4 x 44.3 cm
(56½ x 17½ in.)
Restricted gift of Maymar Corporation,
Mrs. Maurice L. Rothschild, Mr. and
Mrs. Chauncey McCormick; Mary and
Leigh Block Charitable Fund; Ada
Turnbull Hertle Endowment; through
prior gift of Mr. and Mrs. Edwin E.
Hokin, 1954.270. Fragment: Gift of Pablo
Picasso, 1968.100

Richard Yoshijiro Mine

(American, b. Japan; 1894–1981)

*Competitive Entry for the
Chicago Tribune Tower
Competition, Michigan
Avenue Elevation,* 1922

Ink, graphite, and wash on paper;
140.3 x 59 cm (55¼ x 23⁷⁄₁₆ in.)
Gift of Richard Yoshijiro Mine,
1988.408.5

Louis H. Sullivan

(American; 1856–1924)

Impromptu!, 1922,
plate 16 from *A System of
Architectural Ornament,*
1924

Graphite on paper; 57.7 x 73.5 cm
(22¾ x 29 in.)
Commissioned by The Art Institute
of Chicago, 1988.15.16

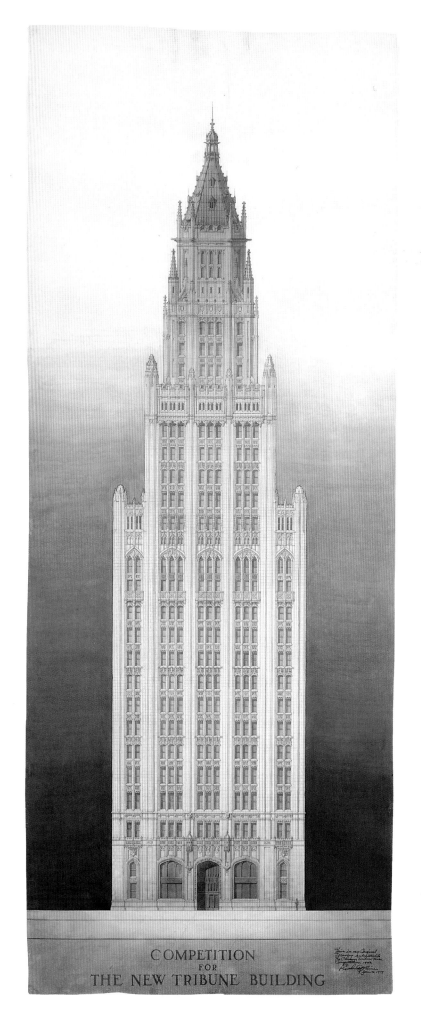

COMPETITION
FOR
THE NEW TRIBUNE BUILDING

Paul T. Frankl
(American, b. Austria; 1887–1928)

"Skyscraper" Cabinet,
1927/28

Lacquered wood with silver detailing;
213.4 x 83.8 x 40 cm (84 x 33 x 15¾ in.)
Gift of Mr. and Mrs. Thomas B. Hunter
III, Mr. and Mrs. Morris S. Weeden,
and the Antiquarian Society, 1998.567

Joan Miró

(Spanish; 1893–1983)

The Kerosene Lamp, 1924

Charcoal, with red conté and colored
crayons heightened with white oil paint
on canvas prepared with a glue ground;
81 x 100.3 cm (32 x 39⅝ in.)
Purchased with funds from the Joseph
and Helen Regenstein Foundation,
Helen L. Kellogg Trust, Blum-Kovler
Foundation, Major Acquisitions Fund,
and gifts from Mrs. Henry C. Woods,
Members of the Committee on Prints
and Drawings, and Friends of the
Department, 1978.312

Joan Miró

(Spanish; 1893–1983)

The Policeman, 1925

Oil on canvas; 248 x 194.9 cm
(97 x 76¾ in.)
Gift of Claire Zeisler, 1991.1499

Edward Weston
(American; 1886–1958)

Washbasin, 1925

Platinum print; 24.3 x 18.9 cm
(9⁹⁄₁₆ x 7⁷⁄₁₆ in.)
Harold L. Stuart Endowment,
1987.377

Tina Modotti
(American, b. Italy; 1896–1942)

*Interior of Church,
Tepotzotlan, Mexico,* 1924

Platinum print; 24.1 x 18.2 cm
(9⁵⁄₈ x 7⁳⁄₁₆ in.)
Laura T. Magnuson Endowment,
1991.62

André Kertész
(American, b. Hungary; 1894–1985)

*Mondrian's Eyeglasses and
Pipe, Paris,* 1926

Gelatin silver print; 15.7 x 18.2 cm
(6³⁄₁₆ x 7³⁄₁₆ in.)
Julien Levy Collection, gift of Jean and
Julien Levy, 1975.1137

Henri Matisse
(French; 1869–1954)

Lemons on a Pewter Plate,
1926 and 1929

Oil on canvas; 55.6 x 67.1 cm
(21⅝ x 26⅛ in.)
A Millennium Gift of Sara Lee
Corporation, 1999.371

Lovis Corinth

(German; 1858–1925)

Self-Portrait, 1924

Gouache, with possible additions in
oil paint on heavy ivory wove paper;
48.6 x 30.5 cm (19⅛ x 12 in.)
Clarence Buckingham Collection,
1987.280

Man Ray
(Emmanuel Rudnitzky)

(American; 1890–1976)

Tanja Ramm, 1929

Gelatin silver print from a solarized
negative; 21.9 x 16.8 cm (8⅝ x 6⅝ in.)
Julien Levy Collection, Special
Photography Acquisition Fund, 1979.95

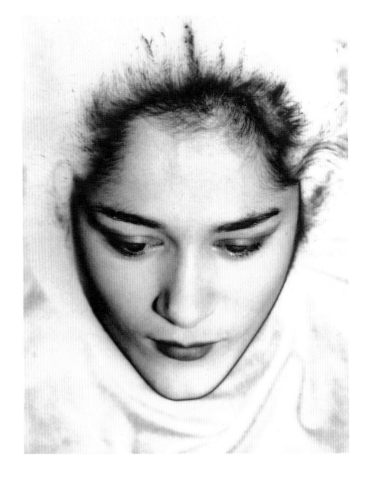

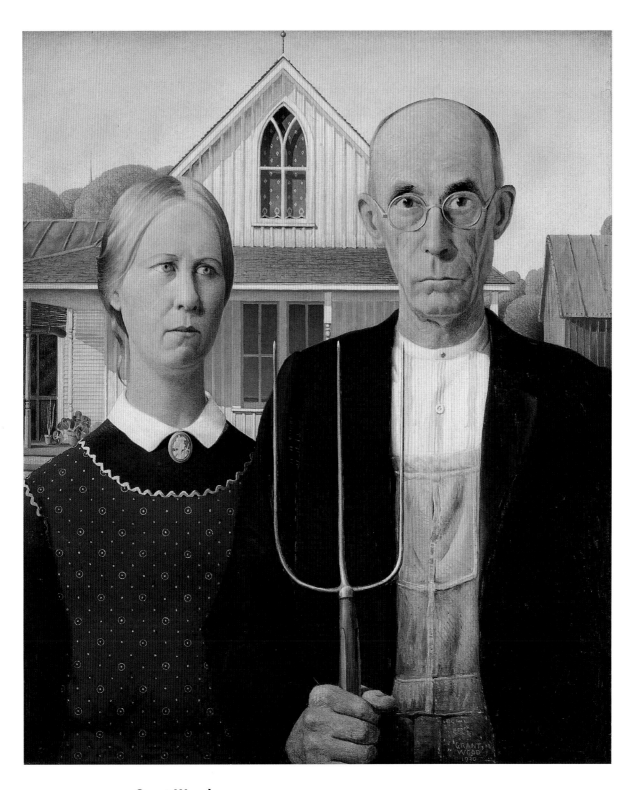

Grant Wood
(American; 1891–1942)

American Gothic, 1930

Oil on beaverboard; 74.3 x 62.4 cm
(29¼ x 24⁹⁄₁₆ in.)
Friends of American Art Collection,
1930.934

Lewis Wickes Hine

(American; 1874–1940)

Empire State Building, 1931

Gelatin silver print; 49 x 39.6 cm
(19⁵⁄₁₆ x 15⁹⁄₁₆ in.)
Mary L. and Leigh B. Block
Endowment, 1987.222

László Moholy-Nagy

(American, b. Hungary; 1895–1946)

Berlin Radio Tower, c. 1928

Gelatin silver print; 36 x 25.5 cm
(14³⁄₁₆ x 10 in.)
Julien Levy Collection, Special
Photography Acquisition Fund,
1979.84

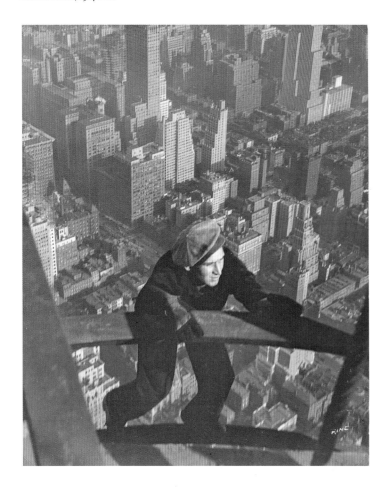

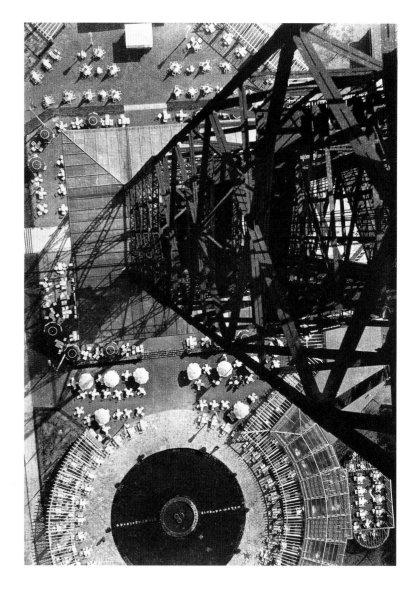

Henri Cartier-Bresson

(French; b. 1908)

Hyères, France, 1932

Gelatin silver print; 19.8 x 29.5 cm
(7¹¹⁄₁₆ x 11⅝ in.)
Julien Levy Collection, gift of Jean and
Julien Levy, 1975.1134

Georgia O'Keeffe
(American; 1887–1986)

Black Cross, New Mexico, 1929

Oil on canvas; 99.2 x 76.3 cm
(39 x 30 1/16 in.)
The Art Institute of Chicago Purchase
Fund, 1943.95

Ivan Albright

(American; 1897–1983)

*Into the World There Came
a Soul Called Ida,* 1929–30

Oil on canvas; 142.9 x 119.2 cm
(56¼ x 46¹⁵⁄₁₆ in.)
Gift of Ivan Albright, 1977.34

José Clemente Orozco
(Mexican; 1883–1949)

Zapata, 1930

Oil on canvas; 178.4 x 122.6 cm
(70¼ x 48¼ in.)
Gift of the Joseph Winterbotham
Collection, 1941.35

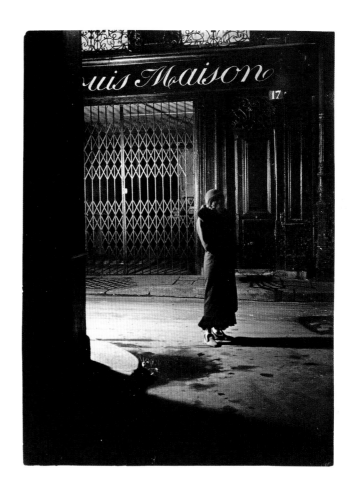

Brassaï (Gyula Halász)
(French, b. Transylvania; 1899–1984)

Untitled, 1932

Gelatin silver print; 23.3 x 17.3 cm
(9⅟₁₆ x 6¹³⁄₁₆ in.)
Restricted gift of Leigh B. Block,
1983.55

Alexander Rodchenko
(Russian; 1891–1956)

Untitled, 1936

Gelatin silver print; 28.9 x 39.5 cm
(11⅜ x 15⅝ in.)
Wirt D. Walker Endowment, 1989.486

Voorhees, Gmelin and Walker

Perspective Rendering of the Final Design for the Proposed Tower of Water and Light, Century of Progress Exposition, Chicago, c. 1930

Rendered by Ralph Walker
(American; 1890–1973)
Delineated by John Wenrich
(American; 1894–1970)
Graphite colored pencil and watercolor
on illustration board; 66.5 x 44.6 cm
(26³⁄₁₆ x 17⁹⁄₁₆ in.)
Gift of Haines Lundberg Waehler in
honor of their centennial, 1983.222

Le Corbusier (Charles Edouard Jeanneret)

(Swiss; 1887–1965)

Chaise Longue, c. 1933
(designed 1928)

With Pierre Jeanneret (Swiss; 1896–1965)
and Charlotte Perriand (French; b. 1903);
manufactured by
Embru-Werke A.G., Ruti
Chrome-plated steel and iron with pony
skin; 54.6 x 157.5 x 59.1 cm
(21½ x 62 x 23¼ in.)
Bequest of Hedwig B. Schniewind,

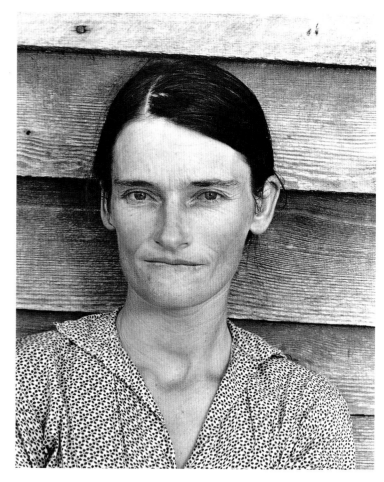

Paul Klee

(German, b. Switzerland; 1879–1940)

In the Magic Mirror, 1934

Oil on canvas on board; 66 x 50 cm
(26 x 19¹³⁄₁₆ in.)
Gift of Claire Zeisler, 1991.321

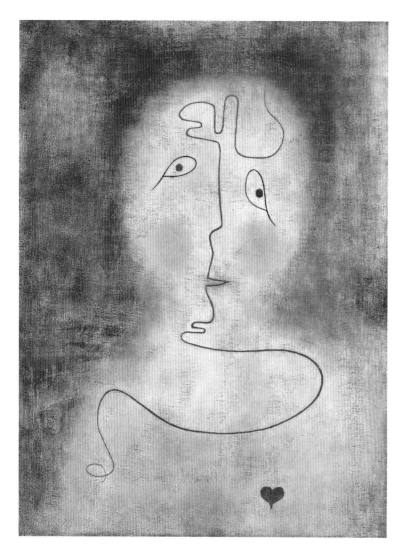

Walker Evans

(American; 1903–1975)

*Alabama Cotton Tenant
Farmer's Wife,* 1936

Gelatin silver print; 20.8 x 16.8 cm
(8³⁄₁₆ x 6⅝ in.)
Gift of Mrs. James Ward Thorne,
1962.158

Max Beckmann
(German; 1884–1950)

Self-Portrait, 1937

Oil on canvas; 192.5 x 89 cm
(76 x 35 in.)
Gift of Lotta Hess Ackerman and
Philip E. Ringer, 1955.822

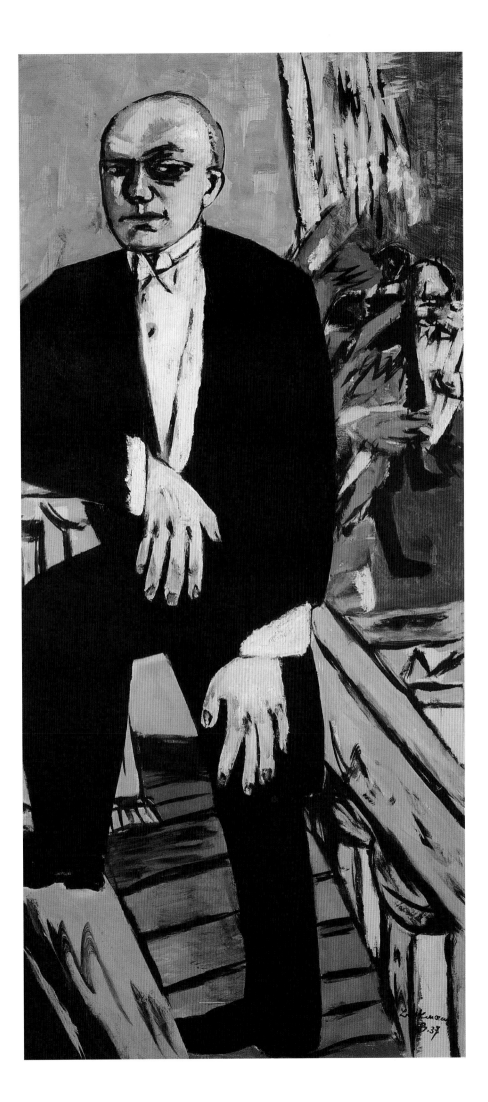

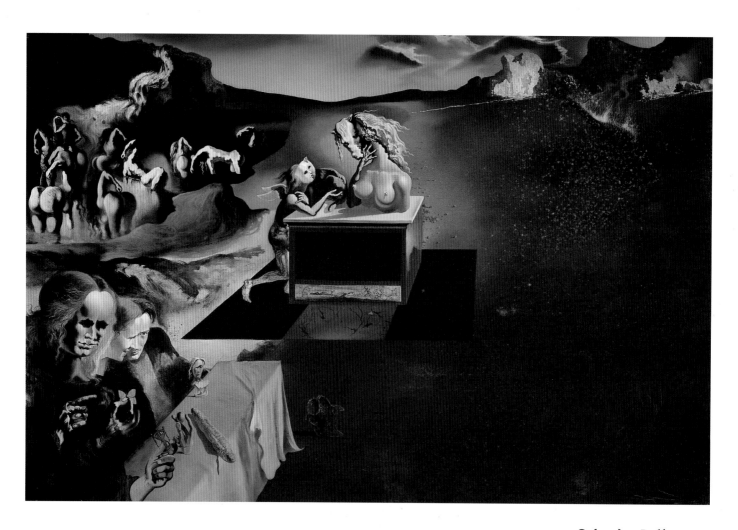

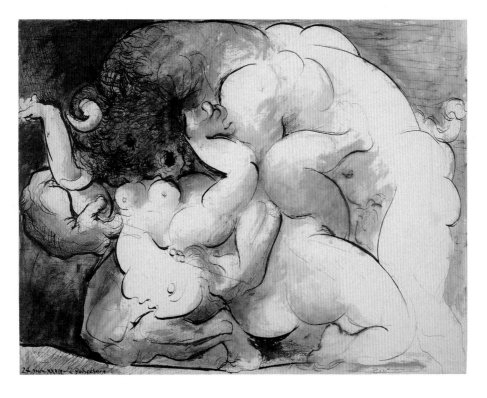

Salvador Dalí
(Spanish; 1904–1989)

Inventions of the Monsters, 1937

Oil on canvas; 51.4 x 78.1 cm
(20¼ x 30¾ in.)
Joseph Winterbotham Collection,
1943.798

Pablo Picasso
(Spanish; 1881–1973)

The Embrace of the Minotaur, 1933

Pen and black ink with brush and gray
wash on blue wove paper; 48 x 63 cm
(19 x 24⅞ in.)
Margaret Day Blake Collection, 1967.516

René Magritte

(Belgian; 1898–1967)

Time Transfixed, 1938

Oil on canvas; 147 x 98.7 cm
(57⅞ x 37⅞ in.)
Joseph Winterbotham Collection,
1970.426

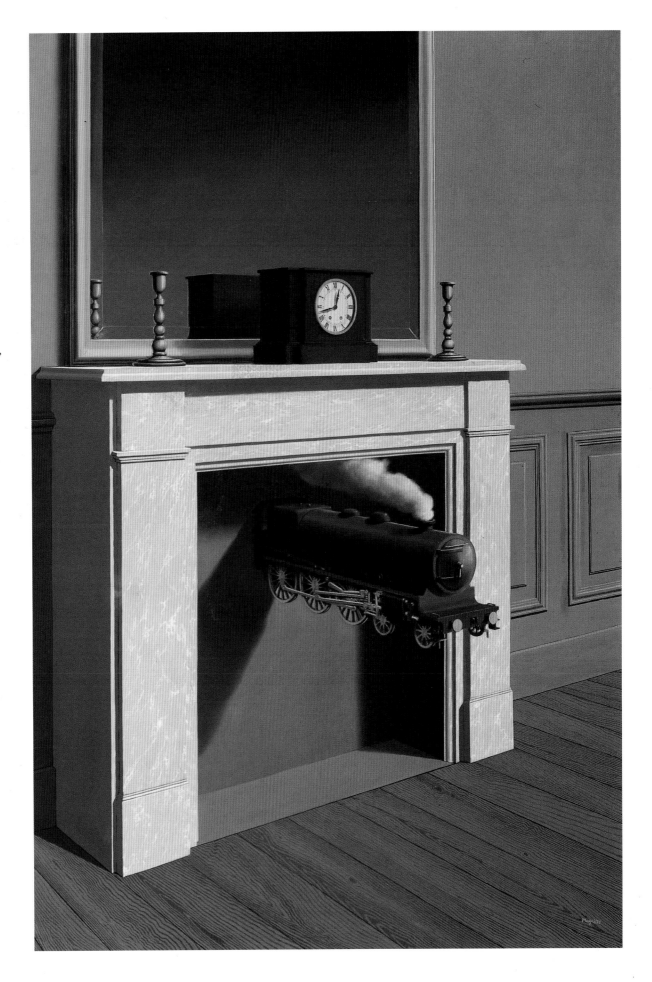

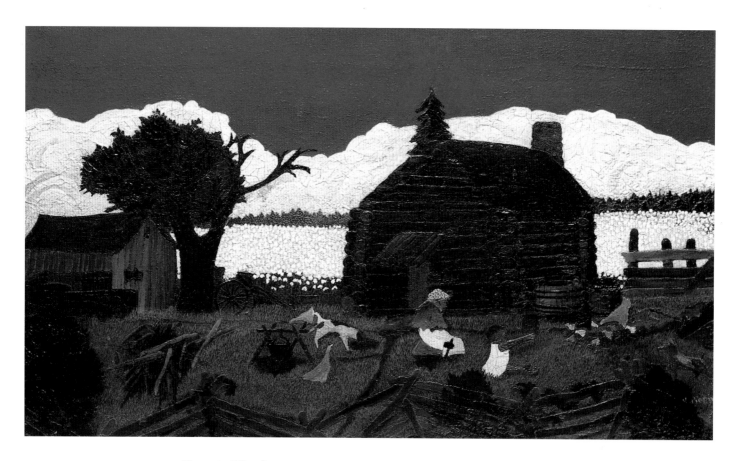

Horace Pippin
(American; 1888–1946)

Cabin in the Cotton,
before 1937

Oil on panel; 46 x 84 cm (18⅛ x 33⅛ in.)
In memory of Frances W. Pick from her
children, Thomas F. Pick and Mary P.
Hines, 1990.417

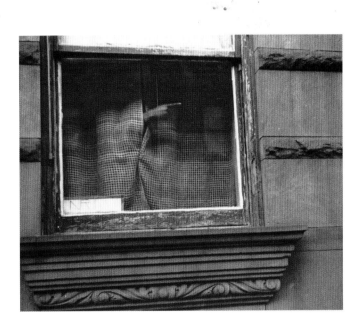

Helen Levitt
(American; b. 1918)

New York City, c. 1940

Gelatin silver print; 15.7 x 18.8 cm
(6 3/16 x 7 3/8 in.)
Restricted gift of Lucia Woods Lindley
and Daniel A. Lindley, Jr., 1991.63

Frank Memkus
(American; 1895–1965)

Whirligig Entitled *America,*
1938/42

Wood and metal; 205.1 x 73.7 x 101.6 cm
(80 3/4 x 29 x 40 in.)
Restricted gift of Marshall Field, Mr.
and Mrs. Robert A. Kubiceck, Mr. James
Raoul Simmons, Mrs. Esther Sparks,
Mrs. Frank L. Sulzberger, and the Oak
Park-River Forest Associates of the
Woman's Board, 1980.166

**Roberto Matta
(Roberto Matta Echuarren)**

(French, b. Chile; b. 1911 or 1912)

The Earth Is Man, 1942

Oil on canvas; 182.9 x 243.8 cm
(72 x 96 in.)
Gift of Mr. and Mrs. Joseph Randall
Shapiro (after her death, dedicated to
the memory of Jory Shapiro by her
husband), 1992.168

Arshile Gorky (Vosdanig Manoog Adoian)
(American, b. Armenia; 1904–1948)

Carnival, 1943

Crayon with graphite and scraping on
off-white wove paper; 57.8 x 73.3 cm
(22¾ x 28⅞ in.)
The Lindy and Edwin A. Bergman
Collection, 1999.937

Archibald J. Motley, Jr.

(American; 1891–1981)

Nightlife, 1943

Oil on canvas; 91.4 x 121.3 cm
(36 x 47¾ in.)
Restricted gift of Mr. and Mrs. Marshall
Field, Jack and Sandra Guthman, Ben
W. Heineman, Ruth Horwich, Lewis
and Susan Manilow, Beatrice C. Mayer,
Charles A. Meyer, John D. Nichols, and
Mr. and Mrs. E. B. Smith, Jr.; James W.
Alsdorf Memorial Fund; Goodman
Endowment, 1992.89

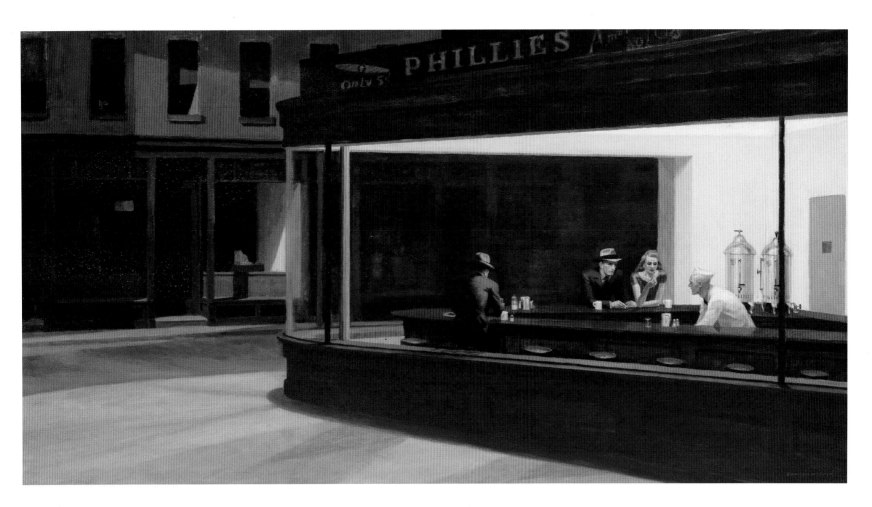

Edward Hopper
(American; 1882–1967)

Nighthawks, 1942

Oil on canvas; 84.1 x 152.4 cm
(33⅛ x 60 in.)
Friends of American Art Collection,
1942.51

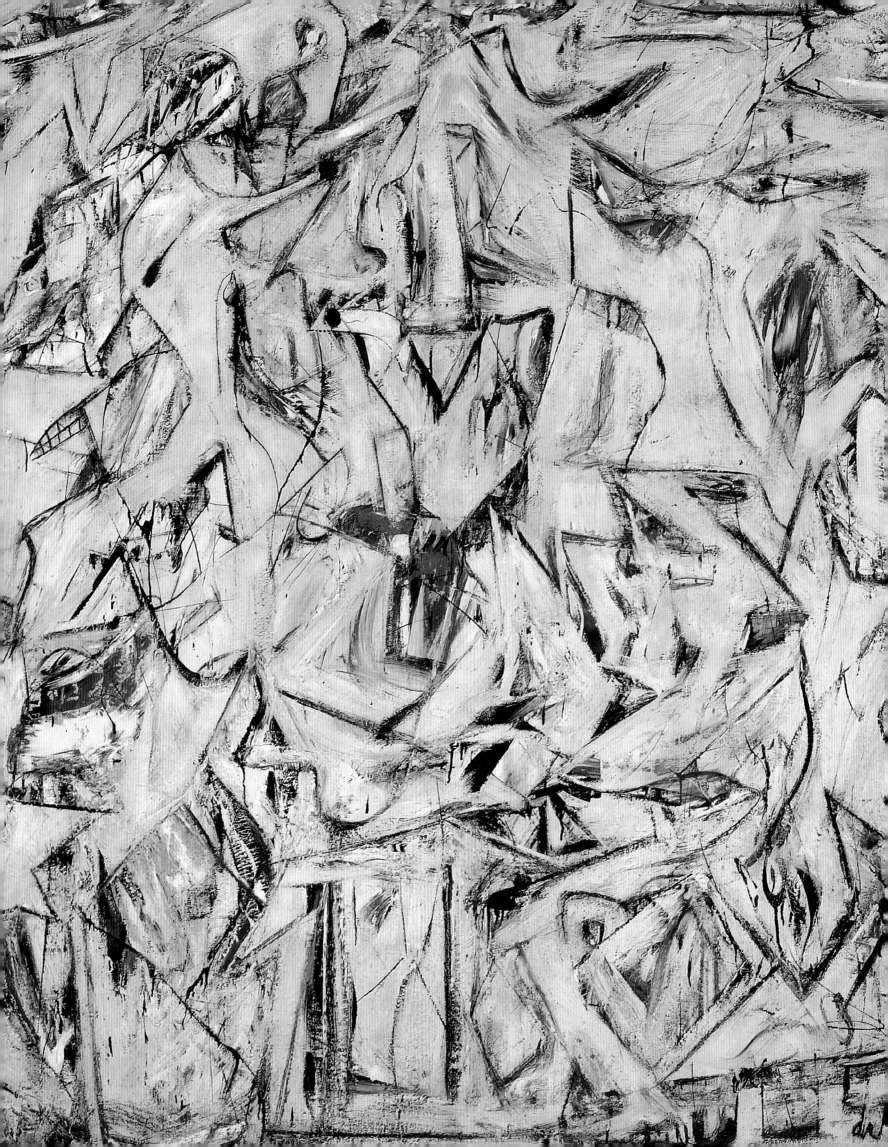

The specter of rising fascism and Nazism drove many European intellectuals to the United States, adding an international dimension to American modernism. In the wake of the closing by the Nazis of the Bauhaus (a school that had revolutionized art education by providing a stimulating environment for artistic innovation of all kinds and eliminating the boundaries between the fine, industrial, and applied arts), a number of its faculty settled in the United States. In Chicago Laszló Moholy Nagy (see p. 270), founded the Institute of Design—the influential American version of the Bauhaus—which produced a number of outstanding artists (for example the photographer Harry Callahan; see p. 291). Another Bauhaus leader also moved to Chicago; in designs such as those he made for the Illinois Institute of Technology (see p. 296), Ludwig Mies van der Rohe emphasized the integrity of modern materials through an austere, functional aesthetic that transformed the vocabulary of urban architecture in his adopted country.

The Twentieth Century Part 2: 1946–2000

After the turmoil of the war years, New York City—where many exiled members of the European avant-garde had lived during the conflict—emerged as the international capital of contemporary art. Abstract Expressionism emerged there from the fusion of European theory and American energy.

Armenian-born Arshile Gorky worked with form and color in an unpremeditated and unmediated method, attaining, as in *The Plow and the Song* (p. 288), a unique combination of Surrealist-inspired, organic shapes, and vigorous brushwork. The very act of applying paint to canvas became the essential expressive force in painting. Jackson Pollock (see p. 289) used form to record gesture, while Mark Rothko (see p. 294) explored the evocative, mysterious power of modulated color. For these artists, pure form never supplanted content; they sought to convey non-narrative meaning through a purely visual language.

While Abstract Expressionism held the world in thrall as the first purely American modern style, artists experimented with other approaches: Ellsworth Kelly (see p. 301) promoted Minimalism, the process of stripping art of all but the barest formal essentials and eschewing the painterly gesture so important to the previous generation of artists. Pop artists Roy Lichtenstein (see p. 307) and Andy Warhol (see p. 310) incorporated into their work iconic images from mass and popular culture, countering the high passions of Abstract Expressionism with coolly rendered, ironic representational forms.

Post-Modernism, a movement most clearly articulated in architecture, challenged the mandates of modernism by expanding its lexicon to referencing historical prototypes and incorporating unorthodox combinations of form and color. The opulent materials and polychrome palette of John Burgee's and Philip Johnson's luxurious lobby design for 190 South LaSalle Street (p. 319) contrast dramatically with Miesian minimalism. In our Post-Modern world, it is not possible to define current artistic developments as representing the primacy of one dominant nation, medium, or movement. Video and installation art challenge the idea of what constitutes a "work of art"; Bill Viola's *Reasons for Knocking at an Empty House* (p. 316) and Bruce Nauman's *Clown Torture* (p. 327) introduce time, movement, and sound into the viewing experience. Largely excluded from the mid-century, American narrative of modernism, Europeans such as Lucian Freud (see p. 333) and Gerhard Richter (see p. 302), and South Americans such as Guillermo Kuitca (see p. 331) have pursued very strong, individual styles. Women artists have steadily gained prominence, with artists like Cindy Sherman (see p. 311) exploring gender roles and identity, and Kiki Smith (see p. 332) examining the human body and its vulnerability. Similarly, the often neglected minority artists, including Kerry James Marshall (see p. 329), have used art to send a powerful message of diverse racial identity and to add a missing dimension to contemporary experience. New media, new voices, and new reasons for expression propel contemporary art into the new millennium.

Willem de Kooning. *Excavation* (detail). See page 295.

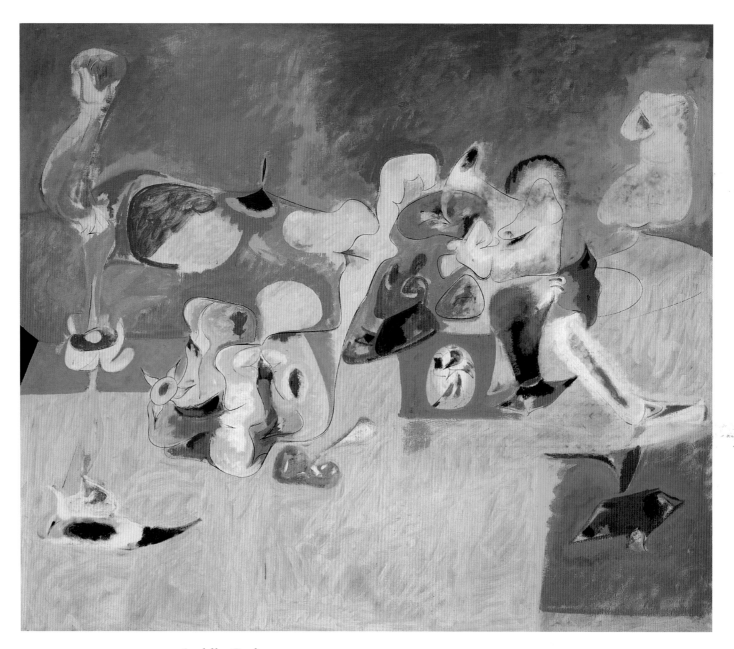

**Arshile Gorky
(Vosdanig Manoog Adoian)**

(American, b. Armenia; 1904–1948)

The Plow and the Song, 1946

Oil on canvas; 128.9 x 153 cm
(50¾ x 60¼ in.)
Mr. and Mrs. Lewis Larned Coburn
Fund, 1963.208

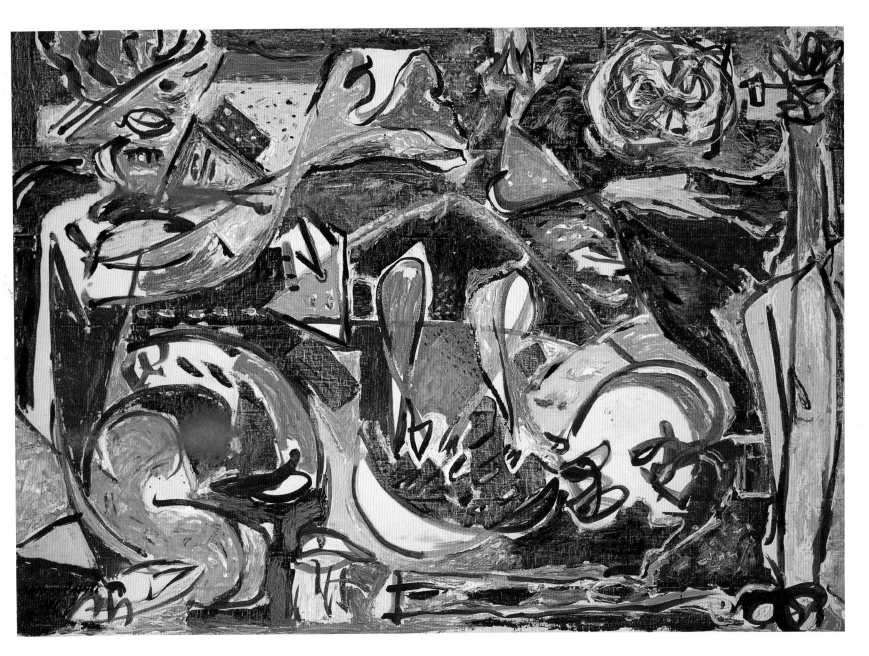

Jackson Pollock
(American; 1912–1956)

The Key, 1946

Oil on canvas; 149.9 x 215.9 cm
(59 x 85 in.)
Through prior gift of Mr. and Mrs.
Edward Morris, 1987.261

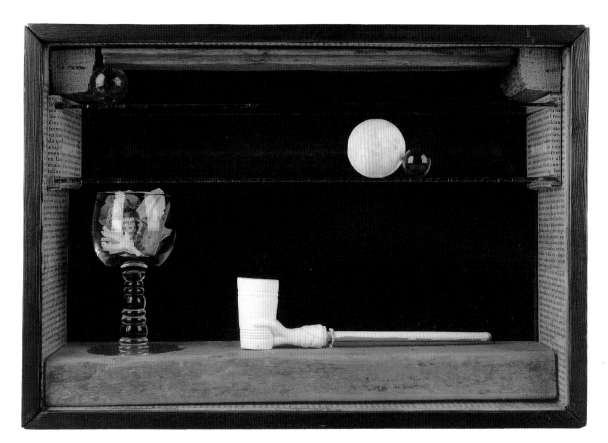

Joseph Cornell

(American; 1903–1972)

Soap Bubble Set, 1948

Mixed media; 22.5 x 33 x 9.5 cm
(8⅞ x 13 x 3¾ in.)
The Lindy and Edwin Bergman Joseph
Cornell Collection, 1982.1861

René Magritte

(Belgian; 1898–1967)

The Balcony (after Manet),
c. 1949

Red chalk with stumping on cream
wove paper; 45.5 x 36.5 cm
(17¹⁵⁄₁₆ x 14⅜ in.)
Gift of Mr. and Mrs. Joseph R. Shapiro,
1992.243

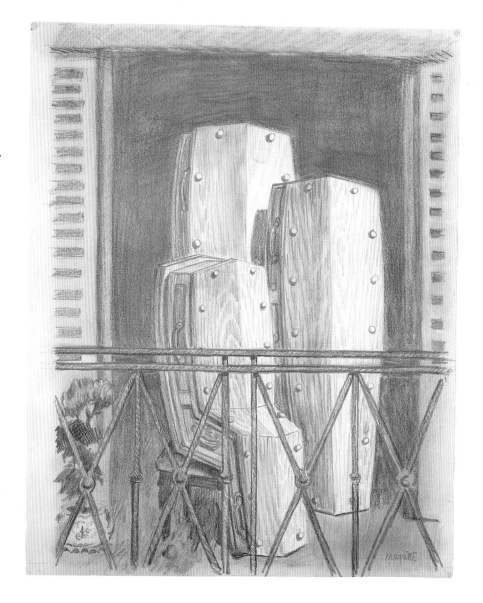

Harry Callahan
(American; b. 1912)

Chicago, 1950

Gelatin silver print; 19.2 x 24.2 cm
(7 9⁄16 x 9½ in.)
Mary L. and Leigh B. Block
Endowment, 1983.65

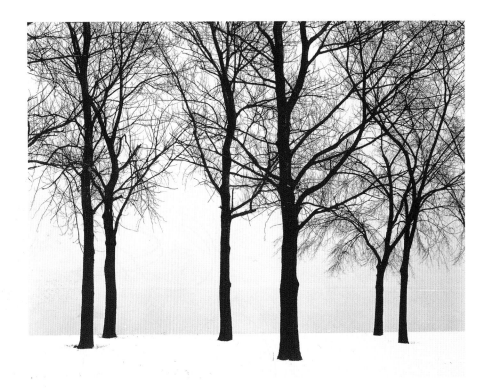

Jacob Lawrence
(American; b. 1917)

The Wedding, 1948

Tempera on board; 50.8 x 61 cm
(20 x 24 in.)
Gift of Mary P. Hines in memory of
her mother, Frances W. Pick, 1993.258

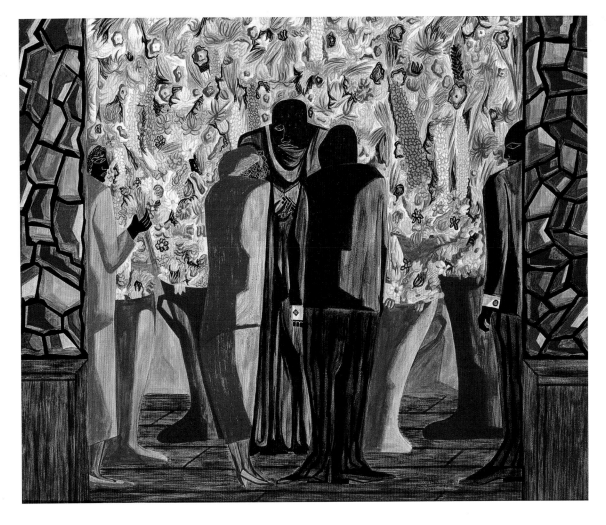

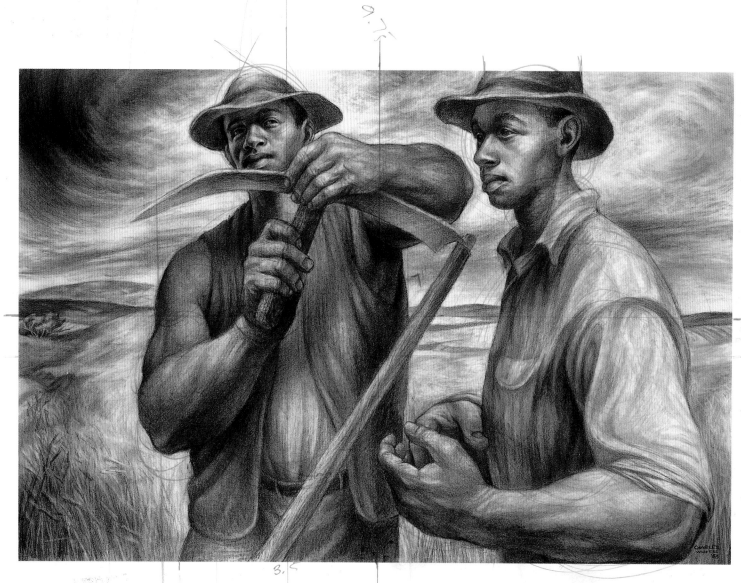

Charles White
(American; 1918–1979)

Harvest Talk, 1953

Charcoal, Wolff's carbon drawing
pencil, and graphite, with stumping
and erasing on ivory wood-pulp lami-
nate board; 66.1 x 99.2 cm (26 x 39 in.)
Restricted gift of Mr. and Mrs. Robert
S. Hartman, 1991.126

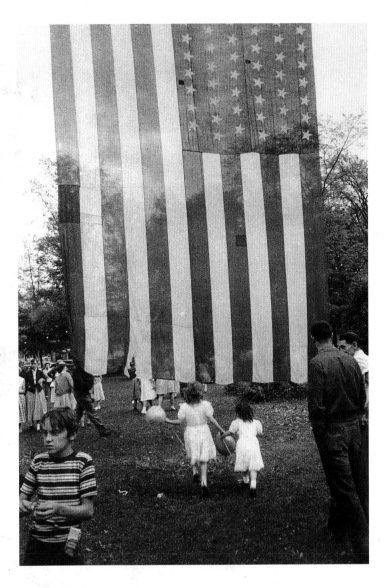

Robert Frank
(American, b. Switzerland; b. 1924)

Fourth of July, Jay,
New York, 1958

Gelatin silver print; 33.9 x 22.5 cm
(13¼ x 8¾ in.)
Photography Gallery Fund, 1961.942

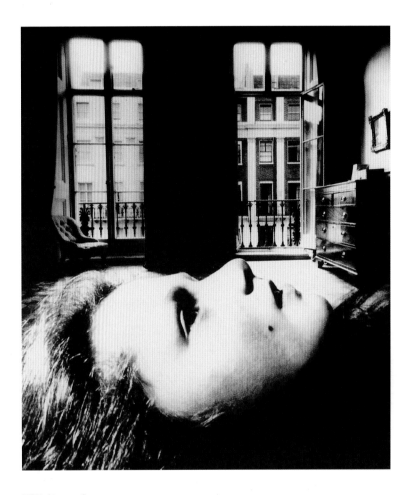

Bill Brandt
(English; 1904–1983)

Portrait of a Young Girl,
Eaton Place, London, 1955

Gelatin silver print; 33 x 28.7 cm
(13 x 11⁵⁄₁₆ in.)
Gift of Helen Harvey Mills, 1981.724

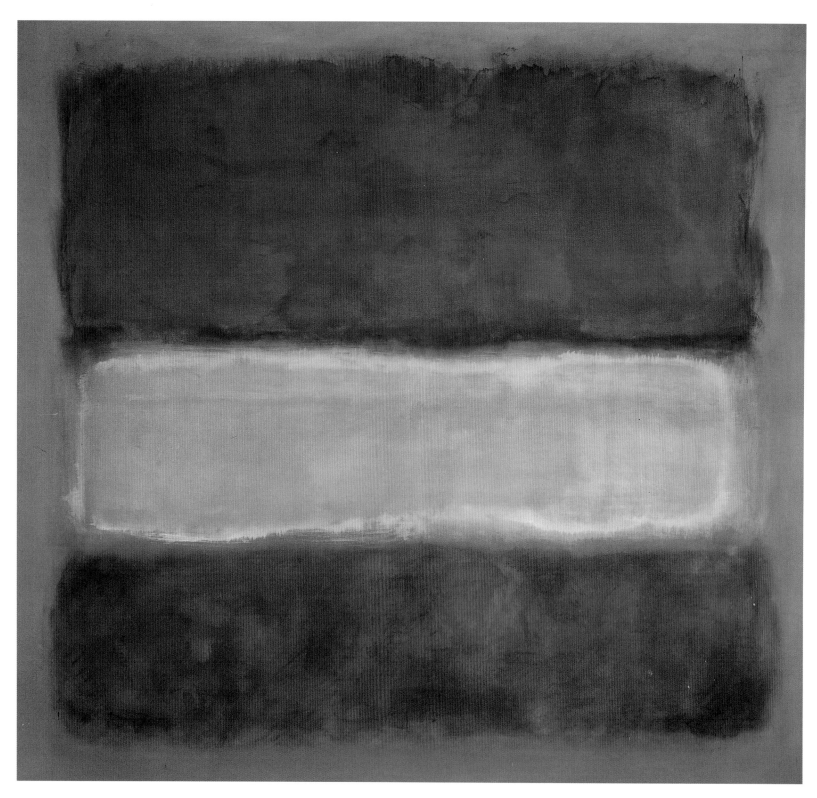

**Mark Rothko
(Marcus Rothkowitz)**

(American, b. Russia; 1903–1970)

Untitled (Purple, White, and Red), 1953

Oil on canvas; 197.5 x 207.6 cm
(77¾ x 81¾ in.)
Bequest of Sigmund E. Edelstone,
1983.509

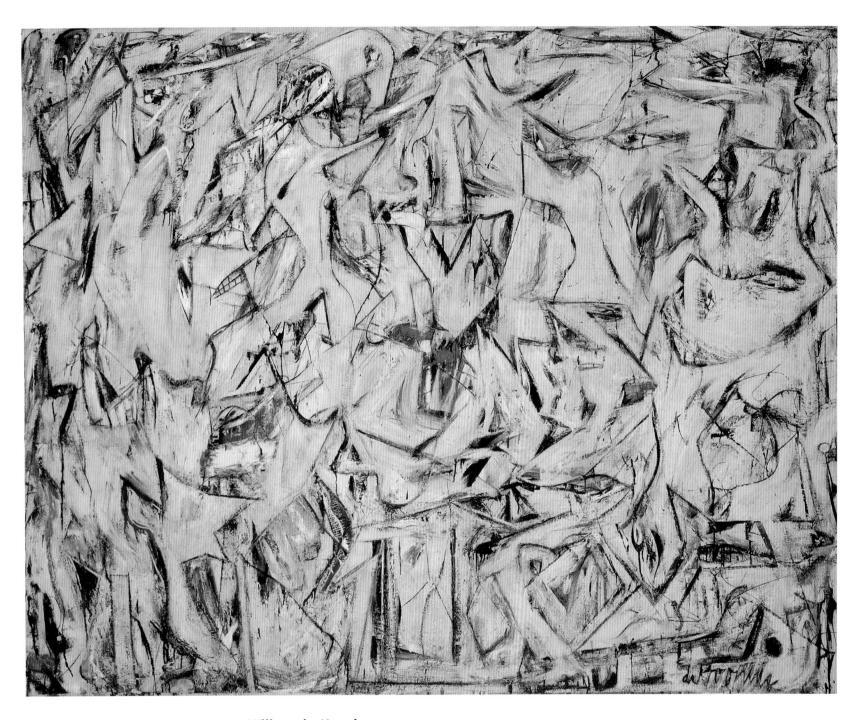

Willem de Kooning

(American, b. Netherlands; 1904–1997)

Excavation, 1950

Oil on canvas; 206.2 x 257.3 cm
(81¼6 x 101¼6 in.)
Mr. and Mrs. Frank G. Logan Purchase
Prize; gift of Mr. and Mrs. Noah
Goldowsky and Edgar Kaufmann, Jr.,
1952.1

Bruce Goff
(American; 1904–1982)

West Elevation of the Bavinger House, Norman, Oklahoma, 1950

Colored pencil on paper; approx. 60.5 x 81.5 cm (23¹¹⁄₁₆ x 32 in.)
Gift of Shin'enKan, Inc., 1990.811.14

Ludwig Mies van der Rohe
(American, b. Germany; 1886–1969)

Preliminary Drawing for Architecture Building, Illinois Institute of Technology, Chicago, 1955

Charcoal, graphite, and yellow colored pencil on tracing paper; 72 x 106.7 cm (28⅜ x 42 in.)
Restricted gift of the Auxiliary Board of The Art Institute of Chicago, 1987.46

Eugene Masselink
(American; active mid-20th cen.)

Screen for Frank Lloyd Wright's Thomas Keys House, Rochester, Minnesota, 1952

Painted plywood; panels: 137.1 x 35.5 x 1.9 cm (54 x 14 x ¾ in.) (each)
Gift of Mr. and Mrs. Thomas E. Keys, 1985.8

Skidmore, Owings and Merrill

First Model for the Inland Steel Building, 30 West Monroe, Chicago, c. 1954

Preliminary design by Walter A. Netsch (American; b. 1920)
Thermoplastic resin sheet and enameled steel; approx. 28 x 27 x 18 cm (11¹⁄₁₆ x 10⅝ x 7¹⁄₁₆ in.)
Gift of Walter A. Netsch, 1991.270

Joan Mitchell
(American; 1926–1992)

City Landscape, 1955

Oil on canvas; 201.9 x 201.9 cm
(79½ x 79½ in.)
Gift of the Society for Contemporary
American Art, 1958.193

Clyfford Still
(American; 1904–1980)

Untitled, 1958

Oil on canvas; 292.2 x 406.4 cm
(114¼ x 160 in.)
Mr. and Mrs. Frank G. Logan Purchase
Prize Fund; Roy J. and Frances R.
Friedman Endowment, through prior
gift of Mrs. Henry C. Woods; gift of
Lannan Foundation, 1997.164

Lee Bontecou

(American; b. 1931)

Untitled, 1960

Steel and canvas; 182.9 x 182.9 x 45.7 cm
(72 x 72 x 18 in.)
Gift of the Society for Contemporary
American Art, 1965.360

Kelly 60

Ellsworth Kelly
(American; b. 1923)

Study for *Blue White*, 1960

Brush and blue (Higgins) ink on
cream wove paper; 77.7 x 57.5 cm
(30⅝ x 22⅝ in.)
B. C. Holland Memorial, restricted gift
of Mr. and Mrs. B. C. Holland in honor
of Douglas Druick, 1995.55

Wendell Castle
(American; b. 1932)

Music Stand, 1964

Oak and rosewood; 135.9 x 68.6 cm
(53½ x 27 in.)
Gift of Mr. and Mrs. David E. Barnow,
1989.437

Gerhard Richter
(German; b. 1932)

Woman Descending a Staircase, 1965

Oil on canvas; 200.7 x 129.5 cm
(79 x 51 in.)
Roy J. and Frances R. Friedman
Endowment; gift of Lannan
Foundation, 1997.176

Eva Hesse
(American, b. Germany; 1936–1970)

Hang Up, 1966

Acrylic on cord and cloth, wood
and steel; 260.4 x 228.6 x 200.7 cm
(102½ x 90 x 79 in.)
Through prior gifts of Arthur Keating
and Mr. and Mrs. Edward Morris,
1988.130

Bob Thompson

(American; 1937–1966)

Death of the Infants of Bethel, 1965

Oil on canvas; 152.4 x 213.4 cm
(60 x 84 in.)
Walter Aitken Endowment, 1997.217

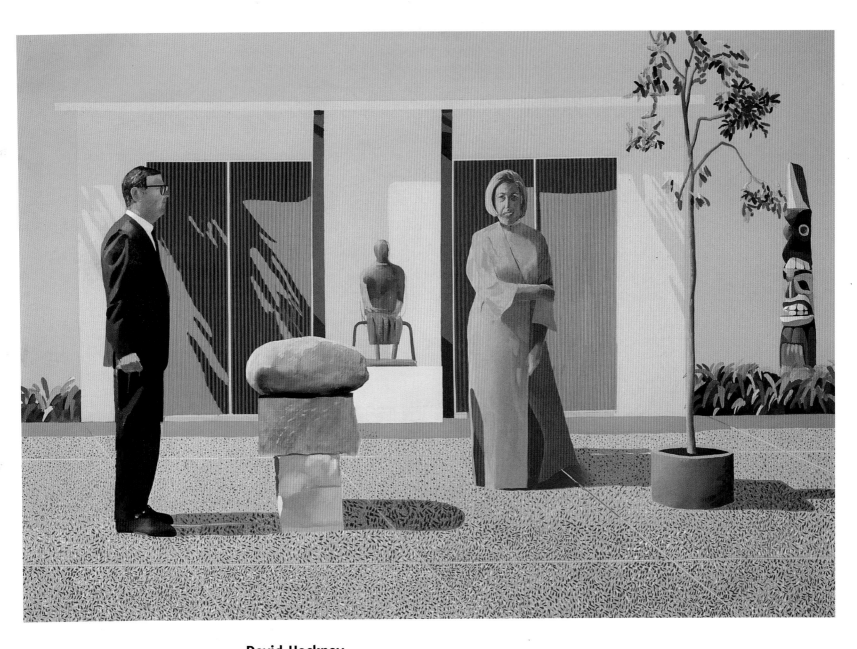

David Hockney
(English; b. 1937)

American Collectors, 1968

Acrylic on canvas; 213.4 x 304.8 cm
(83⅞ x 120 in.)
Restricted gift of Mr. and Mrs. Frederic
G. Pick, 1984.182

Vija Celmins
(American, b. Latvia; b. 1938)

Explosion at Sea, 1966

Oil on canvas; 34.3 x 59.7 cm
(13½ x 23½ in.)
Gift of Lannan Foundation, 1997.138

Diane Arbus
(American; 1923–1971)

Identical Twins, Roselle, New Jersey, 1967

Gelatin silver print; 37.8 x 37 cm
(14⅞ x 14⁷⁄₁₆ in.)
Gift of Richard Avedon, 1986.2976

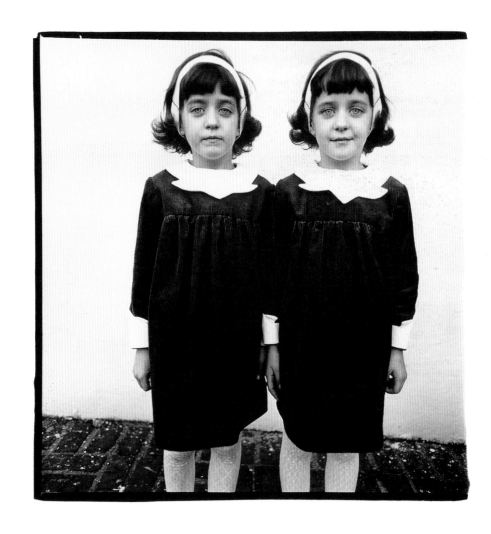

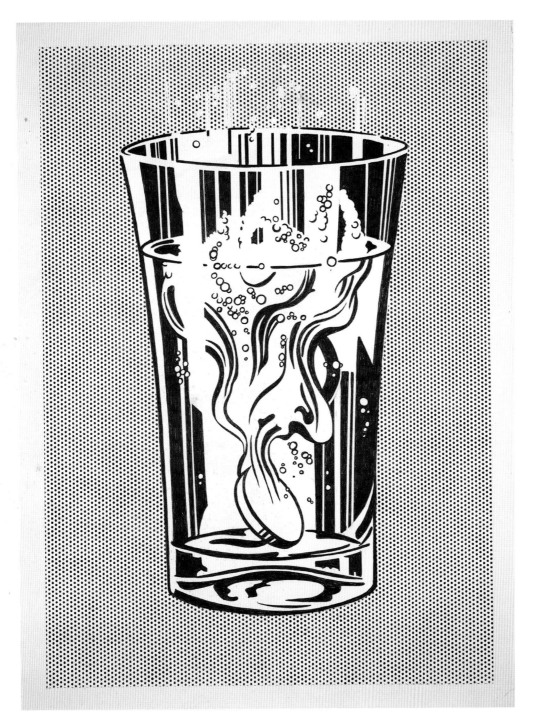

Roy Lichtenstein
(American; 1923–1997)

Alka Seltzer, 1966

Graphite with scraping, and
lithographic crayon *pochoir* on cream
wove paper; sheet: 76.3 x 56.7 cm
(30⁵⁄₁₆ x 22⁵⁄₁₆ in.)
Margaret Fisher Endowment, 1993.176

Robert Smithson
(American; 1938–1973)

Chalk Mirror Displacement,
1987 (version of a 1969 work)

Eight mirrors and chalk; 25.4 x 304.8 x
304.8 cm (10 x 120 x 120 in.)
Through prior gift of Mr. and Mrs.
Edward Morris, 1987.277

On Kawara
(Japanese; b. 1933)

Oct. 31, 1978 (Today Series, "Tuesday"), 1978

Acrylic on canvas; 155 x 226 cm
(61 x 89 in.)
Twentieth-Century Purchase Fund,
1980.2

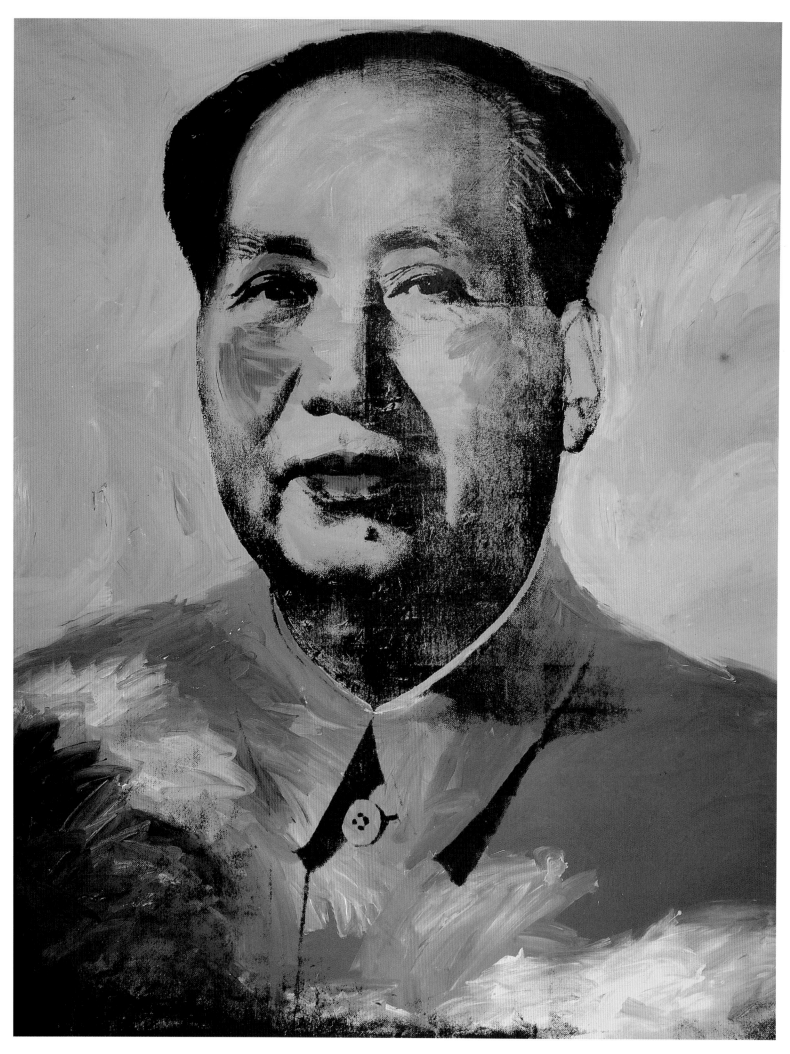

Dieter Appelt
(German; b. 1935)

Untitled, from the series
Memory's Trace
(Erinnerungsspur), 1977–79

Gelatin silver print;
58.1 x 48.2 cm (22⅞ x 19 in.)
Acquired through a grant from Lannan
Foundation, 1997.229

Cindy Sherman
(American; b. 1954)

Untitled Film Still MP #56,
1980

Gelatin silver print; 16.4 x 23.7 cm
(6⁷⁄₁₆ x 9⁵⁄₁₆ in.)
Restricted gift of Allen Turner, 1988.389

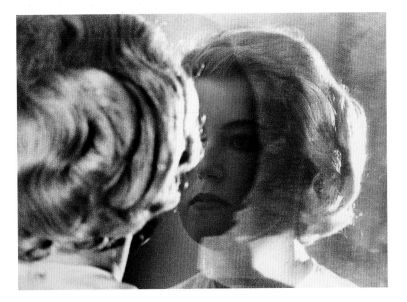

Andy Warhol
(American; 1928–1987)

Mao, 1973

Acrylic and silkscreen on canvas;
448.3 x 346.7 cm (176½ x 136½ in.)
Mr. and Mrs. Frank G. Logan Purchase
Prize, Wilson L. Mead funds, 1974.230

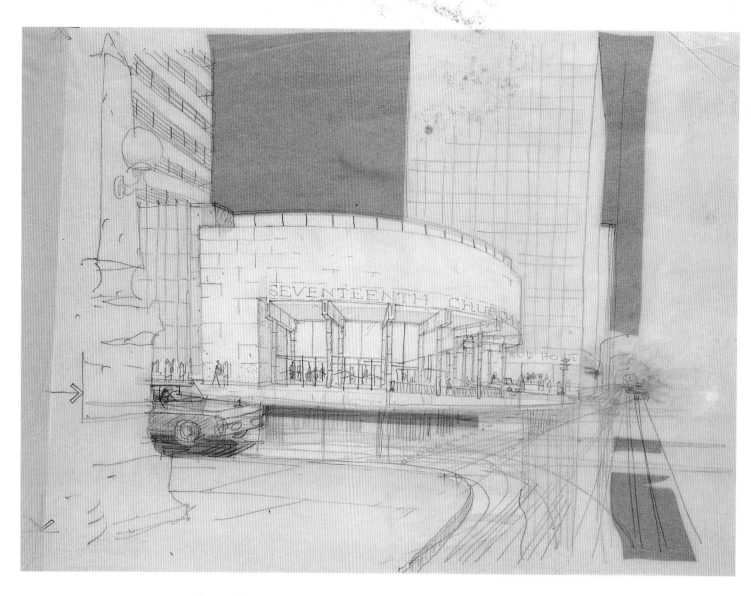

Harry Weese
(American; 1915–1998)

Exterior Perspective of the Seventeenth Church of Christ, Scientist, 55 East Wacker Drive, Chicago, c. 1968

Graphite on yellow tracing paper and collage; 36 x 61 cm (14³⁄₁₆ x 24 in.)
Gift of Harry Weese and Associates, 1982.762

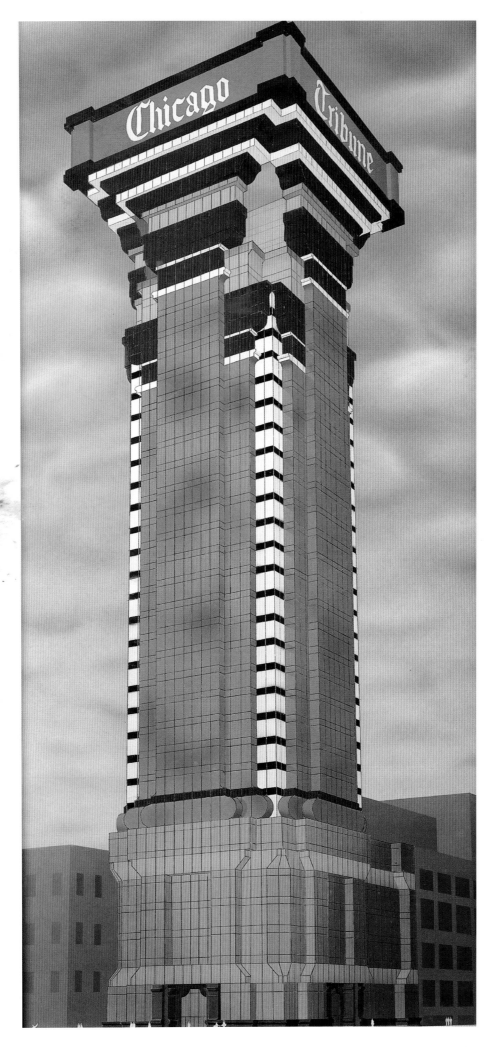

Robert A. M. Stern
(American; b. 1939)

Perspective Rendering of a Late Entry to the Chicago Tribune Tower Competition,
1980

Designed and rendered by Mark Albert (American; active late 20th cen.) and Charles D. Warren (American; b. 1954)
Airbrushed ink on illustration board; 152.4 x 76.2 cm (60 x 30 in.)
Restricted gift of Mr. and Mrs. Thomas J. Eyerman; Mr. and Mrs. David Hilliard; Mrs. Irving F. Stein, Sr., in memory of B. Leo Steif; and Mr. and Mrs. Ben Weese, 1983.14

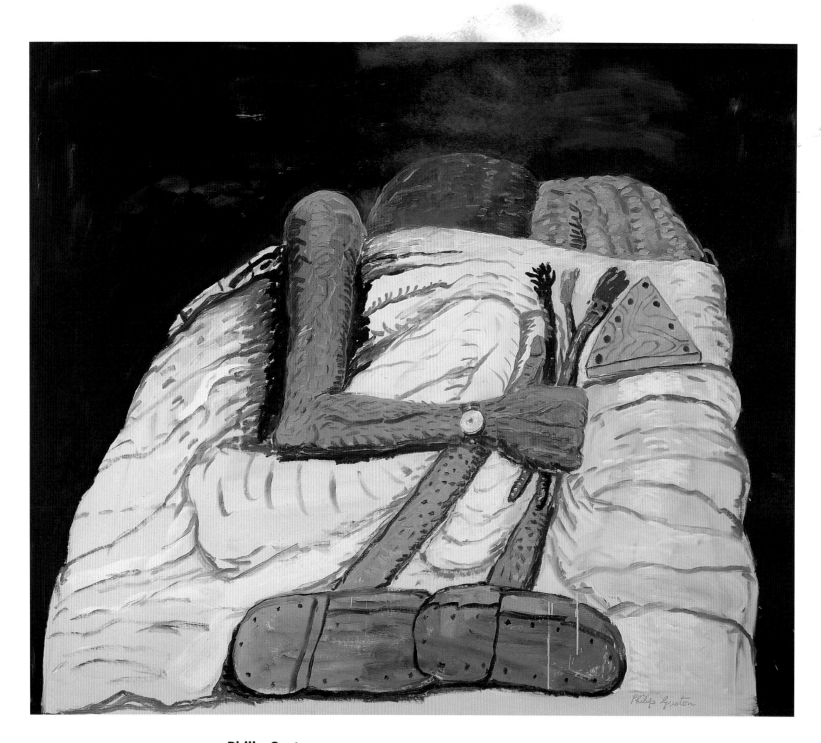

Philip Guston
(American, b. Canada; 1913–1980)

Couple in Bed, 1977

Oil on canvas; 205.7 x 240 cm
(81 x 94½ in.)
Through prior bequest of Frances W.
Pick; restricted gift of Mrs. Harold
Hines, 1989.435

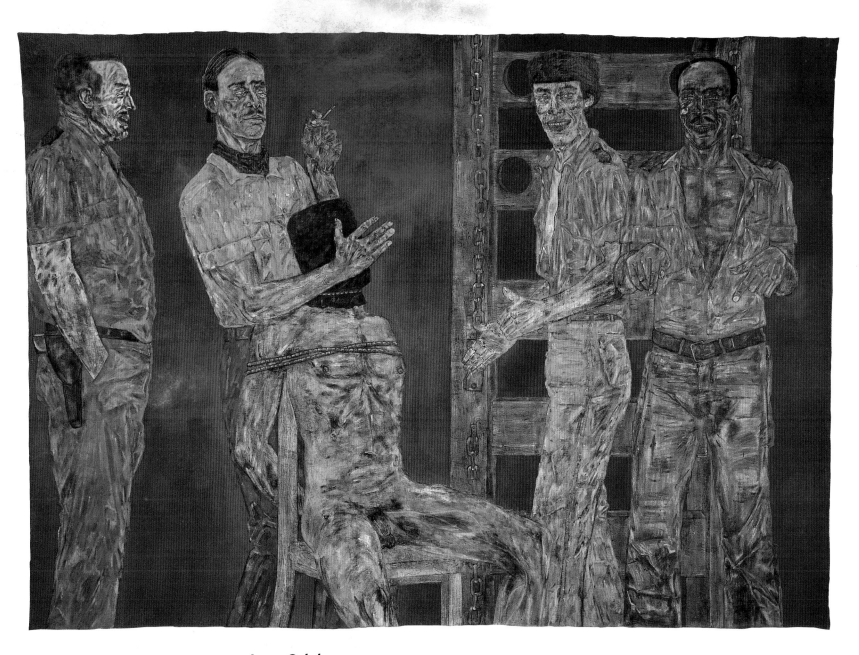

Leon Golub
(American; b. 1922)

Interrogation II, 1981

Acrylic on canvas; 304.8 x 426.7 cm
(120 x 168 in.)
Gift of the Society for Contemporary
Art, 1983.264

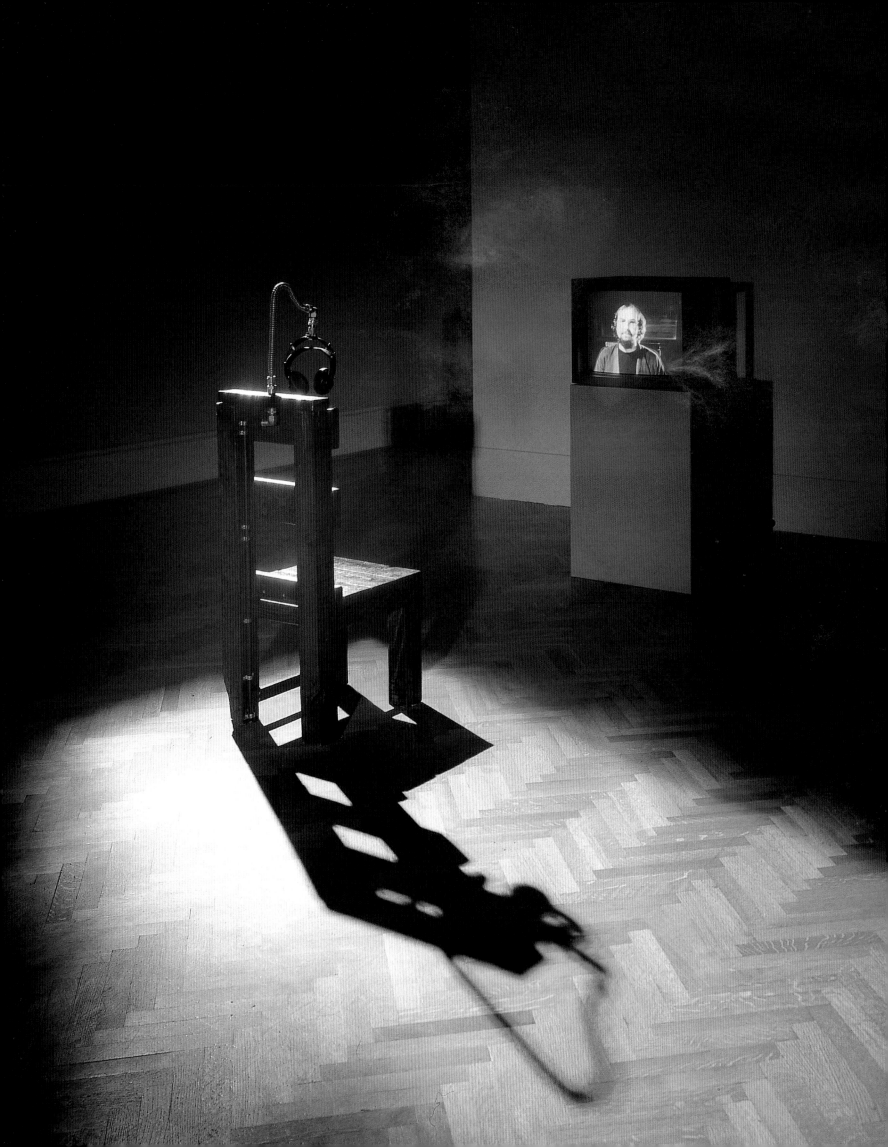

Bill Viola

(American; b. 1951)

Reasons for Knocking at an Empty House (detail), 1982

Video and sound installation with wooden chair, headphones, pedestal, and monitor; dimensions variable Restricted gifts of Barbara Bluhm, Mrs. Thomas H. Dittmer, Ruth Horwich, Susan and Lewis Manilow, Marcia and Irving Stenn, Dr. and Mrs. Paul Sternberg, and Lynn and Allen Turner; through prior acquisitions of the Mary and Leigh Block Collection, 1993.246

Jasper Johns

(American; b. 1931)

Perilous Night, 1982

Ink on frosted mylar; 100.4 x 240 cm (39⁹⁄₁₆ x 94⁷⁄₁₆ in.)
Through prior gift of Mary and Leigh Block; Harold L. Stuart Endowment, 1989.82

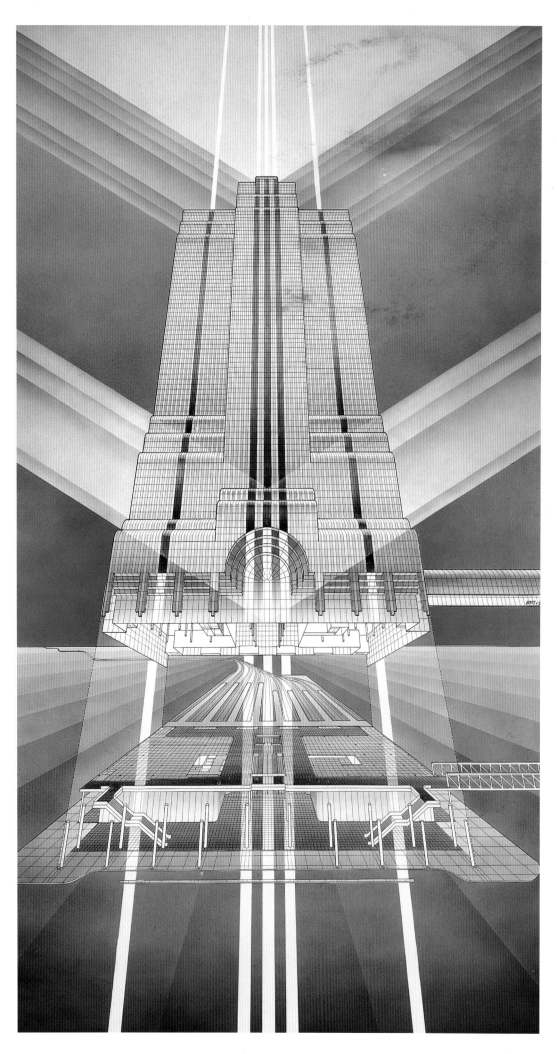

Murphy/Jahn Architects

Axonometric Rendering of Northwestern Atrium Center, Madison and Canal Streets, Chicago, 1982

Rendered by Helmut Jahn (German; b. 1940) and Michael Budilovsky (American, b. Ukraine; b. 1928)
Airbrushed ink on resin-coated paper; 182.9 x 101.6 cm (72 x 40 in.)
Anonymous gift, 1982.629

John Burgee
(American; b. 1933)

Philip Johnson
(American; b. 1906)

Shaw and Associates, associate architects

Cutaway Model of the Lobby of 190 South LaSalle Street, Chicago, 1983–84

Mixed media; 46.3 x 129.2 x 66 cm (18³⁄₁₆ x 50⅞ x 26 in.)
Gift of the John Buck Company, 1988.145.2

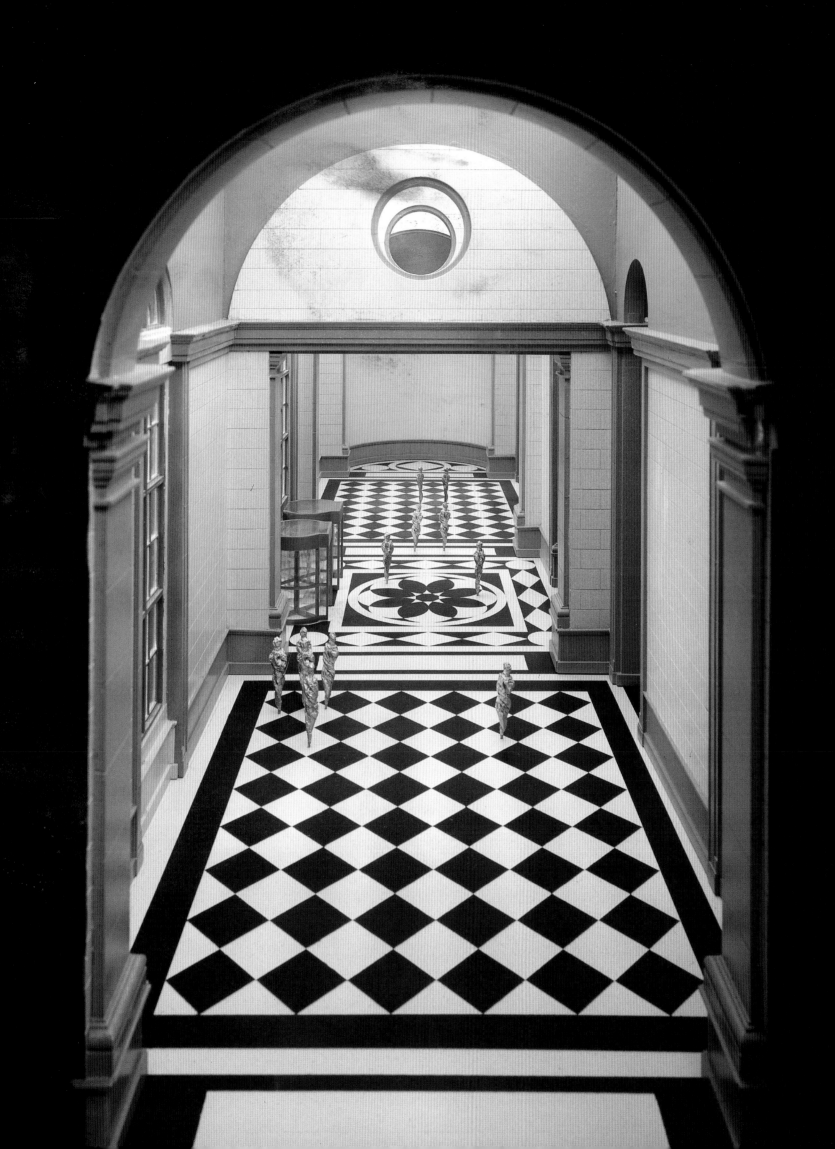

Lenore Tawney
(American; b. 1907)

Hanging Entitled *The Bride
Has Entered*, 1982

Cotton, plain weave; painted with
pigment and gold leaf; attached linen
threads in grid pattern; 176.5 x 177.6 x
213.3 cm (69½ x 69⅞ x 84 in.)
Gift of Lenore Tawney; restricted gifts
of the Textile Society, Joan Rosenberg,
Mr. and Mrs. Richard J. L. Senior, Mrs.
William G. Swartchild, Jr., and Mrs.
Theodore D. Tieken, 1990.537

Claire Zeisler
(American; 1903–1991)

Fiber Structure Entitled
Private Affair I, 1986

Executed by Claire Zeisler Studio,
Chicago
Hemp, knotting technique known as
macramé (multiple chain knots),
twisted and wrapped cords; cut fringe;
h. approx. 320 cm (126 in.);
spill diam. approx. 229 cm (90 in.)

Marion and Samuel Klasstorner
Endowment, 1986.1050

David Hockney
(English; b. 1937)

Sunday Morning, Mayflower Hotel, N.Y., Nov. 28, 1983, 1982/83

Collage of chromogenic color prints; 116 x 184.5 cm (45¹¹⁄₁₆ x 72⅝ in.) Mary and Leigh Block Photography Fund, 1983.827

Lissy Funk

(Swiss; b. 1909)

Hanging Entitled *The Other Land* (Das andere Land), 1986–87

Executed by Lissy Funk and her studio, Zürich
Linen, plain weave; embroidered with linen, wool, silk, horsehair, hemp, and gilt-metal-strip-wrapped silk in open buttonhole filling and stem stitches; laid work and couching; 207 x 335 cm (81½ x 131⅞ in.)

Restricted gift of the Woman's Board, Wirt D. Walker Endowment, and Lissy Funk Acquisition Fund, 1989.414

Martin Puryear
(American; b. 1941)

Lever #1, 1988–89

Red cedar, cypress, poplar, and ash;
429.3 x 340.4 x 45 cm
(169 x 134 x 17¾ in.)
A. James Speyer Memorial, UNR
Industries in honor of James W.
Alsdorf, and Barbara Neff Smith
and Solomon Byron Smith funds,
1989.385

Sigmar Polke
(German; b. 1941)

Raised Chair with Geese,
1987–88

Artificial resin and acrylic on
various fabrics; 290 x 290 cm
(114¼ x 114¼ in.)
Restricted gift in memory of
Marshall Frankel; Wilson L. Mead
Endowment, 1990.81

Irving Penn
(American; b. 1917)

*The Hand of Miles Davis,
New York,* 1986 (printed
1992)

Selenium-toned gelatin silver print;
49.9 x 49.5 cm (19⅝ x 19½ in.)
Gift of Irving Penn, 1996.222

Bruce Nauman
(American; b. 1941)

Clown Torture (detail), 1987

Color video, color video projection,
sound; dimensions variable
Watson F. Blair Prize Fund; W. L. Mead
Endowment; Twentieth-Century
Purchase Fund; through prior gift of
Joseph Winterbotham; gift of Lannan
Foundation, 1997.162

Gary Hill
(American; b. 1951)

*Inasmuch As It Is Always
Already Taking Place*
(detail), 1990

Sixteen-channel video, sound
installation with sixteen modified
monitors recessed in the wall; 40.6 x
137.2 x 167.6 cm (16 x 54 x 66 in.)
Gift of Lannan Foundation, 1997.144

Luis González Palma
(Guatemalan; b. 1957)

Portrait of a Boy
(Retrato de niño), 1991

Collage of painted gelatin silver prints
and manuscript material; 76.3 x 94.1 cm
(30 1/16 x 37 1/16 in.)
Photography Circle Fund, 1992.103

Joel Sternfeld
(American; b. 1944)

*Gateway National
Recreation Area, Rockaway
Peninsula, Queens, New
York, September, 1993*, 1993

Chromogenic color print;
47.5 x 60.1 cm (18 11/16 x 23 11/16 in.)
Acquired from the Center for
Documentary Studies, Duke
University, through an anonymous gift,
1997.279

Kerry James Marshall
(American; b. 1955)

Many Mansions, 1994

Acrylic and collage on canvas;
289.6 x 343 cm (114 x 135 in.)
Max V. Kohnstamm Fund, 1995.147

Robert Gober
(American; b. 1954)

Untitled, 1994/95

Wood, bronze, paint, and handmade
paper; 60.9 x 180.3 x 186.7 cm
(24 x 71 x 73½ in.)
Watson F. Blair Prize Fund, 1996.402

Guillermo Kuitca

(Argentine; b. 1961)

Untitled, 1995

Chalk and acrylic on canvas;
180.3 x 233.7 cm (71 x 92 in.)
Gift of the Society for Contemporary
Art, 1998.350

Kiki Smith
(American, b. Germany; b. 1954)

Blood Pool, 1992

Wax and pigment; 40.6 x 61 x 106.7 cm
(16 x 24 x 42 in.)
Twentieth-Century Discretionary
Fund, 1993.126

Lucian Freud
(English, b. Germany; b. 1922)

Sunny Morning—
Eight Legs, 1997

Oil on canvas; 234 x 132.1 cm
(92⅛ x 52 in.)
Joseph Winterbotham Collection,
1997.561

Katharina Fritsch
(German; b. 1953)

Monk, 1997–99

Polyester and paint; 193 x 58.4 x 43.2 cm
(76 x 23 x 17 in.)
The Anstiss and Ronald Krueck Fund
for Contemporary Art; through prior
acquisition of Mary and Leigh Block,
2000.49

Chuck Close
(American; b. 1940)

Alex, 1991

Oil on canvas; 254 x 213.4 cm
(100 x 84 in.)
William H. Bartels and Max V.
Kohnstamm prize funds; Katharine
Kuh and Marguerita S. Ritman estates;
gift of Lannan Foundation, 1997.165

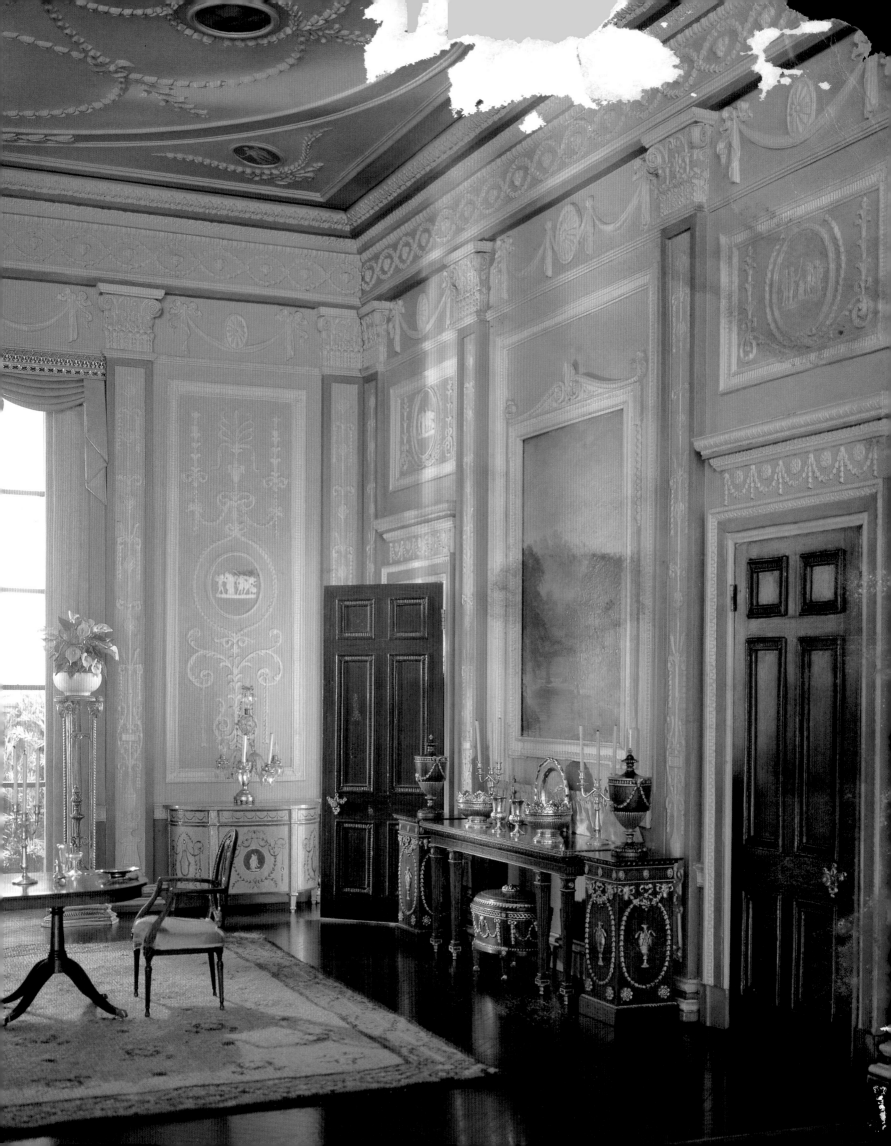

The Thorne Rooms

re-creations [o]f historic interiors, became popular in North [American] museums [in the fi]rst decades of the twentieth century. In the 1920s, the Art Institute quickly respond[ed t]o this trend, combining its decorative-arts collections into displays that represented the French Gothic, Rococo, Dutch, and Portuguese styles. But by 1940 these installations were superseded when Mrs. James Ward Thorne gave the museum an extensive group of miniature rooms. Installed as a permanent exhibition in 1954, the sixty-eight individual Thorne Rooms speak to the public's continuing interest in historical interiors. The sense of detail and charming scale of the Thorne Rooms explain their enduring popularity among visitors across generations.

The origins of this extraordinary ensemble can be traced to Mrs. Thorne's own fascination with miniatures. While traveling in Europe in the early 1920s with her husband—a member of the family that founded the Montgomery Ward stores—she began to acquire exquisitely crafted furnishings that were originally made for lavish dollhouses in previous centuries. Her passion for miniatures grew, as did her collection, which soon became too large for her elegant Lake Shore Drive apartment. She rented a studio on Oak Street, and by 1932, with the assistance of several highly skilled artisans, she produced a set of perfectly scaled, miniature period rooms. Each had its own architectural shell, housing a fully fabricated interior of ornamental plasterwork, wall coverings, and hand-carved moldings, providing a realistic setting for her miniature treasures. Four years later, by expanding her stock of antique miniatures with newly made furnishings and accessories, Mrs. Thorne undertook a broad survey of European interior design, including one Chinese room and one Japanese room for the sake of comparison. By 1940 she and her staff had finished a corresponding set of American rooms. Taken as an ensemble, Mrs. Thorne's miniature interiors represented a personalized history of design from the point of view of a singular and passionate collector.

In selecting the styles for her miniature rooms, Mrs. Thorne revealed the preferences in interior design of an upper-class woman of her time. All but one of the European rooms are either French or English, and the American examples focus almost exclusively on styles of the Eastern seaboard. She particularly admired the symmetry of Neoclassical aesthetics, as demonstrated in the gracious English dining room of the Georgian period (p. 337), based on Robert Adam's design for Home House in London (1774–78). Mrs. Thorne fashioned her Virginia dining room (p. 339) after a known example as well—Kenmore in Fredericksburg. To achieve more pleasing proportions in her room, Mrs. Thorne changed the over-mantel and moved the doors of the back wall closer to the fireplace. In fact many of these rooms resemble the eclectic, revivalist decors of the interiors of the apartments and homes of Mrs. Thorne and others of her social circle as much as they do the historic spaces that inspired them. Only a few of the rooms feature modern decor: the elegant California hallway (pp. 340–41) displays actual, original modernist paintings by Fernand Léger, Marie Laurencin, Amédée Ozenfant, and others. While Mrs. Thorne intended such careful attention to detail to give her rooms a sense of authority, she also believed that these minute but realistic objects implied a human presence. Only a bit of imagination is necessary to experience the pleasure of gracious living in these perfectly scaled period rooms.

Mrs. James Ward Thorne
(American; 1882–1966)

English Dining Room of the Georgian Period (1770/90) (detail), by 1937

Miniature room: 50.8 x 89.5 x 65.1 cm (20 x 35¼ x 25⅝ in.)
Gift of Mrs. James Ward Thorne, 1941.1195

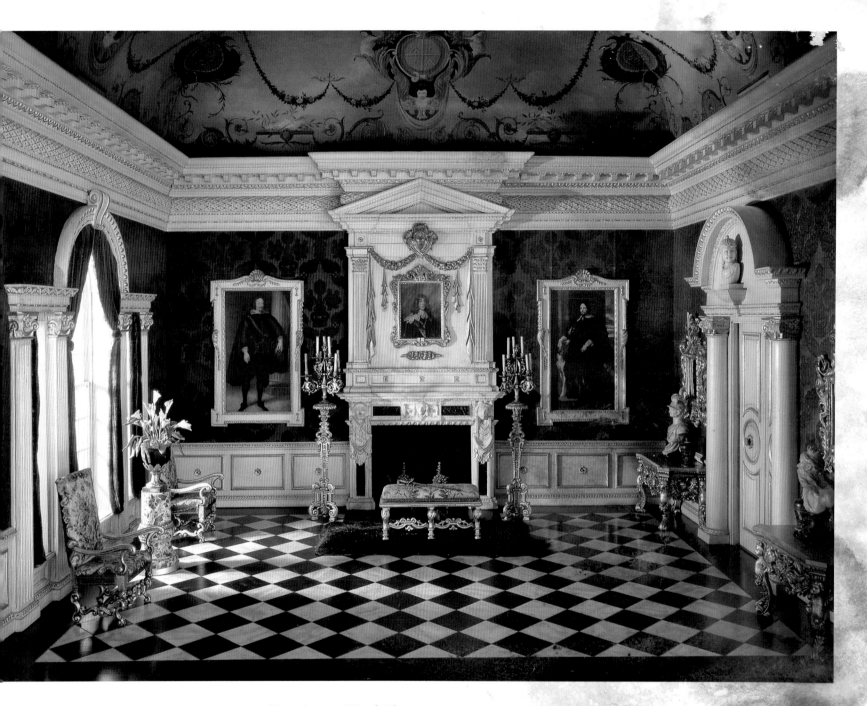

Mrs. James Ward Thorne
(American; 1882–1966)

English Reception Room
of the Jacobean Period
(1625/55), by 1937

Miniature room: 41.3 x 62.2 x 48.9 cm
(16¼ x 24½ x 19¼ in.)
Gift of Mrs. James Ward Thorne,
1941.1188

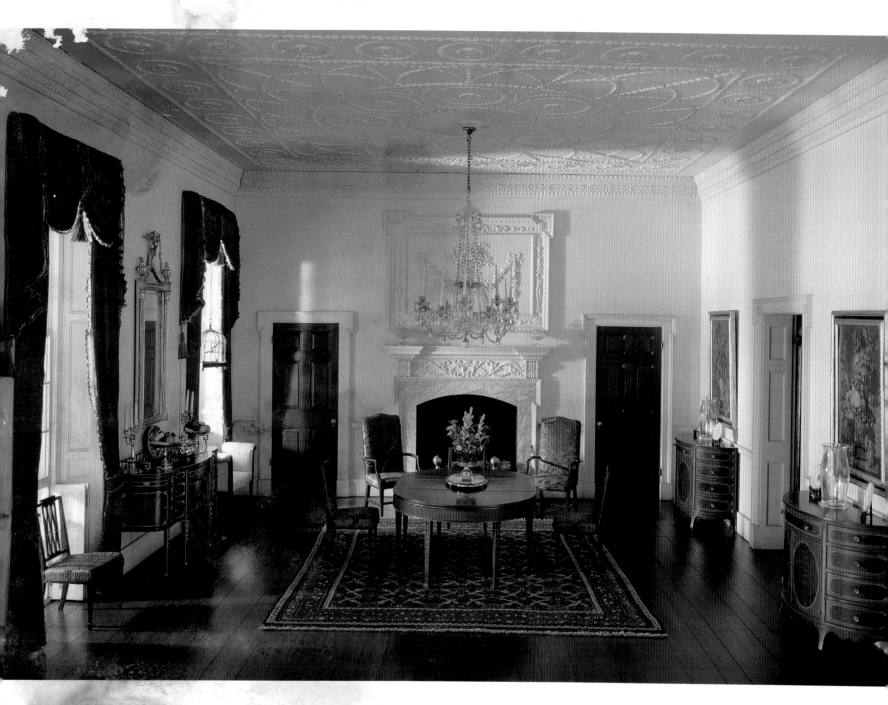

Mrs. James Ward Thorne

(American; 1882–1966)

Virginia Dining Room
(c. 1752), 1937/40

Miniature room: 35.6 x 53.3 x 54 cm
(14 x 21 x 21¼ in.)
Gift of Mrs. James Ward Thorne,
1942.502

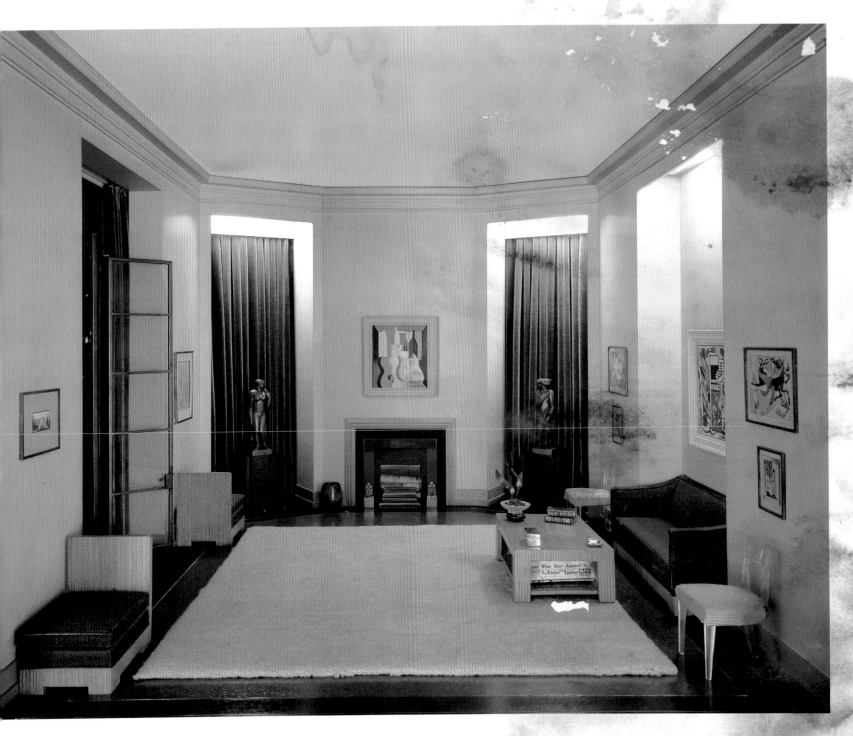

Mrs. James Ward Thorne

(American; 1882–1966)

California Hallway
(c. 1940), 1937/40

Miniature room: 35.2 x 42.2 x 50.2 cm
(13⅞ x 16⅝ x 19¾ in.)
Gift of Mrs. James Ward Thorne,
1942.517

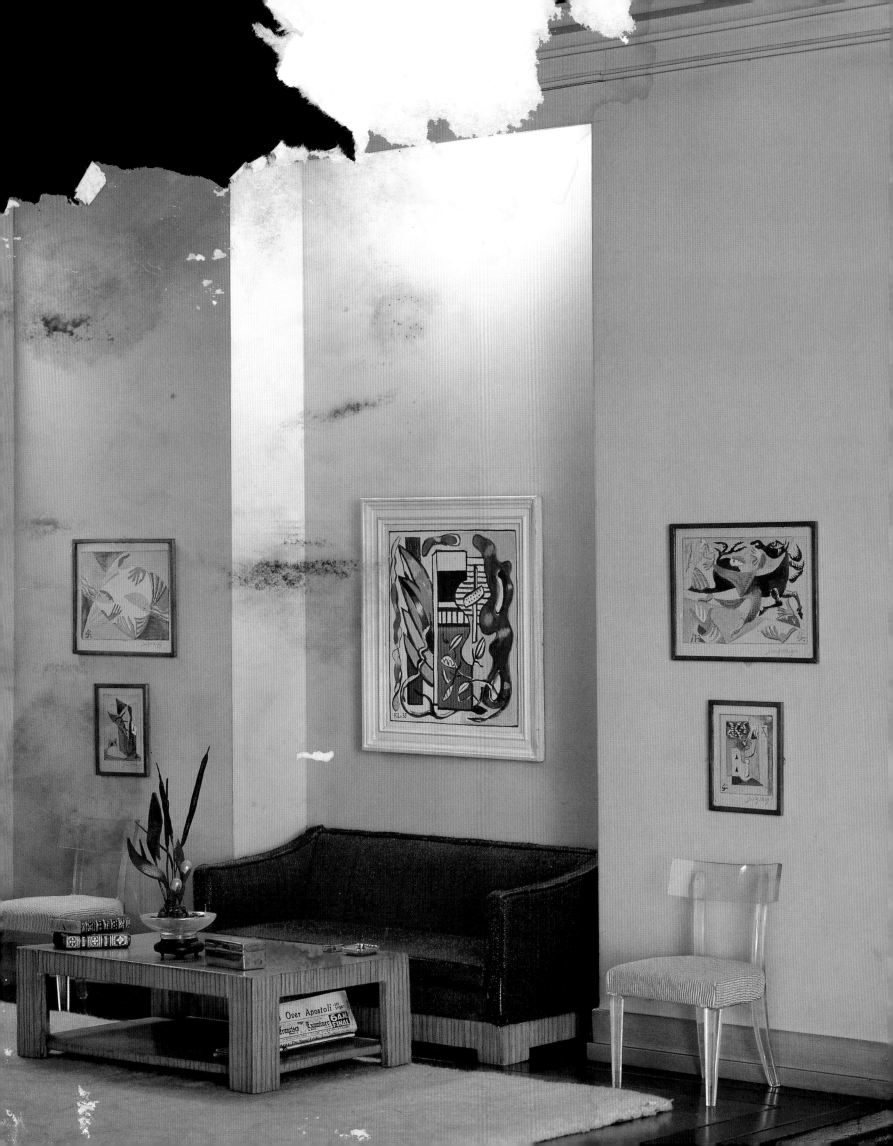

Index of Artists and Makers